DESIG
REALITI..

STUART WALKER is Professor of Design for Sustainability and a Director of the ImaginationLancaster design research centre at Lancaster University. His research focuses on design for sustainability; product aesthetics and meaning; practice-based design research; and product design that explores and expresses human values and notions of spirituality. He has written and edited several books on these themes and his propositional design work has been exhibited across Canada, in Italy and the UK, including an exhibition at the Design Museum, London.

He is Visiting Professor of Sustainable Design at Kingston University, UK and Emeritus Professor at the University of Calgary, Canada.

DESIGN REALITIES

CREATIVITY, NATURE AND THE HUMAN SPIRIT

STUART WALKER

R Routledge
Taylor & Francis Group

LONDON AND NEW YORK

First edition published 2019
by Routledge
2 Park Square, Milton Park, Abingdon, Oxon, OX14 4RN

and by Routledge
711 Third Avenue, New York, NY 10017

Routledge is an imprint of the Taylor & Francis Group,
an informa business

British Library Cataloguing-in-Publication Data
A catalogue record for this book is available from the British
Library

Library of Congress Cataloging-in-Publication Data
Names: Walker, Stuart, 1955– author.
Title: Design realities : creativity, nature and the human
 spirit / Stuart Walker. Description: First edition. |
 New York : Routledge, 2019. | Includes bibliographical
 references.
Identifiers: LCCN 2018023500| ISBN 9781138580183
 (hardback) | ISBN 9781138580206 (pbk.) |
 ISBN 9780429489037 (ebook)
Subjects: LCSH: Design–Philosophy.
Classification: LCC NK1505 .W355 2019 |
 DDC 745.2–dc23
LC record available at https://lccn.loc.gov/2018023500

ISBN: 978-1-138-58018-3 (hbk)
ISBN: 978-1-138-58020-6 (pbk)
ISBN: 978-0-429-48903-7 (ebk)

Typeset by Alex Lazarou

DEDICATED
to those taking it forward, especially
Lucas, Nik, Sebastian, Spyros, Xiaofang

Contents

Figures and Tables x

Abbreviations and Acronyms x

Acknowledgements xi

Prologue xiii

PART I: REALITY

1 As it is 3

2 A Competitive State 4

3 Share Price 6

4 Property 9

5 Branded 18

6 Inversion 20

7 Unbranded 22

8 Reality 24

9 Prestige 25

10 Icarus Falls 28

11 Sellers All 29

12 Waste 30

13 Bypassed 32

14 Fair Game 33

15 What else is on? 35

16 My next fear 38

17 Time closed 39

18 A Moment in the Life of a Reed 40

19 Illusions of forever 41

20 Local? 42

21 Burying Your Dead in the Sand 44

22 Air 46

23 Carbon 47

24 Becoming Human 55

25 Internationalization 57

26 Craft 'n Kitsch 59

27 Modern and Traditional 61

28 Design Think 63

29 Enough 65

30 Damage 66

31 Seeing 67

PART II: ANOTHER REALITY

32 How should we live? 77

33 Moderation 80

34 Legacy 83

35 Ashes of Myopia 84

36 Closest to the Dreaming 85

37 Fragile 87

38 Being Alive 89

39 Nature's Wisdom 90

40 Repeated Patterns 93

41 Profits and People 96

42 Return to Syros 99

43 What reward have ye? 102

44 Atomization 103

45 Lost 105

46 Authenticity 106

47 Change 108

48 Seriously 110

49 New 111

50 The Comb Shop 112

51 Repair 114

52 Resurrection 116

53 Photograph 119

54 The Human Touch 121

55 Perspective 123

56 Art 125
57 Drive 127
58 Elevator 129
59 And more 141
60 Economy 142
61 Beyond Protectionism 144
62 IP 147
63 Commonality and Originality 149
64 Secular Society 154
65 Sacred Time 156
66 Misreading Religion 157
67 A Stultifying Dualism 160
68 Faith 161
69 Rubens' Jesus 163
70 Enculturated Blindness 164
71 A Christmas Story 167
72 Mythic Objects 171
73 Another Reality 182

PART III: A FUTURE REALITY

74 A Wisdom Economy 201
75 Fair Share 203
76 Design Rhapsody 206
77 Spiritual Renewal 208
78 Cultural Highs and Lows 211
79 Improving Things 213
80 Moving on 217
81 One Manifestation of Wisdom 218
82 Why 220
83 After this? 222
84 A Creative Life 223
85 Delicate, Evanescent Things 224
86 Useless Things 226
87 Dying to Create 227

88	Live	229
89	RAW Design	230
90	Ruination	233
91	Rejuvenation	237
92	Things that Endure	240
93	The Mark Made	244
94	Handmade	247
95	Whittling	249
96	Foraging	251
97	Artefacts	253
98	Life	264
99	Improvisation	265
100	Progressive Design Praxis	268

Endnotes	295
Bibliography	319
Index	335

FIGURES AND TABLES

Figures

1 The Interdependent Relationship between
 Commonality and Originality 153
2 Art's transcendence reduced to a fridge magnet 281
3 Progressive Design Praxis 289
4 Progressive Design Praxis, Charity and Sufficiency 291

Tables

1 The inadequacies of eco-modernist, technological
 routes to sustainability 270
2 Illegal, immoral or reprehensible practices among
 prominent institutions 277

ABBREVIATIONS AND ACRONYMS

ASA Advertising Standards Authority
CAD Computer-aided design
IP Intellectual property
LP Long playing record; a vinyl album
TDI Turbocharged diesel injection

ACKNOWLEDGEMENTS

I would like to thank the Arts and Humanities Research Council and the Arts Council of England for funding my research and design projects, which, in a variety of ways, have informed many of the writings in this volume. I also thank the University of Wollongong, New South Wales for their Visiting International Fellowship Award, which brought many new opportunities for learning. Thanks also to the various peer-reviewers who have provided such constructive and positive feedback on this project, and to Routledge for their encouragement and efforts in bringing this work to publication, especially Jennifer Schmidt and Fran Ford. And, as always, I am grateful to my wife Helen for her expert copy-editing and unwavering support.

Prologue

Ideas, styles, opinions and recollections – we gather them up. They may be interesting, amusing, troubling or useful, or they may strike us as simply irrelevant. Yet, together they take on meaning and significance – a picture emerges that is more than the sum of the parts. This picture may be fractured, there may be pieces missing, but it is our picture, our perspective on the world. And it is never fixed. New pieces are constantly being added as others are set aside.

Creativity is a synthesizing process. Artists and designers draw on many things and, from their own particular viewpoint, attempt to give them coherence through forms of expression that are both imaginative and original. Their work may be shaped by observations, assumptions, materials, techniques and chance incidents. The creative process can embrace virtually anything, but to be relevant, it must speak to the times.

In keeping with this diversity and serendipity, this book covers a wide range of topics and employs a mix of forms, from critique and personal reflection to rational inquiry. These are presented in different styles – short essays, lyrical pieces, photo studies and longer discourses. There are different ways of writing and different ways of reading. Academic texts tend to be written in a straightforward, rational manner, the aim being to clearly communicate concepts and information in a step-by-step, linear way. And when we read such texts we do so with the intellectual mind. Other kinds of writing convey ideas in a different way – through rhythms and tones, images and impressions. As we read such pieces, a picture is painted – the process is more experiential and holistic. Both kinds of writing are capable of carrying meaning, both have value, and both are present here. This variety of forms and styles seems appropriate for a book on creativity and the human spirit because it permits imaginative evocation as well as logical discussion. It also offers some advantages over more standard formats. It is especially suitable for tackling ideas that do not necessarily warrant

prolonged arguments or elaborate treatments; there is often more potency in brevity.

The book is arranged in three parts. The first, *Reality*, looks at the world as it currently is. This is an unembellished and somewhat unrelenting recognition of our present state, which is becoming increasingly untenable. The second, *Another Reality*, discusses many of those things we have tended to devalue or ignore in modern society but which are essential for a more balanced and more fulfilling way of life. The third, *A Future Reality*, offers a constructive way forward – one that holds the potential of recovering and restoring a more holistic, more positive outlook. My hope is that, taken as a whole, these essays offer a broad picture of the creative process and its relationship to inner development and spiritual well-being. I trust they also reveal the obstacles facing creative pursuits in our highly rationalized, instrumental culture and demonstrate why forms of creativity that are grounded in enduring values and notions of human meaning are so essential for addressing the major challenges facing us today.

Some people argue that it is only logical argument that allows us to think correctly,[1] the inference being that other forms of thought are somehow unsound or flawed. But the human imagination is not bound by logic and the creative process in particular is characterized by unreasoned connections, flights of fancy, tacit knowledge, values, aesthetic judgement, passion and emotional resonance. These may not be logical and they are certainly less explicit, nonetheless, they are all vital aspects of being human. It is on this account that these other forms of expression have a legitimate, indeed a necessary, place in this book. The topics and styles may be diverse but, like passengers on a train, each has a reason for being here and all are bound together by a common direction of travel.

I should also make clear that in these pieces I am not especially concerned with definitive resolutions. Creativity is about wrestling with ideas; this matters more than reaching conclusive answers. As Storr has said, *"each new creative step points the way to the next artistic or scientific problem"*.[2] Meaning and value reside in the process; in the possibility, frustration, hope and doubt and, potentially, in the sense of accomplishment and joy one experiences when a satisfying creative expression is achieved.

There have been many books written on creativity and the applied arts. There are practical, well-illustrated 'how to' books about the use of certain

media or materials, from charcoal drawing to CAD, and from textiles to plastics. Others focus on particular themes, like graphics, products, services or co-design. And there are books on the theory and philosophy of design and technology. All these offer in-depth knowledge about particular elements of the creative process and their implementation. However, their very specialization often tends to preclude consideration, and therefore understanding, of the wider issues, dilemmas and questions that our creative activities can, and in my view, should, be addressing. This book is an attempt to fill this gap. Its many and varied topics mean it can be dipped into at any point. A good number of the pieces can be read in just a few minutes. In these essays I implicitly or explicitly contest many aspects of our present course; the intention being to question assumptions, stimulate ideas, and provide food for thought.

Many of the ideas and observations in the book are drawn from first-hand experience. They are the result of many years of international travel, most of which has been associated with my career, first as an engineer and later as an academic. I am aware, too, that in this there is both an irony and something of a double-bind. Such international travel, which has become the norm and the expectation in many fields, is part of our unsustainable problem. At the same time, without such travel, many of the insights and experiences presented here would not have been possible and, without them, the basis and direction for positive change proposed in the final chapter would have been less substantiated and therefore less convincing. That said, it is a direction that is grounded in imagination, creativity and compassion – it is through such means that we have the potential to build a more considerate, more responsible and more hopeful way forward.

PART I

REALITY

1

As it is

We have a strong inclination to categorize, classify, order and structure our concepts of reality by creating systems and taxonomies. By dividing them into ever smaller, easily digestible parts we feel we are better able to grasp complex things. And we then use this information to control and transform our world.

I have sat through I don't know how many humourlessly earnest presentations in which another ambitious academic or company employee has created a chart, system or structure for something or other. And I have to admit that I, too, have participated in this tendency to tidiness. But the more I have seen, the less convinced I have become of their value and validity.

Cumulatively, such artificial separations push us towards understandings of reality that are both false and prejudicial. All this rigorous organizing may actually be doing more harm than good because it allows us to create the world entirely in our own image. We divide and conquer and force it to obey our will, but that world is lacking – not least because such structured approaches to knowledge seem to reduce our capacity for creativity.[1] And sadly, in the process, we blind ourselves to the world as it really is, with all its complexities and magnificent, inexplicable beauty.

It is entirely predictable that, in our overly simplistic classifications and orderings, we place humankind at the top.[2] This conceit has wrought havoc on all the other forms of life with which we share this planet. From this exalted, self-appointed position, our conception of the world is one of hierarchies and utility. Other animal species, as well as plants and minerals, become fodder for our ambitions – things to exploit, use and bend to our will.

As it is, the world – the real world – is an unclassified, uncategorized, unimaginably rich and intricately precious wonder that we must learn to truly see, appreciate and care for.

2

A Competitive State

Greece needs to become more competitive – we've heard this time and again from politicians and economists.[1,2] In the UK, our health system needs to become more efficient; our universities need to grow to survive; our schools need to be run by private sector providers; and our public services need to be more business-like.

None of this makes much sense and most of it is patently foolish because it represents a complete inversion of everything we have traditionally held dear.

The overly simplistic and severely deficient mantra of economic rationalism is being crowbarred into situations where it has no business. The above examples represent complex collective conditions that, at their heart, involve people. But when everything becomes market-led, the competitive edge slices away all that does not contribute to earnings. Responsibility, morality, loyalty, empathy and trust become relegated to quaint, half-remembered impressions of a bygone age. In the resulting ambience of anxiety, we become more focused on our own individual needs, more concerned with our own personal success, less comfortable with, and more resentful of, the achievements of others; it is a formula for discord and unhappiness.[3] And, steadily, our society becomes less convivial, more hardened, a little uglier.

It is bizarre that we have come to think of countries in the same way we think of corporations and that a statement like 'Greece needs to become more competitive' is met with general nods of approval. A country is not a company. It is land and place, history and tradition, culture and religion, art and dance and song. It is people – families, friends, births, marriages, living and dying together, sharing joys and sorrows, lending a hand, caring and being cared for. These things are also true of our health system, places of learning and public services, which can and should be about nurturing, tending and supporting each other. Competitiveness has little or no place here, because it is a blunt and brutal instrument ruled by profits and

performance indicators. It creates winners and, thereby, losers, failure, resentment and division. The attempt over recent years to marketize every aspect of our society represents an assault on human connections and relationships.[4]

Of course, these things still have to be paid for, as our local *"pragmatist in a suit"*[5] is only too keen to point out. But when everything becomes market-driven, the available funds tend to end up in the wrong places. A prominent American university that enthusiastically adopted the business model was found to have low rates of degree completion, high rates of student loan defaults, and twice as much money being spent on marketing as on teaching.[6] Similarly, in British universities, growth in market values and increased student fees have been accompanied by many vice chancellors receiving exorbitantly high salaries.[7] And a leading grammar school in the UK that expelled A-level students who failed to achieve top grades in their interim exams has been accused of prioritizing league tables over the education and welfare of its students.[8] Clearly, these are not the features of a better education system.

We also have to recognize that these developments towards free-market competition in virtually all sectors of life are due *not* to some unalterable force of human destiny. They result from decisions made by those in leadership positions and they are fundamentally ideological in nature.

3

Share Price

When companies are answerable to shareholders, time horizons shrink – decisions are made around quarterly profits and dividends rather than being guided by a long-term vision. This can have very destructive effects. It marks an alteration in purpose. The company changes from being an enterprise that creates worthwhile products and good work, and becomes a means to another end. In its efforts to maximize shareholder value, the board might well look favourably upon a takeover bid from another organization, which could be in another region or another country. To sweeten the deal, extravagant promises will often be made – to keep the head office where it is, to invest heavily, to increase jobs. The share price surges and shareholders, swayed by thoughts of large returns, willingly oblige by voting for the acquisition.[1]

For the financial services industry such deals are highly sought after – part of an aggressive game of mergers, consolidations, expansion and growth – this is their *raison d'être*. Politicians typically praise such moves, with words like 'in the nation's best interest', 'good for workers' and 'good news for the economy'. In reality, they have little option but to make reassuring noises because they are helpless in preventing such takeovers. And there are no legal frameworks for dealing with organizations that renege on their pre-deal promises, as they so often do.

This kind of acquisition can be deeply corrosive, because key decisions are taken away from the people who built the company and are placed in the hands of the new owners. For the creators and the employees, this can undermine their sense of identity and of being part of something worthwhile – something that people can point to and say we built this together here, in this place.[2] As a consequence, being taken over by an outside organization represents a major loss in meaning, significance and purpose.

When a company is taken over, profits that once would have stayed in the community are now directed elsewhere. There is no reason why foreign owners would commit funds to the local community of another region or

country; they don't shop in the town centre or picnic in the park and their children don't go to the local school. The building of community and sustainable futures depends on locally owned enterprises, and their owners, managers and employees being committed to and investing in place. Local ownership means there is a vested interest in community, the state of the local environment, use of local resources, support of local suppliers, and adapting to local markets. All these contribute to cultural distinctiveness, colour and character, which, in turn, contribute to people's sense of identity, belonging, self-worth and personal well-being. Such things matter.

Hence, actions that may well be in the best interests of shareholders often represent an evisceration of things that, although intangible, are vitally important to people. Indeed, it is these very things – purposefulness, accomplishment and self-determination – that motivate us and give our lives meaning. Take them away and a person's spirit and sense of hope about the future become eroded. But these critical human considerations will not be found among the euphemistic jargon of decision-makers and government policies. An advisory paper for the European Union on the effects of foreign takeovers puts it this way, *"the threat of takeovers diminishes the expected value of investing in firm-specific human capital"*.[3]

Contrast this with independent, family owned businesses that are in charge of their own destiny. They are not concerned with quick profits and 'making a killing' but with longer term goals. Investment in the future is important for them because the future is their children and grandchildren. One finds too, that there is care for employees and their families – there are apprenticeships that bring the next generation into the fold. This, of course, benefits the company but it's a two-way street – it also provides local people with good work. There is continuity, caring and community fostered through intergenerational knowledge among employees, and a sense of belonging and being part of something that is rewarding and worth working for. This is the true value of enterprise and the true purpose of work.

4
Property

Land, rivers and pathways become privatized for the privileged and reserved for the rich, with spikes, grilles, systems and signs.

Through such artefacts of possession, places of one's birth, memories of one's youth and the sights and sounds of one's soul are purloined, owned and closed off to the likes of you and me.

It is of little comfort to learn from the wise that property is illusory.

5

Branded

On returning to Britain after spending much of my working life abroad,
I was struck by how much everyone was talking about brands. Mention of
them was everywhere, such talk had even penetrated academia. This looked
to me like a major sell-out – not least because acceptance of the idea of
brands buys into the corporate business model. The endorsement of brands is
probably the most significant consequence of a remorseless and burgeoning
marketization of every aspect of society. For such a model to be embraced
by academia appalled me because it indicated acquiescence to, rather than
critically challenging, the shallow vested interests that lie at its core. It turns
academics into service providers, students into customers and reduces educa-
tion to a stylishly advertised, fee-seeking, results-oriented transaction; some
institutions have even resorted to 'buy-one-get-one-free' degrees.[1]

When we concern ourselves with brands there is a propensity to substi-
tute surface for substance and involve ourselves with outer image rather than
inner integrity. The 'selfie' and social media are symptoms of this focus on
appearances – getting just the right image of oneself to create a self-made
'brand' for the world to see. This is a path lined with temptation, lies and
deceit. And once created we have to maintain it – irrespective of whether it
is warranted or true. Companies, educational institutions and individuals
devote time to fabricating how they wish to appear – often before they have
actually achieved anything. This, of course, is a much easier alternative than
building something over many years through hard work and to the very best
of our abilities. But it is only through such means that, slowly and patiently,
one can build a deserved reputation – as an organization or as a person. Such
reputation as one might acquire will then be based on what has been accom-
plished rather than what we claim about ourselves. To have any legitimacy,
it should be others who affirm our reputations, not ourselves. The former is
earned whereas the latter is immodest and susceptible to exaggeration and
pretence.

In 2010, the *Deepwater Horizon* drilling rig in the Gulf of Mexico suffered a blow out and explosion and subsequently sank. It had a devastating environmental effect. BP's branding with its green and yellow Helios logo that suggested sunshine and flowers, and its claims of being an environmental leader and aiming to be 'beyond petroleum' suddenly looked very shallow indeed and it made the company look foolish and insincere.[2,3] Similarly, when the Volkswagen emissions scandal was revealed in 2015 it made a mockery of the company's pro-environmental brand image – an image that was self-constructed and self-asserted. Shortly before the scandal broke, it had launched a high-profile ad campaign claiming that its VW TDI engine was 'Clean Diesel'[4] – yet cars with this very same engine had been fitted with technology aimed at deliberately cheating emissions tests. When the deception was revealed, it left Volkswagen's reputation in tatters.

In Britain, the Advertising Standards Authority (ASA) has been finding more and more universities breaching the advertising code by making unsubstantiated or inaccurate claims about themselves – that they are in the top 1% of universities worldwide; that they have been awarded 'university of the year'; or that their teaching quality is 'gold standard'.[5] The misleading self-aggrandizing nature of such messages seems especially undignified when they concern universities – which are supposed to be about accuracy and trustworthiness. Six UK universities were recently told by the ASA to change their marketing claims.[6] When universities are named and shamed they bring the whole sector into disrepute by undermining the public's confidence in legitimate achievement and excellence.

These high-profile examples demonstrate that when we focus on brand and image rather than building a reputation with integrity and honesty there is a tendency to substitute surface for substance, profits for principles and, potentially, infamy for honour.

6

Inversion

At the age of eighty, the distinguished British philosopher and humanist Bertrand Russell turned his hand to fiction and published a volume of short stories.[1] After a lifetime of philosophical inquiry, it is no surprise to learn that his fictions raise deep ethical questions. A particularly malignant character is his Dr Murdoch Mallako who takes occupancy of a villa in Mortlake, a suburb in the London borough of Richmond. His speciality is planting malevolent seeds in the minds of his clients, which he does with a clarity of logic that befits the author of these tales. The mysterious Dr Mallako inverts normal understandings of right and wrong and does so in a manner that serves the unspoken and, as yet, unacknowledged self-interests of his visitors. They leave his house shaken by his suggestions. But the seeds have been sown and, in time, they take root. However, the fruits they bear are not what they expected. All their wished-for rewards turn into depression and misery.

Russell imaginatively explores these worldly temptations, how the power of suggestion inveigles its way into our minds to prey on our self-absorbed weaknesses – by making black seem white, up seem down. And he shows the toll this takes on our composure and our conscience.

He conjured his fictional world in the post-war years of the early 1950s, a time that saw a ramping up of suburban development together with huge expansions in the mass production of consumer products. The separate 'little boxes' of this new suburbia, which all look just the same, according to Malvina Reynolds' 1962 song,[2] are still rapidly spreading around the world, constantly pushing the edges of our cities outwards. And all are furnished with their local shopping mall because these 'ticky-tacky' boxes are the perfect containers for ever more, ever new products. And it is this consumption that drives the economy.

Today, however, the devious psychoanalysis of Russell's Mallako is the territory of another, more socially acceptable purveyor of doubt, unease and discontent. In the years since Russell put pen to paper, the seeds have been

planted continuously and liberally in every living room, in every magazine, on every billboard and every website. Does greying hair make you look older than you feel? Why not treat yourself, you deserve it? Will you be able to enjoy the retirement you planned for? When your child is safe, you can have peace of mind. Are you paying too much for car insurance? For a richer, simpler life, you need this phone.

7

Unbranded

On weekends, in the town where I live, there is a market. Appropriately enough, it is held on Market Street. The townspeople have had the right to hold a market here for centuries – the first charter was issued in 1193.[1] Today, tens of thousands of people use it every week.[2] Locally grown vegetables, seasonal produce, freshly baked bread and other such products can be bought from vendors one sees regularly and with whom a rapport can be established. Such markets are all about human relationships, trust and reputation, and they are entirely independent of brands. Likewise, purchasing items from a local potter and knitting a woollen jumper from regionally grown wools have nothing to do with brands, over-considered logos, meaningless taglines or corporate mission statements. They are about encounter, provenance, knowing people and places, and human understanding. And they are about the role of all these things in contributing to our lives and making us who we are. The products we acquire by such means play a similar role – when we live with things that we comprehend in terms of their materials, where they came from and who made them, they acquire a deeper significance and a deeper meaning for us.

In what seems a particularly cynical move, a major UK supermarket chain recently launched seven new 'brands'[3] in an attempt to tap into this growing preference for local products. With names like Boswell Farms, Willow Farms and Redmere Farms, one naturally thought the produce inside the packaging was traditionally British, locally grown and somehow more genuine. These farms, however, didn't actually exist, except perhaps in the minds of marketing executives, and the produce inside the attractive packaging was from Belgium, Spain, Chile and the USA, amongst others.[4]

In an age of mass communication it is increasingly difficult for large corporations to get away with this kind of thing. Many would say rightly so, because such schemes are not what they appear; they are not about human relationships and they reduce trust. With a history of such techniques, we

have become suspicious of large corporate brands. They are the diametric opposites of the place-based businesses that depend on human connections and they have undermined their own credibility. Consequently, they are finding it difficult to maintain their position, and the value of many large brands is in decline.[5]

It is important to recognize that when we look at and consider purchasing unbranded goods, we tend to be more discerning. This is because we examine the thing itself – how it is, how it strikes us – uninfluenced by corporate rhetoric that tries to sell us an image – a contrived idealization of a consumption-oriented lifestyle. It is a lifestyle to which they want us to aspire because it is highly profitable for them. Unbranded goods appeal to us because we feel they are untainted by the hype and the discontentedness cultivated by the corporations. We have become fatigued by their barrage of empty promises. Giving precedence to locally produced, unbranded goods and services is one way of showing appreciation for place, community and people's efforts, one way of rebuilding trust while deepening our own sense of belonging and identity.

8

Reality

We hear much talk and there is much excitement about augmented reality. But, we should bear in mind who is doing the talking and who is becoming excited. Usually we find it starts with those whose interests are profit, power and control, all of which are pursued through the conduit of commerce.

Let us pause for a moment to reflect. 'Augmented food' companies have persuaded us of the convenience and value for money of processed concoctions that are filled with sugar, salt and additives, rather than unaugmented fare that is simple, natural and organic. This has led to obesity on a grand scale, a multiplicity of health problems and escalating medical costs. 'Augmented beauty' procedures can turn natural looks and aging into visages that in some cases are sadly bizarre and in others are doll-like, expressionless notions of some sexualized ideal.

Augmented reality, through its clever modifications and additions, may be useful in certain specialist applications because it can provide us with various kinds of superimposed information via sight, sound and touch. This might be helpful in areas like navigation, emergency rescue and medicine. But for everyday use, which is where the money is to be made via mass consumerism, it raises serious questions. It places barriers and distractions between us and the real world. It gets in the way by preventing us seeing and appreciating the world as it actually is. Personally I prefer unaugmented reality or, in short, reality.

9

Prestige

The values promoted by consumer capitalism are often the polar opposites of those taught by the world's great traditions. The epitome of this inversion is found in the contemporary airline industry. This sector has become exceptionally proficient at imbuing its services with petty class divisions that are guaranteed to make one feel uncomfortable, wherever one stands in the pecking order. At the lower end, it manifests as a sense of inferiority, at the upper end as an unsavoury feeling of precarious superiority.

There is economy class, premium economy, business class and first class. One can even have a first-class private suite with one's very own 'privacy doors' and where, we are told, one can drink exclusive wine and have a personal mini-bar and private cinema,[1] which seems something of a contradiction in terms. There are differences, too, in frequent flyer benefits, which are determined according to a tier system that starts with bronze and progresses through silver, gold, platinum and something called platinum one;[3] no doubt platinum two will be along shortly to prevent platinum one travellers becoming complacent. The tier is determined by the customer's 'Status Bonus' earn rate. As is to be expected in a consumer capitalist system, this is related to the amount one pays for a ticket, which spans discount economy, economy, flexible economy, premium economy, flexible premium economy, business, flexible business and first. And, where the individual traveller is positioned in all of this will determine whether they board the plane first, thereby allowing them to walk self-importantly past those who will be boarding just a few minutes later but, in doing so, will be made to feel the full ignominy of their inferior status.

Once seated, social order is manifested through finely graded increments of differentiation. Higher status tends to bring a rather more attentive and obsequious steward service. Premium economy is distinguished from the lower orders by an inch or two of additional seat width, a little more recline, and a slightly larger screen.[2] There may be some other technological

'luxuries', but the fact that such gadgets have become indicators of exclusivity seems especially tacky. Nonetheless, marketing psychologists know very well how to exploit our susceptibilities so as to ensure these minor gradations matter to us. Their manoeuvrings exaggerate the significance of trivialities with the aim of affecting how we feel about ourselves in relation to others. For some, this may be a sense of superiority, for the majority, who will always be looking enviously at those successful, beautiful people in the slightly wider seats, a sense of inadequacy and ordinariness. And it extends well beyond the journey itself to include pre-boarding, on-board and last chance, post-flight shopping – all in glitzy packaging and supported by airbrushed photos of film stars – a glamorous facade that, for decades, has belied the reality.

This active promotion of social differentiation and the use of these small-minded hierarchies and ever thinner increments of prestige have become accepted norms throughout all aspects of our society. But it is incredibly tawdry, undignified and tremendously sad. It not only affects our behaviours, it also diminishes meaningful human values.

> *The powerful are greedy.*
> *Those who stand alone are always mocked.*
> *Men of means*
> *have much to fear.*
> *Those with none*
> *know only bitterness.*
> *…*
> *If you conform to the world*
> *it will bind you hand and foot.*
> *If you do not, then*
> *it will think you mad.*[4]

In virtually all cultures, spiritual traditions have cautioned against becoming ensnared in "*the dross of the world*".[5] We are told that worldly things lead one astray, being presented with desirable things brings confusion of the heart, and exalting some people over others creates resentment and leads to conflict.[6] Despite this, we separate and categorize and in doing so we dis-unify and create division, difference and discontent.

But creativity and design are concerned with synthesis, aesthetics and coherence. Sustainability also rests on wholeness and harmony. And so, instead of competitiveness and constant social jockeying, we have to empty ourselves of such desires. Only then may we be able to develop a different perspective.[7]

10

Icarus Falls

Emasculated men
stand listlessly,
belts and shoes
in hand, sadly
shuffling through
pot-bellied indignity
to the illusory
glamour of siren-
scented stalls.

11

Sellers All

Arthur Miller's wrenchingly raw play *Death of a Salesman*[1] is a lesson for our times. Like no other piece of writing I know, it exposes the rotten under-belly of an American Dream that has long since been exported and embraced everywhere.

Willy Loman, the exhausted protagonist, is an ordinary man, sixty-three years old, still waiting for his dreams to materialize, still hoping for his big break. He lives in a permanent state of delusion – a world of fair-weather friends and self-aggrandizing puffery. His blindness to his own circumstances and those of his unavailing sons is heart-breaking and inescapable. *Death of a Salesman* traces the demise of the soul as much as the body – a slow, relentless death by attrition. We are witness to the fag end of a life filled with missed opportunities, unfulfilled dreams and rose-tinted memories; a worn out finale brought on by the ruthless reality of a sink or swim society.

Penned in 1949, its underlying themes are uncannily prescient of our times where information exchange and social media are turning each and every one of us into a salesman. Like Willy Loman's world of thwarted loyalties and frustrated hopes, this digitized world of endless repetitions, rehashings and petty 'likes' has no upside. It is a world that strokes our ego as it simultaneously stokes our fears. It demands our unending attention, feeds us trivia and meaningless affirmation and creates a feverish sense of wanting to be noticed.

When we all become salesmen, we all wander into Miller's world of self-delusion, fair-weather friends and self-aggrandizing puffery. We all willingly step on to a path of anonymous, soul-destroying distraction and displacement, constantly waving as the soul slowly withers, fades to pale and ultimately dies. At which point – just like Willy Loman – we no longer know who we really are or how we got here.

12

Waste

In the 1995 film *Apollo 13*, there is a scene in which NASA scientists in Houston have to figure out how to make an improvised 'air scrubber' connection from materials on board the stricken spacecraft. A pile of random items is dumped on a table and the team leader says, "We gotta find a way to make *this* fit into the hole for *this* using nothin' but *that*."[1] As one might expect, this being Hollywood, they quickly come up with a solution. However, the scene is based closely on the actual transcripts of the Apollo 13 mission[2,3] and it demonstrates an important point. When working with what we have rather than what we pre-plan and pre-define, we employ direct, intuitive approaches that can lead to new insights and unexpected, often ingenious solutions.

In any design and making project there will be materials left over. While, with forethought, waste can be minimized, offcuts, shavings and scraps are inevitable. But instead of discarding them, many of these remnants will still be useful and they can be an inspiring source of ideas. Odd pieces of wood, leather or glass, short lengths of cord or wire, bits of metal, unused fasteners, scraps of fabric – their very arbitrariness in size and shape, and their juxtaposition can stimulate fresh thinking. Keeping leftover materials and finding new uses for them is not only a good way of minimizing waste, it is also a good way of breaking free from predetermined approaches and jolting the mind out of linear, methodical modes of thought.

Many of the materials I use in my own work have been found, and one might assume that, because they have already been discarded, any new role and value they can be given will be a bonus. But I don't quite see it like this. The majority of these materials should never have been thrown away in the first place. Not only are they potentially useful, such waste has no legitimate place on the landscape or in the sea. The growing presence of waste is a violation of nature and a testament to our profligacy and it should be regarded as immoral. Morality refers to behaviours that conform to accepted standards. As a society, if we are prepared to accept such low standards then this is a

damning reflection of our contemporary sense of goodness and moral character.

In a world that is straining under the burden of human exploitation, where there is unprecedented wealth alongside unprecedented want, waste is something we should regard as symptomatic of an inequitable, unethical and entirely unsustainable system. It is perfectly within our capability to drastically reduce waste by ensuring that, through legislation, tax incentives or other means, products are designed to endure. Economic policies can encourage imaginative new uses of waste and the development of a circular economy. Such measures would result in a more intelligent use of natural resources, a cleaner environment and a more thoughtful and worthwhile notion of material culture. All that is needed is the will to make it happen.

13

Bypassed

It never had been a beautiful town but when the works closed down it became uglier still. A lot of shops are boarded up. The ones that struggle on sell cheapjack goods, tattoos and betting slips, and the discount stores in the precinct peddle yesterday's fashions. The only hotel was demolished years ago. No one ever stayed. That is where they built the bypass.

Second-hand vans and hatchbacks line the narrow streets and plastic bins obstruct the cracked, weed-strewn pavements. Satellite dishes cling to the pebble-dashed fronts, filling the living rooms with surrogate lives.

The male voice choir is much older than I remember – a sea of snowy heads. Its website, long out of date, touts for work at weddings and funerals.

Time passes. Fly-by-night businesses come and go. The names and the faces change. Yet, the town remains, pretty much the same. Less confident than it once was and less communally minded, but still there, carrying on – wheezing unhealthily into the future, hoping without expectation.

14

Fair Game

Respect can no longer be inherited through birthright or claimed through position. While this hardly needs saying, the eclipse of deference is actually a recent phenomenon. Its decline began with the social upheavals of the 1960s, especially among young people. This period was marked by protests in Europe and North America that challenged societal norms, changed attitudes and furthered the cause of human rights and social equality. Any last vestiges of positional deference have been purged of late by revelations of corruption and degeneracy among politicians, church leaders, bankers and media personalities. In Britain, government ministers, business executives, and bankers are among the least trusted by the general public.[1] As numerous individuals in these professions have fallen from grace, they have revealed systemic failings at the heart of the establishment. So, in turn, the standing of these institutions and the fields they represent has become diminished.

In some ways these developments are a good thing; they have exposed malpractices and toxic behaviours at even the highest and wealthiest echelons of society. They have demonstrated that we are all in the same boat when it comes to human failings and that no one is above the law. There is a levelling effect, which recalibrates our normative understandings about the nature of society. But there is also a wrenching sense of loss about such duplicity and betrayal – an anger coupled with a pervasive sense of sadness that trust has died. We are wounded by its departure, we mourn its absence and we resent the fact that we have to become more sceptical, more stoical and a little more cynical. The longer term effects are even more saddening. In an atmosphere of trustlessness and suspicion, we justifiably demand ever more transparency and accountability, ever more evidence and proof; when trust dies the pen pushers rise. As a result, we become engulfed in a Kafkaesque quagmire of bureaucratic complexity.

And anyone and everyone become fair game. Political leaders are lampooned and become the butt of tasteless jokes on late-night TV shows,

bankers are belittled as money-grubbing sharks, eminent scientists are humiliated by the mob, and religious belief is eviscerated by social popularists and stand-up comedians alike. Everything is called into question, mocked and undermined.

This loss of trust has been extraordinarily damaging to contemporary society because it has spawned one of its greatest ills – what American writer Marilynne Robinson has called a *"generalised irreverence"*.[2]

15

What else is on?

When travelling by train or bus, or sitting in a restaurant, it is common to see people staring at personal devices – they may be watching a show or scrolling through social media. When travelling by air, our vision is filled by an eye-level screen through which we have access to hundreds of choices – movies, TV, games and music. Asked about the benefits of driverless cars, a representative of a major manufacturer said that, during the journey, people can continue to watch a movie they had started at home. Walking along the street, people constantly check their phones. And today's living room is incomplete without a state-of-the-art TV and sound system. Entertainment has become an all-consuming aspect of modern life.

These forms of diversion are almost entirely passive. They require little in the way of thought or imagination, and they demand almost no effort on our part. We simply sit, listen and stare – our eyes and ears filled, our minds occupied. The moving image is bright and constantly changing – it is easily accessible and totally captivating.

As a consequence, we no longer fall into conversation with the passenger sitting next to us – they are plugged in and engrossed. And gazing out of the window now seems a boring alternative; a waste of time. Yet, looking at the landscape can prompt daydreaming and contemplation – but, increasingly, we prevent this kind of introspection. It is as if we have become frightened of being alone with ourselves, of sitting quietly and thinking.

The dominance of entertainment is a worrying development because it is not just an overpowering distraction, it is also mostly trivial. The very nature of these media reduces everything to transient amusements, disconnected soundbites, and irrelevancies that lack depth and coherence. This unremitting barrage of superficiality has the effect of diverting us from more serious things, from deeper engagement, active consideration, and fuller comprehension. And, as Postman has argued, such directions lead to the death of culture.[1]

Many of the so-called creative and cultural industries are involved in the development, promotion and purveying of such entertainments, which, if Postman's analysis is correct, can be understood as a kind of cultural malignancy. According to the UK government, these 'industries' comprise a wide variety of sectors: architecture, art, crafts, design, fashion, music, radio, the performing arts, publishing, museums and galleries. In addition, there are film-making, videography, computer games and television.[2,3] However, there are significant differences in the kinds of contributions these various creative endeavours are able to make – differences that may serve to contribute positively or negatively to culture.

When we experience a work of art or a live performance, or when we read a novel or a poem our imagination is stimulated, we conjure thoughts and pictures in our mind. These forms of creativity engage us in ways that – either individually or collectively – demand our active participation. For example, a work of literary fiction or a poem can prompt aesthetic appreciation and ethical reflection.[4] Scruton distinguishes these kinds of creative works from those that offer us only a substitute reality. He argues that when a substitute reality is presented to us – as it is in movies and computer games – interpretative thought and the imaginative emotions of the viewer become dispersed and nullified.[5] We are left only with a fleeting, superficial spectacle – one that is temporarily absorbing but easily forgotten. Unlike a work of art, they have no more to offer; they have little or no lasting meaning. When realization is made manifest, there is no room for personal interpretation.[6]

In a time of rapid digital development and expansion, a critical aspect of this debate is the role of innovation and technology. Corporations and government tell us that both are socially and culturally beneficial, principally because there is much economic potential associated with developing, selling and using new products. But technology is never neutral and its 'benefits' should not go unquestioned; it comes with an agenda and its adoption causes social change. When it is geared towards mass entertainment the effects can be substantial. Our heads become filled with images, words, music and sounds – quite literally, we cannot think, we just passively receive – it hinders imagination, critical thought and discriminating judgement. This is precisely why clothing shops often play loud music.

In recent years, there has been a proliferation of university courses in these areas, especially games development. The justification for such courses

often involves asserting their social, innovative and educational merits. While this may legitimize their inclusion as an appropriate sphere of higher education, there may also be a sidelining of reflective discernment. The whole notion of the university is, or should be, one of edification – of developing character, critical thought and ethical understandings. It is an institution that is supposed to be morally, intellectually and spiritually constructive. But all-absorbing entertainments that present us with substitute realities are frequently none of these things.

The principal reason for pursuing such areas is economic, counterarguments are depicted as naïve or idealistic and potentially adverse cultural impacts are summarily dismissed. The benefits to ordinary people are often trivial or negative because nothing creative, imaginative or tangible is being produced; little worth doing is actually being achieved. Consequently, one is inevitably left unfulfilled and dissatisfied. And the only option, if we are to avoid self-reflection, is to ask, "What else is on?" [7]

16

My next fear

It will come.
But uncertainty
is the measure
of my anxiety.
I crave time to
reflect to think
of nothing to
attend to the
sky and reply
to the brook.
It will come
as always too
soon, jabbing
my mind,
pilfering
my life,
worrying my
thoughts,
poisoning my
peace.
It will come.

17

Time closed

At the ending, time closed round the dimming haze as the ferryman oared his solitary passenger silently 'cross the elegiac waters of Marmara. The stones of Helena had long since faded from the memories of this place and Jerusalem … O Jerusalem … And in the dying light, spectres of Byzantium mourned the passing of this last unnumbered soul. Caravanserai in Nineveh, Baghdad, Palmyra and Aleppo bore the trade on these routes, relaying silks and spices, pomegranates and quince, lapis lazuli and sweet perfumes, but as their gaze looked down on these exotic delicacies, the colours dwindled and a leaden miasma enclosed the ancient walls.

18

A Moment in the Life of a Reed

I was walking along the towpath of the Lancaster to Glasson canal in early December. The track was muddy, the trees bare and the skies gunmetal grey. Yet, the canal was teeming with life – two startlingly white swans sailed towards me looking for food, moorhens twitched and scooted along the banks, pairs of mallard shuffled into the safety of the water, and a heron stood silent over it all like a watchful undertaker.

At the lockkeeper's cottage, where the Glasson branch meets the main Lancaster–Preston canal there is a beautifully arched stone bridge with cobbled pathway; it is a picturesque garden of a place – like a Constable painting. It is marred only by the distant noise of the M6 motorway, an intrusive reminder of haste that is the background soundscape of so many places in these parts.

As I approached Glasson Dock and the traffic became fainter, I came across a tall stand of reeds, harvest gold and topped with silver feathers. I stopped and was marvelling at their beauty when the breeze withered through them, quivering their dried stalks into a rush of rustling that ceased almost as soon as it had begun. I walked on, glad to have witnessed this moment in the life of a reed.

Illusions of forever

All these things,
all these burning
bright baubles,
are but fleeting
markers in the
sand; illusions
of forever that
last only till the
tide turns.

20

Local?

Each spring, the town of Boorowa in New South Wales holds its Irish Woolfest – a celebration both of its Celtic roots and of the merino fleece that is its main source of wealth.

The highlight of the first day is the Quick Shear championships, where learners, intermediates and experts compete for prize money; a top shearer can have a sheep cleanly cropped in thirty seconds. It is a day of reunions, banter and beer.

The second day begins mid-morning with the blessing of the fleece by the local minister, who gives thanks for the wool and everything it has come to mean to the community. The street parade that follows kicks off with the 'running of the sheep', under the skilled control of well-trained Australian sheep dogs. It is a tongue-in-cheek replication of Pamplona's famous 'running of the bulls'. An Irish pipe band, local gymnastic and dance clubs, mock outlaws on horses, vintage tractors, the volunteer transport service, and the fire trucks and ambulance slowly and noisily make their way past cheering crowds who have arrived from far and wide; the campsites are busy and there are no rooms left in the town's hotels.

Side stalls sell locally made beef jerky in all kinds of flavours as well as sweets, raffle tickets and local handicrafts. There are fleeces on show, in various states of processing, and factory-produced active wear and outdoor clothing – proudly made in Australia from the local wool.

But there is a distinct lack of cottage-style spinning, weaving and knitting. I learn that the raw fleeces are sent to China for cleaning and processing into yarn. The proprietor of the active wear stall tells me that, ironically, it is more cost-effective to ship the wool thousands of miles and then ship it back as yarn than it is to process it locally.

In the nearby town of Crookwell, at the top of the Great Dividing Range, is a small, family-owned business, The Lindner Sock Factory.[1] Of German origin, the Lindners have been producing socks here since 1921. Today, their

socks are made on 1960s vintage machines built at the Komet Works of the Bentley Engineering Company in Leicester, England. Twelve additional machines have recently been acquired from Perth, where they were rescued on their way to the scrapyard. The shipping cost more than the machines, but the family were glad to have them to add to their production capacity.

The socks are made from Australian merino wool with mixes of alpaca and cotton. The more expensive lines are from locally produced merino. But here again I learn that all their yarns are processed in China.

This internationalized element of the processing is a pattern repeated all over the world, from Australian wool to Scottish shellfish.[2] It is one of the ludicrous outcomes of cheap oil and a form of globalization that privileges the vagaries of the market and, in doing so, defies common sense. By prioritizing financial value but ignoring the true costs, which include the social and environmental costs, our current system frustrates efforts to grow truly local businesses that adhere, in a comprehensive way, to sustainable principles.

Responsible governance requires policies that work towards the common good, create quality jobs at the community level, localize production, and reduce the unnecessary transportation of resources back and forth across the world. It is time we stopped this foolishness, so that well-established small family businesses like the Lindner Sock Factory can benefit from reliable local resources, processors and suppliers. In doing so, the community will benefit from more jobs and the knowledge and pride that these goods are genuinely a product of their own making.

21

Burying Your Dead in the Sand

For a long time I lived way out west in cowboy country. The foothills of the Rockies are rich, rolling pastures that are home to cattle, horse ranches, pine and aspen. This narrow ribbon of land stretches north–south for hundreds of miles – hemmed in on the west by snow-capped peaks and bordered on the east by flat, endless prairie of wheat and corn. Rivers run through it – the Athabasca, the North Saskatchewan, the Bow and the Old Man. And even this close to the mountains, they are already powerful as they drain the spring melt from the upper slopes. On their long journey east, they will merge to become mighty watercourses that eventually find their way into the Hudson's Bay.

This high country is beautiful and harsh. The winters are long and bitter. It is country that demands hard work and a stalwart attitude, and it breeds character and a dignity of bearing. The cowboy here has a stature shaped by heritage, family, fortitude and, most of all, the land itself.

But things are changing. The suburbs of the city are rapidly supplanting these traditions, changing the vistas and the values. Wealthy urbanites in multi-million dollar mansions on two-acre plots expect more than a tack store and a feed supply on Main Street. And so the lines change to country fashions and pet food and all the other paraphernalia. A chichi coffee shop opens offering spiced turmeric lattes and in a few years the place has transformed into another upmarket development. And, bit by bit, a proud way of life withers and dies, replaced by stockbrokers and oil executives who glance fondly at the faded photographs on the walls of the *Chuck Wagon Grill*.

The lavish houses are more fashion statements than homes, the over-sized automobiles in their four-car garages status symbols and weekend playthings. None of it lasts – in a season or two it will all be refitted, rebuilt and replaced. Nothing endures.

The cowboys who once rode these hills, and before them the Blackfoot and the Stoney, slowly sink into sepia, buried not by the sands of time but by

the vast riches, unmitigated filth and ecological devastation of the tar sands operations well out of sight to the north.

Air

From Nature's splendour
the clean crisp of Spring
unfolding its newborn
freshness in vibrant
innocence … to
fragments of dread
as all that was solid
is turned into air to
glide on the breeze and
the sigh of the breath and
the rasp of gasping
hacking corruption
for the prize of a trinket
and the price of a soul

23
Carbon

Primordial green that flowered under a geological sun turns and churns through the eras, silently sinking into the deep. And as the millennia pass, the molecules move into a black, permeating ooze that penetrates the pores and the fissures of a petrified past.

Single-use camera

Broken action figure

Out-of-date credit card

Defunct mobile phone

Disposable razor

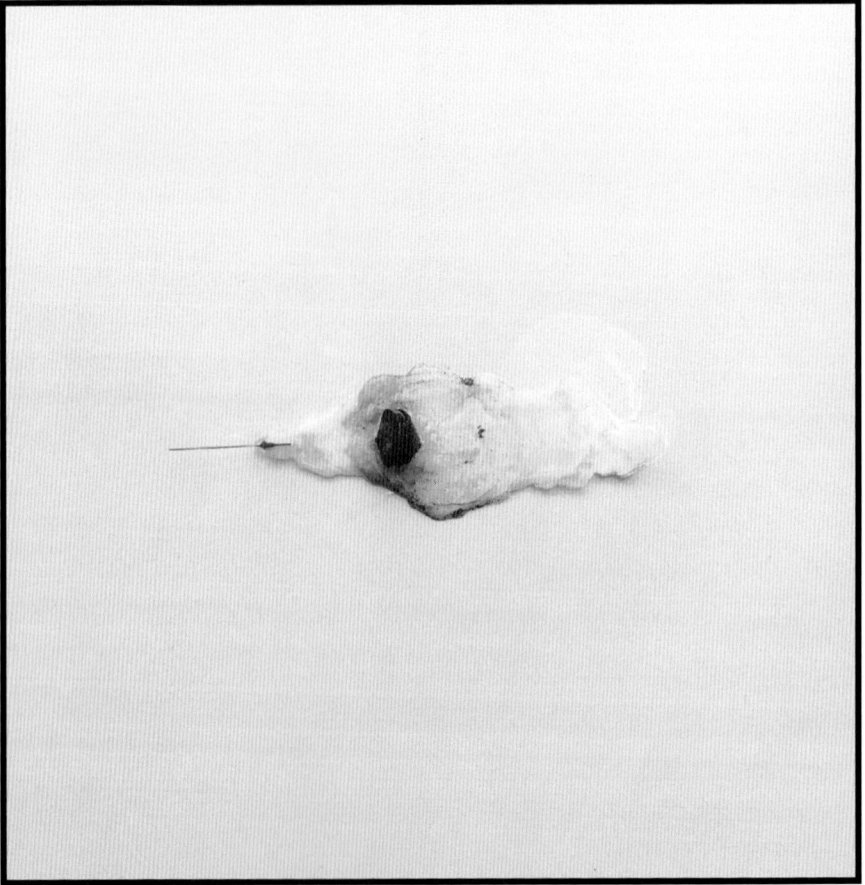

Used hypodermic syringe

24

Becoming Human

It is one thing to recognize that the sciences, for all their remarkable contributions, do not hold all the answers, but it is quite another to live out this recognition in our professional and personal lives. Though politicians and bureaucrats might pay lip service to the creative arts, our society has become so biased towards technoscientific ways of thinking that any substantive commitment to supporting and paying meaningful attention to the arts is thwarted from the outset.

There is an enormous imbalance in modern society between, on the one hand, science, technology and engineering and, on the other, the arts and humanities, including the visual and performing arts, history, philosophy, language and religious studies. In our education system, priority, investment and esteem are given to the so-called STEM subjects of science, technology, engineering and mathematics from the early years, through our national curricula for schools, but the arts are all downgraded. And, unlike other subjects, religious studies is not on the national curriculum and its content is not regulated. While non-regulation of content by central government might be a good thing, when combined with other factors, the implication is that religious studies and other 'softer' subjects matter less. This devaluing continues into higher education and research policy. Annual net expenditure on the arts and humanities amounts to a paltry three per cent of the total, whereas expenditure for scientific, engineering and medical research accounts for more than ninety per cent.[1]

These kinds of policies and budget decisions, which diminish the place of the arts and humanities not only in education but in society as a whole, are at least direct and plainly visible. However, there are more insidious institutional tendencies that add to their marginalization and downgrading. Government departments demand burdensome accounting and reporting methods that prioritize empirical evidence and quantification. Even fundamentally qualitative endeavours have to be reported in terms of facts and

figures and, increasingly, bodies such as the Arts Council of England have to justify what they do in terms of instrumental and financial benefits.[2] Similarly, to secure funding for research, one has to adopt methods and justifications that are attuned to the sciences but maladapted to the arts and largely incompatible with the creative mind. Similarly, we see the emphasis on quantification and numerical methods in the highly divisive practice of ranking schools, universities, research and scholarly journals. Through such approaches, technoscientific thinking has become a pervasive and damaging force in our society and in our notions of what counts as legitimate scholarly output. In fact, the very word *scholarship* has fallen out of favour these days, being replaced with *research*, which itself implies a more systematic, scientific approach with defensible results based on analysis of empirical data. Such methods have come to dominate the arts and humanities, and other avenues for developing human knowledge and understanding have been systematically excluded. These other avenues include: creative methods; trial and error; learning through doing; playing with ideas and making mistakes; taking time to immerse oneself in practice in order to build skill and experience; and engaging in these things in ways that are free from the pressures of learning outcomes, grades and key performance indicators.

When we deprive society of its human character and attributes by creating systems that are intentionally designed to eliminate any room for circumstance, imagination, trust and reasonable judgement, society becomes progressively dehumanized. When we devalue emotion, creativity and conscience, society becomes progressively dehumanized. And when we seek to replace people with machines, skills with automation, and community care with *"biomimetic autonomous companion robots"*[3] intended to *"provide emotional engagement"*,[4] our society becomes progressively dehumanized. The result is a coarsening and brutalization of society. However, when facts and intellectual knowledge are mediated by values, imagination, empathy and experience, they become absorbed at a deeper level and ideas become understood more fully. They then become meaningful to us and can take root in us. When this occurs, we not only become wiser, we also become more fully human.

25

Internationalization

In today's universities, the incentives, accolades and career progressions for academics are all geared towards the international, which is seen as far more significant and prestigious than anything achieved at the local level. For some reason, recognition by people elsewhere is of greater value. Universities also actively seek international students rather than home-grown students. I have regularly taught postgraduate classes of thirty or more, none of whom have been from the UK. Not only is this detrimental to our own young people, it also does a disservice to those students from abroad who are expecting to learn alongside and get to know their British peers. And, in our increasingly marketized education system, we have created franchise campuses in Dubai, Beijing, Kuala Lumpur and Accra – anywhere but here. It is a pattern led by the corporate model of globalization and free trade that has so devastated communities, eradicated manufacturing bases and, for many, eliminated any hope of quality employment.

There is often deep knowledge among academics who have been raised and educated in a particular place. And among many there is a commitment to community, and a passion for and meaning in local initiatives. But such research projects, and the staff involved in them, often lose out to bigger, international work; it is those involved in these larger schemes that receive the honours and promotions.

This state of affairs is a product of an outdated way of thinking. In focussing on the international, with little or no relationship to place, universities not only neglect their host community, they continue down a path that has proved deeply destructive. In universities everywhere, there is a chasm between town and gown. At one meeting I attended recently, a member of the municipal council and an active promoter of the arts community said, *"This university has virtually nothing to do with the city. It's like a gated community."* I have heard the term used elsewhere in reference to universities – it is a damning indictment of a publicly funded entity.

It is time we realized – even in the rarefied heights of our long-established and often very conservative institutions – that locale, environment and the specificities of place and community are critically important in developing more informed and wiser paths forward. Our knowledge has to become rooted and be more sensitive, embedded and empathetic so that it is both respectful and meaningful.

The current onus could be reversed. It is within the realms of human imagination to put the weight on the other foot – to see prestige in, and have career development through, locally based endeavours. Research funding could be geared towards place and community initiatives, self-reliance, good work, and local business innovation. Such a reversal could transform towns, regions and, most importantly, people's lives because it would break down the barriers between academic research and the so-called 'real world' by developing understandings in both directions and knowledgeable relationships of mutual respect.

26

Craft 'n Kitsch

The term kitsch can refer to one of two things. Either it points to characteristics associated with pretentiousness or it describes an object whose appearance, replete with sentimentality and vulgarity, is intended to coerce emotions. Today, a great deal of so-called 'craft' displays ample evidence of both – such objects are not only vacuous, they do a grave disservice to bona fide traditions that are purposeful, meaningful, often deeply representative of sustainable principles, and rooted in cultural beliefs.

Like many other countries, Britain has a long history of craft practices, which, over the centuries, provided locally appropriate, practical solutions for everyday life. The list is long and includes thatching, hedge laying, dry stone walling, metalsmithing, furniture-making, basketry and pottery, as well as a host of textile crafts such as spinning, weaving, knitting and felting. There are also crafts that have less utilitarian ends. The carving of a love spoon, a Welsh tradition that dates back to the mid-17th century, was how a young man expressed his feelings for his beloved. The wooden handle is so elaborately carved that its decorative value far outweighs any latent functional attributes.[1] There are also crafts associated with religious traditions, and there are decorative folk arts for the home. Some, like whittling, scrimshaw or cross-stitch were practised by ordinary people for their own purpose and amusement or as gifts for family and friends. Others, like thatching, metalsmithing and bodging[2] were done professionally, as a source of income.

In the transformation from a traditional production economy to a modern consumption economy, crafts have declined all over the world. Relatively inexpensive products have become readily available to large proportions of the population through mass manufacture, innovation and globalization. But in our enthusiasm for the latest novelty, we too readily forgot many culturally important practices and the context-related customs and knowledge they embodied, all of which came to be seen as outdated, uneconomic and backward.

Today, however, surrounded by the digitally created sterility of much contemporary material culture, we hanker after the authentic, the handmade, and the appeal of the human touch. This is perfectly understandable because there is a natural affinity to this kind of work – this less precise but more singular aesthetic. But with the waning of its traditional, purposeful role, craft has faced a difficult time and something of an existential dilemma. One result of this has been the rise of a new kind of craft endeavour – the production of beautifully finished but, essentially, pretentious kitsch for well-heeled, middle-class suburbia. While for some, this kind of transformation may stick in the craw, it is a perfectly understandable and logical adaptation to a consumption-based economy. It seeks to raise crafts in wood, ceramics, glass, metalwork and leather to the status of art – an affectation readily fostered by the vendors of such frippery. These kinds of crafts are invariably sold in over-priced 'galleries' – a term much preferred to 'shop' – in wealthier or up-and-coming parts of town. By striving to raise the status – and thereby the prices – of such artefacts, the makers at least have the potential to make a living from their work. And as one would expect, the artefacts on show in such places are eminently attractive, easily digested, skilfully executed and entirely superfluous. We find furniture in which the emphasis on woodcraft, finishes and showiness far outweighs any thought of good design, utility and reasonableness of price. And we find pottery items whose function is simply to be there – demonstrably pricey *objets d'art* for the loaded living rooms of the socially situated. This predilection for the exclusive and the individualized yields a form of craft that is tawdry in its pretentions and kitsch in its aspect. There is neither tradition nor purpose, and certainly nothing to trouble or challenge the self-assured complacency of the potential purchaser. Consequently, it is neither craft nor art but simply a more exclusive, exclusionary form of consumerism and as such, in terms of meaning and sustainable futures, it has little to contribute.

Modern and Traditional

Years ago, when I first learned about modernism at design school, I was enamoured by the clean lines, the purity of form and the seeming logic of the design intent. Like so many other students then and since, I was enthralled by the early heroes of modernism, which every lecture and course text honoured. They were conveyed as larger-than-life figures, bravely freeing themselves from the comforts and security of the past and fearlessly forging ahead into a bright new future of their own making.

Today, we are still in their grip but the cracks have been showing for some time. Not that you would know it from an exhibition I recently saw at the Gemeentemuseum in Den Haag entitled *Mondrian & De Stijl*.[1] It was very much a homage to Theo van Doesburg, Piet Mondrian, Gerrit Rietveld and all things that were once modern. It was a rather typical display of the work, aims and achievements of this loose collective of post-WWI artists and designers who sought to make art and life inseparable. But there seemed to be an incredible arrogance in their assertions about how people should live. This came through, despite the reverential tone of the exhibition.

A hundred years after *De Stijl* began, we need a more critical appraisal than was evident here. There can be little doubt about the huge contribution and lasting impact it has made. It influenced the course of 20th-century design and still inspires designers today. But, it is 'modern' and despite its political dogmatism, much of modernism turned out to be just another design style[2] – too narrowly framed, sterile and didactic for contemporary society. Its time has passed. However, none of this was evident from the *Mondrian & De Stijl* show, which was especially ironic because, in the same building, was an exhibition of another, equally well-known, but much older tradition of Dutch design – one that is still in production today.

The *Delft Wonderware* exhibition[3] showcased four hundred years of Delft pottery. Its distinctive blue and white decorative patterning originated as an imitation of porcelain imported from China by the Dutch East India

Company. Delftware was domestically produced earthenware, even though it was marketed as porcelain. In one of those strange twists of history, *Delftware* proved so popular in Europe that it was imitated by Chinese manufacturers.

One of the most iconic products of the Delft potteries is the tulip vase with small spouts for individual blossoms. Such vases range from table-top items to large towers designed for grand houses and made up of stacked ceramic pieces of decreasing size. Unlike *De Stijl*'s austere, implicitly prescriptive and rather admonishing severity, *Delftware* encapsulates – for good and ill – the whole panoply of human frailties, tastes and aspirations, from a humble tourist souvenir to an ostentatious display of wealth and status. Rather than rejecting history and tradition, through new commissions *Delftware* embodies and builds on the past by combining tradition with contemporary ideas, needs and tastes. The *New Delft* tableware[4] is printed rather than hand-painted, which makes it much less expensive. It is mostly white, but bears a simple calligraphic motif that is almost Zen-like in its simplicity and based on the traditional trademarks found on the bottom of *Delft* pottery. Hence, this contemporary design has its roots in the trading history and the culture and people of the Netherlands. Unlike *De Stijl*'s rigid ideology, *Delftware* is infinitely flexible, adapting as tastes, priorities and needs change. This is the essence of tradition. In contrast to modernism's break with history, it draws on the past but makes it relevant to the times. This is essential for building a sense of culture and identity. It is also incredibly popular – people like it and use it and surely this must tell us something.

Design Think

A passage in Orwell's *Nineteen Eighty-Four* states that, in the near future, all great works of literature will *"exist only in Newspeak versions, not merely changed into something different, but actually changed into something contradictory of what they used to be"*.[1] There is a term that has become much used in design circles in recent years, as well as in business management, that holds a similar contradiction. This is *Design Thinking*. It is a misleading phrase because it misrepresents the design process and, in doing so, diminishes the discipline while creating false expectations.

There is no such thing as *design thinking* – there is just *thinking*. Designers do not have their own unique mode of thought; the suggestion seems absurd. Yet, courses are taught on it and workshops are offered to the business sector.

Crucially, the creative activity of designing involves not just thinking but a unified process of *thinking-and-doing*. This includes intention, action, reflection, modified intention and further action. A design outcome emerges from trial and error and iteration. Hence, designing is an indivisible, mutually informing combination of internal thought and external deed. When it is working well, when we are in a highly focussed state, we talk of being in the flow or in the zone. This state is not restricted to design. It applies equally to making music, painting, practising a craft or indeed any creative pursuit. It also applies to physical activities like running and rock climbing. It is a process through which we strive for excellence and which has its own intrinsic rewards.[2] The Japanese term for it is 知行 (chi gyō). It means *knowing-doing* – a single entity in which thinking is the instigator of doing and doing is the engine of thinking.[3]

To develop this way of working takes time and practice – we must engage in it and learn through experience. It is not something that can be taught per se – though one can, of course, learn from those who know the process. Rather, it can be facilitated, nurtured and encouraged. This is why the studio model has long been the accepted way for training designers. Students are set

exercises to help them develop their visualization skills and their thinking and they are given the space and time to experiment and practise. Only they can put these things together for themselves. Only they can experience the flow of creativity and the unity of *thinking-and-doing*. Such learning requires perseverance and discipline and it is never finished. We cannot get it from books. Like riding a bike, we have to practise, fall and start again until eventually we begin to move forward.

The workshop format, often used today to teach so-called *design thinking*, strikes me as especially inappropriate for this kind of learning. These are typically half- or full-day sessions and usually involve group work, Post-it notes and much text and talking. Business sector participants will rarely be accomplished in 2D and 3D visualization and expression and so they resort to words and simplified diagrams. All these conditions are entirely unconducive to the unified *thinking-and-doing* process. Workshop activities demand modes of thinking associated with the left hemisphere of the brain, which is the part we use in much of our everyday lives. It is associated with verbal, analytical, symbolic, temporal thinking. Creativity is associated with the right hemisphere and non-verbal, synthetical modes of thought.[4] Silence is important, and interruptions break the mood. Clearly, talking and time pressures serve to impede these ways of thinking, and lack of visual skills means that modes of expression are inevitably abstract, symbolic and schematic. For these reasons, workshops are generally unable to create the right conditions for participants to engage in *thinking-and-doing* and experience creative flow; an entirely different kind of environment is needed, and a far longer period of learning.

29

Enough

As the world around us continues to degrade at an alarming rate, we are simultaneously suffering from too much design. Our continued preoccupation with private trivia in the face of public calamity exposes an extraordinary degree of self-deception. We simply refuse to acknowledge that these two phenomena are intimately related; two sides of the same coin. And while many might suggest that design is not such a significant player, when the results of its decisions are mass-produced over and over again and distributed globally, its cumulative effects become substantial.

In design schools and corporate practices, the approaches developed in the early 20th century remain a powerful force, even though they are increasingly anachronous and damaging. The mantra *"God is in the details"*, attributed to Ludwig Mies van der Rohe,[1] has long distorted design's priorities and resulted in a compulsive and ultimately destructive concern for minutiae. From phones to automobiles, consumer products are created with almost fanatical care for particulars, which for purposes of promotion the macro lens pores over with the lingering devotion of the sycophant. Yet, the wider implications of such indulgence have long been ignored. Today, in light of the devastating consequences of our materialism, such practices need to be regarded as an obscene obsession; an outdated emphasis on the wrong things.

Design is a discipline that should be looking at the bigger picture and finding harmonious and meaningful synthesis. To do this, we have to raise our eyes above our screens and the over-magnified specifications of an injection moulded part, to see our actions within the larger context. And in doing so, we must recognize the important difference between sufficiency and excess, quality and precision, enough design and unseemly over-design. Too much design, with its immoderate concern for aesthetic detailing, reveals an imbalanced and outmoded emphasis on the importance of material things. Given its effects, it is time for design to consider that which is needed, that which is warranted, and that which is enough.

Damage

Memories of a broken world
on the beach where Shute
may once have walked
I recall reading an account of a
leaking, seeping, incipient fusion as
I look out on the plaything of the
pleasure seekers and the sickness
unseen from land – an Eden
sentenced to a filthy dying that
even with the best of intentions
and will in the world cannot be
restored to the splendour of
once upon a time but sags
forever askew, out of kilter,
irrevocable.

31

Seeing

How we see things and how we interpret what we see change with time; this is the case for each of us over the course of our lives and for societies over the centuries. These changing perspectives affect our tastes and our material expectations. To illustrate the significance of this for the creative arts, I would like to discuss changing attitudes towards the work of a certain artist, before moving on to consider how we see our material culture today and why this view is changing.

There is a particular Renaissance artist whose work, for the longest time, was severely criticised, indeed vilified. More recently, with changing societal mores and preferences, he has been vindicated and his work lauded. The paintings themselves have not changed, which suggests that criticism and acclaim may have more to do with expressing and bolstering one's own view of the world than any sense of objective or disinterested aesthetic judgement, as was once proposed by theorists such as Kant and Schopenhauer; a position since maintained by some while being contested by others.[1]

When we produce a visual work of art or a design, we go through a process of creative thinking, which is largely inseparable from the process of making. During this progression of *thinking-and-doing*, the ideas and intentions of the artist or designer become embedded into the evolving work and, hence, are made tangible and visible. However, when other people view the resultant creation, they interpret what they see according to their own understandings, and these understandings affect their view. The values that informed the creation of the work, which are related to the intentions, time and culture of the artist, may be very different from those of the viewer. So the work may be interpreted in a way that is entirely different from that intended or expected by the artist.

For centuries, the work of Michelangelo Caravaggio (1571–1610) was belittled and disparaged. French painter Nicolas Poussin (1594–1665) said that Caravaggio *"had come into the world to destroy painting"*.[2] The Italian

painter and critic Giovanni Pietro Bellori (1613–1696) said he lacked invention, decorum and *"any knowledge of painting"*, he *"suppressed the dignity of art … what followed was contempt for beautiful things"* and *"has been most harmful and wrought havoc with every ornament and good tradition of painting"*[3] and he *"emulated art … without art"*.[4] Some decades later, the Italian historian Luigi Lanzi (1732–1810) wrote that Caravaggio's figures *"are remarkable only for their vulgarity"*.[5] And British art critic and social commentator John Ruskin (1819–1900) said Caravaggio was *"seeking for, and feeding upon, horror and ugliness, and filthiness of sin"*;[6] he accused him of *"Vulgarity, dulness"* and *"impiety"*,[7] and suggested he was among the *"worshippers of the depraved"*.[8]

For more than three hundred years, Caravaggio's work was despised or ignored. Yet, today it is highly praised by critics, and regular exhibitions featuring his paintings are widely acclaimed and well attended.[9] His biographer, Howard Hibbard, writes that he *"is the most arresting European painter of the years around 1600"* … *"a great painter"* … *"often considered the most important Italian painter of the entire seventeenth century"*.[10] He says that the paintings *"speak to us more personally and more poignantly that any others of the time"*[11] and his work is *"an art of unprecedented immediacy and power"*.[12] The views of Robert Hughes, who for many years was art critic for *Time* magazine, are particularly revealing. He says that Caravaggio is *"the first avant-garde artist"*,[13] his paintings suggest *"how little, in art, can be more radical than a hunger for the real"*,[14] that he *"was one of the hinges of art"*[15] and after him, art changed. Hughes tells us that Caravaggio's art is *"a return to the tangible, the vernacular and the sincere"*,[16] he freed art from the *"musty envelope of allegory"* and moved to *"simplicity"*.[17] Another biographer, Francine Prose, offers particularly high praise, saying that Caravaggio's *"genius"*[18] has produced *"something stronger than time and age, more powerful than death"* and that his work *"is beautiful by any standard"*.[19]

How can critiques of the past be so different from those of more recent times? Caravaggio's paintings are the same now as then, so what has altered? To understand why there is so much variance between past and present critiques, we have to appreciate something of the changing contexts and conventions of beauty and art. More specifically, we have to appreciate the differences between pre- or early-modern and late-modern sensibilities and worldviews.

Condemnation by 17th-century and later commentators concentrated on the fact that Caravaggio's art did not adhere to traditional concepts of beauty and was therefore neither dignified nor elevating. Consequently, critics dismissed his work as coarse and vulgar. Artists of the time created idealized visions of beauty; the aim was to convey an idea of perfection. Much of the art was religious and holy figures were depicted in an ethereal manner. Nicolas Poussin's *The Annunciation* (1657) is plainly not a representation of reality. The Virgin Mary has a haloed dove hovering above her head, indicating the presence of the Holy Spirit, and as she sits with her eyes closed, the winged angel, Gabriel, tells her that she is to be the mother of Jesus. In Paolo Veronese's *Virgin and Child with Angels Appearing to Saints Anthony Abbot and Paul, the Hermit* (1562), Mary, with the baby Jesus and attended by angels, sits on a cloud hovering above the awestruck saints. Such representations are not of this mundane world, nor are they meant to be. The figures are depicted as being 'higher', sacred and worthy of our veneration because they symbolize everything that is good and virtuous. Through the conventions and traditions of painting, such exalted figures were accorded reverence and dignity.

In stark contrast, Caravaggio was a realist. Unlike his contemporaries, he painted directly onto the canvas without reference to preparatory drawings. He also painted from models, who were mainly tramps and prostitutes gathered from the streets of Rome close to his studio. And he painted what he saw, without embellishment or idealized notions of perfection; as Hughes said, he stressed the vernacular and the tangible, not the allegorical. For example, compared to paintings of the same subject matter by Titian (c.1535) and Veronese (1559), Caravaggio's *Supper at Emmaus* (c.1601) is far more down-to-earth and realistic: there are tears in the clothing of the seated figures, one of the disciples has a ruddy nose from drink, and the fruit on the table is bruised and worm-eaten. Yet, the painting is highly dramatic because of his expert use of lighting and contrast and his ability to capture the very moment when the disciples realize that the person in their midst is Jesus.

Caravaggio's rehabilitation began when Roger Fry (1866–1934) referred to him as the first 'modern' painter.[20] However, his work only started to become widely appreciated by contemporary audiences when, in the 1950s, Italian art historian Roberto Longhi mounted an exhibition of his work in Milan.[21]

This more recent, far more laudatory reception reflects late-modern perspectives and sensibilities. While this helps explain why contemporary critiques are virtually the polar opposites of those of earlier times, it does not mean that today's assessments are correct in any absolute sense. So let us consider the remarks of the modern critics and try to understand them within a wider frame of reference.

Warwick says that when Fry claimed Caravaggio as the first 'modern' painter this neatly reversed *"Poussin's accusation of artistic iconoclasm"*.[22] However, while Fry's classification may be accurate, it does not follow that this reverses Poussin's criticism, it merely offers a different view at a different period in time. Poussin was writing in the early 1600s within a tradition of religious art in which there was a sacred sensibility; that is, at a time when there was an entirely different worldview from our own. In similar vein, when Hughes says that Caravaggio freed art from the *"musty envelope of allegory"* and moved to *"simplicity"* he seemingly fails to acknowledge that allegory is a traditional way of creating layers of meaning. According to the conventions of the time, there would be an outer or worldly meaning and an inner or spiritual meaning within the same painting. Moreover, sacred art was intended to be not just allegorical but also anagogical – serving as a ladder that leads the viewer to a higher spiritual understanding.

Prose tells us Caravaggio's *"genius"* has produced *"something stronger than time and age, more powerful than death"* and his work *"is beautiful by any standard"*. Bearing in mind the criticisms by his near contemporaries, this assessment is highly questionable. Caravaggio's work is not stronger than time – it happens to be applauded today because we see it as beautiful according to our contemporary standards, within a secular society that has little reverence for the sacred, the holy, and the perfect. The assessment of Caravaggio's art and his significance may, of course, change again in the future, as it has done in the past.

A small painting by the Spanish artist Francisco de Zurbarán (1598–1664), which hangs in the Museo del Prado in Madrid, exemplifies the layers of meaning that were often embedded in early-modern paintings. *Agnes Dei*, created between 1635 and 1640, can be understood on many levels. It can be interpreted in terms of the four levels of meaning conventionally applied to religious texts. At the *literal* level it depicts a merino lamb, perhaps a year old, with its feet bound; it is obviously still alive. It lies on a grey-coloured table

and appears brightly lit against a dark background of deep shadow. At the *moral* level, the attention to lighting and expert detailing serves to focus our attention on the bound lamb, which lies in a sacrificial position and seems to be passively accepting its fate. The scene is descriptive, expressive and emotive, perhaps stimulating in the viewer feelings of sympathy or compassion. At the *allegorical* or symbolic level, it is clearly a religious painting and the sacrificial posture of the lamb is similar to images of martyred saints, such as Stefano Maderno's sculpture of Saint Cecilia. And at the anagogical or spiritual level, it is interpreted as the *Agnus Dei* or Lamb of God. When it was painted, the religious connotations of this subject matter would have been well understood; the sacrificial lamb being associated with the figure of Jesus.[23] Consequently, it can be seen as a deeply spiritual painting that is concerned with sacrifice and redemption.

Moving to our own time, it is possible to interpret artefacts within our contemporary material culture along similar lines – in terms of their literal, moral, allegorical and anagogical meanings. Considering modern artefacts from these various angles allows us to better appreciate their attributes and their deficiencies. If we take, for example, a smartphone, we can interpret it as follows.

At the *practical* level it is a slim, glass-fronted, rounded rectangular form that enables a number of modes of communication including voice, video, text, and email, as well as photography, online access and a host of applications such as navigation, purchasing and entertainment. At the *ethical* level it enables people to keep in touch with family and friends. However, its use also has addiction-like qualities, which tend to encourage time-wasting and it is a conduit for advertising and impulse purchasing. In addition, the manufacture of such devices has been long associated with exploitative labour practices and environmental harm. In terms of *allegorical* meaning, its clean, crisp design is symbolic of the particular design ideology of modernism. This is especially associated with the early-20th century Bauhaus design school in Germany. The work of the Bauhaus continues to be highly influential, through figures such as Dieter Rams at Braun and, in some respects, Jonathan Ive at Apple. Rams' ten principles of good design suggest that a product should be innovative, useful, aesthetic, understandable, unobtrusive, honest, long-lasting, well-detailed, environmentally friendly, and indicative of *"as little design as possible"*.[24] In the case of the contemporary smartphone

and a host of similar devices, these principles are only ever partly adhered to. Such principles also need to be challenged and critiqued. For example, the constant pursuit of innovation, which usually involves new technological applications wrapped up in newly styled casings, is a primary driver of positional competitiveness and consumerism. Its place in a set of principles of good design today, therefore, is questionable because consumerism is a major cause of waste, resource depletion and environmental harm. Furthermore, the smartphone may be useful but its addiction-like qualities are a matter of concern, especially in regard to stress among younger people.[25,26] The clean, glossy aesthetic of modernism also has to be challenged because it represents an outdated international style that is culturally anonymous and homogenizes our material world into a pervasive blandness that lacks the 'situated' qualities so closely associated with sustainability. Also, these aesthetic treatments are incapable of effectively absorbing everyday wear and tear without severely detracting from the visual attributes of the product, which, in turn, spawns user dissatisfaction and encourages consumption. While such products may be considered unobtrusive, their complexity and multifarious functionality places them beyond the comprehension of most people, thereby reducing them to passive users. And changes in contemporary products are often rather hidden and manipulative, such as built-in obsolescence, thereby bringing into question the principle of honesty. What is more, the smartphone is anything but long-lasting; new models are brought out at regular intervals, encouraging rapid product replacement. They may be well-detailed and they are certainly minimal in their outer aspect but their virtual disposability, relative fragility, and use of materials, energy resources and batteries hardly make them environmentally friendly. Consequently, the idea that 'less is better' also needs to be questioned today. The aesthetics of minimalism has become a cultish style peddled by glossy magazines through artfully posed compositions – fantasies of calm and order amid a frenetic, confusing reality. It may be time to set aside such utopian but ultimately destructive visions and recognize that '*more is better*' if it enables our material goods to be robust, enduring, culturally relevant, and truly meaningful. Finally, in and of themselves, our everyday functional products may be too mundane in their purpose to possess *anagogical* or spiritual meaning. However, they can be understood as being in accord with spiritual well-being if, in their production, use and ultimate demise, they enable good work,

encourage patterns of behaviour that are conducive to individual flourishing and community cohesion, and are environmentally benign.

It is evident from this discussion that how we 'see' things is strongly tied to our worldview, which is continuously evolving and changing. Caravaggio's work was castigated by his contemporaries for not adhering to the principles of that age. Three hundred years later it is celebrated with blockbuster exhibitions and much hyperbole. Our contemporary views, however, must also be questioned or else we complacently pat ourselves on the back for our 'superior' knowledge and taste without admitting our own failings. The layers of meaning embedded in the work of Caravaggio's predecessors and close contemporaries may seem less relevant and appealing to a modern secular eye. Even so, we can surely respect their ability to instil layers of depth and subtleties of symbolism in their work rather than dismissing it out of hand as merely the *"musty envelope of allegory"*. Their work alludes to metaphysical apprehensions that have always been a critical aspect of our humanness. As such, its aim is far higher and its meanings far deeper than just the tangible, the simple and the physically 'real'. And we can look for such depth, layers and subtlety – or, indeed, their absence – in the creations of our own time, including in such utilitarian devices as mobile phones. By seeing them more fully, we become better aware of what they represent, what they enable and, crucially, what they lack.

PART II
ANOTHER REALITY

32

How should we live?

Throughout history, philosophers and sages have wrestled with the question of how we should live and what kind of life is capable of bringing us some degree of happiness and contentment.

Socrates described a way of life he regarded as true and healthy. His vision embraces a wide variety of professions from farmers, carpenters and blacksmiths to tailors, shoemakers and bakers. Through such occupations, everyone's basic needs can be met, along with a few modest desires. Everyone is clothed and housed and the community is able to grow sufficient food for its needs, as well as wine, which should be drunk in moderation. What cannot be produced in the community may be acquired through trade. People observe religious practices and have children according to their means. By living in this moderate manner, both poverty and conflict can be avoided.[1,2]

Ecclesiastes is one of the so-called Wisdom books of the Bible. Though its date and place of origin are disputed, it was probably written in the second or third century BCE. It teaches that human happiness is not to be found in wealth, possessions, status, honours or indulging oneself in worldly pleasures; such things, it says, are meaningless.[3] This ancient book can be understood as an unequivocal critique of ways of life that are caught up in materialism, acquisitiveness and undisciplined pleasure-seeking, and it exposes the false-hood of individual autonomy and self-sufficiency.[4] However, as Christianson says, understanding the influence of its overarching theme of the vanities of this world requires us to reach beyond the limitations of intellectual reason. It is through the imagination that its deeper, spiritual meaning is revealed, through poetry, art, and music.[5]

For two millennia, the *Meditations* of Marcus Aurelius have been seen as an important source of wisdom. The true virtues of life, he says, are self-discipline and regulation of one's impulses and actions; justice and fortitude; and a simplicity of living that contrasts markedly with the habits of the rich. He says that we will never find ease and contentment in life if we pay attention to

what others may think of us, or if we are concerned with celebrity, wealth or worldly pleasures.[6]

In a different age and context, the 13th-century Japanese sage Kamo-no-Chomei wrote *Hojoki*. In his mature years, after witnessing the destruction of Kyoto by a series of natural calamities that included earthquake, storm and fire, he retreats from the world to live in the hills. He builds himself a small shelter – a ten-foot by ten-foot hut. Its contents are simple and few. Bedding is of dried bracken. A screen conceals holy images and a sacred text. A shelf holds baskets for poetry, scripture and sheet music. He also has two musical instruments – a *koto*, a horizontal stringed instrument, and a *biwa*, a kind of lute. Outside, under the shelter of the eaves, are a fireplace, a bamboo mat and a shelf for sacred offerings, and nearby there is a water-pipe. Living in this simple manner, he meditates on life, its dilemmas and contradictions. He reflects on the sorrows of poverty but pities those who are preoccupied with wealth and honour.[7] He lives humbly, wearing modest clothing, eating simple foods. But he is also aware that he may be becoming too attached to his hut and his quiet way of life. He offers no answer to this dilemma, and readers are left to ponder these things for themselves.

In his descriptions of how he has chosen to live we see that, in terms of utility, his needs are very basic and limited to the essentials. Yet, these are not sufficient to feed our quest for meaning. So, in addition to functional objects, we read of a variety of other things, which transcend basic needs – poetry, music, and religious imagery and texts.

The 19th-century American philosopher Henry David Thoreau made a similar retreat from the world, to live a life of solitude for a period in the woods south of Concord, Massachusetts. He too lived in a small cabin, which he built himself.[8] It had an adjoining woodstore and a fireplace, and was furnished with a few items, including a bed, a table, some chairs and a writing desk, as well as various cooking utensils.[9] And, like Kamo-no-Chomei, he also had with him various books, including spiritual texts such as the *Bhagavad Gita*.[10] His cabin was situated on the north shore of Walden pond, and the work of philosophy he wrote bears its name.

Thoreau reflects on the nature of contemporary society and criticizes many of its features for being misguided and missing life's true purpose. He, too, warns against becoming embroiled in superfluous tasks and being concerned about rank and public opinion. He advocates a life of simplicity,

with adequate provision for food, clothing, shelter and warmth. He regards luxuries as unnecessary and obstacles to wisdom, inner development and fulfilment. And he is outspoken in his criticisms of fleeting fashions, the quality of work offered by the factory system, the actions of profit-oriented corporations, and the so-called benefits of new innovations and technologies.[11] He famously said, *"a man is rich in proportion to the number of things which he can afford to let alone"*.[12]

All these works – written at different times and in different places – address essentially the same question, *How should we live?* And while their answers are neither definitive nor prescriptive, they are in agreement about certain traits of human behaviour that suggest how we ought *not* to live. They tend to hold worldly accoutrements – rank and status, riches and possessions – in low regard and as barriers to ways of life that can offer peace and contentment.

Some will undoubtedly dismiss them as too romantic and impractical, but this has always been the case; the world tends to ridicule and reject such teachings. Nonetheless, they have something important to tell us because they have provided people with wise counsel for hundreds or, in some cases, thousands of years. Significantly for a society driven by consumerism, they tell us we should not be seeking happiness through acquisitiveness. Although such dilemmas have been faced by successive generations since the earliest of times, there may never have been a period in human history where this message is more acutely needed. We are currently living in a period of accelerated production and marketing; their scale and reach are unparalleled. Through digital technologies, we have created the means for distributing targeted advertising messages to vast numbers of people around the globe. These kinds of distribution are especially insidious because they are capable of commandeering our attention in a compulsive manner and, in so doing, they hinder reflection, discernment and our ability to, as Thoreau put it, *"live deliberately"*.[13]

33

Moderation

Moderation is a universal teaching that contemporary society ignores at its cost. It is a philosophy that, until recent times, has been advocated by human societies as a path to self-fulfilment and happiness, social harmony and justice. Today, it has much to teach us about our approaches to material culture and their critical relationship to environmental care.

The Doctrine of the Mean, attributed to the ancient Chinese philosopher Confucius, teaches that the middle course is the way of perfection – the way of virtue, harmony and equilibrium.[1] In India, Gautama Buddha advocated *The Middle Way*, which avoids the extremes of, on the one hand, self-mortification and punishing asceticism and, on the other, self-indulgence and sensual pleasures. *The Middle Way* is seen as a guide for acting morally – an intrinsic good with its own value and rewards; if followed, it leads to self-purification.[2,3] Similar teachings are found in the classical philosophies and Abrahamic religions of the Middle East and the West. And as we saw in the previous chapter, Socrates taught that to achieve happiness we should avoid excess and choose a life between extremes in either direction.[4] Aristotle advocated much the same thing, saying that the life of virtue is one that ploughs a course between abstinence and unrestrained self-indulgence and pleasure seeking. The virtue of courage, for example, is found between the extremes of timidity and recklessness.[5] In Judaism, the middle way of moderation is a religious ideal. According to the 12th-century Jewish philosopher Maimonides, moderation is the way of God.[6] Christian writings also call for moderation,[7] and behaviour that is *"temperate in all things"*[8] and, when it comes to resources, we should strive to ensure just distribution and equality.[9] Similarly, moderation is a fundamental teaching of Islam, where the balanced median or *Wasatiyyah* applies to virtually all areas of life. It is a way of guiding one's own individual conduct as well as the conduct of communities and nations. Seen as a moral virtue, moderation is related to integrity and one's sense of self-identity and it is part of the shared worldview of Muslims.[10]

These widespread teachings reflect the accumulated wisdom of humanity in its struggle to determine how we can live in ways that foster social accord and some sense of individual contentment and happiness. They remained a prominent part of the Western heritage up to the modern period.[11,12] Since the dawn of modernity, however, we have taken a different course, one based in the ideology of continual progress and growth, which is highly dependent on levels of individual consumption. Consequently, we are encouraged to spend more than we can afford and buy more than we need. Industry has intentionally created products to last only a limited time, which means their disposal and replacement is a consciously created part of the system. Developed in the West, this entirely immoderate system, with its fundamentally divisive and damaging ideology, has been exported all around the world.

Timani argues that globalization had the potential to unite humanity by breaking down boundaries and fostering equity, but this potential has been thwarted by our failure to be guided by moderation. As a consequence, globalization has had a highly detrimental effect by increasing social divisions.[13] Lack of restraint is seen not only in today's extremism and terrorist acts, but also in the unbridled actions of corporations and governments in their pursuit of economic growth. This has led to extraordinary levels of social inequity within and between countries as well as widespread environmental destruction. And it has constantly promoted lifestyles characterized by self-indulgence, pleasure seeking and excess – from immoderate eating habits and binge drinking, to unprecedented levels of shopping, consumption and waste, to extreme adventure vacations and life-threatening leisure activities.[14]

These are not the ways to personal happiness, social accord and environmental recovery, and they are certainly not the ways advocated by the wisdom teachings of the world. As it always has been, moderation – the middle way – is our most promising course for dealing with the severe challenges of our times.[15] From our current condition in the more affluent countries, this means reducing – resource use, production, consumption and waste. It means being satisfied with fewer material things, paying greater attention to the needs of others, building community and working to ensure a more equitable distribution of resources and goods. And rather than constantly looking for extrinsic rewards via the consumption of goods, services and experiences, it means finding fulfilment elsewhere. From a design perspective, it means creating a material culture that is modest and long-lasting both functionally

and aesthetically, that is capable of being produced and repaired locally via good quality work and, wherever possible, through the use of locally available resources and skills.

34

Legacy

The contemporary eye is forever looking ahead, entirely enthralled by advancement and change. What comes next is far more important than what is happening now. And the past is of no consequence. Those who are most successful and admired in this milieu are decidedly future-facing. They are the much-lauded leaders of innovation and economic growth. But the costs have been twofold. One is the spoiling of the world; the new idea and the latest thing are not just the darlings of consumerism, they are also the harbingers of ruin. The other is a pervasive sense of unease; our focus on the future has gone hand-in-hand with a waning in the significance of depth and rootedness.

When we constantly look to the future, there is a price to pay. It is manifested as a loss of tradition. While tradition also involves change, the pace is slower – one that can be more reasonably accommodated. Knowledge from the past is built upon. Expertise is gradually adapted to respond to new circumstances. The inter-generational transfer of skills enables tried and tested techniques and practices to be passed on. Change is accepted, but prudently. The past is brought into the present and adapted to serve the future in a way that is not disruptive, nor does it denigrate the efforts of those who came before us. As a result, the past is not lost, disregarded or devalued.

If we heed the past, it can infuse the present with the ghosts, legacy and prowess of our forebears – they make their mark on who we are, our identity, our sense of ourselves, where we come from and where we belong.

35

Ashes of Myopia

Experiments in extinction
continue into the small hours;
the dark days of diminishing
returns. The closing light,
the lowering sky in the
grey chill imperceptibly
fading into a
collective ending.

36

Closest to the Dreaming

In modern culture, artistic development for most people ends early in life. Typically, adults will continue to draw at the level of a ten- or twelve-year-old.[1] Drawing expert Betty Edwards has said that it is around this age that children want their drawings to be more realistic but most will find it difficult to achieve the representational accuracy they desire. She calls this 'the crisis period'. They become frustrated and it is at this point that they often give up; they simply stop trying to draw.[2]

Our culture and education system prioritize rational, analytical thinking, associated with the 'left brain', over the more intuitive, imaginative, holistic ways of thinking that are needed for drawing.[3] By an early age we have been taught to think in a particular way and art classes generally play a minor role in secondary school education.

The modern perspective places great emphasis on material reality. We value detailed knowledge of the physical world and precision in its representation. But we fail to recognize that this serves to reinforce an extremely limited outlook. It is an outlook that is becoming increasingly questionable because of its bias towards analysis and material particulars, its suppression of more holistic, more imaginative understandings, and its disregard of the metaphysical and the spiritual.

Artworks from cultures outside Western philosophical and industrial development do not typically strive for realism. Frequently they exhibit an entirely different sensibility, which is about meanings and imaginative stories, not physical accuracy. In the reflection *Art* (Ch.56), I discuss symbolic works from the pre-Renaissance, which have a timelessness about them that speaks to us across the centuries. In many other cultures we not only find a similar emphasis on symbolism but also that artworks are constituent elements within a larger world of stories, myths and meaning-making. Artworks are not separate from, but integral to, everything else. There is a holistic outlook that results from a balance between left and right, physical and spiritual, particulars and whole.

We also find this sensibility in pre-adolescent children. In their drawings, the various elements – intuitively arranged – often result in a near perfect composition. If we remove just one element, the whole balance of the picture falls apart.[4] This innate, unaffected creativity reflects a sensibility that has not yet been suppressed by the dominance of rationalistic, left-brain thinking.

Children's natural sense of harmony and unity, their closeness to the earth and their intuitive ways of apprehending the world around them, all of which are conveyed in their drawings, are part of a more holistic view associated with balance, goodness and virtue. This has been long recognized in spiritual traditions. In Australian Aboriginal cultures, which are very ancient, adults looked to the children to learn from them about how to be more spiritual because children were seen as being *"closest to the Dreaming"*,[5] that is, closest to a state in which there is a balanced relationship between natural, spiritual and moral elements of the world. The Dreaming stories were ways of passing on traditional knowledge about the world, law and religion.[6] Similarly, in Chinese scripture from the 4th century BCE, we read, *"Ever true and unswerving, become as a little child once more"*;[7] that to the world, the wise person often seems confusing because they *"behave like a little child"*;[8] and that, *"He who is filled with virtue is like a new born child"*.[9] Western traditions also recognize that children are closest to the more holistic, spiritual sensibility. In the New Testament we read, *"Let the little children come to me, and do not hinder them, for the kingdom of heaven belongs to such as these"* and *"you have hidden these things from the wise and learned, and revealed them to little children"*.[10] And it is recognized too in the 18th-century Romantic tradition. In 'Auguries of Innocence', Blake admonishes, *"He who mocks the infant's faith"*;[11] and in 'We Are Seven', Wordsworth depicts the child's closeness to nature and a unified sensibility free of categorization and compartmentalization. The child he writes of recognizes no separation between heaven and earth, or between her living and dead siblings. To her, all is one.[12]

We have much to learn from these non-modern and, today, largely unfamiliar understandings about our relationship to the earth, each other and, perhaps most of all, ourselves. It is only by developing a different sensibility – one that is more balanced, less demanding, and more contented – that we can ever hope to achieve a way of living and a form of material culture that are truly sustainable.

37

Fragile

When carefully and skilfully designed, an artefact of human ingenuity may be regarded as beautiful. There can be an internal harmony to its design which offers a certain aesthetic appeal. However, our judgement of beauty can no longer be limited to such a narrow frame. Something cannot be judged beautiful until we understand how it sits within a larger context. If we see that it is the cause of social or environmental harm, how can it be beautiful? But when our interventions are sensitive to their surroundings and in harmony with them, we become cognisant of a richer, deeper notion of beauty.

Achieving such harmony is not easy. It results from a host of complex relationships, interplays and tensions. In many ways it is beyond the ability of any one designer, who is necessarily practising within a limited period of time. It requires observation, trial and error, change and development, perhaps over many generations. This is what is meant by tradition – development that draws on and adds to knowledge, from one generation to the next. Traditional ways of living, practices and artefacts emerge. Their pace of development is slow and they are redolent with the rhythms of the years, the living and dying and new births, and the accretions of existence. Time is a vital ingredient of their character, as is respect for and deference to the expertise of our forebears. Such design eschews fads and fashions and extravagant statements in favour of accordance with the learned ways, accrued wisdom and sound judgements of a community living in a particular place. This is deep knowledge that is grounded in the land, the soil, the natural life and the climate. It is an accumulated sensitivity that matures into a delicately balanced interdependence of people in sympathy with their surroundings.

I have only rarely witnessed such communities. Many years ago I visited a village high up in the Jebel Akhdar on the eastern edge of the Arabian peninsula. Stone houses clustered on the steep slopes, below which were terraces abundant with pomegranates, citrus fruit and fodder grasses. Despite the hot desert climate, there was the constant sound of water, brought to the village

by the *falaj* – an irrigation system of tunnels and troughs that channel clean water from deep in the ground; such systems are at least five thousand years old. And hanging in the glassless windows were large earthenware jars, made in nearby Bahla where the art of the potter goes back centuries.[1] Stoppered with hay to keep out dust and insects, these porous containers catch the breeze, and slow evaporation from the outer surface passively cools the water inside.

As I walked along the path outside the village, following the watercourse back to the source, birds flitted around me, bees hummed among the blossoms and the air was filled with the sound of children playing. In this high, cool and isolated place I was witnessing a very old way of life. Its beauty filled me with joy, even a feeling of reverence. But there was a poignancy too because, even then, I knew it was under threat.

Some of the oldest landscapes resulting from human habitation and intervention were once to be found in Australia. Recent studies suggest that agricultural practices had altered and shaped these lands over thousands of years but often, blinded by a sense of cultural superiority, early settlers failed to recognize the causes even as they appreciated the effects. As Pascoe has explained, the traditional land management practices of the Aboriginal peoples yielded landscapes that were not only practical but also very beautiful. Thomas Mitchell, exploring the continent in the early part of the 19th century, wrote in his journals that this 'accident of nature' *"gave the country the appearance of an extensive park"*.[2] Such vistas, which were actually created over millennia through the accumulated expertise and care of the Aboriginal people, were also fragile. European settlers introduced alien crops, sheep and cattle. The thin, delicate soils quickly became compacted, increasing the run-off during rains and making agriculture more dependent on irrigation, fertilizers, and herbicides.[3]

And today, too, the Jebel Akhdar is losing its verdant hue. There is a lack of water because of changes in the climate, and young people are leaving the villages to find jobs in the city.[4] It is a familiar pattern repeated time and time again all over the world.

38

Being Alive

Samuel Johnson once said, *"when a man is tired of London, he is tired of life"*.[1]

If Johnson's notion of life was busyness, fashion and finance, then he may have been right, but personally I regard such things as mere accoutrements to life that, for the most part, I prefer to set in the background.

For me the stuff of life is found elsewhere.

It is in the morning mist lying low in the valley before the sun has warmed, and in the blossom of the blackthorn in early spring.

It is in the flicker of the jay and the jump of the trout and the exhilarating vista from a windy hill.

It is in books and travel, ideas and conversation, the uncertainty of creativity and, as Maugham once put it, the *"excitement of the unforeseen"*.[2]

But most of all it is in time – lost in thought, imagining and reverie. It is here that we live – when we muse on the sheer wonder of being alive.

39

Nature's Wisdom

The modern mind is reluctant to accept things without seeing the evidence. As a consequence, we tend to dismiss as unreliable many ideas that once would have been accepted as common sense. I have always thought such attitudes rather narrow-minded, even arrogant. It is as if the experiences and insights of our predecessors count for nothing, even though their perceptions benefited from a slower pace of life in a less artificial environment; a circumstance that would have permitted them a more lingering view of the world and a more acute awareness of its moods. And although writers of the past may have expressed their understandings in non-scientific terms, this does not mean their insights were any less discerning. Instead of always demanding evidence or proof, we might better attend to the spirit and astuteness of their words.

A recent study by a team of psychologists found that we become less stressed when we spend time in rural and natural environments rather than busy streets, and that parks are more restorative than shopping malls. They conclude that adding more green spaces to cities would make a positive contribution to people's mental health and well-being.[1,2] Similarly, a review of dozens of research papers that looked at the impact of nature on well-being suggests that spending time in natural environments reduces anger, stress, depression and anxiety, makes us feel better emotionally and increases our ability to pay attention. It also seems to contribute to physical health, reducing blood pressure and muscle tension among other things. Being able to see natural places also increases our ability to tolerate pain and reduces hospital time. In terms of lifestyle, environments with trees and green spaces appear to enhance a sense of community. People living in such places report higher levels of engagement with neighbours, greater levels of concern for others, an increased sense of belonging, and fewer incidences of violence. In contrast, less time spent in natural places, together with more screen time, is associated with depression, loss of

empathy and lack of altruism.[3] Research from the UK suggests that *"individuals are happier when living in urban areas with greater amounts of green space"*, experiencing significantly lower mental distress and a higher sense of well-being.[4]

These findings from science are important and, clearly, we should take them seriously and heed their recommendations. However, people who have spent time in natural places know much of this already. Some of them have written about it, but from an entirely different angle. Yet, if we consider the meaning of their words, we come to much the same conclusion.

Scottish author John Buchan, best known for his novel *The Thirty-Nine Steps* (1915), was also Governor-General of Canada from 1935 until his death in 1940. He toured Canada extensively, meeting the people and getting to know the land. In 1937, he travelled by steamer down the Mackenzie River in the North West Territories to the Beaufort Sea and it was this journey that formed the basis of his final novel, *Sick Heart River*, published posthumously in 1941.[5] In it, he records his observations and reflections about the Canadian landscape, including the impact of the logging industry in that region. He writes, *"The hillsides had been lumbered out and only scrub was left … the sluices had been opened and the dam had shrunk to a few hundred yards in width, leaving the near hillsides a hideous waste of slime, the colour of a slag-heap. The place was like the environs of a town in the English Black Country … He remembered its loveliness when Château-Gaillard had been innocent of pulp mills … Now all the loveliness had been butchered to enable some shoddy newspaper to debauch the public soul. He had only seen the place once long ago at the close of a blue autumn day, but the desecration beat on his mind like a blow."* And in a different spot, unscathed by logging, *"There was something tonic in the air which gave him a temporary vigour. … The place was so green and gracious that all sense of the wilds was lost, and it seemed like a garden in a long-settled land, a garden made centuries ago by the very good and the very wise. … Almost he had a sense of physical well-being".*[6]

A hundred and forty years earlier, the poet William Wordsworth was inspired by his time spent in the English landscape. In *The Tables Turned* (1798) he writes, *"Come, hear the woodland linnet, / How sweet his music! on my life, / There's more of wisdom in it. … Spontaneous wisdom breathed by health, / Truth breathed by cheerfulness, / One impulse from a venal wood / May teach you more of man, / Of moral evil and of good, / Than all the sages can".*[7]

As the greenbelt around London comes under increased pressure by developers for housing – along with roads, shops and infrastructure, and as motorways, high-speed trains and industrial parks take over more and more of our natural places and increase noise levels and air pollution, we lose not just the green spaces but also the quietness, the calm and the clean air to breathe. Such developments may be conducive to economic growth, but they are hardly conducive to peace of mind. As stress levels and mental health problems rise, even among young children, we must listen not just to the scientists but also the artists, the writers, the poets and, perhaps most of all, to nature itself.

40

Repeated Patterns

The Industrial Revolution in England created enormous wealth for entre-
preneurs, especially the new mill owners in the north-west of the country. It
was a period in British history that also saw immense social upheaval. With
the advent of mechanized production, traditional cottage industries were no
longer competitive. Consequently, people migrated from the rural villages to
work in the new factories that were springing up in and around Manchester.
Rapid urban expansion brought overcrowding, squalor and noxious smog.
Working days were long, conditions were noisy and dangerous, and there
were few workers' rights.

But money was to be made, and in vast quantities. The grand town
halls that still stand in Manchester and nearby Bolton, Blackburn, Oldham,
Preston and Rochdale bear witness to the expense that went into establishing
and proudly exhibiting the status of these new economic engines – far to the
north of London.

All this change, social turmoil and filth was looked upon by some as
shabby, shallow money-making; greed run wild, trampling roughshod over
long-established ways of life. So, in parallel with the growth of industry and
urbanization arose its virtual mirror image. This occurred a little further to the
north, in the English Lake District of Cumbria. Here, William Wordsworth
and Samuel Taylor Coleridge wrote *Lyrical Ballads*. With titles like *The
Nightingale* and *Lines written in Early Spring*, these poems were a celebra-
tion of nature and a recognition of ordinary country people, whose voices
are heard through these verses. *Romanticism*, as this artistic endeavour came
to be known, extolled beauty, customs, the aesthetic sensibility and human
emotions.

The Industrial Revolution and Romanticism are two sides of the same
coin. The urge to move forward towards new horizons and exciting, unlimited
futures is accompanied by a feeling of disquiet, that something important is
being lost – something that is vital to human culture and the human spirit.

In modern China, we are seeing parallels with these dual patterns of innovation and conservation. In the years following the Cultural Revolution (1966–1976), with its violent atrocities and economic decline, China instituted major reforms. It moved from a centrally planned to a market-based system and, with investment in infrastructure and industry, the economy grew rapidly. The cities also grew rapidly because, as in England two centuries earlier, people left their villages to find work in the new factories. And again, these social upheavals brought overcrowding, pollution, long working days often in dangerous conditions, and few workers' rights.

China's growth was accompanied by other major changes across the world – economic development in other parts of Asia, including the Indian subcontinent; the relocation of major manufacturing centres from West to East; shifts, often downward, in employment opportunities in North America and Europe; deregulation of the markets; economic globalization; and increased movement of people within the European Economic Community and from poorer to richer countries. At the same time, a host of economic and practical possibilities arose from new developments in digital technologies and global communications. And with all this wealth generation, innovation and change, there again arose the feeling that something important was being lost.

Over the last decade or so, I have received PhD applications from students in China, Iran, Malaysia, Taiwan, Thailand and Turkey, all wishing to study traditional craft practices and investigate how design might make a constructive contribution in ensuring their survival. The implication is that such practices are in decline. Furthermore, as the 20th century turned into the 21st, a UNESCO Round Table of experts met in Italy to draw up a working definition of *intangible cultural heritage*, which reads as follows:

> *Peoples' learned processes along with the knowledge, skills and creativity that inform and are developed by them, the products they create, and the resources, spaces and other aspects of social and natural context necessary to their sustainability; these processes provide living communities with a sense of continuity with previous generations and are important to cultural identity, as well as to the safeguarding of cultural diversity and creativity of humanity.*[1]

This definition, although rather wordy, is wide-ranging. It recognizes that cultural heritage is not limited to objects, buildings and monuments, but includes oral traditions, social practices, rituals, festivals, worldviews, skills, and tacit and explicit knowledge related to traditional craft production.[2] Safeguarding intangible cultural heritage means ensuring that this knowledge and these practices are passed on from one generation to the next. Part of this involves comprehensive documentation. In Shanghai, for instance, dozens of examples of intangible cultural heritage have been recognized. Each is recorded in its own beautifully illustrated book with an accompanying DVD that demonstrates the practice. UNESCO's Intangible Cultural Heritage initiative now lists some two hundred and eighteen participating countries.

In Industrial Revolution England, the significance of traditional practices, perspectives and ways of life was acknowledged through artistic expression, especially poetry and painting. Today, it is being recognized globally through conservation initiatives, systematic documentation and film. In both cases, the importance and value of this heritage has become more acutely felt because it is perceived to be under threat. These various efforts – artistic endeavour, academic study, design initiatives, UNESCO recognition, documentation and tuition – are not alternatives to innovation; they are an integral and vital part of it. Change and conservation represent two aspects of our character – the rational and the intuitive, the physical and the spiritual. We should not think that one is right and the other wrong. The two co-exist in our very being.

41

Profits and People

Over the course of the modern era, society has become increasingly defined, and divided, by economics.[1] Frequently, business leaders seem to pay little attention to people's welfare, the social good and common decency. The recent demise of the high-street chain British Home Stores is one case in point. Closure of its hundred and sixty-three stores put some eleven thousand people out of work and left an enormous pension deficit.[2] And just as this was happening, its former owner, a knighted billionaire, was receiving delivery of his new superyacht.[3] Moreover, the trend of hiring people as independent contractors, rather than full-time employees, enables companies to avoid paying for health coverage, maternity leave, vacations, pensions schemes and other benefits.

While such exploitative practices have always blighted economic development, this is not the whole story. There have also been people who, in their business affairs, have taken a more considered and considerate view of the role and purpose of work. A number of 19th-century industrialists provided for the physical and spiritual well-being of their employees. Though these did not represent the norm, they are examples of very successful industries in which substantial profits were achieved in tandem with a caring attitude towards workers and their families. Some made very considerable efforts – providing housing, hospitals, schools and places of worship, as well as parks and sports facilities. The Rowntree confectionary company in York was a pioneer of social care at work. It was one of the first companies to have welfare officers, who looked after the needs, education and moral character of younger employees. The company also provided a medical officer and adult schools, and built the village of New Earswick, with housing for managers and factory workers, a library, a social club, green spaces and other amenities.[4] Similarly, the Cadbury chocolate company in Birmingham[5] provided good-quality living conditions for its employees well away from the pollution of the city.[6] A few miles north of Bradford, the industrialist and philanthropist Titus Salt

created the town of Saltaire adjacent to his large woollen mill. It included well-planned housing for thousands of his employees, shops, schools, a hospital and churches. The extensive Saltaire Club and Institute had social and educational functions. It housed lecture theatres, reading rooms, games rooms, classrooms and a gymnasium. In addition, forty-five alms houses provided rent-free accommodation for the aged and infirm, and residents received a pension. In 2001, Saltaire was designated a UNESCO World Heritage Site in recognition of its international status as a model 19th-century industrial development.[7] In these examples, we see the coming together of business acumen and emotional awareness, instrumental rationality and aesthetic experience, the industrial and the rural – a harmonious fusion, perhaps, of commerce and romanticism. By considering not just profit but also people's welfare, this integration into a holistic vision can be realized.

A rather different approach, but with similar socially minded values, is the cooperative model. Also with its roots in the 19th century, it has provided a more equitable approach to business up to the present day. Cooperatives were advocated by E. F. Schumacher in the 1970s; his ground-breaking book *Small is Beautiful* bore the subtitle, *A Study of Economics as if People Mattered*.[8] Cooperative models work on principles of equity, social responsibility and caring for the community. They have been very successful among women's groups in Africa where they have enabled empowerment, leadership and economic development, and have helped promote gender equality.[9] Elsewhere, there are thousands of cooperatives, from dairy farmers and olive growers to financial services, and large-scale manufacturing.[10]

There are also contemporary philanthropic examples, the most prominent being Bill and Melinda Gates. Unlike their 19th-century predecessors, their charitable activities are distinct from and largely subsequent to their business activities. The Gates Foundation dedicates tens of billions of dollars to their chosen causes, which are aimed at improving the health and well-being of people around the world, through agricultural projects, education programmes, healthcare and family planning.[11,12] The Foundation's motto is *"All lives have equal value"* and its stated purpose is to make a difference in the world.[13]

Some of these projects might be criticized for selective 'do-gooding', and the idea of employee villages and company-built libraries, social clubs and parks might seem overbearing. Such concerns, however, must be considered

in context. During periods of rapid economic change, the norm is too often characterized by exploitation and poor conditions. Despite inevitable short-comings, projects aimed at the social good can be beacons of positive change that, given a chance, can evolve and improve over time.

There is a fine line between well-intentioned, ethically minded projects aimed at the collective good, and intrusions into individual autonomy. This, however, is the balance we must always find in society – between economic efficiency and doing the right thing, between being individuals and living in proximity to, and caring for, others.

42

Return to Syros

After a three-year hiatus I have come back to Syros to teach a week-long design workshop to students at the University of the Aegean. I was here before as part of an international programme, which brought together professors and students from the Netherlands, Germany, Italy, Greece and the UK. This time it is just my research associate and myself. It means we are able to spend more time with the Greek students and I learn more about them and their perspectives. The week has been noticeably calmer and more reflective. Their presentations are beautifully put together and they are very knowledgeable about the island – many of the students were born and brought up here and they reveal aspects of the place I had not heard about during my earlier visits.

Syros may seem like a paradise to the outsider, but its history bears down on the present and when one knows what to look for, it is a history that becomes visible. A good number of houses in the capital of Ermoupolis are long-abandoned and dilapidated. With their old, sun-bleached wooden doors and their crumbling stucco they have a beautiful sadness about them. We learn that they are empty because, in the Second World War, thousands of the city's residents died – not from the fighting but from starvation. The island was precariously dependent on imported food and when this became unavailable, there were many deaths – perhaps as many as eight thousand.[1] Their houses, some with the furniture and belongings still in them, pepper the town, slowly decaying into dust.

We learn too that for many years the main square in front of the grand belle époque town hall was prohibited to the poor, who were mainly Catholics living in the original settlement of Ano Syros, set high above the modern city. A social divide was drawn along religious lines. Catholics were generally working-class, with jobs in construction, heavy industry, factories and domestic work. And there were the Greek Orthodox bourgeoisie who lived in the imposing villas overlooking the waterfront, with wealth from Athens or local

enterprise. The large natural harbour here has long supported trade as well as a substantial shipbuilding industry.

And we learn that the refugee crisis that has created such challenges for many of these islands in recent times has all happened before. In the 1820s, during the Greek war of independence against the Ottoman Empire, Syros was the centre of an earlier refugee influx, with thousands arriving from all over the region. A century later, thousands more arrived when Smyrna – present day Izmir on the coast of Turkey – was destroyed by fire.[2]

All these events and more have helped create this present 'paradise' in the centre of the Cyclades. Today, Ano Syros is a gem of architectural history. High on its mountain top it looks out over Homer's wine-dark sea.[3] The large-scale shipbuilding has gone, though the cranes still stand, rusting on the skyline – and with its demise the restrictions on the square in front of the town hall have also disappeared. Today it is a place for families, with toddlers chasing the pigeons, and old men sitting in the shade of the orange trees. The steps of the town hall have become a favourite rendezvous for young couples. And, on summer evenings, this is where the town comes alive together.

The legacy of the earlier refugee crises is reflected in the ethnic mix of the businesses, the cuisine and the cultural life of the island. The refugees brought skills, knowledge, art and song, which have all contributed to modern-day Syros.

I have never before experienced such a vibrant cultural life in such a small community – painting, sculpture, dance, music and theatre. Last night I was at a concert in the local art gallery, which is exhibiting work inspired by the wild, undeveloped northern part of the island; the concert was put on to raise awareness about its ecological importance. Local musicians and singers played traditional songs and new compositions of their own making. There was sublime jazz guitar and, from a mathematics professor, music of political protest.

Later, under the shade of café umbrellas, looking out over the Aegean, we pick up the conversation with our Greek colleagues. The philosopher-theologian Pherycydes is mentioned. He was born on the island in the sixth century BCE and two caves in the north bear his name. According to some sources, he taught Pythagoras.[4] Antigone, the daughter of Oedipus and the subject of a Sophocles tragedy, also crops up. And the local dance troupe, who won the top prize in Greece for their production of Medusa, is

rehearsing again to take it on tour. And I am reminded that this place is not only very ancient, its long roots are what give it its incredibly rich character and cultural depth.

What reward have ye?

Scum filth
mob herd
louts hooligans
activists extremists
fanatics fundamentalists
islamicists ragheads
terrorists militants
predators perverts
paedophiles priests
tramps travellers
skivers squatters
psychos schizos
victims scapegoats
people

44

Atomization

When used in moderation, personal electronic devices can be superb tools for keeping in touch and organizing social gatherings or community activities. The facility they offer for communicating and scheduling has been transformative. From arranging a time to meet a friend in the park to coordinating an international conference, the smartphone, tablet and laptop have become indispensable, and the ease and speed they allow are unprecedented. At the same time, there can be little doubt that use of these devices has had a severe atomizing effect on society, and the very notion of virtual 'friends' and virtual 'relationships' is highly questionable. The rapid, global-scale take-up of these products may have brought benefits, but the costs of their convenience are substantial.

The shift from communally shared to domestically shared products and subsequently sole-use, individualized products has been accompanied by a social transformation. Our enthusiastic adoption of communication and entertainment devices has eroded the need for social interaction, negotiation, compromise and heeding the views and wishes of others. We can choose whatever we personally want in an instant, and everyone else can do the same.

The telephone box once served the needs of a whole village. The town cinema showed one title a week, which was enjoyed and discussed together. The traditional British pub was a centre for conversation, self-made entertainment and sometimes heated debate. Today, the pub is in rapid decline. Unable to compete against cheap supermarket booze and personalized entertainment, dozens are closing every week.[1] Many of those that remain open have converted themselves into so-called gastropubs. This ugly hybrid of a term indicates a transition from pub to restaurant – with bookable tables pre-set for formal dining. Among their clientele there will inevitably be several couples who go out for the evening seemingly to ignore each other. They can often be seen eating distractedly while scrolling through their social media and saying not a word.

In 1920, the Spanish artist José Gutierrez Solana painted *The Gathering at the Café Pombo*. It depicts a group sitting at a table, and standing in their midst is the author Ramón Gómez de la Serna, who was an inspiration to the Spanish avant-garde.[2] The key concern of this painting is the importance of people getting together in cafés and bars to debate ideas. This kind of gathering was a relatively new social phenomenon in Madrid at the time but it was seen as a critical ingredient of the intellectual regeneration of Spain.

Cafés, bars and pubs have long been associated with the flourishing of ideas – from the coffeehouses of 18th-century London to the cafés of Zurich and Paris in the interwar years. These were places where intellectual movements began and the avant-garde was nurtured. They are places that allow the conversation to go where it will – for its own sake – without object or end. They are places for airing and sharing views without risk of the pack-mentality viciousness that we see so often today on social media. And they are places, too, to listen to others and deepen and widen our own perspectives.

Perhaps the biggest cost of the atomizing of society is the narrowing effect it is having on our own perspectives, because they are not being subjected to discussion and development. We become less self-assured and more ready to judge others in ways that are anonymized and free of responsibility and accountability. In other words, free of those very things that allow us to grow as social beings.

45

Lost

Looking
for something
out there
in the faraway
in there
in the glowing glass
on the other side
of where we are.
Ever seeking
that place where
the cup
overflows where
the greener grass
grows.

46

Authenticity

Ambling through a maze of narrow streets below the main square, I turned a corner and almost bumped into a long line of people. They were from all over the world and, in the hot August sun, they were lining up outside a shoe-maker's shop. It produced espadrilles, the traditional peasant footwear of the Pyrenees. This little shop had been making these shoes for five generations. But we were not in the Pyrenees. We were in Madrid, the sophisticated capital in the centre of Spain. This made no difference – the very longevity of the place, where things were done in the old-fashioned way, gave it a validity and a sense of the genuine.

A world of mass-produced goods and relentless advertising has made us hungry for tradition, authenticity and origins, but when it comes to mate-rial culture, it is not so easy to pin down what these terms actually mean. We may think they have something to do with tracing a practice back to its foundational source, but on closer examination one finds there rarely is a foundational source, no single point at which a traditional practice can be said to have begun. Everything relates to what has gone before. Everything is derivative and is constantly changing, being adapted and responding to societal demands. In fact, this is at the very heart of tradition. If traditions fail to adapt, they quickly die or else become mere pastiches of themselves for the tourists. And yet, our search for origins is not a hiding to nothing even though it may be unable to provide an entirely satisfactory answer. It does suggest that our notions of tradition and authenticity are related to time and its passing.

A more fruitful route would seem to lie in the connection to the human condition – the touch of the hand, human relationships and the stories we tell. It does not seem to matter that a practice is being continued in a place quite separate from its historical roots, or that the practice has changed over the years. It does not seem to matter that its origins are *not* lost in the mists of time, as we had assumed, but turn out to have been invented relatively

recently for purely commercial reasons. What matters more than all these are the perceptions, the stories, the romance, and the human encounters.

Our ideas about tradition and authenticity are related to time and place but not as strongly as we may initially think. Some 'traditions', like the Scottish kilt and a particular tartan being linked to a clan or family name, as well as certain fishermen's sweaters and native rugs, are relatively recent inventions. With time, their fabricated origins become enveloped into the story and, ultimately, it is the story that matters.

47

Change

When I was very small there was a department store in our town called *The Bon Marche* where I sometimes went with my mother. A faded postcard shows that in 1910 it was already well-established. When I knew it, it was a major feature of the high street. It seemed like *The Bon Marche* sold everything – dresses and suits, coats and bags, fabrics, jewellery and toys. We went there mainly for the fabrics because my mother made curtains and chair covers for the house, as well as clothes for herself and my brother and me.

The Bon Marche sticks in my memory because, when you paid for something, the shop assistant would put the money in a brass canister, place the canister in a cylindrical holder and pull a lever. It then shot along an elaborate pneumatic contrivance of vertical and horizontal pipes up to a cashier's office that overlooked all the different serving counters. A minute or two later, it would come back with the change and the receipt – magically finding its way through all these pipes to just the right counter. Seeing these wonderful whizzing canisters was always a thrill.

Only a few years later *The Bon Marche* closed. It had been there for my forever – it was part of the way the world was and, as far as I was concerned, always had been. I couldn't comprehend it. What happens now? What about my mother's fabrics? What about the money canisters?

And so my small world shifted and my perspective altered. I can recall it vividly so many years later because it wrote itself indelibly into my being. It was my first experience of the fragility of permanence and it disrupted the landscape of this once small boy.

Accelerated change is now endemic to the world we have created. While there has always been change, today, its pace, magnitude and relentless promotion are unparalleled. Change, innovation and newness for their own sake have come to be seen as inherently good, and so they are constantly encouraged and expected. This normalization, however, seems not to have taken sufficient account of the low-level, but virtually permanent, sense

of anxiety it imbues in each of us and, therefore, in society as a whole. We simply have to look around to see this – it is written in the faces we encounter every day. Value is found not in change per se, but in relationships – the human community is the basis of value.[1]

48

Seriously

It is not a trivial thing it means much more than we seem to imagine it is not just greener products it is not electric cars or solar panels or windmills or hemp clothing and it is not just vegetarian diets it is a major shift in how we live a fundamental commitment to each other proscribing greed an end to unconscionable concentrations of wealth and steps towards substantial population reduction in the medium term there are no two ways about it there is a need not just to curb but cease our profligacy to cherish the benefits of living modestly to propagate less and see a child as a gift to the community abandoning societal atomization in favour of extended communal sharing and integral social care our endeavours have to be for people not profit equitable environmental and meaningful everything that big business and big industry is not and never can be it means embracing life more intimately and recognizing our interdependence with each other and the earth itself not growth or technology or genetic modification but radically reassessing who we are and how we should live and where happiness lies rejecting the false promises of extrinsic rewards and finding something deeper within ourselves call it tao brahmin the ground of being this is life free of distractions wants status centred in timelessness at-one-ment imagination and love.

49

New

There is nothing new under the sun, or so the wisdom of old tells us.[1] In ten thousand years of *Homo sapiens*, we have surely said all there is to say, we have surely known all there is to know. But one generation after another discovers this for itself and each inevitably privileges the present.

So the circle turns. The old are gently pushed aside, dismissed as has-beens and the young eagerly take their places with their 'new' ideas, 'new' directions and 'new' mistakes. It has happened always and will, inexorably, happen again. The old are simply yesterday's young. The young are the old of tomorrow.

So too the discoveries we make are not new. They merely throw light – often a dim light – on that which already is. Seemingly new, seemingly solid, in time they too dissolve and disappear as subsequent discoveries and interpretations supersede them.

And as for all the 'new' gadgets and gizmos and bells and whistles that preoccupy us so completely, these are but passing trinkets. They burn brightly under a flourish of fanfare, they amuse us for a moment, but like the firefly their flame is soon extinguished. Their transient distractions are of little consequence. In the scheme of things, their purely extrinsic rewards count for nought.

There is nothing new under the sun, and pondering this ancient wisdom allows us to set our sights elsewhere, on a more precious prize. For where our treasure is, our heart is also.[2]

50

The Comb Shop

It was a bright, blue morning in early autumn when I arrived at Tokyo's Kaminarimon Gate. A huge paper lantern, red and black, hung from the rafters. Through the gate, thousands of people were already packed into a narrow boulevard lined with colourful stalls selling sweets, postcards and gaudy souvenirs. Ahead, in the distance, was the ancient Sensoji Temple. Ceremonial smoke rising from the entrance created a hazy backdrop for couples taking selfies.

I knew that this was one of Tokyo's most popular sights, but had not anticipated such numbers on a weekday in October. I soon felt the need to flee and, leaving the bustle behind, wandered through the adjacent park into the nearby streets.

I found myself in front of a shop window that held nothing but combs – beautifully made wooden combs. There were all kinds, from plain and functional to intricately carved, ornamental designs.

Inside, all was calm and subdued. The display cabinets and drawers were old-fashioned and well-used. The proprietor, who welcomed me with a broad smile, turned out to be one of the makers – there were five in all. One specializes in carving, another in polishing or lacquerware or decoration. The combs were hand-crafted from boxwood. The Yonoya comb shop, he told me, had been in existence for three hundred years, and the making and carving skills had been passed down from one generation to the next. He was a fourth generation comb maker. In one of the cabinets were photos of his father and grandfather.

He laid out a selection of combs on the counter. At first, I thought they all looked the same, until he pointed out subtle variations in tooth length and thickness. Each was designed to suit a particular hair type. He pulled open a drawer in one of the old cabinets. It was copper-lined and full of camellia oil. In the bottom lay five combs. Camellia oil, he explained, is good for the hair.

I had failed to notice his workshop because it was so small. His seat was a cushion on the floor. A block of stone anchored a simple holder for the work-piece, next to it stood a task lamp. A small stock of wood lay nearby, with some baskets containing tools and brushes.

I continued on my way and, turning a corner, found myself back at the Kaminarimon Gate. The crowds were still milling and incense still burned on the temple steps.

51

Repair

One of my earliest childhood memories is of my grandmother sitting by the fire darning a sock. I remember the way she wore it like a glove on her left hand so she could spread the heel tight with her fingers, and the way she wove the needle in and out across the surface of thin threads until there was a neat patch of fresh wool. The result was as good as new, even better than new.

Around the house there were many other repairs, a few – like the sock – expertly done, many – mainly in the furniture and hardware department – very badly done but solid and functional. My grandfather was far less adept. His repair of a wooden chair entailed an overly large screw and a roughly hewn countersink. It did the job but was startlingly ugly.

Whether accomplished or inept, repairing things is not so prevalent today. We live in a culture of disposal and replacement in which consumption has superseded conservation. This is not an intelligent development. Despite the continually reinforced illusion that the shiny, the latest and the next automatically possess intrinsic value, this is not progress.

Things made from plastics and other synthetic materials tend to hang around. And things that are discarded have an annoying habit of turning up unwanted in all kinds of unexpected places – in the stomachs of fish, for instance; fish that are subsequently caught for our dinner plates.

My journey to work takes me along a country road with stunning views over east Lancashire and the Yorkshire Dales. Being a relatively lonely road and close to a city, it has become a favourite venue for fly-tipping. Consequently, on my morning drive in recent weeks, I have passed a couch, a mattress, and an old caravan with flat tyres stacked with trash and emblazoned with graffiti. Such sights do little for my mood but, for some, the fee charged by the waste disposal facility is too steep. This does not excuse such behaviour, even in economically austere times, but it does help explain it.

Repair can be beautiful. It can actually improve the aesthetic experience of an object and make it something we especially cherish. The Japanese art

of *kintsugi* is a traditional way of repairing broken ceramic with gold. Based in the *wabi sabi* aesthetic philosophy, it respects the pieces and sees beauty in age and imperfection. When an object bears the marks of time, the scars of its history and the repairs of its past, its appearance will hold a silent story – one that can be endlessly interpreted. Such an object is an invitation to the imagination. If we happen to know its past, it will take us back there – we will remember the mending and the sense of accomplishment. It is a uniquely satisfying task to work out how to fix something and to execute it well. And if we do not know its past, we can conjure a thousand stories and possibilities. In doing so – object by repaired object – we begin to re-enchant our world. We surround ourselves with quiet chronicles, we ease the burden of waste on the earth, and we add to the music of our lives.

52

Resurrection

In the last decades of the 20th century, sales of vinyl records plummeted as new technologies and new formats for listening to music entered the market. In the 1980s, music cassettes became popular – they were smaller and more convenient and, unlike records, they could be listened to while on the move – either in the car or on the new Sony Walkman personal cassette player, launched in 1979. In the 1990s, the compact disc became the format of choice. Consequently, at the beginning of the 21st century, vinyl was virtually dead. Compact disc sales were also in decline due to the emergence of digital downloading, music sharing and streaming. The future, it seemed, was digital and intangible.

However, vinyl never completely disappeared and, against all predictions, a decade later, sales began to grow year by year. Recently, record sales in the UK reached their highest level in thirty years[1] and were generating more income for artists than YouTube.[2] Vinyl sales also began to outstrip digital purchases.[3] This resurgence in vinyl is not confined to young people following the latest trends nor is it restricted to the most popular forms of music. Record sales are also consistently growing in classical music genres where, it seems, the average customer is over forty.[4]

Digital downloads are very attractive to companies because production costs are practically zero. There is a cost, but it is of a different kind. The reversal of fortune of the vinyl record can, perhaps, be best understood as a reaction to the steady erosion of experience and value for the customer.

Before its decline, the long playing album offered the purchaser not just a vinyl disc but also a record sleeve with artwork, song lyrics and liner notes. Frequently, the sleeve was a gatefold, which doubled the available space for artwork and information. The smaller format of the cassette reduced this to a flimsy piece of paper. The CD booklet provided more information than the cassette, but still a lesser experience than the LP.

With the ability to download individual tracks, there was a further loss – not just of graphics, lyrics and information but the whole idea of an album

– a set number of tracks that, together, formed some kind of completeness. The ability to pay for and download individual songs rather than a whole album gave the impression of increased consumer choice, but in so doing there was a decrease in meaning and value. An album is a finite piece of work. Meaning is inherent to, but also transcends, the individual tracks. Hence, the demise of the tangible object was accompanied by a loss of wholeness. With this, there was a loss of connection between musician and listener, a loss of intimacy, a loss in the idea that a musician's creative accomplishment was being attended to and enjoyed by an appreciative ear. As music became more abundantly available it also became more disposable.

Aficionados of vinyl will say that the sound is warmer and richer than digital, which loses quality through compression and is often regarded as more sterile. This may be true, but much of the attraction of vinyl may be less to do with the sound quality and more to do with ritual. Vinyl records are large, rather cumbersome and delicate objects that have to be treated with care. One has to set them down on the turntable and lower the stylus. There is a direct, dynamic relationship in which one is fully aware of the needle tracking the groove and the sound emerging from the speakers. In addition, vinyl records offer only a short period of continuous play – perhaps thirty minutes – before they have to be turned over. Unlike the longer playing time of a compact disc or the virtually continuous playing time of digital music, vinyl requires our attention – we have to take a break from the daily rush and, in doing so, are invited to focus on this one thing – to fully engage and listen with attention. They draw us in to a different, slower mode and, before we know it, we are lying on the floor just listening.

When we play digital music while doing something else – cooking or working or jogging – our mind tends to be elsewhere, on the task in hand; the music is in the background. At other times we may want a different kind of experience, one that is more involved and absorbing, and vinyl seems to provide exactly this. Its use has a ritualistic quality, but ritual is not for the everyday. Ritual is about setting things apart, separating things out from more routine, mundane tasks. It is about 'making special' those times and activities that we find meaningful, that feed the soul. And this might well be centred on certain pieces of music and creating occasions when we can dedicate our time and attention to listening and fully appreciating the music, the album, the artwork, the composers and the performers. Such single-pointed attention

is not always possible or desirable – so when it occurs it is distinctive – quite literally extra-ordinary.

Music is often associated with ritual, not least because it tends to take one out of rationalistic, analytical thought processes. It stimulates emotional responses and the imagination and, through its repetitions and rhythms, it can induce more contemplative ways of thinking associated with creativity and the spiritual sensibility.

In a secularized, digitized and increasingly frenetic world of technologies, products, images and information, the resurrection of the vinyl record provides an opportunity to buck the trend, slow down, and pay attention. It is indicative of an important human need. Its technological format may be outdated and it undoubtedly has a certain nostalgic charm, but its clarity of function combined with physical ritual offer a rare opportunity to be still, focussed and thankful.

Photograph

While there will be people who want a first edition or a beautifully bound volume, a book is generally appreciated for its contents. Its real value lies in the ideas and concepts conveyed by its words. It does not matter whether these words – by Plato or Aquinas, Swift or Dickens, or any other – are contained in a leather-bound tome or a cheap paperback. Such works can be written by hand, copied by hand, typed into a computer, scanned or photocopied. They can be read in books and on screens and are endlessly reproducible. This characteristic of the written word enables creative works in this medium to be affordable and accessible to all.

This is not the case with paintings, sculptures and designed goods. Their value lies in the concrete presence of the actual thing. We put enormous store in the notion of an original work, and the price of a painting by a well-known artist can be astronomical. We also put enormous store in the exclusivity of an expensive product, which becomes a symbol of status and social differentiation. Unless purchased by the public purse, such things are not available to all but are confined to the realms of the rich. This search for distinction and exclusivity propels the competitive spirit in contemporary society. It is a spirit that knows no bounds. It is driving consumption and taking us towards environmental catastrophe and, potentially, self-destruction.

The closest we have to the paperback in the visual arts is the digital photograph. For years I used a film camera and I went through roll after roll in my attempts to get the lighting just right for the artefacts I was photographing. The film itself was expensive and so was the development process, and it took a fair amount of time before the results could be examined. For me, the advent of digital photography was a godsend. I embraced it immediately and loved the flexibility, affordability and opportunities it offered.

The photograph is so familiar to us these days that we take it for granted, but capturing an image of something or somebody is actually a quite wonderful, magical thing. It is capable of bringing a loved one closer. It allows

an artwork to be seen by people who might never be able to stand in front of the original. And it can communicate in ways that words can never capture – it speaks to us visually, intuitively and taps into our tacit understandings. It is also an important way of documenting and democratizing ideas and creativity. While a photograph is a very different thing from an original work, it does have its own virtues. It not only makes works accessible it also makes them indestructible by capturing and preserving a record of that which is perishable. Without photography, the archaeological treasures of Nimrod, Ninevah and Palmyra would be lost forever and forgotten – the photograph is all we have left to preserve the memory and the wonder of these places that were so deliberately destroyed.

In an era that has become overwhelmingly materialistic, recognizing the value of an endlessly reproducible image can, perhaps, go some way to assuaging our acquisitiveness. Having a photograph of the thing, rather than the thing itself can often be sufficient to convey the ideas we appreciate and the aesthetics we contemplate, in the knowledge that this way is non-hierarchical, infinitely accessible, truly democratic and reasonably eco-friendly.

The Human Touch

Raskolnikov, who kills an old woman in Dostoyevsky's *Crime and Punishment*, is described as completely self-absorbed and so isolated that he dreads meeting other people.[1] At the end of the book he has a dream. The world is suffering from a strange new plague that causes people to consider themselves *"so intellectual and so completely in possession of the truth"* that they regard their decisions, scientific conclusions and moral convictions as infallible. But, like Raskolnikov, each individual believes they alone are in possession of the truth. They cannot agree on what is good and what is evil and this leads to conflagration, famine, and the destruction of the world.[2] The contemporary Russian author Boris Akunin explains that Dostoyevsky's novel deals primarily with the nature of human existence. Dostoyevsky had a deep mistrust of rationalism and considered its development in the latter part of the 19th century, in Russia and the West, to be extremely dangerous and that it would lead to total catastrophe.[3]

The influence of rationalism has only expanded in the years since this novel was published. And we are seeing the havoc wreaked by this limited but doggedly self-assured way of apprehending the world. As I am writing this, ten years after the publication of the *Stern Review: The Economics of Climate Change*,[4] the author, Nicholas Stern, has said that, *"With hindsight, I now realise that I underestimated the risks. I should have been much stronger in what I said."* In the intervening years, global temperatures have risen to record levels, polar ice is shrinking, and there are many more instances of flooding and forest fires.[5] Despite this, we are still pumping enormous amounts of carbon dioxide into the atmosphere; current global emissions are over sixty per cent higher than 1990 levels and atmospheric CO_2 concentrations continue to rise.[6]

These developments are lacking the human touch. They are, quite literally, inhuman. Those non-material, higher dimensions of life, which are expressed through compassion and kindness, have been systematically

stripped away and devalued. The focus of our governments, major corporations and, increasingly, our education systems, is on mundane, material interests that feed a growth-based machine. This can only serve to create a society that is more unfeeling. The human touch is found not in faceless, over-bureaucratized institutions and the mind-numbing logic of their rationalized online systems. It is found in the antitheses of these ways of working – in the hundreds and thousands of small enterprises around the world where knowledge, care, skill and personal encounters are still important. And, today, we are seeing the emergence of all kinds of creative activities by young designers and entrepreneurs who are looking for more meaningful ways forward – community initiatives, repair workshops, and design work that reuses, combines old with new, and which takes into account the environmental implications. We are, at last, leaving behind the antiseptically 'new' and the damning legacy of 'perfection' and developing directions that are more considerate, and that honour the dignity and accumulated meanings of age. These directions are constructive, ethical and optimistic and, importantly, they imbue our activities with the human touch because they are more comprehensive expressions of our full humanity.

55

Perspective

There is a wood close to my home. It is a quiet place, well off the beaten track. I go there when I need respite from words and screens and the relentless demands of email.

Walking along the path towards it, the burdens of the day slough away, my step lightens, and my mind begins to lift. Soon I am amongst the trees – stooping under boughs, stepping over fallen logs and palming away tendrils of new growth. Soft sounds and scents fill the air – the flutter of a bird, the smell of pine and blossom and damp soil. I feel the texture of bark and hear the crunch of my boots. Sunny clearings give instances of pause and then I am into the trees again – negotiating an impromptu route, experiencing each moment.

I come upon a stream flowing quickly and shallowly through the vibrant forest grasses. It has not cut deep into the ground but looks as if it just arrived here, sparkling, new and clear, like a scene from Kirosawa's *Dreams*.[1] I slow my pace, stop, look and breathe it in. I crouch to scoop a handful of water. It is icy and tastes of earth and sky and creation.

The irks and worries of an hour ago have dissolved into a larger vista. And while they have not disappeared, from here they seem neither so urgent nor so important. I can let them go, at least for now. I soak in the splendour and the solitude and the gentle chatter of the runnelling water. And I see the world again. Things coalesce into a new awareness. At such times we achieve ways of knowing that feed and restore the spirit. We involve ourselves directly through encounters that are distinct and personal. In this state of alert attentiveness, knowledge is absorbed that is holistic, experiential and concrete. This particularized form of understanding is quite different from, but complementary to, those obtained from deductive reasoning and abstract theorizing.

Yet, our contemporary world gives precedence to the latter. The dominance of rationalism in today's neoliberal societies manifests itself as a stark meritocracy in which an individual's worth is dependent on their possession

of abilities and skills that have economic utility. Longley has suggested that it is a system in which people are regarded as autonomous, rational, self-interested individuals disconnected from culture, family, community and faith.[2] In contrast, intuitive, experiential ways of apprehending the world allow us to see facts and data within a larger sphere of significance and value, and to see connections and interdependencies. These kinds of relational, experiential knowledge are closely tied to human creativity, spiritual awareness and compassion as well as to culture and community.

There are many aspects of our lives that cannot be expressed through the precise factual language of science. Meanings are more nuanced and layered and many phenomena are multi-faceted and defy definition or singular interpretation. This is especially true of relationships and love, but it also applies to culture, art, music and faith – all of which call upon the imagination, values and conscience. To understand these vital facets of our lives we cannot remain detached, objective observers, we have to immerse ourselves fully in the current of living.

As the philosopher John Cottingham has said, we need both theory and praxis; they represent two quite different modes of awareness and each should be valued.[3] The first provides us with detailed knowledge of specific phenomena, the second allows us to see this knowledge within the greater whole and to put it in perspective.

56

Art

I arrived at the Thyssen Gallery at nine thirty in the morning but the gates were closed. A sign told me I had to wait another half hour, so I went to find coffee.

I returned at ten to discover a long queue. People were slowly making their way across a paved enclosure under the already hot sun and disappearing into a small doorway half way down the length of the building. I joined them.

As my eyes adjusted to the interior light, I was ushered to the end of another long queue, this time weaving through a ribboned zigzag to the ticket counter. I inched forward with everyone else.

At the counter I was given an entrance time and pointed along a corridor to the first gallery. With my ticket and audio guide in hand, I duly followed my instructions and joined the end of another queue. At ten thirty we started to shuffle.

I entered a subdued space filled with solemnity and listened in dutiful silence. It was all very interesting I'm sure but I was unmoved. I was already familiar with many of the artists and so there was a sense of replay and emotionless obligation. I think the idea of a designated viewing slot had sullied my mood. It was too regimented for my liking.

I drifted through the religious art of the early Renaissance with its new-found realism, thinking how much I preferred the more symbolic artworks of the pre-Renaissance,[1] which possess a timelessness that speaks to us more distinctly down the centuries. And I walked somewhat briskly through many old Dutch portraits thinking they were a dour lot.

Eventually, I came to the early 20th century and again admired a Braque and Picasso dancing their cubist duet, and a Kandinsky and what I had thought to be a Malevich but turned out to be a lesser pretender. I was repelled again by the disturbing distortions of Bacon and recognized the distinctive brushwork of an early Hockney. But for some reason none of it stirred me. I felt I was going through the motions.

Passing into the next room, I turned and before me was a rather small painting in a dark frame that brought me to an abrupt halt – a loose composition of blacks and greys with scrawling strokes and greens and reds on a white ground. It looked fast, almost childlike and, I thought, magnificent in its bold confidence. It was by an artist I could not remember having seen before, Arshile Gorky. I learned later that he was an Armenian who had emigrated to America. He had been a major force in the development of Abstract Expressionism but had died young by his own hand. This, his final work, was called *Last Painting (The Black Monk)*[2] and it had been on his easel the day he hanged himself.[3] But I knew none of this as I stood in silence before it. I was transfixed.

The queuing, the shuffling, the ticket price and the ten thirty slot all faded from my mind. Such is the transformative power of the wonderful human endeavour we call Art.

Drive

To pursue something one loves can be a wonderful thing. Spending one's life in the creative arts can be a joy. Writing, music, dance, painting, the applied arts – they offer tremendous rewards. They are also uncertain, frustrating, stressful, and sometimes deeply depressing. It is life on a roller coaster.

There should be no illusions that dedicating oneself to creative pursuits will bring fame, fortune and honour. Such ideas are foolish and a formula for disappointment. It is also misguided because it does a grave disservice to the arts. Fame, fortune and honour are all temporal rewards that depend much on chance and place, connections and the mood of the moment. If one is ruled by these concerns, one will find them fickle and forgetful masters.

When the arts become involved with such worldly interests they become swayed by fleeting fancies, fashions and the preferences of the privileged and fixated on visitor numbers, social media likes and other forms of quantification and evidences of 'impact'. Granting institutions are often more concerned with an applicant's social media and outreach prowess – so they can promote the institution – than anything to do with the work itself. Similarly, today's print and broadcast media are constantly compiling lists – the ten best books, movies, shows, whatever. We drive and thrive on such competiveness and the opinions of others. And when the arts become part of this, the world refers to them as 'creative industries'. In this milieu, fine art becomes a bloated behemoth that services the vanities and susceptibilities of the rich. Design becomes a hackneyed bauble daubed in hype to dazzle the passer-by. And the theatre stage becomes an endless rerun of derivative musical nostalgia based on the hit songs in the soundtrack of the blockbuster film of the best-selling book. To find a deeper sense of meaning, we have to put aside the fripperies of such a capricious and distracted world.

The drive that spurs creative pursuits must come from a different source altogether. Not very long ago we used to speak of vocation – an inner calling to pursue a particular kind of work or activity. The term was often used in

the arts, as well as in teaching, nursing and religious orders. It seems to have fallen out of favour in today's insistently pragmatic society; we tend to only hear of it in the context of vocational training for practical and manual trades. Even so, it is precisely this notion of vocation – an inner calling or inner drive – that is vital for a life in the arts. The drive has to come from deep within oneself and the rewards must be intrinsic – the deepening of knowledge, the learning of skills, the building of expertise and the striving for excellence. Through such means there is inner growth, and from time to time a sense of accomplishment. Perhaps most of all the reward lies in knowing that, despite the heartache and frustrations, there is nothing one would rather be doing.

Elevator

In the prairies of the Midwest, small-town grain elevators next to the train tracks once served the local family farms. When the farms finished, the elevators became redundant.

Industrialized agrobusiness brings monocultures, chemical fertilizers, herbicides, genetic modification, patented seeds and corporate profits.

The neglected elevators still stand – decaying sentinels to a past life. The higher decks become home to cell towers and pigeons, the lower decks to junk, old cars and graffiti.

Their diminished resale value means that, sometimes, they become colonized by artists.[1]

59

And more

Some have a mind for science,
others have a mind for art,
but some have a mind
for life itself and it is they
that know science
and art and more – from
the drum of the dawn,
the soothe of the sun and
the dance of the earth.

60

Economy

When we hear the word economy we usually think of gross domestic product, interest rates, company profits and growth, but this is just one interpretation of the term. A more general definition refers to how something is managed, especially the material resources of a community or a society.

Traditional ways of living tended to be relatively modest in their use of material resources. Knowledge was handed down from parent to child, things were kept in a natural balance and people lived in a sustainable manner for centuries. In modern times this changed. Since the Industrial Revolution, we have not so much been managing resources as exploiting them, and at unprecedented rates. This is not wise management – it represents extravagance rather than economy.

Today, traditional cultures are in rapid decline and in their efforts to retain some of their practices and material heritage, they try to adapt to the dominant, consumption-based economy that has been imposed upon them. In doing so, however, they risk losing those very things they are seeking to preserve. Because they cannot compete with cheap mass-produced imports, they have to adapt their designs and improve quality standards to appeal to a wealthier, upscale clientele. But when traditional practices become redirected to serve external customers, their relevance within their own culture risks becoming purely instrumental – a means to a monetary end. While income generation is important, the production of artefacts will no longer be a living part of the traditional culture but, instead, becomes just another element within the dominant consumer culture.

There is no easy solution to this dilemma. If people are in need of income, they may be less concerned with the demise of some of these traditions and willingly choose a more modern way forward. Later, that decision may be regretted, when they realize that their history and heritage are lost and irrecoverable. In addition, today's primary sources of income are often in 'regular' jobs – in industry, commerce, government, healthcare and education.

Younger people, especially, are attracted to such employment opportunities because they are seen as dynamic and more lucrative.

Traditional making practices can be sustained outside the dominant cash economy. This means pursuing them on a part-time basis, for the sake of the culture rather than as an income source. It also means passing on the knowledge and skills to children, so the traditions become part of their identity and which, later in life, they may wish to reclaim. Through such means, the integrity, place and important cultural role of the practices, objects and rituals can be retained without pandering to the pressures or the wishes of a distant, unpredictable and purely commercial notion of economy.

61

Beyond Protectionism

Protectionism aims to shield local markets and businesses from international competitors by imposing tariffs and import taxes. In principle, this could benefit local producers and reduce environmental harm. On the other hand, protectionism is associated with inward-looking priorities and self-regarding values that are often accompanied by suspicion and hostility towards other peoples. The issue is broader and more complex than this.

Moving materials and goods all around the world creates an energy-hungry, one-way distribution. For the safe shipping of fragile goods, such a system requires enormous amounts of packaging, most of it disposable and much of it plastic. And, centralized production and global distribution do not facilitate the economic repair and maintenance of goods.

Companies not only move materials and goods around the world, they also move their production to locations with cheaper tax regimes, lower labour costs, and fewer environmental regulations. All this helps minimize production costs and maximize profits.

The globalization of business and finance, the setting up of free-trade deals among nations, and the movement of capital around the world have also led to an avoidance of tax by large corporations and wealthy executives. Tax laws apply within nation states, so by spanning national borders, tax law loopholes can be exploited. In turn, public finances become reduced and there is less money for public services – housing, schools, hospitals, public transport and so on.

Clearly, it is difficult to do anything about this by applying stricter regulation and tax laws at a national level. Some progress might be achieved through partnerships among nations, like the European Union. However, ideally, we would have universally agreed and rigorously implemented environmental and tax laws and trade regulations. But this is very difficult to achieve because there are so many players, all of whom are at different stages of economic development. And, when large profits are at stake, exploitation

and corruption seem inevitable accompaniments to the best of intentions. Too often, economic expediency takes precedence over other considerations, like ethics and principles.

The rise of populism, nationalism, the far right and authoritarian regimes is an unfortunate and very present development of our recent emphasis on neo-liberal economics and globalization, which has allowed gross economic disparities to arise. This should never have occurred – the forms of capitalism advocated by Adam Smith and John Maynard Keynes were supposed to be oriented to the public interest and the common good – but this has fallen by the wayside. As Rhonheimer writes, *"laissez-faire is only a necessary,* but not a sufficient, *condition for coordinating private interests, attaining thereby the common good".*[1]

Some form of unilateral protectionism is not the way forward. We have to cooperate with, and look kindly towards, others and their particular circumstances. But we also have to be more vigilant about importing goods that are able to undercut, and thereby undermine, home-grown goods because they are produced using socially and environmentally damaging work practices. In the accounting associated with production, packaging, transportation and disposal, the product costs should include the costs of using up finite natural resources, degrading natural ecosystems, loss of habitats and pollution; the lack of repairability; and the costs of landfill or recycling. In other words, we should be looking at the true costs to people and planet of our activities and the full-cost pricing of our goods and services.

If all these factors were taken into account, we would have a more level playing field across the international stage and, consequently many of the advantages of importing goods from elsewhere would disappear. Naturally, the price of consumer goods would rise. However, with more expensive goods we would consume less and we would expect those goods to last, which would have environmental, cultural and, potentially, heritage benefits.

This would seem a more equitable and sustainable direction for producing and maintaining our material culture, compared to some form of narrow protectionism. It would contribute to the development of a kind of 'cosmopolitan localism'[2] that simultaneously holds on to two somewhat opposing ideas by affirming *"the richness of a place while keeping in mind the rights of a multi-faceted world".*[3] It would also help curtail our destructive

levels of consumption while creating a material culture of greater permanence, continuity and meaning.

There are many obstacles to putting such a vision into practice. But doing the right thing, acting in ways that work towards the common good, and striving to reduce our tendencies towards selfishness and self-interest are all the challenges of being human. They aspire towards virtue, which has been part of the human endeavour for millennia. Just because they are difficult should not prevent us working towards them – even though they may never be fully achievable.

62

IP

There is much concern these days with intellectual property, especially its protection. Large corporations fight fiercely in the courts to retain what they claim to be rightfully theirs.

Much of this so-called intellectual property is pretty suspect – the result of innumerable decisions and serendipitous events whose provenance is impossible to determine. It can arise from something taught in school or research conducted at a publicly funded university, a chance remark, or a minor tweak to an already existing thing – designed elsewhere for a different purpose.

But even if the origin of such an idea is incontrovertible, what does it say about our society when we try to restrict its use for the purpose of accumulating exorbitant profits? The most egregious example is probably found in the pharmaceuticals industry, where pricing is often excessive and corporate returns far outweigh any reasonable recovery of research and development costs;[1] in some cases price hikes have been up to 12,500 per cent.[2] As a consequence, massive earnings for the few take precedence over any consideration of the common good, and luxurious lifestyles are enjoyed on the backs of the sick. Such practices are an abuse of corporate power that our elected representatives should be mitigating against to safeguard the interests of the wider population.

The principle is the same whether the product is a drug, a safety device, a phone or a fridge. When we orient our conventions to the protection rather than the sharing of ideas, we create a society of disparity, division and discord. These, in turn, nurture the blame game – those with the most point the finger at the poor. To maintain their positions of privilege and power they look for easy solutions, identify scapegoats, the other, anyone but them. And these are the seeds of racism and hatred, resentment and resistance and perhaps even war. The Renaissance humanist, philosopher and statesman Thomas More wrote *"as long as there is any property, and while money is the standard*

of all other things, I cannot think that a nation can be governed either justly or happily: not justly, because the best things will fall to the share of the worst men; nor happily, because all things will be divided among a few (and even these are not in all respects happy), the rest being left to be absolutely miserable".[3] Here, More echoes the thoughts of Plato, writing two thousand years earlier,[4] and anticipates 21st-century social research, which demonstrates that more equal societies bring greater happiness to everyone.[5]

Intellectual property only came to prominence in the 20th century, but we have known throughout the history of civilization that such monopolizing and protectionism bring disharmony and hardship. While intellectual property law may be useful in safeguarding people's work and legitimate claims, to ensure a just and equitable society its use requires judicious and proportional regulation.

63

Commonality and Originality

Change and the anticipation of change can be disconcerting and stressful; we have to be constantly on our toes. In comparison, sticking to regular routines is more relaxing; routines become habitual, safe, known. At both the social and the individual level, rituals and repeated practices are important because they are instrumental in fostering community cohesion and, somewhat paradoxically, they can also stimulate the imagination.

Social conventions are learned during one's upbringing. Appropriate behaviours become enculturated and we recognize what is expected of us in given situations. Also, there is often a sense of the 'special' about many of our regular social occasions and gatherings, which separates them from our ordinary everyday lives, with all their cares and worries. The aesthetics of the occasion can also play a role in reinforcing this difference – be it a festival, wedding, birthday, family dinner or weekly religious service. Through learned conventions and aesthetics, a mood is created for a limited period; a mood that is comfortable and relaxed. In this atmosphere, where everything has been prepared and considered beforehand, we dedicate ourselves – depending on the nature of the occasion – to socializing and conviviality, to communal thanksgiving or inner reflection. And while the forms of expression may vary from one culture to another, all societies have examples of such practices.

Historically, these kinds of communal routines and rituals – from Whitsuntide parades to annual summer fêtes – were occasions in which everyone participated. As such, they helped build, bolster and bind the community. It is notable that they were fundamentally equitable in nature; everyone participated and felt they belonged, whether they were educated or illiterate, rich or poor. And because they shared the same experiences, on a weekly, monthly or annual basis, common understandings, values and a common culture developed.

Religion, the traditional expression of so many communal activities, was perhaps the pre-eminent example in which certain times and a special

environment were set aside. In Christianity, these followed the cycles of the liturgical year. The stained glass, altarpieces, the accoutrements of ritual, and music, from Gregorian chant to hymns, all contributed to the creation of a time and space set apart from the ordinary. The aesthetics, in conjunction with an atmosphere of convention, produced an environment conducive to reflection, imagination and inspiration. And it was fundamentally inclusive due to its traditional emphasis on ceremony, which centred on the mystery of the divine.[1]

In contrast, modern society has prioritized the individual and, in so doing, has eroded the significance and place of ceremonies and rites. Religious observance has declined, and family rituals such as eating together have fallen by the wayside – replaced by eating on the go or in front of the TV. And those festivals that have remained, such as Christmas and Halloween, have become instruments of the market and commercialized out of all recognition. In the process, individual contributions to such gatherings – baking, making, music and games – have been replaced by commercial alternatives – off-the-shelf substitutes and professional catering and events services. This, in turn, has reduced opportunities for learning, socializing and passing on knowledge from one generation to the next. Interestingly too, a modernizing reorientation of emphasis of the Christian mass, away from aesthetics and mystery, has resulted in a more divisive atmosphere. Since the reforms of the early 1960s, a focus on social justice in the Catholic Church in the United States has had the opposite effect of that which was intended and anticipated. It has created a feeling of haves and have-nots, in which the poor – the have-nots – become recipients rather than equitable participants; as a consequence, they have become disenfranchised and their regular attendance at mass has fallen away.[2]

At the individual level, especially when it comes to creative activities, there are also rituals and routines that are about separation from everyday life. Author Zadie Smith writes, *"there is something to be said for drawing a circle around our attention and remaining within that circle"*.[3] Many of the patterns of behaviour associated with creative practice are concerned with just that – spending regular, routinized periods of time in a particular place that is comfortable, secure, tranquil and detached from normal activities.[4,5] Such a space, which one can control in terms of warmth, lighting, furnishings and aesthetics, helps ensure an atmosphere that is both relaxed and free from distractions – conditions that are conducive to imaginative thought

and creativity.[6,7] Welsh poet Dylan Thomas had a small, simply furnished writing shed at the top of his garden. It was a sanctuary where he could be alone, think and write, as he sat overlooking the peaceful waters of the Laugharne estuary. Fellow Welshman and writer Roald Dahl was inspired by Thomas' shed, and built one for himself, to similar dimensions, at his home in Buckinghamshire. Here, he had an old wing-back chair, a suitcase as a foot-stool, and a sleeping bag to keep his legs warm. His writing desk was a piece of wood that spanned the chair arms. He kept the curtains closed to shut out distractions and worked by the light of a reading lamp. Before settling down, he sharpened a number of his favourite pencils, had a yellow legal pad before him, a wastepaper bin next to him, and his sweets, cigarettes and ashtray close to hand. Everything was prepared and cosy. He entered this space at the beginning of each day and, uninterrupted, wrote all morning, then stopped. He referred to it as his nest, his womb.[8,9] Other creative people – painters, sculptors, designers – have equivalent spaces, their studios, where they can think and practise.

Of course, there are also forms of creativity that bridge between the communal and the individual. There are individual screenwriters, playwrights, musicians and architects, but the realization of a movie, a theatre perfor-mance, a ballet or a building is a collective endeavour that depends on many different people fulfilling specific roles to achieve a particular creative vision.

From the foregoing, we see that communal forms of ritual and routine can serve to motivate communities, leading to neighbourhood projects, innovations and creative endeavours that generate civic pride, support the common good or contribute to the artistic culture and spiritual well-being of a society. Individual forms of ritual and routine foster personal forms of creativity, resulting in individually authored outputs such as books, plays and paintings. These works, however, also have a communal role in that they are created for an audience. They can stimulate thought, invite reflection and offer new perspectives on the world around us.

In design circles, individual creativity is more strongly associated with modernism and people such as Eileen Gray, Gerrit Rietveld, Dieter Rams, Zaha Hadid, Vivienne Westwood and Philippe Starck. In contrast, communal creativity is more strongly associated with traditional cultures and with postmodernism and its socially oriented emphasis on service design, co-design, participatory practices, transition movements, and design for social

innovation and behaviour change. Clearly, both individual and communal forms are necessary because they represent the fact that we are, at once, individuals and social beings. Being alone in a suitable environment nurtures individual forms of creativity and originality, working together nurtures collective forms of creativity and a sense of mutual understanding and commonality. The two are rather different, but they are also intimately related and are, ultimately, interdependent and inseparable (see Figure 1).

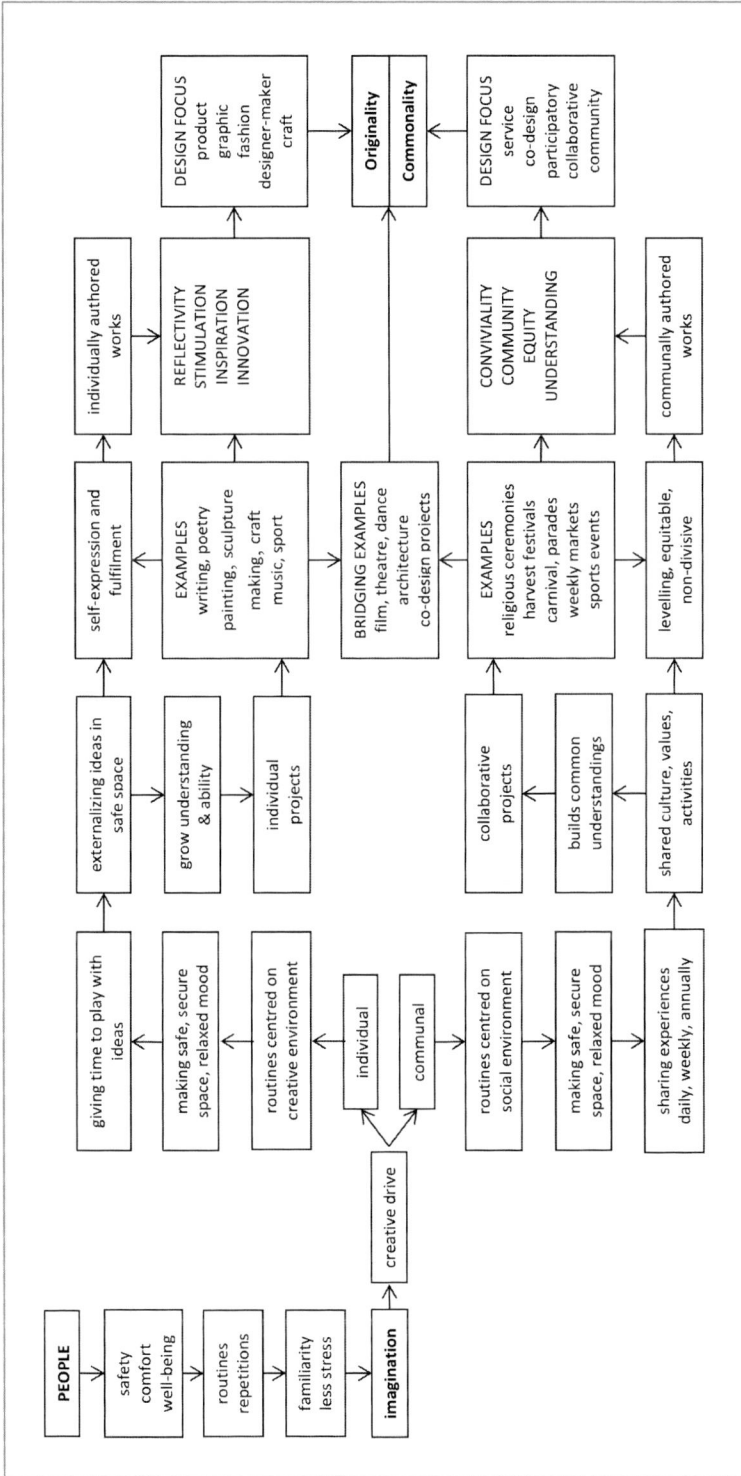

FIGURE 1: The Interdependent Relationship between Commonality and Originality

64

Secular Society

A dominant narrative in the West, especially northern Europe, has been that secularization is the norm for all 'developed' nations. As other countries adopt these ways of democracy, technology and consumerism, it had been confidently assumed, at least until recently, that they, too, would become enlightened by instrumental rationality and utilitarian pragmatism and shake off their beliefs in what is often pejoratively referred to as mere superstition and fairytales. It is clear today that this view was misguided.

The presumption of universal acceptance of Western priorities and ways of thinking was always a conceit based on a pervasive sense of cultural superiority. Its foundations lie in colonialism and empire; a period of social and economic exploitation that was made possible by military, industrial and technological advantage.

Not unconnected to this history, the West's peculiar notion of 'religion' as a coherent set of beliefs and rituals is, in fact, an unprecedented and inherently modern conception. It emerged in the post-Reformation era to be in accord with the evolving modern worldview. Religion came to be seen as a separate entity, one that could and should be relegated to the private realm[1] and kept out of politics, the boardroom and, in some countries, school education.

Such an interpretation of the core spiritual teachings of a culture, which concern the eternal quest for meaning, is anathema to many, including many in northern Europe, which is especially secular. For vast numbers of people, religious, spiritual and/or philosophical understandings and beliefs are all-pervasive aspects of being human that cannot be simply separated out and put to one side; to appear to do so is a mere artifice. Rather, they are seen as essential to a sense of self within one's socio-cultural context, and they represent the most profound aspects of life, providing both meaning and purpose. They permeate and transcend ordinary worldly activities and foster continuity, cohesion and a sense of personal, familial, communal and

even inter-generational identity. For many, they are worth defending when perceived to be under threat. And they are not something to be forfeited for the price of a shiny electronic device, a Western soda, or a pair of sneakers emblazoned with a much-touted brand. Such beliefs go far deeper.

In recent years, there have been some signs of change – even in staunchly secular France. Here, *laïcité* – legally protected secularism – goes much further than simply separation of church and state. But, ironically, in its progress towards an essentially post-religious society, *laïcité* itself has become a new form of state religion.[2] In the name of secularism, the political and cultural left is seen as having exerted a dominating control that has effectively blocked debate about values and religious beliefs.

However, things may be changing. A decline of the political left has opened up new opportunities for discussion. Part of this revolves around the perceived imposition of ideologies and social changes by a small, centre-left elite; impositions that many see as subverting cultural norms and traditions, but which they do not feel at liberty to freely discuss. Part of it, also, is about recognizing one's historical, political and cultural roots, the role of religion in those roots, and the values and sense of identity that this yields. Another aspect is discussion about terrorist atrocities, which have so egregiously distorted and misrepresented the teachings of Islam.[3,4]

Wherever one sits on the spectrum of opinions about such issues, the important thing is to be able to discuss them and not feel that one's own cultural and political milieu is actually preventing open and constructive dialogue about such critical contemporary issues.

65

Sacred Time

Adrift in the turmoil, it was easy to become lost. The anchors were cut long ago, so as not to impede progress. But even as conditions worsen, the destination remains unknown. Does the centre hold? Is there a place left for stillness? A time for silence?

Not here, perhaps – it is so long past. The remnants of what used to be are ever retreating. Yet it holds, still. Not here, perhaps, but in the hinterlands of the south and in the east, even in the city. A time set apart. A place set apart. A place where time is unchanging.

Can I enter this place? Can I enter this time?

Do I know how? Do I step over the threshold?

Into … what?

Stillness? Silence?

Can it be so simple?

It begins this way – a first step taken. Willingly. Receptively. And the second is the same, and the third – the same step, into the same place – again and again. Into time unchanging. Into silence and stillness. Returning. Repeating. For a lifetime.

The centre holds – it is constant. Still and silent it remains forever – unmoved. The change is not there, it is here. In here. I change. Imperceptibly. Outwardly, it can be seen – the greying hair, the lined face, the stooped frame. Inwardly, it is unseen. A deepening. A realizing. A knowing. A seeing – of a kind. Always just out sight of the mind's eye.

And here – a few simple things, sacred, enduring. A book written long ago, for a time set apart, a place set apart. Its passages are unchanging. They last forever and are repeated again and again. And an image, also created long ago – contemplated over and over again. And threaded beads – an ancient practice, a movement, a rhythm, an entering into another place, another time. Again and again, for a lifetime.

66

Misreading Religion

In the Yanaka district of Tokyo, a moment's walk from busy Shinobazu-Dori Avenue, I chance upon a diminutive Japanese garden. Amid the bustle, Sudo Park is a leafy haven of calm and quiet. Stepped pathways rise and fall among the tall trees and a shaded stream runs into a sunlit pool, home to carp and turtle. Arched footbridges cross to a small island where a torii gate stands before a small, red Shinto shrine. On this weekday morning, young business people in dark suits walk through the park on their way to nearby Sendagi subway station. When they reach the shrine, they stop, put down their brief-cases, bow, say a few words in prayer and clap their hands twice,[1] then they continue on their way.

In Dubai International Airport, the early morning call to prayer fills the departure lounge in seeming admonition of the brightly lit shops selling luxury brand clothing and accessories, alcohol and tobacco. The same sounds are repeated from Casablanca to Jakarta. Elsewhere, candles are lit by ordinary people in Buddhist temples and Christian churches, flowers are arranged, incense is burned, and prayers and dedications are written on paper, wood, even oyster shells, and hung on racks, pinned to boards, tied on lines, or pushed into masonry. In places of worship all over the globe, people kneel in prayer, they hold beads, they stand or sit in silent contemplation, and they show reverence to sacred places. Such practices are not confined to any particular belief system but are common features of our humanity.

Sitting at a restaurant on Syros with two colleagues, one Greek, the other Dutch, we were joined by a woman who was very knowledgeable about the local community and was helping us with our project. The conversation flowed and everyone was at ease until, when talking about the two cathedrals on the island, Catholic and Orthodox, my Dutch colleague made an off-the-cuff remark that implicitly questioned religious belief. In northern Europe, such a remark would have been perfectly acceptable – a mildly humorous ribbing of religion. Our guest, however, found it rather insulting and was

quick to point this out, telling him that faith should not be made fun of in this way, that it was very important to many of the people here. He was taken aback and, indeed, mortified that he had unwittingly caused offence.

A few days later, I witnessed something of the depth of this faith. The nearby island of Tinos is famous for its holy icon of the Virgin Mary. The church that houses it, Panayia Evangelistria, is one of the most important sacred sites in all of Greece. The road leading to it from the harbour is a kilometre in length and a steady ascent with little shade. A metre-wide strip on the right-hand side of this road has been cordoned off and laid with red carpet because, even in the blistering heat of the day, devout pilgrims will make this final stage of their journey on their knees.

For many, many people in the world, religion is a crucial aspect of their lives. It gives them a sense of meaning and purpose, and provides them with an idea of what is right and true. We have largely forgotten this in the Western economically developed countries. Some actively ridicule religion, politicians systematically eliminate it from public life, and fervent secularists try to impose their particular ideology on every aspect of society. And despite the frequency of our travels, we mistakenly assume that people in other parts of the world think the same, or should think the same, which clearly they have little inclination to do. This ignorance of religion and our arrogance in making such assumptions was admitted recently by Germany's Home Secretary in relation to his country's refugee policy of integration.[2] He conceded that, *"We have underestimated the role of religion".*[3] Another commonly held view in the West is that religion has been the cause of all the major conflicts throughout history; an assertion that conveniently ignores the fact that the two world wars had virtually nothing to do with religion. Armstrong thoroughly debunks this, suggesting that faith has been made to take the blame in modern society. One of the main reasons for war, she says, has always been competition for resources.[4] And while those who belong to a particular religious tradition may often fall short, it is an error to conflate individual and even institutional failings with spiritual ideals and faith.

Religion is as much about practice as it is about believing a set of precepts. It combines routinized, often communal, practices with imaginative concepts and intellectual understandings. In this sense, it addresses the whole person, both sides of who we are – the rational and the intuitive, the logical and the creative, the pragmatic and the meaning-seeking. Through the

ages, religion has provided the basis for some of the world's greatest texts, art and architecture, and has contributed substantially to philosophical understandings, ethics, legal systems, education, and teachings and practices about charity and compassion towards others. In terms of material wealth, the great religions generally teach restraint and simplicity. The 14th-century Buddhist priest Kenkō writes, *"It is excellent for a man to be simple in his tastes, to avoid extravagance, to own no possessions, to entertain no craving for worldly success. It has been true since ancient days that wise men are rarely rich"*.[5]

Hence, faith traditions are concerned with how the individual can lead a meaningful life, with how we should behave towards other people and, when it comes to worldly goods, with self-control. In today's context, this suggests a drawing back from the excesses and inequities so characteristic of the modern market system. Curbing our consumption would not only have beneficial human consequences, it would also alleviate pressures on scarce resources and reduce the burden on the natural environment. Yet, despite the prudence of these teachings, religion in the West has been marginalized and maligned and is commonly regarded as irrelevant. On the one hand, many left-leaning environmentalists are often ardent secularists and as such may be quite hostile to religion. On the other hand, the idea of restraint and reduction poses a threat to right-leaning advocates of free trade and economic growth. But if we are prepared to look at these essential teachings more impartially, we see that they align very closely with our contemporary understandings of sustainability.

A Stultifying Dualism

It is precisely because I do not believe God 'exists' that I regard myself as a person of faith. There is no reason for this and that, surely, is the point. In my case, that faith is expressed and enriched by the Christian canon and its rites – not that I am either a diligent or devout ritualist. The word 'faith' is also used in Zen Buddhism. It refers to trust in life, ultimate reality, true Self.[1]

I also consider myself a person of reason capable of measured, systematic and rational argument. And a creative person, capable of drawing upon and manifesting products of the imagination, a person of compassion, empathy and love, and impatience, intolerance and anger. I am not one of these things; I am all of these things. And in one way or another, we all are for the simple reason that we are all human beings.

But you would not know it from the dominant narrative of our times, which has, for too long, naively but self-satisfyingly considered itself the sole possessor of reason, fighting against the illogical forces of religion; the custodians of progress pitted against the Luddites of tradition. This stultifying dualism[2] has created untold harm and, with reason, is continuing to progress an ever more frightening form of irrational chaos. Science can describe and explain and furnish us with knowledge, but we are aware of a reality that is far greater than that which can be conveyed through such language. Science cannot tell of the aesthetic experience or of human feelings or of empathy and love, or guide us in how we ought to live – these are the concerns of philosophy, the arts and religion. Science might be able to offer us descriptions and explanations but it cannot furnish us with insight and sagacity.[3]

68

Faith

Faith and the creative act are closely connected, though it is a link that is not much talked about these days. I suspect this is partly because the very idea of having faith – in anything – seems to have become a fool's game. This is hardly surprising given that many of the things we used to have faith in have let us down so badly – politicians, bankers, the Church, to mention just a few. The scandals of recent years have left us jaded. However, the marginalizing of faith goes back further than these recent revelations. It has its roots in the scientific revolution and the Enlightenment. Ever since Darwin's discoveries and his publication of *On Origin of Species*, and even though he wrote, *"I see no good reason why the views given in this volume should shock the religious feelings of any one"*,[1] religious faith in particular has come under continued attack by certain scientifically minded people; most prominently in recent years by academics Richard Dawkins and Anthony Grayling, author and neuroscientist Sam Harris, and social commentator Christopher Hitchens. While their arguments strike me as rather simplistic, often relying on literalistic interpretations of sacred texts, they may have succeeded in furthering a general decline in perceptions of faith. The result is that, in modern times, faith is probably one of our most misconstrued, misrepresented ideas. Commonly, it is linked to religion and dismissed as an irrational belief in scientifically unproven concepts – a kind of belief that is given credence only by the gullible. This understanding of faith is naive and, in my view, both a travesty and a tragedy.

It is worth pointing out that the 'enlightenment' claimed by the rationalists is of a quite different type from that referred to by religions like Buddhism. The first is allied to empiricism, reductionism, individualism and progress, whereas the second is a process of inner awakening and profound understandings that emerge from, but transcend, physical phenomena. Such insight is not only closely wedded to the creative process, it is deeply rooted in traditional knowledge and wisdom and, critically, it is dependent on faith.

The devout Jewish artist Marc Chagall was acutely aware of this association. To him, the interior world of the mind was just as real as our everyday reality and he used to tell young painters, *"If I create with my heart almost all my intentions remain. If it is with my head – almost nothing".*[2] In this wise advice he distinguishes between rationalistic and intuitive ways of knowing. While we depend on both, the former is dominant among the institutions, educational systems and enterprises of contemporary society, whereas the latter is far more closely tied to the creative act and the spiritual path.

To be creative we have no choice but to engage in an act of faith; we have to trust in the process. It is this leap of faith that paves the way for wholehearted engagement. If the process is not regarded as trustworthy, if there is doubt, our actions will be tentative and the outcomes unconvincing. Creativity requires deep immersion, commitment and confidence without the benefit of evidence or proof. And while we can look to the ability of others to see that something might be possible within us, this is no guarantee of our own ability or our own potential – this has to be taken on trust. Hence, creativity defies rationalistic thinking. Before there is any tangible verification of our own ability to achieve our intention, there has to be a belief in and acceptance of process and promise. This act of faith applies equally to one's creative development and to one's inner or spiritual development. Both demand a giving of oneself. The novelist Isabel Colegate wrote that the lessons of this act of giving, this act of unselfish love, are *"too harsh to be learnt without the ferocious discipline of faith".*[3] In the Christian tradition we are told to believe we have received that which we have asked for in order for it to be ours.[4] In other words, it is necessary to believe in our capacity for inner growth in order to achieve inner growth. Equally, we have to have faith in the creative process in order to be creative.

Rubens' Jesus

Late Spring in Provence
before the hordes
peel from the planes to
beach themselves with beer
and burgers under pricey parasols
at Club Paradis.
Into the hills away from
the blinding blue to
the cool dark of an
ancient church where
musty saints are
brightened by widows'
tears and Rubens'
Jesus is forever
crucified.

70

Enculturated Blindness

The enlightened eyes of reason predispose us to look at the world in a particular way. They are quick to classify and judge and their self-asserted authority has bred a dangerous overconfidence. They tend to see only surfaces and they have consistently failed to recognize the depths of human knowledge and accumulated wisdom that have been in plain sight.

Nineteenth-century European explorers, perhaps especially the British, were armed with a cultural assuredness that was rooted in their industrial capabilities and military might. When encountering societies different from their own, they did not grasp what they were seeing[1] and all too often they were not interested in finding out; their purpose was resource acquisition and colonization, not understanding. Evidently, they did not appreciate the delicately balanced ecologies that traditional societies had created and managed, often over many centuries. These were ecologies of interdependencies between people, plants and animals that were the result of collective learning over generations. Such ways were eminently sustainable. They were characterized by a highly sophisticated set of synergistic practices within a finely tuned whole in which everything had a purpose. In other words, an elegant but easily disrupted 'fit' had been achieved between human society and the natural environment.

This enculturated blindness is not merely an artefact of the past – our biases about what is of value and the dogmatic correctness of our particular outlook continue to obscure our vision, even as the results take us down an ever darkening road.

Today, we look upon the ancient myths as mere fantasies of pre-modern peoples who were, we believe, primitive, ignorant and ruled by superstition. Because they defy the bounds of reason, we regard them as suitable only for children and not worthy of serious consideration by enlightened adults capable of logic and reason. In taking such a view, we fail to appreciate that which lies beneath the surface, which is often a highly complex interweaving

of history, belief, imagination and even utility. Recent studies argue that the 'wine-dark sea' of Homer's epics *The Iliad* and *The Odyssey* is actually a reference to the night sky. The various elements mentioned throughout the poems are, it seems, references to the moon, the stars, the constellations and astronomical events, and, within an oral culture, these were woven into intricate poetic tales that serve as a mnemonic device. This analysis suggests that these works not only recount the history of astronomical events but they also served as a kind of aural map, based on a lunar calendar – a key to the night sky for ancient navigators that could be easily remembered because of how the tales had been constructed.[2] This understanding of the ancient stories of Greece and their relationship to astronomy, navigation and occurrences and cycles of the natural world are perfectly plausible. Unlike the interior, artificially lit lifestyles of today, the night sky for pre-modern cultures was a significant presence. Similarly, many of the traditional stories of the Aboriginal peoples of Australia also have astronomical connections – and here, too, they have practical applications related to wayfinding as well as to harvesting.[3]

The stories of the Western spiritual canon, the Bible, are today given short shrift by many because they are interpreted merely in terms of their surface meanings. In a society that privileges material facts and physical evidence, such meanings are often condemned as cruel and morally reprehensible. Many argue against the truth of these stories because of the lack of physical evidence. Some place them in the same category as leprechauns and, on that basis, summarily dismiss them.[4] These contemporary critics seem not to pause to reflect on why such stories, in virtually every human society since the dawn of time, have held such sway and, for many, have been the most powerful feature of their lives, through which they have found purpose and meaning.

To interpret these texts in such a superficial manner is not only to fail to understand their true nature,[5] it also does them, those who wrote them and those who have dedicated their lives to them a grave injustice. They are not about believing the unbelievable and they are no more about physical evidence than are love, compassion or joy. Nicoll has explained the layers of meaning present in these books;[6] layers that lie below the surface. When we drill deeper we find ethical understandings, symbolism and allegory associated with vineyards, towers, water, wine and stone, and spiritual allusions that, if contemplated, can lead to a more profound understanding of ourselves and how we should live. This is why these kinds of texts have, for millennia,

acquired such a powerful place in human civilization and in our imagination. They are endlessly revealing and instructive because each generation has no choice but to start their spiritual journey anew.

71

A Christmas Story

Probably the most famous – or infamous – painting of Kazimir Malevich is his *Black Square* of 1915. Malevich was strongly influenced by the tradition of Russian icons – he drew on their colours and compositions and strove to conjure their deeply spiritual, timeless qualities, but in unfamiliar, non-figurative forms. In the West, he is often associated with European movements of the same period, such as *Futurism*, but he saw things very differently – in fact, in virtually polar opposite terms. Where the Europeans were caught up in speed, technology, progress and the new, Malevich was immersed in *"centuries-old laws and time-honoured principles"*[1] and was seeking a sense of constancy in form. Through his paintings, he was attempting to reach beyond history, the contingent, and notions of newness that so preoccupied European artists of his day. He regarded the emergent forms of such ideas as fleeting, and the subjective, creative presumptions on which they were based as individualistic and futile.[2]

Malevich's art was aligned with a more ancient tradition. Icons do not attempt to represent or replicate the concrete world of material reality. Through their stylized rendition of a prototype, they manifest an awareness of the spiritual that lies outside the reaches of time. With their reverse perspective, they draw the viewer into another realm, a different reality. In essence, Malevich was doing the same – but with a distinct visual difference. He recognized that the forms of the icon tradition were not capable of deterring or offering an alternative to the West's ruinous ideas of progress. Consequently, he sought a path that was unencumbered by the conventions of history and time.[3]

The work of Malevich, with its roots in the visual language of Russian spirituality means that his paintings, and the icon tradition on which they are based, are of a different type or category than we are accustomed to in the West. The image in the icon is not simply a depiction of someone in the way we generally understand representation. Since the Renaissance in southern Europe and the Protestant Reformation in the north, religious art has left

behind the symbolic language of previous times. It has emphasized either an awe-inspiring idealism or a down-to-earth realism. But neither align with the Eastern tradition of the icon. Icons are not about representation, they are carriers of ideas. Indeed, the image and the idea are inseparable.[4] But what is the idea the icon is conveying? There are many, but the main thing is that they are not concerned with our normal, material world – they are not a portrait of someone – at least not in the way we usually think about a portrait. They are concerned with spirituality – their space is not the regular space of the world, where things happen and time passes. Theirs is sacred space, a timeless space that is outside the realm of concrete reality. This is why, traditionally, the iconographer has to be a contemplative person, not preoccupied by the ways of the world. Only when they are, let us say, spiritually mature, can they properly create an icon. In this sense, there is no distinction between contemplation and the act of icon making.[5] And this is what Malevich was seeking in his work.

To understand the meaning and power of this tradition, we have to appreciate these differences. In the West, when we look at a piece of art we tend to look first at who painted it; the artist is hailed as an individual genius of original ideas. In the icon tradition, the name of the iconographer and originality are both irrelevant – the main intention is to continue the tradition by accurately reproducing the images again and again. Original ideas are inappropriate to the process, as is an individual attaching themselves to such an image through a claim of authorship. The most important thing is the image itself – the sacred space it delineates and the nature of what we are looking at. Consequently, we must put out of our mind everything we think we know about looking at images and art.

Bearing these understandings in mind, let us now turn our attention to interpretations of the Christmas story. In her book, *Christmas Days*, Jeanette Winterson asks why Mary had to be a virgin.[6] She attempts an answer by suggesting that, because lineage in Judaism is through the mother, sexual purity is important for identity and, if Mary were a virgin, Jesus' divine descent could not be in doubt. She also argues that the virgin birth represents a break with more ancient pagan beliefs in which symbols of fecundity were represented by practices of goddess worship.

While these explanations may throw some light on the meaning of the Christmas story – another, very different, interpretation is possible, one based

on ancient ideas of timelessness and continuity. Such ideas seem especially pertinent to our contemporary anxieties, how we see the world and how we might develop a way forward that is less preoccupied with innovation and consumption. But before we consider this more allegorical interpretation, we might take a moment to ponder what a virgin birth might signify and what manner of child might be the fruit of such a birth. The Christmas story may be less dependent on a leap of faith than on a leap of imagination; a way of saying something that holds profound meaning and truth but is only graspable by the creative mind.

A much reproduced icon of the Virgin and Child depicts Mary, usually sitting, holding the infant Jesus. In worldly terms, we see a woman and a child – two people. But in spiritual terms, we must set aside this literal interpretation. When we do, we can interpret this image quite differently – as representing not two people but one. It can be seen as an image of two aspects of ourselves, the outer and the inner person. At the outer level, Mary represents material reality, the natural side of us, our physical selves. This is the part of us that is time-dependent, that is born physically, grows, lives and dies. The other figure represents the spiritual side of us, born of this earthly, material self. This can be understood as the birth of inner or spiritual awareness, which occurs at a certain stage of maturity.[7] In the Biblical account, Mary is a young woman at the dawn of adulthood. It is at this point in life that we become cognisant of the spiritual self within us. It is a time that many cultures recognize as the beginning of a new phase, a new awakening and, traditionally, there is a ritual to mark it. In Christianity, the adolescent is confirmed into the Church; in Judaism, there is the Bar Mitzvah for boys and the Bat Mitzvah for girls; in Native American culture, young people entering adulthood go on a vision quest. All these mark a change in the person – a new awareness. And this is one way of interpreting the icon of the Virgin and Child; the child of the innocent young person can be seen as a representation of this new awareness. Down the ages, many and diverse cultures have taught that this spiritual side imbues our lives with true purpose and is the route to happiness and inner fulfilment. But to achieve this, it needs to be developed – through self-discipline, effort and dedication.[8]

In modern secular societies these stories tend to either remain undeveloped or are dismissed as being of no relevance. Yet they represent the heart of our spiritual tradition and suggest a way of understanding the world that puts

our contemporary endeavours in a different perspective. It is a perspective that sees value in continuity, spiritual development and notions of timelessness. And like Malevich before us, with such an outlook, we can begin to see many of today's activities, which are so individualistic and fleeting, as not just damaging but also creatively presumptuous and ultimately rather futile.

Mythic Objects

Instrumental reason, pragmatism, efficiency and realpolitik direct the actions of our age but their astringent indifference leaves us wanting. These guiding lights know of everything except wisdom. Let us set them aside for a season to better recognize that efforts of no practical value are not for nothing. Metaphorical relics transcend thoughts of usefulness and make visible allusions that have always sustained us.

Heavenly Oil

– that glistens upon the gods

Homer's *Odyssey*, Book VIII

Gift of Aeolus

– binding the winds of every quarter

Homer's *Odyssey*, Book X

Stones of Pherecydes

– mementos of the everlasting soul

Pherecydes of Syros, 6th century BCE

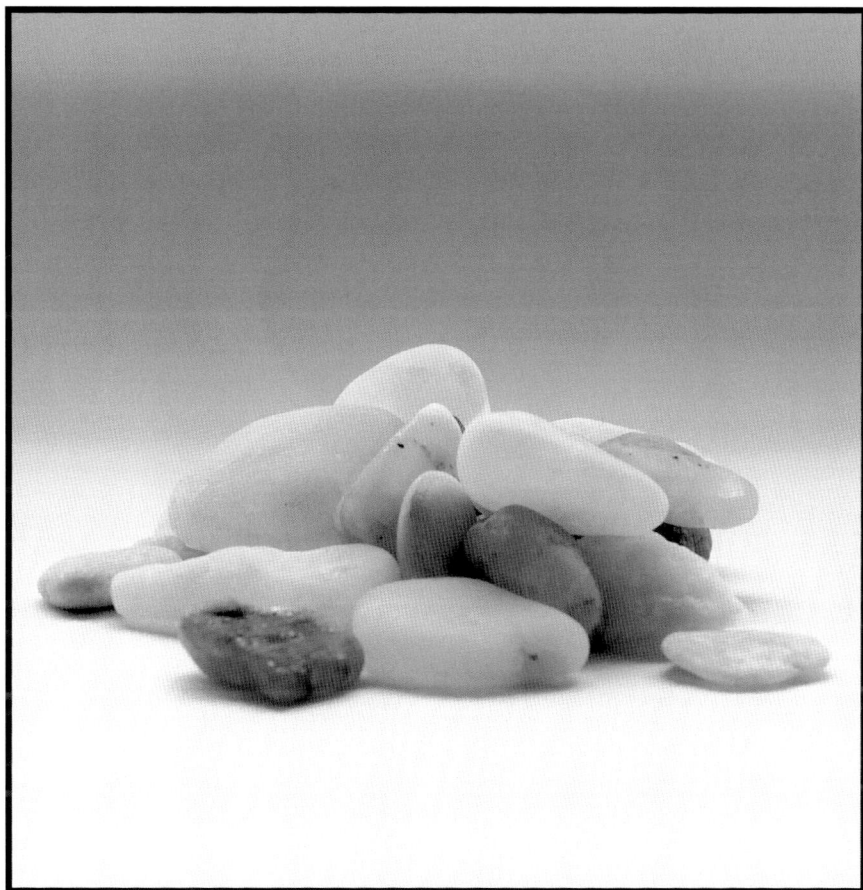

The Punishment of Prometheus

– that which remains

The Myth of Pandora

73

Another Reality

And other spirits there are standing apart
Upon the forehead of the age to come;
These, these will give the world another heart
And other pulses. Hear ye not the hum
Of mighty workings? –
Listen awhile, ye nations, and be dumb.

<div style="text-align: right">JOHN KEATS (1816)</div>

Our day-to-day lives have become exceptionally frenetic, overloaded and, at times, disorienting. While change is a fundamental ingredient of being alive, the *pace* of change today is unprecedented, and it is a function of our modern preoccupations. The way of life that results can be overwhelming, even exhausting, because of the sheer volume of information people have to deal with on a daily basis. At home and at work many basic services that were once common have either diminished or disappeared altogether. It has become the responsibility of the individual to sort out all the options and details of each and every task using online systems. Whether booking a flight, making a bank transaction or checking out groceries at the supermarket, it is a case of 'do it yourself'. To complete these tasks we have to use systems that are frequently poorly designed, mind-numbingly repetitive and extremely time-consuming. This so-called service economy – a misnomer if ever there was one – offers us a host of choices but few opportunities to talk with experienced people who can provide informed advice. In this milieu of rapid change and instability, we continually have to make multiple minor decisions, but it is difficult to know if they are the right decisions and what overall effects they are having.

Along with these developments and intimately related to them, is another unprecedented phenomenon – a society that has turned its back on its own spiritual heritage and, for all intents and purposes, chooses to live in way in which sacred traditions, beliefs and practices play no part. This state of affairs

inhibits our ability to make wise decisions. Significantly too, and as we shall see, the spiritual sensibility is strongly related to creativity.

Since ancient times, people have asked fundamental questions regarding the human condition. We, however, tend to disregard such questions. The governing elites in modern Western societies focus their efforts on more mundane things – material benefits, economic growth and, when convenient, human rights. This has led to a bland, homogenizing globalization that is dangerously dependent on constantly rising levels of personal consumption. In the process, more profound existential questions – about where these agendas are taking us and why – have been assiduously avoided.

It should come as no surprise that these developments are proving to be not only damaging but also utterly facile.[1] Indeed, late capitalism has been said to foster *"a culture of mindless hedonism, sexual obsession, and moral shallowness"*.[2] Deep down, we always knew that ever more consumer choice promising contentment, excitement and narcissistic gratification was not going to make us any happier or more fulfilled. On the contrary, if it is happiness we are after, then, instead of credulously succumbing to the self-oriented pleasures and indulgences promoted by the market, we would be better off being more considerate and more generous towards others – for it is this kind of behaviour that is linked to greater happiness.[3]

Despite current trends, we can choose to develop new directions that are more moderate and benevolent and which take seriously long-enduring concerns about identity, community, place and a higher sense of purpose. As the destructive norms of contemporary society become less and less tenable, we are charged with developing new, positive alternatives because, unless such alternatives are forthcoming, those yearning for something more in life, beyond material well-being, may be drawn to populist ideas that are often narrow and divisive and sometimes violent.[4]

In this discussion, I will consider how our predominant worldview and the malaise it has generated are deep-rooted – the result of years of small changes that, cumulatively, have led to our present predicament. Fundamental to this worldview is its rejection of tradition, mythical thinking and practices that instil common understandings and shared values and give our lives depth. Following a consideration of the origins and nature of these developments, I will discuss the meaning of mythical thinking and why it matters so much today. From this, I will explore a way forward that brings together our

dominating rationalism, which favours facts and evidence-based accounts, with deeper, intuitive understandings that are the basis of values and meaning-making. When combined, these two necessary and complementary forms of knowing can yield a more holistic, more balanced and more benign outlook.

THE ROOT OF THE PROBLEM

The momentous developments in Europe from the early 16th to the start of the 19th century have had profound and lasting effects. Through the Reformation and the Enlightenment, and the ideas of people like Luther, Descartes, Newton and Locke, a fundamental change occurred in how we understand ourselves in relation to the world. The birth of the modern heralded, among other things, freedom of thought, civil liberties and the development of modern democracies.[5] At the same time, a gulf was created between the physical and the spiritual, and there was a devaluing and ultimately a rejection of sacred understandings of the universe.[6] This resulted in the so-called disenchanted worldview.[7] But, as Adorno and Horkheimer have said, *"the wholly enlightened earth is radiant with triumphant calamity"*.[8] Prior to this, the world was held to be sacred and as such was to be honoured, cared for, and treated with respect.

The modern sensibility has increasingly embraced rationalization, secularization, and bureaucratic accountability based on quantification and physical evidence. In the process, abstraction, theory and generalization have undermined deeply experiential, situated ways of knowing. The result is a stark division between the outer, physical world and the inner world of contemplation and human imagination; between materiality and meaning; between rational self-interest and ethical behaviour;[9] and between literalism and richer, more nuanced understandings that involve metaphor and symbol. Bound up with these developments, modern secular societies have progressively pushed spirituality to the margins and excluded its voice from the public square;[10] Smit has pointed out that, *"Instead of those grand myths which had given shape to the Classical world, poets' territory becomes steadily more constrained to the personal and subjective"*.[11] Many people today might regard this as normal and even desirable, but we should not forget that shared spiritual practices have been a traditional way of not only building community cohesion but also for addressing 'things that really matter'. Yet, to some, religion has become

anathema – a convenient scapegoat for all kinds of modern ills.[12] In the history of civilization this is unparalleled but as Campbell has pointed out, *"Anyone unable to understand a god sees it as a devil"*.[13]

A critical ingredient of this transformation was the abandonment of tradition. In the Reformation, tradition was rejected as a source of religious truth[14] and in the early 20th century, it was rejected because it was seen as an obstruction to progress.[15] This has had severe and lasting social consequences. It has eroded a sense of continuity in society, a continuity grounded in and reified by communal, often religious, practices. These practices fostered shared values and were a mainstay for reconciling differences within the community.[16] Perhaps even more importantly, they helped foster a sense of perspective and the long view. Through their repeated cycles, such practices can convey a feeling of timelessness by raising one's sight towards that which is permanent – beyond self, selfishness and short-termism. The rejection of tradition meant that a worldview that had combined factual, physical materiality with intergenerational knowledge, values, symbolism and meaning-making was systematically dismantled. It was a worldview that had sustained societies for centuries, if not millennia, because it offered a coherent, stable basis for living.

As a consequence of these developments, scholars have argued that the history of Europe over the course of the modern period has resulted in an inordinately pluralistic culture that has no substantive basis for mutual agreement about values and understandings of truth. Hence, it has no basis for meaningful ideas of society and governance that are rooted in shared beliefs.[17] In this situation, the role of government is reduced to that of management – tinkering with mundane agendas about material comfort, economy and defence but bereft of any deeper sense of purpose or long-term vision.[18,19]

Our prioritization of instrumental rationality, in a world stripped of the sacred, combined with the decline of community, the rise of individualism, and the prioritization of material benefits, has led to a century or more of excessive production and unprecedented environmental harm. In addition, social equity, an ethical principle and fundamental ingredient of sustainability, demands some degree of societal coherence based on common values. All this make us singularly ill-equipped to deal with today's most pressing challenges. Social and regional inequities remain unconscionably prevalent in the world's wealthiest countries, and in some cases are worsening. And there are no substantial efforts being taken to address the causal links between our ways of

understanding the world, which inform our actions and material expectations, and the severe environmental breakdown we are facing on a global scale.

The lack of depth in modern society has been a debilitating legacy of these historical upheavals, which effectively ended the coherence and continuity of the Western spiritual, moral and intellectual tradition.[20] Earlier ways of life had been replete with meaning, even though they were often burdened by physical hardship and material deficiency. By comparison, modern life is, for many, materially rich and physically comfortable but is also spiritually impoverished and bereft of any sense of social identity or deeper significance.[21,22]

Today, we are experiencing rising social divisions; terrorism in our streets rooted in cultural rifts that cannot be separated from the absence of a firm sense of identity in an increasingly uniform world;[23] and a looming existential threat in the form of potentially catastrophic climate change. Faced with these challenges, we need something more profound than yet another, somewhat slimmer, mobile phone. But tragically, this and other essentially extrinsic benefits – be they products, services or experiences – are virtually all that modern consumer culture has to offer. It is a culture that is wholly dependent on the encouragement of individual acquisitiveness, which Gregory has argued can be linked right back to the early modern period and the fragmentation of Western religion during the Reformation.[24] The decline in commonly held beliefs and the subsequent marginalization of spiritual practices produced a society that increasingly exhibited materialistic values and a preoccupation with consumption. As Walton explains, instrumental reason acquired an unquestionable authority, and as rationalism became a self-ruling force, intuitive apprehensions and impulses came to be disregarded and all living creatures, including human beings, were transformed into mere things. En masse, peoples' consumption patterns are important but, *"as individuals, consumers count for nothing"*.[25]

We should also bear in mind that consumerism is not simply about needs and reasonable wants. In affluent societies especially, it is largely about ego, self-enhancement and distinguishing ourselves from others through material possessions. Advertising and marketing messages are constantly stoking in us feelings of discontent with our lot, implying that we can be more beautiful and successful if we only buy a particular perfume, digital device or car. It is a message that is psychologically damaging because it normalizes

dissatisfaction and selfishness. It also flies in the face of the world's mythologies and religions, which are primarily concerned with how we can live together in harmony.[26] And the answer to this question has always been found, not in rigid ideologies or control, but in practice – community-based practices, including spiritual practices in the form of rituals and shared events. Significantly, these practices invoke imagination, visualization, symbolism, and the metaphorical language of myth, which, as we shall discuss, is fundamental to a sense of permanence.

A related constituent in the historical development of modern society, which has seriously affected our views about imaginative pursuits, creativity and the arts, has been the elevation in importance of the word over the image.[27] The Reformation provoked a widespread and systematic destruction of imagery. Text-based understandings were given precedence and this was reinforced through developments in printing; for the first time texts became both widely available and affordable. This helped cultivate a rise in intellectual knowledge and an attendant devaluing of intuitive, imaginative ways of knowing in which image, symbolism and metaphor are so important. And this continues right up to the present day, as is evident at all levels of our education system and in the gross discrepancies in funding allocated to the arts compared to more rationalistic, pragmatic disciplines in science and engineering. A recent study in Britain concluded that there has been a lack of investment, education and participation in the cultural and creative sectors and that not enough has been done to stimulate and develop people's creative potential for the benefit of society.[28] However, a minister in the Department for Education dismissed concerns about the decline of arts subjects in British schools by telling Parliament that this decline was counterbalanced by a significant increase in the number of students taking computing and information technology.[29]

The damaging effects of our activities on other people and the natural environment demand not just rational answers but also empathy and emotion. We are social beings and, as such, each of us has a moral responsibility to be concerned about the welfare of others. A stark example of such inadequacy was the British Prime Minister's response to London's Grenfell Tower blaze, a disaster that killed dozens of people. Theresa May visited the site the following day. She met with members of the emergency services but not with the traumatized survivors. People reacted with anger and outrage

because they felt she lacked compassion and had not shown any basic humanity.[30,31]

Today, a new philosophical outlook is needed. One that leads us away from our prioritization of individualism and consumption and, instead, rebuilds community, mutual understandings, shared beliefs and cooperation. If history is anything to go by, this requires communal practices that, in addition to physical, practical matters, also attend to spiritual matters. And it is here that the language of myth becomes so important because it points to that which cannot be explained, evidenced or rationalized but can, nevertheless, be intuitively apprehended.

THE LANGUAGE OF MYTH

In modern Western societies, myth has acquired a rather poor name – when we refer to something as myth, we mean it is untrue, or the result of a misunderstanding, or that it is irrational. Yet, myths have always been a vital part of the human story. They are important because they teach us how we should behave and they enable us to adopt an appropriate frame of mind, spiritually or psychologically, for right action,[32] for the benefit of ourselves, others, and the world itself.

When we regard mythic stories and religious texts either as absurd fictions or as historical facts we do them a disservice because we misjudge their meaning and their purpose. They are not descriptive accounts of events that can be located in a particular time and place. Rather, they are timeless stories about how to behave and how to lead a meaningful and fruitful life. Myths are true because they are useful – but they are not factually or physically true. When they cease to 'work' for us, they lose their relevance – at which point they are either revised or they fall out of use.

Nowadays we are more interested in facts than stories[33] and we tend to dismiss anything that is not scientifically provable. Consequently, traditional mythical thinking has become marginalized. This is equivalent to throwing out jazz because we've figured out how to make solar panels. Science and myth are not at odds, or shouldn't be, because they represent two very different ways of encountering the world; two ways that are not unrelated. Science investigates and strives to understand the world of physical phenomena and materially based agency, whereas mythologies and religions are concerned with sense-making and humanity's perennial search for

meaning. To address these critical areas of concern, which lie beyond physical evidence and proof and beyond explicit description, we call upon the human imagination and employ symbolism, metaphor, allegory and allusion. And, of course, imaginative ideas, thoughts and mental pictures, none of which actually exist, are as relevant in science as anywhere else. Advances in science often depend upon leaps of the imagination – mental pictures about what could be and what intuitively seems to be true and have value, and is therefore worth pursuing. Such insights are not based in what has been physically created or proven. So, we should not think of science as a replacement for myth. We need science and myth and their interactions because they address different but complementary aspects of being human.

Understanding myth: In the 19th century, myth was assumed to offer primitive explanatory knowledge about events in the physical world. With developments in modern science, such explanations came to be seen as irrelevant. While this view of myth is still held by some, it is now generally regarded by scholars as outdated and invalid.[34] Even so, this legacy means we continue to use the word myth in popular culture to refer to a false explanation, something to be debunked – as in news headlines like *"The Myth of Male Menopause"*.[35] However, myth has a much richer and deeper meaning.

A myth can be understood as a story about something of import, the function of which is weightier than that of a legend or folktale.[36] Typically, it is a traditional sacred story of universal or archetypal significance; it is not set in any specific historical time and its author is unknown.[37] Indeed, the mythic stories that have come down to us may be the result of multiple contributors over many generations.

Myths are told within communities and they point to a unified and ordered understanding of the universe, human society, and the meaning of an individual's life.[38] Like science, myths extend human understandings. They are concerned with that which is always true in human experience, whatever age we live in. They are related to the fact that we know one day we will die and they are closely associated with religion and ritual. Through community-based practices, mythological understandings allow us to transcend the hectic occurrences of an ever changing world because they provide a stable foundation for making wise judgements. However, for the truths of myth to become known to us, they have to be put into practice – this is achieved not through

abstract intellectual understandings or analysis but through ethical practices, emotional engagement, and ritual observance. Fundamentally, then, the function of myth is to teach us how to live in social settings, and to give our lives a greater sense of meaning. This being the case, it is unsurprising to learn that, while there are differences in ornament and symbolism, the fundamental themes among the world's various myths and religions are often remarkably similar. A common theme is that of spiritual awakening – the attainment of a new realization that transcends ego – which is typically portrayed as the death of one's former self by passing through a threshold or gateway followed by a second birth, rebirth or resurrection.[39]

Today, we no longer share myth or pass on mythical stories to the next generation. This is unprecedented. People who think they can live without myth are people without rootedness. They are cut off from their past and from each other.[40] As the writer Neil Gaiman has said, *"Without our stories we are incomplete"*.[41] By rationalizing our myths out of existence and thereby rejecting our inheritance, we are left with no practices, symbols or collective understandings to help us, so we must face life's big questions alone, without any effective guidance or clear direction.[42]

Myth and creativity: Mythic stories are not ends in themselves, rather they are means – pointers or signposts. And it is here that we find the critical link between myth and the creative disciplines. Like myth, the creative disciplines also call upon the human imagination and, in doing so, they comingle with myth, which provides the sustenance for ideas to grow and flourish.[43] However, we have to get past the outer cladding of myths, and ask ourselves what they mean, to what inner truths they point. The language of fairy tales, myths and religious stories is symbolic because that to which they refer defies explanation. Read literally, they might appear childish, cruel or incredible – and this can be obstructive *"for the feelings come to rest in the symbols and resist passionately every effort to go beyond"*. However, the various characters and events in these stories symbolize different aspects on the path to inner understanding.[44] The gulf between a naive, literal reading and the deeper meanings and truths of these texts is breached when the outer symbolic interpretation is transcended.[45] This is when we grow spiritually in our understandings and find the core of who we are. And in this, the creative disciplines – poetry, literature, music, and the fine and applied arts – can assist an individual in

their journey towards this inner development.[46] As writer Alice Walker has said, spirituality *"is the basis of Art"*.[47] Mythical stories weave together the outer world with our inner world of imagination, memories, dreams and intuitive apprehensions. In other words, they help create a holistic, unified perspective in which there is no separation between outer and inner, physical and spiritual. Hence, if our lives, activities and material accomplishments are to surpass mere utility and be truly meaningful, we must embrace these realizations, respond to them, and strive to incorporate them in our creative endeavours.

OVERCOMING THE CURRENT CONDITION

While we might be slowly moving away from the philosophical outlook of modernity, its influence is still powerful and its death throes are proving incredibly destructive. There is a need to break free of this view so as to see ourselves and the world differently, and from this new perspective, to develop substantially altered lifestyles. There is a need to become far less dependent on consumption and to learn again the importance of fellowship, stewardship, social justice and individual flourishing – to reset our priorities, slow the pace, learn to live richer lives with fewer material demands, and to take on new responsibilities – to see ourselves not as exploiters but as caretakers of the earth.

Perhaps the most difficult aspect of engendering such a shift is being able to place ourselves outside current norms, to step beyond the strictures of convention in order to see our world anew. Only then can we see our activities in the round and evaluate them in relation to the many serious challenges we are facing. As Walton says, *"True critical thinking requires not just a refusal to identify with the present structures of society and commercial culture, but a deep awareness of the historical tendencies that have brought about the current impasse, and of which all present experience is composed"*.[48] A significant obstruction in this endeavour is our seeming obsession with entertainment culture, online distractions, and 24/7 'news', all of which serve to hinder critical thought.

If myths teach us how we should live, then it is important to consider how they can do this in ways that touch our own lives. I have already mentioned the importance of ritual, ethical practices and emotional engagement. However, for myths to remain functional and potent, they have to be made relevant to each successive age. Otherwise they become fossilized and, as with *The Thousand and One Nights* and many of the Greek myths,

regarded merely as entertainments but of little consequence to contemporary life. On this point, Old Testament scholar Walter Brueggemann suggests a way forward. He relates the trauma and dislocation caused by the destruction of Jerusalem in 587 BCE to that of the 9/11 terrorist attacks in New York. A similar connection might be made to the less shocking but inexorable and debilitating existential angst that pervades our own times, namely, our knowledge of environmental destruction, species extinction, and climate change, which result from human activities.[49] In the face of such trauma, and as a general guide based on his analysis of the prophetic writings, Brueggemann suggests three stages that enable individuals and communities to deal with the process of loss and recovery.

1. **Realism:** facing up to the reality of the situation and the crisis of faith this inevitably causes in regard to prevailing assumptions, conventions and values. Rather than trying to continue with the ideology of the old order, which no longer holds, it has to be overcome by seeing our current state for what it really is.[50]
2. **Grief:** a sense of loss and disorientation ensues due to the demise of the old ideological order and, as this is acknowledged in the face of the new reality, there is sorrow and grief. This is painful and, in the case of environmental destruction, all the more acute because we recognize that, as individuals and as a society, we are thoroughly implicated. Within this process of grief there is a necessary stage of relinquishment of the failed order that has come to an end. This stage is necessary because it prepares us to move forward.[51]
3. **Hope:** this requires imagination – to develop and articulate new ways of thinking, new possibilities, and new ways of living and being. Here, if we rely on precedents, we will simply return to the old, failed order of things. Rather, we must engage fully in the creative imagination, and trust, or have faith in, the process itself so as *"to seek a world other than the one from which we are being swiftly ejected"*.[52]

Hence, to develop more positive and enriching directions based on a changed outlook, there is a crucial role for creativity and the arts, including the applied arts. Probably the most important task for the creative arts today is imagining and articulating new ways forward that challenge the existing

order and demonstrate new priorities, new sensibilities and new possibilities. Unlike many other fields, creative disciplines like design do not just *tell* they also *show*, and in doing so they engage us emotionally and aesthetically as well as intellectually. Creative productions, be they works of art, products or performances, are capable of touching us deeply, viscerally, in ways that facts and evidence-based arguments alone are unable to do. The visual arts in particular can have a remarkable potency because our response to them is not just intuitive but also immediate.

Further still, when we combine the intuitive with the rational, and the imaginative with the factual, our endeavours become far more holistic. Rational arguments and factual knowledge are then expressed in ways that begin to resonate at a much deeper level. This has always been an essential function of the arts – to speak to us in ways that touch the heart and the soul, not just the head. Importantly too, creativity offers hope, the one thing that remains. Relentless stories of impending disaster, resource depletion and overpopulation, so loved by the press, are negative and counterproductive. They envelop us in their depressing pall and gnaw at our peace of mind, which can cause us to lose hope in the future. Consequently, they can become self-fulfilling prophecies.

DESIGN DIRECTIONS

The conventional focus of disciplines like industrial and interior design has been on physical, practical solutions to perceived problems. In recent years, service design and co-design have maintained this emphasis on usefulness and extrinsic benefits. Potentially, such efforts can lead to improvements in standards of living and help drive growth, and they can result in innovative products and product–service relationships. Design research in universities has tended to align itself with such initiatives and, indeed, has often played an integral role in their advancement. However, in doing so, design research may also be contributing to a system that is often exorbitantly wasteful because it tends to result in the production, or over-production, of short-lived, essentially disposable products of no lasting value. Underlying these endeavours is a value system that, like the worldview of which it is a part, is in serious need of reform. In this section I will discuss how practice-based design research within the academy can contribute in more constructive ways, by considering both practical initiatives and more foundational issues.

Practical initiatives: There have been indications of positive change in recent years, with design researchers and others working at the grassroots level. In areas such as service design and through social enterprise and development there has been a renewed emphasis on community and co-exploration of alternative ways forward, beyond anything offered by consumer capitalism. These include the *International Design Network for Social Innovation and Sustainability* (DESIS);[53] the *Transition Network*, a communities-based social enterprise that seeks to build a more sustainable way forward through local-ization, self-reliance, connection and mutual support;[54] Cohousing projects in which residents live in smaller houses but have access to many shared facilities;[55] and a revival of craft, designer-making and repair.[56] These various examples are all concerned with restoring, revitalizing and recasting elements of life that became devalued and sidelined in the modern era. They empha-size community, provenance and place in contrast to modernity's priorities of mass-production, large-scale enterprise and globalization. They are bound together by a shared focus on a transformation of values, perspectives and society itself through the development of new cultural norms.

Foundational issues: In addition to the efforts discussed above, design research within the academy has the opportunity to explore areas that transcend pragmatic concerns, economic viability and immediately imple-mentable solutions. There is also a need to explore ways of expressing new realizations and issues of purpose and meaning. I have been doing just this in my own practice-based research. Rather than focussing on practical utility, I create objects that are a form of argument or display (epideictic) rhetoric.[57] Objects and images have the benefit of being immediately accessible and, as such, can have virtually instantaneous impact and emotional effect. They carry with them implicit arguments or positions. They can be variously inter-preted because the knowledge and contentions they express are less categorical than the explanatory kinds of knowledge conveyed in text. It is important to bear in mind that rational argument and evidence are simply not enough to motivate change – they never have been.[58] However, when objects and images are combined with texts, the result can be a far more integrated and balanced understanding – one that benefits from both intellectual and intuitive ways of knowing, from objectivity and subjectivity, and from rationality, emotion and empathy, all of which become unified and inseparable.

Interdependence: practical initiatives and foundational issues are both critical ingredients for advancing past our current malign state. The first offers community-based practices that help build a sense of belonging, common purpose and mutual understanding – much as religious services might have done in the past, and still do in many countries. The second draws on enduring stories, myths, beliefs and values and articulates them in new ways. It attempts to strip them of their familiar fustiness to make them more compelling and more relevant for today. Both approaches are intertwined and together can contribute to the emergence of a new, more considerate and less harmful worldview.

The cumulative effects of many small, locally based initiatives can be substantial. At the same time, there is a need to progress thinking and ideas about a bigger narrative, one that transcends self-interest and is capable of galvanizing emerging perspectives into a shared worldview; one that reflects a different, more respectful and responsible value system. The fact that, in recent years, there has been growing interest in restoring community and locally based endeavours is recognition of both their loss and their importance. But perhaps an even greater loss has been at the more foundational level, and this has received far less attention. In many Western cultures, traditions have been allowed to erode and, with them, attention to the metaphysical or spiritual sensibility. It is a sensibility that Aldous Huxley referred to as 'the perennial philosophy'[59] because it has been present in all human civilizations throughout history. Its decline in the West can be linked to the continuing influence of Enlightenment thinking and the false dichotomy that arose, which pitted scientific explanations against biblical teachings. This persisted throughout the 19th century with people like Ludwig Feuerbach, who believed religion alienated us from our humanity, Marx who thought religion was an indication of a sick society, and Thomas H. Huxley, who believed there could be no compromise between mythology and science, and people had to choose one or the other.[60] And as discussed in Ch.68, in recent times biblical texts have been regularly ridiculed by well-publicized commentators who, in keeping with the modern scientistic sensibility, base their arguments on literalistic, and therefore over-simplistic, readings of what are, essentially, imaginative metaphorical narratives.[61–63] The decline can also be attributed to the fact that these kinds of traditional teachings are often inherently incompatible with the values and priorities of modern society, in which

individual choice is held up as one of its greatest goods. As a consequence, our foundational myths, teachings and communal practices have come to be seen as largely irrelevant. However, without them, we become tossed about in the turbulence of living – disoriented, directionless and confused, and only too willing to cling to the next 'big thing' that comes along. But it is not simply a case of reviving these teachings from the past – to be relevant they have to be reinterpreted and reformed so they become capable of speaking to us in our contemporary context. Only then can they inform our values, beliefs and actions, only then can they give us hope.

Our enduring stories not only need to be made new again, they also need to become more convincing than the alternatives, especially those of the market. They must valorize ethical responsibilities, community and self-transcending values and, in this, there is a role for creativity and the development of new, compelling productions, stories and practices, including those of the fine and applied arts. Through such means, we become part of a community that has participated in similar endeavours down the ages and, through them, occasionally glimpsed beyond the veil to apprehend a deeper sense of purpose and truth.

While the relinquishment of our foundational stories and spiritual traditions is unprecedented, to understand their importance, we must reject naive readings and strive towards deeper understandings. In the 1940s, Huxley tried to convey the universal significance of such teachings by focussing not on the West's own, overly familiar spiritual heritage of Christianity but on Buddhist teachings, as well as those of other traditions less familiar to Western readers.[64] In the 1970s, E. F. Schumacher, author of the classic text *Small is Beautiful,*[65] did much the same. Here, and for similar reasons, I would like to refer to a contemporary, creative example from the indigenous peoples of North America. It is a visual artefact that is functional, but this function rises above mundane utility. It is concerned with the inner person, values and cultural tradition. More specifically, it combines material expression with spiritual sensibilities to enhance collective understandings.

A Separate Reality was created between 1979 and 1984 by Canadian First Nations painter Norval Morrisseau, a self-taught Anishinaabe artist.[66] In this work, Morrisseau was attempting to reinterpret, re-present, revitalize and thereby preserve the ancient spiritual traditions of his people – to make the stories and teachings relevant and convey Ojibwa values and perceptions to a

contemporary audience, both within his culture and beyond it.[67] The painting depicts the visible cosmos and the temporal world of earth, animals, plants and people. It also depicts the invisible, timeless world of myth, afterlife, spirit and imagination. To achieve this, Morrisseau effectively transmuted traditional iconography, conventionally incised on stone and birch bark, to easel painting.[68] He reinvented his traditions through vibrant colours and striking imagery and, in the process, founded a new school of painting – the Woodlands School of Art.[69] *A Separate Reality* is an especially good example of how creative endeavours can contribute to new realizations and the renewal of collective traditions that, under the onslaught of consumerism and individualism, have fallen into decline.

IN CONCLUSION

Mythical thinking encourages ways of understanding ourselves in relation to others and the world. It draws on intuitive apprehensions and the human imagination to develop ways of being that foster:

- **Bigger-than-self understandings and values** – benevolence, tolerance, appreciation of tradition, and attitudes conducive to building community, caring for the natural environment and pursuing shared objectives. American writer David Brooks has put it this way, *"In order to fulfill yourself, you have to forget yourself. In order to find yourself, you have to lose yourself."*[70]
- **Longer-term perspectives and intergenerational horizons** – such perspectives are badly needed today to counter the rampant individualism and acquisitiveness promoted by modernity; to call into question the short-termism of today's political and corporate agendas; and most importantly, to tackle the social and environmental challenges represented by contemporary understandings of sustainability.
- **Notions of a good and meaningful life** – that are not dependent on the kinds of material and experiential wants and symbols of status and success promoted by our consumption-based economic system.
- **Intrinsic or 'inner' motivations and rewards** – such as doing a job well and to the best of one's ability, pursuing excellence for its own sake, and doing the right thing even when it goes against one's own interests.

All these things have become devalued in today's culture of rationalism, evidence-based 'facts' and self-interest. Facts and instrumental reason may have provided us with physical comforts and labour-saving devices, but they have proved incapable of furnishing our lives with depth and meaning. For this, we need mythical thinking and imaginative ways of knowing that feed the spiritual sensibility. However, the truths that mythical thinking convey cannot be grasped intellectually. They are learned and only make sense when they are animated through situated, physical and, usually, communal practices. Today especially, mythical thinking and the imaginative faculty are needed to resacralize the world, so we begin to see its landscapes, oceans, forests and animal life as more than mere resources for an insatiable system of consumption and growth, and more than a landfill site for our discarded 'innovations'.

To revitalize and restore mythical thinking we need powerful new interpretations of traditional truths, and new forms of practice that are capable of touching our lives and our hearts. In this endeavour, there is a vital role for the artist, the designer, the storyteller and the poet. But here too, we must sound a note of caution for, in our consumption-oriented world, even the arts have capitulated to the curse of commodification. Most of our major galleries and museums have extraordinarily large gift shops, sometimes several, peddling all kinds of tat. And while church services are meagrely attended, on any given Sunday our galleries and museums are packed – not least because they offer *"an ersatz sort of transcendence"*.[71]

Yet, despite these instances of crass commercialism, it is the arts that are capable of presenting new, imaginative possibilities, especially when they are enriched by history and spiritual tradition, unencumbered by self-absorption, and grounded in community and place. Imaginative, values-laden directions can be animated through communal practices and can be combined with the possibilities revealed by science. Through such means, opportunities arise for developing more comprehensive and more profound ideas about 'advancement' and 'progress'. Through image, form, text, symbol and metaphor, the arts can explore more holistic and more hopeful horizons, and offer us glimpses of another reality.

A FUTURE REALITY

A Wisdom Economy

Our industrially based system is grounded in the competitive commercialization of goods and services and driven by an economic rationalism that has resulted in large and growing socio-economic disparities within and between nations. We cannot call this wise. A wisdom economy[1] would be one that pays far greater attention to social equity and egalitarianism, and does not encourage us to admire vast wealth in the hands of the few – as is so often the case in today's celebrity culture. In practice, this means a fair distribution of the profits of industry and enterprise among all those who contribute to its success. These principles were put into practice in manufacturing industry in the 20th century by the Mondragon cooperatives in Spain's Basque country; here, the maximum difference between the lowest and the highest paid workers is strictly limited and earnings are based on the average wage of the region.[2,3]

It is not a mere coincidence that the Mondragon cooperatives were founded by a Catholic priest,[4] nor that many of the biggest names in the industrial development of England who sought actively to support their employees through good-quality work and living conditions came from a religious background.[5] A wisdom economy is an economy steered by these kinds of social considerations and actions.

The nature of work is especially important, because it is at the heart of our economy and constitutes a vitally important aspect of human activity and an individual's sense of self-worth. It is therefore essential that people are engaged in meaningful, stimulating forms of work and are adequately rewarded for their contributions. Monotonous, mind-numbing occupations, exploitative labour practices, unhealthy conditions and the replacement of people with mechanized and automated processes, thereby creating unemployment, are all examples that would seem inconsistent with social responsibility and humanitarian practices. It is necessary for society to create fulfilling forms of work and produce goods and services that are in accord

with understandings of human flourishing, including physical health, a sense of belonging, and spiritual well-being. Work, social activities and material goods will then be consistent with understandings of virtue while also being personally meaningful at the individual level. In addition, we have to consider the environmental consequences of our actions within our economic system; today especially, this has to be a central responsibility.

Together, these various concerns take into account practical aspects of our endeavours, including their environmental consequences; social harmony and the common good; personal well-being; and economic prosperity. It is this more holistic understanding that constitutes a 'wisdom economy'.

75

Fair Share

Consumer capitalism encourages us to think of ourselves as independent beings in charge of our own destiny, which is made evident through the purchases we make. We aspire to have all that we want – a fully equipped kitchen, fashionable clothes, cars, recreational products and so on – all for our own personal use. We acquire all these things according to our income levels – they may not be the top of the range models, but they are the best we can afford at the moment. And we have to store all these things, which means we also need a big enough home. And this, too, requires maintenance and upkeep. To avoid clutter, we have to regularly dispose of older products to make room for more up-to-date versions. These discarded products will often end up in landfill – a scar on the landscape.

This way of living, with its facade of autonomy, has an isolating effect that makes our lives poorer. It is a formula for despondency because it hinders fruitful interactions and relationships with others. There are better ways.

We can substantially reduce consumption – and its knock-on effects – by considering how often we actually use things. A lawnmower is brought out only in the summer and used for an hour or two a week, perhaps less. A tent or skis might be used a couple of times a year. A child's stroller and toys will be used more regularly, but only for a limited period – perhaps three or four years.

Schemes for borrowing products that we use only occasionally have been around for many years. Libraries are the most common example. By joining a library we temporarily borrow books, audiobooks, and music recordings, and we can use the library's computers, reading rooms and meeting rooms.

The same idea can be extended to all kinds of products. Sharing schemes and their relationship to sustainable ways of living have been explored in academia for some years.[1] Facilitated by the Internet, they are now beginning to work in real life. The *Sharing Depot* in Toronto calls itself Canada's first 'Library of Things'.[2,3] A modest annual subscription gives members access to

thousands of products, from children's toys, sports equipment and workshop tools to garden equipment and bike trailers. It also offers community nights, meeting rooms and workshops for learning new skills. In the same vein, *Shareable*, in San Francisco, describes itself as a *"nonprofit news, action and connection hub for the sharing transformation".*[4] It produces an online toolkit and lists examples of sharing and community initiatives, such as repair workshops.[5]

Internet-based home exchange services allow people to swap their house and car for a short period with people living in another part of the country or abroad. Unlike a regular guesthouse or hotel, or even AirBnB, the service is based on a modest annual subscription but there is no monetary transaction for individual house exchanges. Such schemes make vacations, especially for people with young families, much more affordable. Sharing one's home and car via an exchange agreement is not only less expensive, it also makes use of a property that would otherwise remain empty, and so helps keep it secure.

Hence, sharing, rather than owning, can have financial, social and environmental benefits. It nurtures a sense of community because, when products are shared, people are brought together, they cooperate and learn from each other – either informally or through classes. It requires a degree of trust in and consideration of neighbours and other community members. In doing so, it builds connections, relationships and friendships, and a sense of fellowship and interdependence, all of which support an ethic of reciprocity.

Sharing reduces financial expenditure while offering access to a wide range of products – far more than one would normally own – and, potentially, of higher quality and built to last. Thus, sharing schemes can allow access to products that may be unaffordable or unjustified if the only option was to purchase them for oneself.

Sharing can also enhance one's sense of well-being and happiness. It tends to reduce emphasis on ownership as a mark of social status and, because everyone has access to the same products, it fosters a greater sense of equity. Recent studies show that everyone, including the wealthy, has a better quality of life in more equal societies. Greater social equity is also a key aspect of sustainability.[6]

In addition, there are environmental benefits. A society based on sharing rather than consumption reduces the need for product production, packaging, shipping, storage, disposal, waste and replacement. In turn, this

reduces the need for exploitation of natural resources, as well as energy use and pollution. And greater conservation of natural landscapes, and less waste and pollution would, of course, benefit our quality of life.

While there may be many benefits to sharing, there are undoubtedly some shortcomings. Certain things may be better purchased for one's sole use because it is simply more convenient to do so. There may be products we use regularly or feel less comfortable sharing. These might include music equipment, particular tools and kitchen products.

Nevertheless, there will be others that it may be less necessary and less attractive to own. Products such as extra tableware for a party, larger tools that might be used only when doing renovations – a portable workbench, a mitre saw or floor sander – or that are used infrequently, such as a snow blower. The line between purchasing and borrowing from a share centre will be related to proximity and convenience, the range of products available, ease of booking, membership costs, and local factors such as geography and climate.

The prospect of a sharing culture raises important issues for product designers and manufacturers. Many of today's products are built neither to last nor to be maintained. Such products do not lend themselves easily to community sharing. Therefore, if we are to make the transition to a sharing culture, we will need to design and produce longer-lasting products that can be readily serviced and periodically refurbished.

In recent years, we have seen a great deal of research and theory aimed at transforming society from a consumption-based economy to one based in product-service combinations, borrowing and share schemes. These ideas are beginning to take root in local communities and some are already flourishing. This bodes well for the future. Building on these developments, we can learn to disburden ourselves from the shackles of ownership and live more lightly, more communally and more meaningfully. This may allow us to break away from the false facade of autonomy and recognize our mutual interdependencies and the benefits of belonging.

76

Design Rhapsody

A prominent narrative that has been regularly portrayed in books and film over the years might be termed *techno-utopian*. This is a world of automation, robotics, artificial intelligence and genetic engineering. If we are prepared to enthusiastically embrace these possibilities, its advocates tell us, this world will develop rapidly to everyone's benefit. It is a path that takes us ever closer to an ideal state in which disease is defeated, food, energy and all other shortages are overcome, death is conquered, new worlds are settled and endless opportunities are created. Another view, equally well-represented in books and film, is far less positive. The eco-dystopian narrative is one of environmental collapse, over-population, and inexorable decline into chaos, sickness and war. These two narratives are not mutually exclusive. Indeed, they are often depicted as inseparable.

Perhaps a more realistic, and for many a more desirable future, may be one that finds a harmonious balance between global and local, people and technology, materialism and meaning. To explore how an assortment of many local, often disparate, initiatives and practices might constructively contribute to a new kind of whole, it may be helpful to use an analogy from the world of music.

The term *rhapsody* refers to exactly this – the joining together of a group of unconnected pieces. Vaughan Williams' *Norfolk Rhapsody No. 1* is based on folk songs he collected from local fishermen in King's Lynn.[1] He incorporates these traditional melodies into a tenderly wrought orchestral work; the result could be described as both old and new. The original songs of the fishermen are still here, still discernible, but are inseparable from a complete and entirely fresh modern composition. In this way, cultural roots, stories, historical figures and characteristics of place are brought into the present and kept alive and relevant through transformation. And, as a consequence, the new work transcends arbitrary novelty. It is replete with meanings that extend beyond the composer and beyond mere aesthetic

experience because it is enriched by its relationship to place, community, past and present.

The balance that Williams achieves is a delicate one. He artfully transmutes the original songs by respecting both worlds equally – traditional and modern – to create a unified and coherent whole.

There are other examples that, irrespective of their individual merits, are less successful in achieving this particular balance. Benjamin Britten's opera *Peter Grimes* is based on similar themes but, unlike Williams' gentle and sensitive incorporation of traditional tunes into a short orchestral piece, Britten constructs a grand English opera. This has the effect of distancing and thereby disassociating the new work from its roots. As a reviewer remarked at its premiere in 1945, *"The fault is largely with the libretto. It is overloaded with scrappy and not always telling incident, and too much of it is cast in an unreal language".*[2] At an intellectual level, the connection might still be there but its form tends to remove it too far, emotionally and aesthetically, from its origins.

Joseph Canteloube in France also collected traditional folk songs and rendered them into new arrangements for orchestra and voice. He focussed particularly on the songs of his native region, which resulted in his well-known *Chants d'Auvergne*. In contrast to Williams' *Rhapsody*, however, these orchestrations remain as individual songs – albeit linked aesthetically into a harmonious collection.[3] Like Britten's *Grimes*, these elegant transformations are also rather distant from their rural roots.

Alongside Williams' work, these other examples illustrate the difficulty of being true to and, indeed, of honouring traditional artefacts while also transforming them and incorporating them into a new imaginative whole that is relevant to the present.

To develop such a holistic vision in the field of material culture poses a particular challenge, but it is one that designers are very capable of exploring. It will need to draw on traditional practices and crafts, as well as modern production technologies, and recognize the local and the global, and from these create a new material reality. Such an imaginative composition will need to be a multifaceted but unified whole that achieves a new balance, one that is more than the sum of the parts – we might see it as a creative, continuously evolving design rhapsody.

Spiritual Renewal

Designers can follow the latest fashions or they can choose a different course and demonstrate by design how a better future might look. For the latter, they will require some grasp of the bigger picture as well as a basis for thinking about where the discipline ought to be going. These two factors – one historical, the other ethical – offer a starting point for constructively contributing to the important concerns of our age and taking design in directions that are both innovative and principled.

The historian and philosopher Arnold Toynbee considered both these factors. He studied the development of civilizations and concluded that they pass through a period of growth, a period of difficulties, an attempt at resurgence, and finally decline. He also pointed out that older civilizations have given birth to newer ones through the revitalizing energy of *"new and more universal spiritual beliefs"*.[1]

In the latter part of the 20th century, historians tended to lose interest in such overviews and, in keeping with the scientific mood of the age, focussed their efforts on specialized analyses and evidence-based, measurable data that could help explain the socio-economic realities of people's everyday lives.[2] Today, however, Toynbee's ideas seem especially prescient. First, there are strong resonances between his views and prominent voices in the philosophy and the history of religion. Second, his arguments about the role of spiritual factors in cultural renewal offer hope for the future because they resonate with contemporary understandings of sustainability, which recognize the critical roles of localization, tradition and cultural practices and their often substantive links to spirituality.

Few can doubt that Western civilization's period of building and growth is now in the past and that it has entered a period of decline. Its faith in itself has become severely undermined through a wide range of events and occurrences. These have included horrendous acts of terrorism and the realization that there are those who hate what the West has come to represent.

Western governments have become embroiled in wars that have been widely condemned as unjust. Moral decay and corruption have been revealed in our most hallowed institutions, including parliament, the Church and the banking system. We have seen extraordinary levels of corporate greed, even in the face of financial collapse, and the rise of unprecedented levels of social inequity. And there is a realization, too, that younger generations will be worse off than their parents. The backdrop to all this is the ominous threat of climate change, which we know to be the result of our own actions. As Hick has said, Western society is not only the first science-based culture, it is also the first culture that could destroy itself through its own technology. Western civilization, he says, *"may thus be in the process of strangling itself by its own unbridled lust for ever greater wealth and luxury"*.[3]

Despite this litany of ills, we still have the potential to transform society by developing a more positive, re-energized way of understanding ourselves in relation to others and the world. Following Toynbee's argument, the fulfilment of this potential will require us to challenge prevailing dogmas, especially the supremacy of technology and its unhealthy ties to corporate hegemony. And it means contesting essentially modern,[4] literalist and often exclusionary interpretations of religion, as well as a particularly strident form of secular fundamentalism. Toynbee suggested that Christianity and Islam should relinquish their outdated links to the rationalism of classical Greece, and warned against looking at religion through a Western scientific lens;[5] the Bible is not a scientific document that provides factual information about the physical universe.[6] He advocated embracing the truths of religious teaching as revealed through imaginative, poetic interpretations.[7] This view is supported by Armstrong who suggests that *"our modern Western conception of 'religion' is idiosyncratic and eccentric"*.[8] She argues that, traditionally, sacred teachings were generally believed to be true, but not literally. They were interpreted allegorically and found to be true when put into practice. With respect to interpretation, receptivity and intuition were vital, and charity and compassion were its guiding principles.[9] Significantly, it is through such exegesis that these age-old teachings are made relevant to the times,[10] which accords with Toynbee's argument that civilizations are re-energized and reconstituted via new, more generous spiritual beliefs that are grounded in the universal principle of compassion. While the world religions can be understood as different human responses to the intuitive apprehension of a transcendent reality, each

"embodying different perceptions which have been formed in different historical and cultural circumstances",[11] the bond between spirituality and social concern and community is recognized in them all.[12]

If Toynbee's ideas are correct, a positive future for Western civilization will depend on a spiritual renewal that permeates and reinvigorates all aspects of life. This includes the way we do design, the kinds of projects we work on, the materials and processes we use, the implications for people, the nature of human work, and the consequences for the natural environment. All these things can be informed and moulded by a different sensibility – one that recognizes the vital role that spiritual renewal can play in enriching our creative practices.

Cultural Highs and Lows

The terms high and low culture tend to carry with them implications of class distinction, but there is quite another way of understanding the meaning of these terms. There may still be some relationship to class distinction but this is more an unfortunate by-product than a fundamental trait.

High and low can be understood as referring to the concerns and priorities of an individual. By convention, we have long referred to the visible, material world as 'outer' or 'lower' and the world of the imagination, intuition and spirituality as 'inner' or 'higher'. In the traditional language of myth and religion, features of the physical world are often used to stand for or symbolize the intangible world within. Thus, significant incidences of inspiration or spiritual enlightenment and revelation are made to occur in physically high places. In Greek mythology, the home of the gods was Mount Olympus, and the Muses of the arts, poetry and sciences lived on Mount Parnassus. In the book of Genesis, sacred to both Judaism and Christianity, Abraham is called by God to sacrifice his son Isaac on Mount Moriah, which later became the Temple Mount in Jerusalem, and Moses received the ten commandments on Mount Sinai. One of the most important passages of the New Testament is a collection of sayings and teachings known as the Sermon on the Mount, and Jesus' transfiguration is said to take place on a high mountain.

In contrast to these inner or spiritual experiences in high places, stories in which people emphasize worldly or physical pleasures free of inner concerns, are set in low places. Those who indulge in such selfish desires live in the 'cities of the plain', located in the valley of the Jordan, north of the Dead Sea, the lowest land on earth. And Hell or Hades is commonly depicted as being down in the depths.

These foundational metaphors of Western culture can be understood as symbols of our values and preoccupations. 'Low' tends to mean that we are occupied by our own concerns, not looking up to see the wider effects of our actions. 'High' is indicative of ideas and values that transcend self and show

concern for others and the world. These 'beyond self' values are fundamental to the teachings of all the major philosophies and religions.

In terms of creativity, our values affect the nature of the produced work. In music, most pop songs focus on the emotions of the individual – the heartache one feels when one's love is spurned, or the joy when it is returned. In recent years, the emphasis of such songs has often been on physical love, and accompanying videos and performances have become increasingly sexualized, that is, physical, outer or, in traditional symbolic language, low. Here, prominence is given to individual pleasure and satisfaction. Other kinds of music are representative of a very different emphasis – there are many examples of compositions and productions that transcend the passions and preoccupations of the individual, and allude to something beyond the immediate and the mundane. They are elevating – that is, they are capable of taking us 'higher' and suggest a vision that is both transformative and timeless. The works of Palestrina, Beethoven, Bach, and recent composers like John Tavener and Phillip Glass, as well as painters, from Rublev to Rothko, allow us to glimpse a grander vision – one disburdened of the vagaries of temporal preoccupations. In doing so we are able to put our lives in perspective. This 'higher' vision can bring comfort, joy and some degree of reconciliation with the changes, tragedies and brevity of human life. And it is this kind of perspective we are in need of today if we are to overcome the destructive ramifications of our individual wants and see ourselves within a larger – and higher – notion of human society.

Improving Things

Science aims to be neutral in the way it describes the world. It chooses and claims to limit itself to descriptions and quantifications that explain and/or predict phenomena, but it intentionally removes any interpretations associated with meaning and value.[1]

The findings and discoveries of science are often used to inform the creation of new technologies, under the auspices of improving people's lives. However, this movement from science to technology raises a number of critically important considerations.

First, in contemporary society there is no clear separation between the scientific endeavour and technological development.

Second, the close relationship between science and technology, which conflates into 'technoscience', unavoidably introduces *values*. When we develop technologies we are making value judgements. Effectively, we are saying that a future condition that includes a certain technology will be *better than* the current condition where that technology is absent. Scientists and technologists, however, are not experts in moral philosophy or human well-being so are not especially qualified to make judgements about the ethical or even spiritual implications of their creations. Indeed, we often hear scientists say just this – that they merely make explicit the opportunities offered by science but it is up to politicians and lawmakers to determine the ethics of these possibilities. However, in such matters, the law is a blunt instrument – there is a significant difference between what is morally acceptable and what is legally permissible. Consequently, ethical concerns tend only to be raised in the more delicate cases such as genetic modification or use of human tissue for research. For the most part, except in matters involving intellectual property rights, technological developments are not regarded as ethically sensitive – yet they do involve value judgements and therefore they are not neutral. Moreover, collectively they are having an enormous effect on patterns of behaviour, priorities and expectations as well as on the natural environment.

Third, scientific research does not take place in a vacuum. It is supported by very large budgets both from the taxpayer and the private sector. Governments and corporations expect such investments to pay off by having 'real world' benefits. In other words, there is an expectation that scientific discoveries will be converted into technologies that will somehow improve people's lives. Such expectations, of course, are not altruistic. For the most part, any prospective technologies have to be capable of being monetarized and scaled in order to generate profits and boost shareholder returns and the economy in general.

So we begin to see that a main reason, indeed the primary reason, for this whole enterprise is less to do with improvement than it is to do with profits. Some might argue that these amount to the same thing, but in a free-market economic system, that link is by no means clear or proved. In the past, the manufacture of new products tended to generate new jobs. This is no longer the case as many contemporary technological developments are actually aimed at eliminating jobs. Also, today's globalized manufacturing endeavours often result in a race to the bottom in terms of wages, working conditions and environmental stewardship as corporations move their operations to countries where wages are low and regulations are few. Consequently, the contribution of such developments to actually 'improving' human lives becomes highly questionable. Worryingly too, nowhere in this ever expanding chain of developments are the values-based decisions made explicit.

Fourth, the only kinds of improvements that technologies are capable of offering are extrinsic in nature. They are restricted to human comfort, safety and security and these, essentially, are the limited aspirations offered by modern neoliberal democracies.[2] But when it comes to questions of meaning and value, extrinsic rewards are not and never have been sufficient. The human search for meaning demands something more profound than these relatively superficial, transient benefits.

Designers are intimately involved in these questions of meaning and value. They are expected to translate new technological possibilities into usable products that will be attractive for people to purchase. Hence, design is a values-based discipline. Furthermore, product design for mass production, fashion design and graphic design have always been closely related to advertising. All manner of persuasion techniques are employed to ensure new technologies, products and designs are accepted and consumed by the general

public. Marketing experts are adept at creating reasons, taglines, jingles, slogans and brands – so-called 'hooks' – that encourage us to consume. As new products are developed, we may see no reason to own them, that is, until the marketing department has done its work.

This is all values-based but the underlying reason is not to benefit users, it is to drive profits. So, at the heart of the *science-technology-design-production-persuasion-consumption* chain, which has become the driving force of modern culture, is a double standard, even a deception, that connects back to the scientific endeavour, its *raison d'être*, its claims of neutrality, and its alliance with technology, enterprise, commercialization and financial profits. Improvement for society as a whole requires a high degree of equity and justice – but this is certainly not what we are seeing today. Rather, concentrations of wealth and exorbitantly high salaries and bonuses for corporate executives occur alongside low wages, the creation of a working poor and unceasing attempts to eliminate jobs.

To develop an alternative direction, one that holds stronger potential for incorporating more comprehensive and sustainable understandings of 'improvement', we must first recognize that the reality described by science offers us just one version of the world. It is a rather narrow, particular and largely quantitative version that is stripped of interpretation, meaning and deeper values. Once we acknowledge this, then other possibilities and other *"potential disclosures of the world we inhabit"*[3] become possible and worthy of our consideration. These other versions can include aspects of reality that transcend physical, quantifiable explanations and the everyday habits and routines of our lives. They are connected to profound notions of self, purpose and meaning. They concern a bigger vision, a more august and magnanimous aspiration that rises above selfish desires, pettiness and fleeting material attachments.

Historically, two domains have been capable of transcending ordinary, commonplace reality to enable individuals to find some kind of greater meaning and significance. One is the warrior's quest, which offers a higher purpose, a sense of the greater good and an altruism associated with risking one's life for others, but it also involves a dehumanization of one's enemy in order to justify the killing of other human beings. The other centres on the spiritual quest. This, too, requires a higher purpose, a sense of rightness and the greater good but it involves empathy and an ethic of reciprocity.[4] These

two have always been important features of the human condition. Both are concerned with meaning-seeking, meaning-making through interpretation of the world, and human values.

Clearly, then, if we really wish to 'improve' human lives, we are not going to achieve it simply through technoscientific means. A larger sense of purpose is needed that rests on interpretation and values. Furthermore, for improvement, this interpreted world must eschew the destructive path of violence and aggression and choose the path of spiritual development that is characterized by empathy, compassion and love.

80

Moving on

Moving past the will to innovate.
Moving on from digging, processing and
producing the planet – creating and making
the always new. Getting over the need for
novelty – the neat, the cool, the disruptive
this and the ultimate that. Rising above the
things we live by, yearn for – to find
silence, peace, time, earth, love, home.

One Manifestation
of Wisdom

It is extremely foolish to ship great quantities and varieties of unnecessary goods across the seas. If we stopped importing such things from China, we should not yearn for them. Wise people do not esteem things from faraway and do not value products that are difficult to come by.[1] These sentiments were penned over six hundred years ago. In those days, the quantities of goods were relatively small, manufacturing was done by skilled craftspeople, and ships were powered by wind and sail. How much more foolish is it now, when manufacturing and shipping are achieved by burning immense quantities of hydrocarbons and products are so short-lived?

The Port of Antwerp, where I once had the misfortune of becoming entangled on my way north, is a sprawling city of transient storage – mile after mile of shipping containers arranged in long rows and stacked three high, and warehouses, cranes, highways, trucks and gigantic container ships. It is a pattern repeated in Balboa, Bremen, Felixstowe, Hamburg, Hanshin, Jeddah, Los Angeles, New Jersey, Piraeus, Port Said, Rotterdam, Salalah, Santos, Seattle, Sharjah, Valencia and on and on. But as Saul has said, *"There is no noble destiny in moving inanimate objects vast distances"*.[2] All this making and movement depends on cheap oil that we should not be consuming and cheap labour that we should not be exploiting – not least because all these things, all these new inessentials, actually have very little meaning. These endless, placeless enticements are created not to be necessary, useful or lasting but simply to be bought. Once purchased, their role is finished and the next shiny thing takes its place on the shelf ready to make us less satisfied.

Production does not have to be like this and it does not benefit most people when it is like this.[3] Globalization tends to serve only a minority, who reap enormous financial benefits while paying few of the costs. Production done on a local, regional or national basis can be of far greater value to ordinary people. When production depends on skilled labour it creates good jobs. When products are designed to serve regional or national needs and

preferences, they become expressions of culture. And when they are priced to fairly reflect their production costs – in terms of decent wages and environmental impacts – their purchase price is inevitably higher. If production was done in this way, we would undoubtedly consume less and buy mainly those things that were necessary. We would expect them to last and to be repairable. As a consequence, we would tend to appreciate what we have, take care of it and pass it on to our children. We would no longer be esteeming things from faraway and valuing products that are difficult to come by and so we would free ourselves of the confusions and anxieties caused by so much inconsequential choice. While we would have fewer material goods, they would be useful and meaningful because they would be of greater cultural and personal significance. This would not be foolish, it would not be globalization, and it would not be the way of the world, but it would be one manifestation of wisdom.

82

Why

There are many reasons why we strive for self-expression and change. Some people are motivated by the prospect of new scientific discoveries, others by the potential of new technologies. Some draw on lessons from history, while others find fulfilment in physical challenges, the welfare of others, the natural environment, or contributing to the dynamics of human communities.

The opportunities offered by design are rather different from any of these, although it may draw on elements of them all. Design is a synthesizing discipline that embraces a wide variety of often quite disparate factors, and attempts to create a harmonious whole. In the process, it emphasizes certain things over others – aesthetics, affordability, ergonomics, manufacturability.

Within academia, design practice can have an additional agenda. It need be less concerned with pragmatic or economic matters and can be regarded more as a vehicle for probing contemporary issues. Here, the design process itself can be a mode of inquiry, through which there is non-verbal exploration, knowledge development and visual expression.

But still, there is something missing. There is something further to be considered – another why, a deeper why and perhaps a higher why. This is the why that asks us who we are and who we struggle to be. To answer *this* why we have to look inwards, at who we have become, to find a motivating resonance; that place where reason echoes with the soul. Here we find something real, something firm – the best of who we can be amid the forgotten memories of an innocence we once knew without knowing. We must search these places and in doing so, for it to be true, creative expression inevitably reveals something of our core. This is necessary but it also makes one vulnerable.

Perusing the poetry section of a large bookshop in Liverpool, I was picking out various collections but was in the mood neither for pretty verses nor self-absorbed angst. I was looking for something different – more visceral, more reflective of our times. I carried on browsing with little hope of happening upon the kind of thing I had in mind when I pulled out a thin

volume by Martin Hayes,[1] a name I did not know. The poems grabbed my attention from the start – I stood there reading one after another. With titles like *burying the guts* and *give us sellotape*, the poems were a raw, humorous and heartrendingly poignant exposure of desperation and despair among low-paid service sector workers in contemporary Britain. Yet the very fact that this book of poetry exists is a magnificent – even heroic – act of defiance because wherever such creativity exists, hopelessness is held at bay.

83

After this?

What happens
after this?
After
the routines
we live by,
the rules
we play by,
the roles
we fill,
the lies
we tell?
What happens
after this?
When we are
quiet and
silent and
still?

84

A Creative Life

A creative life demands a sustained sense of purpose, without loss of resolution or hope. This is what keeps the artistic enterprise alive – the innate need to create combined with an imaginative vision that can only ever become sharp and distinct through engaged practice.

The creative struggle has little or nothing to do with financial recompense, accolades or celebrity. Such rewards may be pleasant supplements but must never become substitutes for inner purpose and the intrinsic rewards arising from the creative act itself. Artistic integrity inevitably becomes compromised when the tail starts to wag the dog.

Hermann Hesse, best known for his novels *Siddhartha* and *Steppenwolf*, considered himself not simply a writer but an artist. He saw no definitive boundaries between different modes of artistic expression.[1] In the introduction to a collection of his fairy tales, his translator tells us that Hesse was attempting to *"make his own life as an artist into a fairy tale … to find some semblance of peace and perfect harmony"*.[2]

Such a goal is, of course, unattainable. A fairy tale is not real life. It portrays an idealized, dreamlike world. But knowing this takes nothing away from the meaning or the nobility of Hesse's endeavour. Indeed, it could be said that this is life's ultimate purpose – to strive towards something that is beyond our ability to actually achieve. For, in doing so, we learn that it is the effort itself that is the real goal. And with this realization, we begin to understand that, to be truly creative, the means and the ends are indistinguishable.

Delicate,
Evanescent Things

Listen. A silent voice is speaking – a sudden flash, a spontaneous coalescing of whispers that imparts a vision, triggers a thought, an idea. It makes no sense – not at first. It's not clear what it's for. But do not dismiss it. Let it dwell here, at least for a little while. Attuned to these moments, we obtain something not yet apparent to the intellectual mind.

Ideas are ephemeral things – when they flit by we must grasp them, but gently. Enthralled by their radiance, we know not whence they come, nor their destiny as we let them go. And let them go we must, for if they stay too long they become old and stale.

They are the very lifeblood of the creative arts, but they can be easily crushed by pragmatism. In film, for instance, the reality of the bottom-line too often transfers to the screen as formulaic repetition; beneath palatable facades of high-fidelity realism[1] lie worn-out themes and incessant duplication. The design equivalent is not false illusion through hyper-realism, but false purposefulness through hyper-detailing; an abundance of visual and technical minutiae creating the impression of expediency.

Why I find this preoccupation with trivia so objectionable is because it is a kind of con. At worst it is illusory, at best irrelevant. Examples include determinedly rugged cars that have all the appearance of tough, four-wheel drive vehicles but are intended primarily for suburban living where the harshest surface is likely to be a gravel driveway and the heaviest load the weekly shop. Another casualty is the wristwatch. As their utility has declined with the coming of the mobile phone, the aesthetics have become more and more overblown. Attention to purposeful-looking, but essentially meaningless, detail is off the scale. These are perhaps the most obvious examples, but the principle extends to much of our mass-produced culture – kitchen gadgets, backpacks and DIY tools. Everything has to look leading-edge, meant for business, 'professional' – from a tee shirt to a disposable razor. But they are not meaningful. They

are just fads in an over-inflated marketplace. It is ideas that matter, not enticing veneers.

This is especially true for creative disciplines, and particularly so at the university. The generation, development and, when appropriate, discarding of ideas are the stuff of academia. If we want pragmatism we should find a position in industry where concepts are chosen based on their ability to be commercially useful. This is important too, but creative work in universities should not be ruled by such concerns, by their ability to have impact in the 'real world'. Universities are places for developing knowledge and understandings, and for wrestling with ideas that commercial enterprise has neither the time nor, perhaps, the inclination to consider. In giving free rein to ideas, we need to understand the conditions in which they arise. And we should treat them with care otherwise we lose them, because they are delicate, evanescent things.

86

Useless Things

Like many people, I love to create things. Above all, I love to create things that are useless; things that are not necessary or efficient. It is true that in the past I have created chairs, but they are not for sitting, and lamps that are not for lighting. I have built several radios that have never been listened to, and telephones that have never made a call. While they do work at a functional level, their function is not their purpose.

Most of what I create nowadays does not even purport to be purposeful. But I don't think of it as art, though I often get asked if it is. I don't think of myself as having moved away from design – if anything, I am more deeply immersed in it. I think about design. I also think about art. But I think about design more. I think about design when I am doing what I primarily do, which is reading and writing and researching, teaching and making. All these activities are steeped in thoughts about design not thoughts about art.

And, of course, I don't have anything against utility. How could I? The idea is nonsensical. It's just that I prefer to focus my thoughts on other aspects of design, aspects that interest me more. Ever since I got into design, actually long before, I have wondered why we create things in the way we do – why things look the way they do – what this look means, and especially what it does not mean. A shine that is only skin-deep does not express depth. A finish that is flawless and fragile does not suggest good sense. So I wonder what would express depth and good sense. And I read and write and research and teach and make. And in the making, I think about the meaning of making, and about creating and the aesthetics of purpose, of which utility is but one small part.

87

Dying to Create

The creative drive has long been associated with death. Many reasons have been suggested and while none are definitive, it does seem that we create because we die or, more specifically, because we know we die.

One explanation that is especially revealing suggests that we create neither to deny our own mortality nor to seek immortality, though both may play a part, but to give our lives meaning. Through acts of creativity we strive to bring some clarity, however inadequate, to essentially unanswerable questions about life's significance and value. Because of the vagueness inherent to such feelings and ideas, we often employ symbolic forms of expression that allow multiple interpretations, none of which will be complete.[1] It seems that producing creative work offers some resolution or at least some reconciliation with these existential questions. According to this explanation, communication of one's ideas to others, via the work, is of only secondary importance.

Paradoxically, any significance and value creativity holds may only be tangentially related to the activities we pursue, the efforts we make, and the works we create.

> *"Meaningless! Meaningless! … Everything is meaningless. What do people gain from all their labours at which they toil under the sun?"*[2]

We tend to believe that our labours – all the busy, purposeful activities with which we occupy ourselves – give our lives meaning. But if, with consciousness of our own mortality, such labours become meaningless, we are forced to ask ourselves if our life has meaning when it is *not* associated with purpose, objectives and accomplishments; when we focus on 'being' rather than 'doing'.[3]

Another explanation, which enriches our understanding of the creative urge, is that through creative endeavours we connect with others. Through such acts we continue a tradition – we draw from our predecessors, we make

their contributions relevant through confirmation, adaptation or possibly through refutation, and we pass them on to those who follow. Here, meaning is found not so much in the works themselves nor in the creative process, but in these connections.[4] This sense of contribution to community accords with Steindl-Rast's argument that a meaningful life is found through giving, which can include giving time to others, or giving something the time it deserves, giving of our best for its own sake and, in doing so, overcoming selfish desires. It is this transcendence of ego that allows us to become a full person because our personhood is defined not by our independence but by our interdependence – our relationships.[5]

Crucially, the apparently self-absorbed nature of creative acts tends to obscure this relinquishment of self that lies at the heart of creativity. When we give ourselves fully to the creative process, when we become completely absorbed in the present moment, we die to our own will and individuality and become part of the flow of life. We are – and we know we are – truly alive. Anyone who has experienced the creative process will recognize the heightened sense of awareness, vitality and 'being' that it yields.

These experiences take us out of ourselves. We give up thoughts of extrinsic rewards – flattery, fame and fortune – and experience a sense of unity through connectedness with others and the greater whole. Learning to die to ourselves allows us to grow internally, but only if we are fully present in the here and now.

Live

Long ago
it was said
that death
is the end
of each of
us and that
we who live
should take
this to heart
for the dead
know nothing
and nevermore
will have a part
in anything

89

RAW Design

Students of product design are frequently told they should not be designing for themselves; they need to design for the client. In effect, this means that the gift of creativity becomes divested of personal impetus and is directed towards the needs of a highly constrained, economically efficient industrial system. This distances the designer from the world. First, there is the disconnect between the designer and the making – the materials, their sources, the processes, the people, the working conditions – in industrial zones that are often thousands of miles away from the design office. Second, there is the disconnect between the designer and the many different environments in which the products are used. Mass-produced goods can be found in all kinds of contexts but their fundamental qualities of 'thingness' mean they have no specific connection to place, community or the individual. Perhaps this is why these products seem so alien and detached from our essential humanity; their shiny regularity creates a world that is impersonal, unnatural and sterile.

A truly creative process cannot be rationalized to fit a predefined system, it has to emerge from and be reflective of the self, the creator, the person. As the German writer Thomas Mann said, creative works are *"a kind of externalization, 'a realization, fragmentary to be sure but self-contained, of our own nature'".*[1] When creative works originate from deep within us they will often resonate with others because they touch our common humanity.

Yet, there are exceptions – some mass-produced products are capable of overcoming the inherent limitations of the industrialized system and are able to connect with us more directly and at a deeper level; their meaning can be so powerful that an essential human connection is maintained. Indeed, in some cases, it is the facility enabled by the industrialized system that allows the creator to speak to us in an intimate way. In other cases, through the experiences of use, they allow us to transcend the concerns of the everyday and grasp something more profound. These products fall into three basic categories – **R**eligion, **A**rt and **W**ar.

Religion: cheap mass-produced images and rosaries can have much significance for the devout because they provide a focus for prayer, reflection and meditation. They do this just as well as any bejewelled equivalent – perhaps more so because their affordable modesty better reflects the egalitarian ethos inherent to many religious teachings. Through the presence and use of such artefacts, people are able to rise above the mundane to acknowledge a more profound and enduring sense of meaning.

Art: inexpensive, mass-produced recordings, paperback books and online publications allow us to appreciate music, literature and poetry, as well as sacred texts. Through the global distribution of such affordable products we have access to the world's ideas, arguments, and teachings that entertain, stimulate, educate and inspire. We become connected to each other through shared values and collective understandings.

War: mass-produced products such as guns, bullets and bombs – the weapons of war – bring only death, destruction, bloodshed and tears. Despite this, however, as discussed in Ch.79, the life of the warrior can also be a route to self-transcendence.[2]

Religion, art and war have all been constants in the history of human society, and each enables us to rise above the ego, selfishness, and mundane preoccupations of the day-to-day. In their own distinctive ways, they allow us to reach for something greater and aspire to a higher sense of purpose and significance. Hence, in all three cases, their respective mass-produced goods can be understood as a means to a greater end – a conduit through which we can touch a more substantive idea of meaning.

Ruination

Commonplace and customary
essentials of the everyday
in the hands of a soul
without empathy or love
become the shrapnel of dissonance
the dashed hopes of despair.

91

Rejuvenation

Commonplace and customary
essentials of the everyday
in the hands of a soul
with empathy and love
become a source of creation,
a renewed reason for hope.

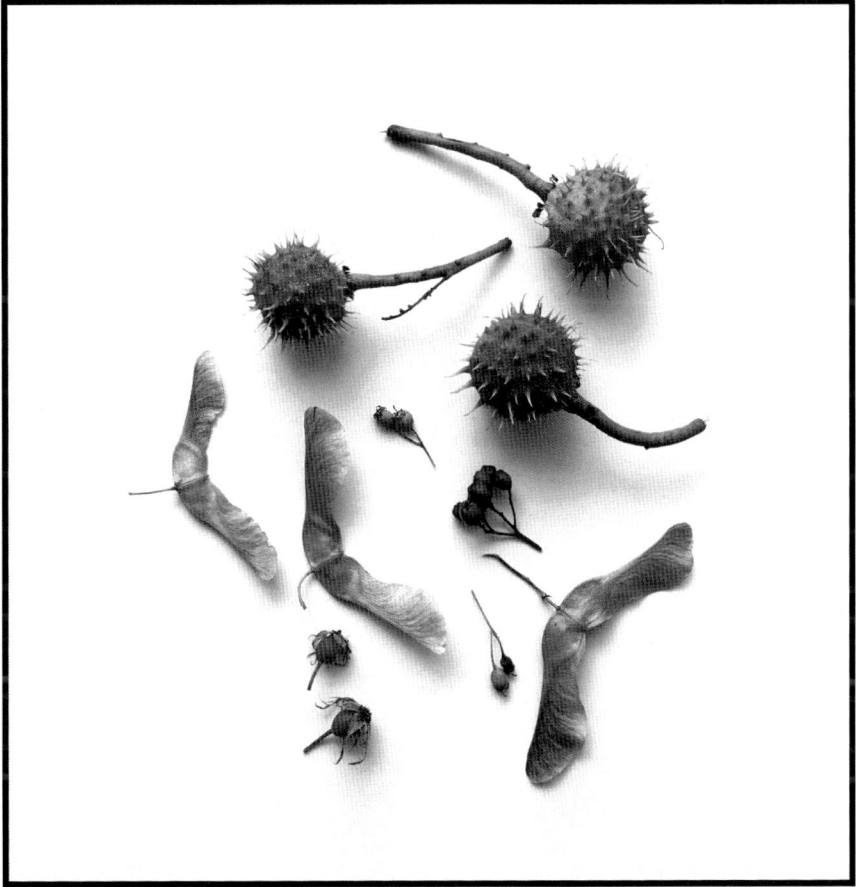

Things that Endure

Scientific accounts provide us with ways of understanding ourselves and the world. Based in the philosophy of materialism, they strive to offer explanations of physical phenomena as well as theories that are consistent with empirical evidence. A statement like *water freezes when the temperature falls below zero* is observably true and the natural sciences allow us to understand what is actually happening when ice is formed. Factual information like this can affect how we live our lives; in this example, it might mean lagging our water pipes or taking extra precautions when driving on winter roads. In other cases, scientific information provides a basis for harnessing energy, or curing disease, or enabling the development of a host of useful products. And while the accounts can become quite complex, the rational explanations offered by the scientific community generally aim to provide clear, unambiguous information about the nature of the physical world and its processes. There are no deeper or hidden meanings to such accounts; what you see is what you get.

But as we have discussed, there are ways of knowing that differ markedly from those that preoccupy the sciences. These involve the imagination, intuition and subjectivity and they find their voice through art, poetry, music, story, ritual, lore, religion and values. Here, meanings tend not to be definitive or explicit but are normative and interpretations are bound up with individual involvement, commitment and experience.

Texts from the world's metaphysical traditions are especially complex. They have layers of meaning and many possible interpretations. Words have their usual literal, external meanings but may also have symbolic, internal meanings that allude to higher levels of human apprehension and inner development. They tell us about ethics and values and point to humanity's most profound notions of spiritual awareness and aspects of human existence that are timeless.[1] Such intimations have been expressed in one form or another in virtually all human societies down the ages. The symbols

and pathways may differ, but it is this struggle for spiritual attainment and inner reconciliation that is at the crux of all the great traditions. In Islam, for example, the terms *zahir* and *batin* refer respectively to the external and internal meanings of the Koran. The 13th-century scholar Jalāl ad-Dīn Muhammad Rūmī wrote, *"The Koran is a two-sided brocade. Some enjoy the one side, some the other".*[2] In the Western tradition, these symbolic stories are known variously as allegories, parables and miracle stories. They are imaginative, poetic pointers to deeper ways of knowing. They are not meant to be taken literally – to do so is both a category mistake and a relatively recent phenomenon.[3] Critically, when such texts are read in an overly simplistic literal manner, they are either dismissed as untenable and irrelevant or, in the case of creationist groups, proposed as viable alternatives to evolutionary theory and the findings of science. Both responses are equally flawed because both fail to recognize that these forms of expression are concerned with vitally important facets of being human. American philosopher Jacob Needleman has spoken of *"our utter loss of spiritual tradition"* in a society *"lost in materialism and technological change, in which the lower nature has been sated again and again"* and where *"traces of higher feelings are vanishing like so many fragile life species".*[4]

To understand these texts at a deeper level, it is important to recognize that they have to be interpreted figuratively. Physical entities often represent states of mind, modes of awareness and inner realizations. While this indirect form of expression might seem unnecessarily abstruse, it is used for a reason. First, the spiritual truths to which these texts point lie beyond the capacity of explanatory forms of knowledge – they have to be experienced and intuitively grasped by each person for themselves. As the Chinese sage Lao Tzu puts it, *"The Tao that can be told is not the eternal Tao. The name that can be named is not the eternal name".*[5] Second, it means that everyone will be able to get something from these texts, whatever their level of inner development. As we grow inwardly, the very same texts allow for new interpretations and reveal higher levels of meaning.

Sometimes, the symbolic language is actually explained in the texts themselves, so that the reader is made aware that there are ways of understanding them that lie beyond the literal. In the New Testament, we are told that *thorns* represent the worries of everyday life and the deceitfulness of worldly riches and pleasures, which prevent inner development.[6] Similarly, a lamb

might symbolize a pure heart, a wolf the uncontrolled passions, the eagle the struggle to transcendence, and the peacock the vanities of the ego.[7] At the literal level, the cross is an instrument of torture and death. At the symbolic level, the horizontal beam can be understood as representing our earthly, physical side ruled by material needs and worldly appetites. In contrast, the vertical beam symbolizes our spiritual side and different levels of the inner path that leads towards virtue and compassion. Being inseparable, the implicit meaning is that these two are intimately connected and mutually dependent – we therefore have to find reconciliation between them, which can entail anguish and sacrifice, but has the potential for joy.[8,9]

Clearly, these forms of expression have to be interpreted if their higher meanings are to be revealed. They are not factual, historical accounts, but nor are they fictions. They are written in ways that are intended to convey timeless spiritual truths.[10] The question to ask of such texts is not, *Did these events really happen?* but *What do they mean?*; it is their layered, inner meanings that make them so enduring. Their literal, worldly meanings may fade in importance as practices change over time; in modern societies we no longer store wine in stone jars or fetch water from the village well. However, their metaphysical meanings will always be relevant because they address fundamental aspects of the human condition. If approached with an attitude of receptivity, they will speak to each successive generation. Unlike science, this kind of knowledge is not cumulative; inner development, and the experiential knowledge on which it depends, is something we have to attain for ourselves over an entire lifetime.

Significantly, these ways of knowing are not concerned with manipulating and changing the physical world around us but with our own inner transformation and outlook on the world. Even René Descartes, that pre-eminent pioneer of modern rationalism who saw great benefits for humanity in the potential of science and technology, ultimately came to have doubts about its power and value. As he grew older he wrote, *"Instead of finding ways to preserve life, I have found another much easier and surer way, which is not to fear death"*.[11]

We can learn much from these different ways of apprehending the world and their relationship to creating and interpreting human-made works. In particular, we can consider how these physical and metaphysical apprehensions relate to forms and qualities associated with transience and fleeting relevance or timelessness and enduring meaning.

Relating the foregoing to the making of materials goods, we can see that objects developed within our dominant outlook of materialism and moulded by the priorities of the techno-scientific mind will be primarily of a pragmatic, utilitarian nature. They will tend to control and manipulate natural phenomena and offer a host of worldly benefits; benefits that, in traditional language, are resolutely focussed on the external, physical, lower aspects of our nature. For these very reasons, and because scientific and technological knowledge is always advancing, the functionality of these kinds of products tends to become quickly superseded and so the products themselves rarely have any lasting relevance. In contrast, artefacts conceived in ways that are informed by the metaphysical will often remain relevant for hundreds or even thousands of years. The Kaaba, the holiest site of Islam, has been recognized as a sacred place for millennia and millions of pilgrims visit it every year. The magnificent European cathedrals, such as Chartres completed in 1220, and the Great Buddha of Kamakura in Japan cast in 1252, continue to play an important role in people's lives; their meaning is unchanging and their relevance is enduring. On a smaller, more domestic scale we can think of the menorah, the nine-branched candlestick used in the Jewish faith during the festival of Hannukah; the prayer rug used by Muslims during their daily worship, and the Christian crucifix displayed in the home or worn around the neck as a symbol and reminder of one's faith. All these things have layers of meaning that tell us about the human condition and the inner self. This is precisely why they continue to be relevant, at least for those prepared to be open to these deeper aspects of our humanity. Moreover, even if the artefacts themselves are destroyed, the ideas they represent are sustained. Consequently, and in contrast to individual works of art, they can be remade without any loss of fundamental value; meaning lies not in the object itself but in that to which it points.

93

The Mark Made

The mark of the hand is important to us. It conveys intention and holds meaning. We value a signature because it indicates authorship – we require it on legal documents, we expect it on paintings, we treasure signed books. Other marks of the hand, though anonymous, can still elicit a sense of connection. Roman soldiers, garrisoned in the Antonia Fortress in Jerusalem two thousand years ago, carved crude game boards into the flagstones. These simple inscriptions conjure thoughts about their lives, their world, their idle hours – and we draw parallels with our own lives because we too experience idle hours, we too seek amusement and conviviality.

In the same way, *objects* that carry the mark of the hand can evoke a sense of connectedness. An artefact that is entirely handmade, that is gauged by the eye rather than the rule, will be one of a kind – as unique as its maker. And it is this particularity that is the basis of connection.

The aesthetics of a handmade object might be described as warm, evocative or authentic, and it is these qualities that enable it to transcend mere functionality. The mark of the hand resonates with us, creating a visual and tactile bond between object and subject, external world and internal person. Such objects bear silent witness to circumstance; skill and ability; needs, desires, oversights, judgements, beliefs and failings – a whole gamut of what it means to be a person. Consequently, objects that endure serve as connectors to the past, tying us to those who came before us and contributing to our own sense of identity, belonging and culture. They enrich our lives and help cultivate an attitude of duty and responsibility.

Scale, financial priorities and dislocated modes of production mean that there are none of these kinds of connections with machine-made products. Indeed, contemporary manufacturing for global markets inevitably proceeds towards ubiquity and short-lived banality. The fearful symmetry[1] of this instrumental rationality yields products that might be functionally beneficial but, in terms of their fundamental characteristics as things, are detached from

human feeling, starved of contextual meaning, and severely damaging. The connections to people and place are cut, unmooring us from our culture, our roots and ourselves. We drift listlessly about looking for meaning and so become easy prey to the promise of yet another purchase. When we succumb to such promises we miss the mark in quite another way.

The original meaning of the Greek word ἁμαρτάνω (hamartanó) is to miss the mark, in the sense of missing a target with an arrow or spear.[2] It came to mean to fail in one's purpose,[3] to be lacking or deficient,[4] or to wander from the path of virtue and honour.[5] In the Western spiritual canon, ἁμαρτάνω is most commonly translated as *sin*,[6] which not only has archaic, religious connotations but also conveys a sense of active wrongdoing rather than falling short or neglecting one's duty. Bearing this in mind, the mark represents the target that we should be aiming for in life. This is precisely where spiritual teachings take precedence over scientific explanations. To hit the mark, to become fully human, we have to develop inwardly. Simply put, how we ought to live is summed up in the law of reciprocity, *act towards others as you would have them act towards you.* Commonly known as the Golden Rule, it is found in one form or another in all the major philosophical and religious traditions. It has a strong egalitarian message that implicitly transcends distinctions of class and ethnicity. It advocates equality and equity, treating others fairly and so on. While it appears simple, putting it into practice is a considerable task that requires inner reflection and development. It challenges many of our assumptions and questions virtually every aspect of modern society. In terms of material possessions, for many it means considerable reduction – towards more modest ways of living. Luxury and excess for some unavoidably mean poverty and exploitation for, and domination over, others and, because of the limitations of land and resources, this inevitably leads to conflict.[7,8] A sense of moral duty and responsibility towards self, others and the world necessarily means overturning many of today's norms. It means thinking about the importance of work and the nature of that work, and not striving to replace jobs with machines and automated processes. And it means creating products that are beneficial in terms of their function, aesthetics, and endurance, as well as their collective impacts.

The mark we make in our material productions has to be in accord with the mark we strive towards in our inner lives. The means and the ends, the process and the product, then become one unified endeavour leading to forms

of work and a material culture that is consistent with long-standing notions of truth and goodness. Only then will our material things achieve a significance, beauty and place in the world that is worthy of the mark made.

94

Handmade

Automated uniformity and robotic inerrancy have given us a form of efficient, low-cost production that is highly prized in today's business environment. Through such means, we have created a world of things that are machine-made, digitally exact, affordable and more or less reliable. If one equates progress with technological advancement, then all this will seem of great benefit to society. But the sell-by date of the technocratic ideology on which these achievements are based has long since passed, because it is an ideology that has been taking us ever closer to a future that is more monotonous, less human and less humane. Abstraction, rationalism and reductionism may still hold sway in corporate boardrooms and government departments but their inadequacies and grave repercussions are becoming increasingly apparent.

This is perhaps why such approaches are now being complemented, or even countered, by a reassessment and recovery of the handmade. Around the world there is renewal and reappreciation of traditional practices, localization and human-scale enterprises. When we make things by hand we not only affirm the importance of quite different material qualities, we also affirm a different set of values. Handmade, hand crafted, designer-maker, local, one-off, bespoke – all these terms have positive associations. They speak of qualities that are individualized, genuine and reliable. While they may be less precise than mass-produced goods, handmade products are also less remote. Their modes of making and their materials mean there is an affinity with people and place, qualities that often make them very attractive. These things matter to us because they are innately human. We see them and feel them – they touch a deeper part of us. There is a resonance with materials of the earth that have been shaped, moulded, woven or cut by hand, be they clay, wood, fibre or stone. Through such practices we form relationships with the natural environment and each other. These practices privilege empathy over exactitude, and cultural distinctiveness and diversity over bland homogeneity.

When we make things by hand, there is a need to work *with* the materials – to understand their qualities and their natural tendencies. There is a slowness of pace that allows for an intimate knowledge and appreciation of material characteristics and their response to tools and processes. It is this knowledge and appreciation that fosters respect – for the materials themselves and also for their sources – the environments from whence they come. There is a realization not only of dependency but, if things are to be continued into the future, of interdependency and a sense of stewardship and care for natural places. And with this ethic, comes an inclination to use resources wisely, even reverentially, to work towards what we believe to be good and to avoid processes and purposes that are inconsiderate, demeaning or wasteful. A line written by Sophocles two and a half millennia ago still holds true today, *"Ignorant men don't know what good they hold in their hands until they've flung it away".*[1]

95

Whittling

Whittling is a slow, meditative process marked by repetitions of movement and quiet concentration and characterized by touch, feel, seeing and attention to detail. When one begins a new piece, the aim is not to finish it quickly but to finish it well; the time it takes is of no concern.

It is inappropriate to think of whittling merely as a pastime, as something that serves to while away time in an agreeable manner. While it might be agreeable, it is not done to pass the time – to refer to it in such a way is to disparage this kind of activity and the type of thinking it helps induce. In fact, it is a process that employs our time exceptionally well – and this is particularly important today. Modern society is completely dominated by speed, deadlines, outcomes and quantification. Consequently, little attention is paid to contemplative and reflective modes of being, which are the foundations of wisdom. In our work lives we feel we have to be constantly achieving, and our leisure time is filled with distractions and passive entertainments. None of these are conducive to contemplation.

Whittling and other repetitive activities, like knitting and embroidery, help calm the mind and engender a more holistic mode of thought. While concentrating intently on the task in hand, the mind uncoils and as it does so it imagines, daydreams, muses and wanders where it will. It flits and soars, and from such heights it can take in the view. This is the creative mode of thinking. In such states of reverie we experience a sense of well-being because we become capable of seeing the whole more clearly. We feel at one with the world – this sense of at-one-ment is crucial to attaining a more balanced view and a sense of personal well-being, and it affects the choices we make and the choices we live by.

The kinds of things I whittle are usually very simple. I avoid intricate shapes and decorative patterns, preferring to follow the flow of the wood itself. Tools are basic and few – a good quality pocket knife, sandpaper, wire wool and a natural oil. I often use greenwoods – straight sticks of small

diameter. The blade of the knife, held at a shallow angle and pushed forward, peels off a thin strip of bark and reveals a damp green inner layer. Rotating the piece in the hand, the action is repeated. A finer set of cuts strips the green lining back to the lighter, drier wood. The piece is cut down and smoothed with repetitive strokes that are shallow-angled to avoid gouging. I occasionally rub my thumb over the surface to feel the texture and gauge the degree of smoothness. A more precise cut smooths out a ridge or knot. In parts, the darker bark may be left in place, contrasting with the lighter exposed wood and providing a natural protection for the place where the piece will be held. The knife continues its work until the desired shape is more or less complete. It is then laid aside and replaced with a small piece of sandpaper – held in the fingers rather than on a block, which allows the sanding to flow over the contours of the material instead of abrading through them. Finer and finer grades bring the surface to a smooth finish. This takes time and patience and requires constant inspection and adjustment. Looking, feeling, sanding – careful not to skimp or take it too far. The final smoothing is with wire wool. The closeness of the process and the careful looking allows one to appreciate the natural beauty of the material. Lastly, a soft rag is used to apply a wood oil. Artist's grade linseed oil is clear and brings out the natural hues of the wood without discolouring it. Made from flax seeds, it absorbs into the wood, dries hard and gives a sheen to the wood that makes it glow.

96

Foraging

Foraging simply means hunting about and rummaging in search of supplies and it is exactly what I do to find materials for my design work. One of the joys of foraging is that it gives me a good excuse to go for a walk in the countryside or on the beach. These walks are good for the soul – they allow me to see again the beauty of nature and they help me put my worries and wants in perspective. And along the way I collect things.

Sometimes I go with a definite idea to find a specific item, but these trips are often fruitless and a formula for frustration. Foraging does not conform to preset plans. Usually, I start out with nothing particular in mind. I look, I come across things, frequently I become fascinated, and I may pick up something that might be useful in a future project. A handful of pebbles of the same colour, a few river stones of similar size and shape, fragments of sea glass or sea plastic, driftwood, wind-fallen wood, seed pods. I often carry a few simple tools, a small saw, a penknife and secateurs, so I can free things or cut them to size.

And these gathered bits and pieces accumulate. I have jars of old bolts, nails and pieces of chain, and sand, and tins of twigs and feathers, and dried grasses and remnants of fishing tackle, and sapling sticks and rusted barbed wire. The serendipity and surprise are all part of the delight. These things can inspire and sadden, and using them to make something new can conjure its own story.

When I use a bright, colourful piece of plastic that has been chamfered by the sea it means that I have removed it from its unsightly place on the sand, where it has no business, and I have given it a new place in the world. It is a small act of clean up and reuse, but it is symbolic of an attitude, a way of behaving. When I include pebbles or river stones in one of my designs, I accept their variety and variations. This is indicative of a way of working. Instead of forcing materials into predefined forms to obey my will and specification, the process is one of give and take – so that the finished piece is a

result partly of what the material is and partly what I want. It is a pliable and symbiotic process, not one of imposition and control. I like to think of it as a mode of making that allows the world in, that respects the world's contribution to the creative endeavour and accepts this contribution as meaningful and valuable. The world is allowed to speak, my job is to listen.

When we take the time to listen, we also learn to see, reflect, and recognize what we are doing and its effects. Foraging not only uses what is already there, it treads lightly, it enables one to see the beauty, the wonder, the fragility and the damage – to see our reality. And it helps create an empathy, a sympathy, and a sense of dependency and reverence. When I am walking through a pristine forest or along a river bank and I see a carelessly dropped can or bottle, when I am walking along the shore and I see plastic junk mixed up with old ropes covered in tar, not only do I feel saddened, I feel ashamed – ashamed of who we have become, ashamed that we do this kind of thing without conscience or care.

When I am out and about collecting materials in natural environments I walk slowly. I dawdle. I stand and stare and look and touch and again and again I am surprised by the sheer splendour – of a splashing brook or a new leaf or a dragonfly landing on a flower or caterpillars weaving their spells on nettles. Foraging is joyful and saddening – it reminds us that it is all such a fragile beauty.

Artefacts

Handmade from local materials, these artefacts express local and intergenerational knowledge, skill, experience, beliefs, ingenuity and resourcefulness. Their processes of making, their use and their physical presence within the community embody practical, personal, spiritual, social, cultural and ethical meanings.

Oak swill basket, England

Drop spindle, Turkey

Satchel, China

Snow goggles, Canada

Sticky-rice basket, Thailand

Ladle, Kenya

Toy boat, Wales

Crucifix, Germany

9 8

Life

Forget
any thoughts
of the future
put aside
such presumptions
of promise
grasp fast the
permanent present
take the here
the now
live
imagine
create
love
till
the doors to the street
are closed
till
the sound of the bird
grows faint
till
desire ceases
to stir
and
the thread ceases
to hold.

Improvisation

Creativity is a process of discovery, surprise and realization in which inner thoughts and ideas become transformed into some kind of discernible expression. Once 'out there', this expression can be scrutinized and, perhaps, modified. Such filtering, focussing and clarifying can be an important part of creative development. Similarly, reflecting on a created work may lead to new thoughts and ideas that may prompt further explorations. Hence, there is a two-way exchange – inner informs outer and outer informs inner. At its best, however, the creative process is one where inner and outer are indivisible.

Skill and experience may be important ingredients, but neither is sufficient to guarantee creativity. While creative expression often depends on skill, skilful expression is not necessarily creative. Nor is creativity a function of systematic practice or a structured approach – many original and innovative works result from serendipity, circumstance and improvisation.

When the creative process really 'works' and one is focussed, progressing in a natural, intuitive and spontaneous manner and in a state of flow – keeping things open, flexible and experimental, entirely absorbed in the moment and unaware of time or external diversions – the process has something akin to the spiritual about it, and often this will be sensed in the outcome.

One of the most creative and original jazz albums ever recorded, *Kind of Blue*,[1] emerged from two studio sessions where there was no prewritten music, no practice in advance and where no run-throughs were conducted at the time. The recordings we hear are the first complete unrehearsed performances of each track. As a consequence, the album possesses a rare quality of spontaneity and freshness.[2] But the creativity evident in this record did not appear out of nowhere, it had deep roots.[3] Composer Quincy Jones explains that the *Kind of Blue* musicians were *"pulling an incredible history with them"*[4] and Kahn sees it as *"a recapitulation of almost every step of the jazz tradition that preceded it"*.[5] Rather than ignoring or disdaining what went before, the

musicians respected their heritage, built on it and took jazz forward through evolutionary rather than revolutionary change.[6]

Kind of Blue was made in 1959 at the 30th Street Studios in New York by trumpeter and ensemble leader Miles Davis and six other highly skilled instrumentalists: John Coltrane on tenor saxophone; Julian 'Cannonball' Adderley on alto saxophone; pianists Bill Evans and Wynton Kelly; bassist Paul Chambers; and drummer Jimmy Cobb. It is an album that is admired for its originality and for taking jazz forward from the predominant bebop style of the 1940s and '50s[7] into new areas of 'modal' jazz, where a background tune was accompanied by a melody played over one or two scales by soloists.

For some time prior to the recording, Davis had been thinking about new directions. A year before the studio sessions, he had given Bill Evans some brief notes and asked him to explore ideas around 'G minor' and 'A augmented'. At the recording sessions themselves, Davis and Evans played around with a few compositional ideas, which provided the outlines for the other musicians. Jimmy Cobb recalled that, instead of using musical scores, there were just conversations.[8] Overall direction was given by Davis, who talked with the others about the kind of sound he wanted from them. Significantly, the first take was very important to Davis – to record the spontaneous improvisation of the players.[9]

Kind of Blue has been called a timeless masterpiece[10] and this notion of timelessness has strong connections with spirituality, which is often understood as being beyond or outside time. Many people have attributed spiritual qualities to this album. Nisenson has said that while it may be difficult to call a record by Miles Davis spiritual, because Davis – at least on the surface – appeared to spurn religion, *"Miles understood spirituality to mean something very different from religion, and it is spirituality that claimed his belief. He said … 'Music is about the spirit and the spiritual'".*[11] Kahn tells us that it has been praised for its *"subtlety, simplicity and emotional depth".*[12] He suggests that *Kind of Blue* is a perfect integration of the emotional and the analytical, the yin and the yang. This, he says, accounts for both its timelessness and the strong emotional effect it can have on the listener – an effect the Japanese call *shibui*, which can be understood as deep appreciation.[13] Spencer says, *"the music has something to do with the spiritual realm"*[14] and he attributes this to the act of manifestation – the performance. Davis *"contested the Western concept of music*

as being first and foremost that which is notated. Rather, he believed that performance made music an entity".[15] Moreover, this could not be predetermined, it emerged through the process itself – a process that was built on improvisation and it was this, in Davis' view, that allowed the music to exude spirituality; a quality that cannot be captured in rigid, fixed notation.[16]

The fact that *Kind of Blue* is talked about in these terms highlights the connection between creativity, spirituality and improvisation. Here was a process that enabled a spontaneous, intuitive, improvisational way of working, where the music unfolded in a manner that was entirely in the moment, in the presence of 'now', where there was no division between inner and outer, spiritual and physical. It was this process, unconstrained by predetermined objectives or expectations, that blossomed into a creative expression that strongly resonates with the spiritual sensibility.

This connection between creativity and spirituality is not confined to music. The Russian painter Wassily Kandinsky maintained that for artistic expression to be about reality it should not be concerned with the outer, physical world but with the inner world as expressed through the intuitive process; it was here that the spiritual was to be found.[17] He advised people to open their eyes to painting and their ears to music, but not to think, and then to ask themselves if the work has transported them to a previously unknown world.[18] And Thomas Mann speaks of *"that element of sparkling and joyful improvisation, that quality which surpasses any intellectual substance"*.[19]

If our creative endeavours are to be both meaningful and enduring, then we should pay special attention to these important process-related characteristics – the absence of a fixed procedure, the lack of predetermined outcomes, the sense of spontaneity, and the prominence of improvisation. These are the characteristics of the creative process that allow the outcomes to resonate with our spiritual selves. However, many of our current ways of working in the arts preclude such characteristics from the very beginning. This is especially true in many of the applied arts such as product design, where production quantities are high, economic risks are significant and market research and manufacturing processes demand meticulous preplanning, costing and risk aversion.

Progressive Design Praxis

Design can be understood as a discipline that seeks to improve the existing condition by synthesizing practical needs with human values. However, a form of design that is truly capable of offering improvement and benefit – as typically claimed by designers – demands careful consideration of the ideas and values that inform design judgements. And here, it is important to recognize that these judgements cannot be sufficiently informed by deductive and/or inductive methods. There is also a need for interpretation and imagination, both of which are fundamental to creative activities. Moreover, and as discussed in Ch.73, values-based judgements need to be grounded in a culture's philosophical and spiritual traditions because these traditions typically prioritize concern for others rather than self, and inner benefits rather than wealth and possessions.

In this concluding chapter, I begin by considering values in the context of modern society and how they influence our attempts to address the social good and the environmental crisis. Importantly, when our activities lead to outcomes that are divisive or that exacerbate existing problems, which often seems to be the case, it becomes necessary to challenge our assumptions and our values. This is an important step in developing a different approach, one capable of balancing the opportunities offered by techno-scientific innovation with the wisdom contained in our philosophical and spiritual traditions. Attaining such a balance can lead to an outlook in which concern for others and the natural environment plays a far more prominent role and we develop more meaningful and lasting ideas of 'improvement'.

These concerns are made relevant to the designer through the articulation of an interpretive, imaginative process that combines practical needs with enduring human values. Based on a hermeneutical circle of interpretation and the writings of Gadamer, among others, this approach integrates multiple considerations within a simultaneous act of interpretation, understanding

and imaginative application. I refer to this values-based process that strives towards virtue as *Progressive Design Praxis.*

A QUESTION OF VALUES

To delineate the potential role of designers in contributing to positive, meaningful change, it will be useful to briefly review some of the most prominent values and priorities evident in modern society.

Human development from the mid-18th century to the present is characterized by major developments in science, industry, urbanization and secularization. This period of human history has emphasized philosophical materialism, individualism and, especially since the early 20th century, an economic system based on consumption and growth.[1,2] Fuelled to a large extent by the advent of mass production and corporate marketing, it has been a period in which there has been a major expansion in the acquisition of material goods. This includes 'positional products', which are promoted by emphasizing self-enhancement values.[3,4,5] These developments are closely associated with the emergence of unsustainable ways of living. They are also related to the so-called disenchantment of the world and an erosion in our sense of meaning and significance.[6,7] Additionally, since the deregulation of the markets in the 1980s and the rise of neoliberalism,[8] economic inequity and social disparity have increased not only between rich and poor countries but also within those richer countries that have well-developed consumption-based economies.[9]

This trajectory is fundamentally tied to current debates about public sector services and the common good, environmental destruction and sustainability. Emphasis on individualism and egocentric values has a negative effect on our concern both for the welfare of others and for the natural environment.[10] Moreover, the worldview that has arisen during the modern period has eroded the relevance and contribution of those traditional routes to meaning-seeking and virtue that emphasized compassion and care for others and the importance of moderation; values that are far more attuned to the principles and priorities of sustainability.[11] Here, it is worth noting that contemporary understandings of sustainability are not restricted to environmental factors but embrace social concerns as well as issues related to the individual, such as personal fulfilment and spiritual well-being.[12,13]

EFFECT	DESCRIPTION
Perpetuation of Consumerism	It maintains the technological optimism and consumption-based models of economic growth associated with unsustainability and perpetuates trajectories that require neither net reductions in resource use nor critique of the social character of consumer products.[14]
Values that Conflict with Sustainability	Its technology-based solutions are promoted in terms of benefits to individuals, reinforcing self-enhancement values. For change to sustainable living, 'beyond self' values must become prominent.[15,16]
Blurring of Knowledge, Understanding & Instrumentalism	Acquisition of scientific knowledge is conflated with resource exploitation for human use. For example, a recent four-year, 10 M€ project funded by the European Commission to explore the North Atlantic specifically aims to not just strengthen the knowledge base of the area but also to improve innovation and industrial application and to sustainably exploit the ecosystems of the Atlantic.[17]
Perpetuation of Growth in Resource Use, Energy Use and Waste	It leads to production of more consumer products, which may be solar- or wind-powered, more efficient, more recyclable etc. But despite any incremental benefits such products may offer, their development and promotion maintains a growth-based economy that is heavily dependent on expanding markets, resource extraction, energy use and waste. Better efficiencies in energy- and materials-use may slow, but do not fundamentally change, this direction.
Top-down Solutions	Mass-produced, technological products and product-based services tend to be top-down solutions and lack sensitivity to people's needs and preferences at the local level (see below).
Limited Conceptual Vision	It is flawed by its limited conceptual vision, which suffers from the conceit that sustainability can be achieved while maintaining our current consumer lifestyles and material expectations; i.e. those lifestyles and expectations that actually contributed to the rise of 'sustainability' concerns in the first place.
Failure of the Imagination	Sustainable 'solutions' that centre on technological products are symptomatic of a philosophical outlook and a culture preoccupied with technological advancement and innovation, where nature is seen in terms of resources. The UK Government puts it this way, *"Environmental assets … provide benefits that enhance economic performance"*.[18] This mindset is exemplified by ill-conceived eco-city projects like Masdar, Dongtan and Huangbaiyu. Here, investors, master planners and architects, typically from the UK or US, take it upon themselves to design and build entire cities from scratch. However, lack of knowledge about local cultural and environmental conditions means these projects have ended in failure time and again. They are beset by problems because, conceptually, they are naïve. They reveal an inordinate faith in technological solutions and an unsophisticated view of reality, including: • a failure to consult with local people[19] • a failure to understand local conditions[20] • a failure to anticipate that conditions change over time[21] • a failure to comply with local government policy[22] • a failure to recognize the complexity involved[23] • a failure of the imagination.[24] As Geiger, co-founder and director of Masdar, says, *"At the beginning of the project, nobody really anticipated how difficult it is to build a city"*.[25]

TABLE 1: The inadequacies of eco-modernist, technological routes to sustainability

Misguided design for the environment: As might be expected, these developments are affecting the ways in which our approaches to the environmental crisis are being tackled. Perhaps the most prominent route is based on the production and implementation of innovative, technological solutions. Known as eco-modernism, this approach is incremental, pragmatic and fits smoothly into our current system. Corporations and politicians tend to be enthusiastic about it because it supports rather than challenges the current system. However, its potential to contribute to significant and lasting change is limited and it can be counter-productive, for the reasons indicated in Table 1.

In many ways, design and perhaps especially industrial design – that is, product design for mass production together with associated services – has been an integral part of these developments, along with transport design, architecture and urban planning. Much of the problem in the way many product designers have been tackling sustainability has to do with the values that have been fostered within the profession, which are closely tied to the values of consumer society in general. The Industrial Designer's Society of America describes the discipline as being concerned with designing products and services that *"optimize function, value and appearance"* and provide improvements that *"benefit"* manufacturers and users.[26] Notably, no basis is offered for judging what is meant by optimizing or benefiting. Another description suggests that design is concerned with *"the definition of the physical form of the product to best meet customer needs".*[27] Computer scientist Herbert Simon suggests that, *"Everyone designs who devises courses of action aimed at changing existing situations into preferred ones".*[28] Again, neither of these descriptions offer any basis for judging 'best' or 'preferred'. The World Design Organization claims that design can *"create a better world"* and defines industrial design as *"a strategic problem-solving process that drives innovation, builds business success and leads to a better quality of life through innovative products, systems, services and experiences".*[29] This, of course, takes for granted that *"driving innovation"* and *"innovative products, systems, services and experiences"* are all essential factors in the creation of *"a better world"* and *"a better quality of life"*. However, given the cumulative effects of such methods, this is by no means self-evident. Significantly, the implicitly favourable view ascribed to innovation, originality and optimization in these descriptions is not a

scientific fact but a value judgement – one firmly anchored in modernist philosophical principles.[30]

Today, the benefits of such directions are becoming increasingly doubtful, which behoves us to ask what basis we have for judging notions of better, preferred, improvement and optimization. The fact that the design profession's explanations take the answer for granted is problematic because doing so perpetuates the fallacious idea that ever more products, services and choices will automatically improve our lives and make us happier. These inferences are highly questionable because the directions they encourage focus exclusively on extrinsic goals and rewards. In the current context, this continued emphasis on technology, innovation and breaking new ground warrants further examination and critique. Indeed, more fundamental change is needed – change based in a deeper consideration of human values, the development of a rather different philosophical outlook, and the envisioning of lifestyles that tend towards post-consumerism. Such a direction suggests less extravagant ways of life in terms of material acquisition and greater emphasis on more enduring notions of human fulfilment, characterized by self-transcendence values and intrinsic goals and rewards.

BALANCE

To advance the discipline of design, it is necessary to develop a clearer and more thoughtful basis for understanding notions of 'betterment' and 'improvement'. To do this, we have to look beyond familiar frames of reference, especially those ways of life in which technological prowess, consumption and waste have become so prevalent. A telling line from the American contemplative Thomas Merton suggests a way forward. He says, *"The eighteenth and nineteenth centuries with their pragmatic individualism degraded and corrupted the psychological heritage of axial man".*[31] The term 'axial' here refers to the period of human history that saw the rise of the great philosophies and spiritual traditions – in China, India and the West.[32] It is a period that represents the foundations of human development, the establishment of long-enduring philosophical and spiritual traditions, and the emergence of what have proved to be time-tested practices and ethical principles. But as Merton points out, the modern period represents a break with these traditions and, in the 20th and 21st centuries, our newer 'tradition-less' lifestyles have resulted in a perilously imbalanced focus on individualism and

self-enhancement values; a focus that consumerism both fuels and reifies.[33] How different this is from the priorities of even relatively recent times, as illustrated in this description of Mr Penny's cobbler's shop in Thomas Hardy's novel *Under the Greenwood Tree*,

> *No sign was over his door; in fact – as with old banks and mercantile houses – advertising in any shape was scorned, and it would have been felt as beneath his dignity to paint up, for the benefit of strangers, the name of an establishment whose trade came solely by connection based on personal respect.*[34]

It will be useful to consider the priorities, motivations and values that prevail in other ways of life, outside Western-style consumer culture. More particularly, ways of life that have endured over prolonged periods can provide us with some clues as to the types of changes we might consider if we are to develop more balanced, less damaging ways forward.

Many traditional ways of thinking and behaving differ markedly from the modern sensibility. They tend to embody a sense of duty and responsibility not just to others in their community but also to the teachings, knowledge, wisdom and practices of their cultural predecessors. A scene in Plato's *Phaedrus* reveals this very point. The young Phaedrus asks Socrates to agree with him about the truth of a particular speech, to which Socrates replies, *"I can't go along with you, because the skilful men and women of old who have spoken and written about these matters will challenge me if I agree with you just to please you".*[35] Other examples, which include making practices, can still be found today. In Victor de Sousa's film *Uma Lulik*, which documents the building of a traditional sacred house in East Timor, one of the villagers says, *"We didn't come up with the wish to build this house. It is a wish preserved from our ancestors".*[36] In Sardinia, a woman continues the ancient practice of harvesting fibres from living sea clams, which she weaves into a golden fabric known as *byssus* or sea silk. She was taught the craft by her grandmother who had learned it from her mother, and she says her *daughter "will have to continue this tradition so humankind can benefit from it".*[37] And in the UK, a Cumbrian shepherd expresses a similar sentiment, *"Some people's lives are entirely their own creation. Mine isn't. … The flocks remain; the people change over time. Someday I will pass them on to someone else".*[38] In these various

examples we see practices that are continued not simply as a matter of individual choice. There is a sense that one has to sustain the traditions of one's forebears as a duty to one's culture, one's sense of identity, one's community, and even to humankind itself. This is quite different from the individualism and preoccupation with personal choice that so characterizes modern times.[40,41]

Of course, returning to a pre-modern era is neither possible nor desirable, and we should avoid romanticizing former and other ways of living. Nevertheless, we can learn from such practices and the enduring values they hold dear in order to see our current approaches within a large frame of reference and to help us develop a different, hopefully more balanced outlook; one that brings together some of the positive values and attributes of traditional approaches with the opportunities presented by our modern technological capabilities. By considering other kinds of practices we may be able to recognize and perhaps relearn some of the important understandings, wisdoms and responsibilities that may have jettisoned too readily in our eagerness to build a technological, labour-saving future. As Scheffler has said, traditions are *"human practices whose organizing purpose is to preserve what is valued beyond the lifespan of any single individual or generation. They are collaborative, multigenerational enterprises devised by human beings to satisfy the deep human impulse to preserve what is valued"*.[41] They result from generations of convention and consensus in which a 'fit' is achieved between human needs and place. There is a tone of sufficiency, waste is frowned upon and the pace of change tends to be slow. These features contrast markedly with the norms and values of contemporary innovation and production with its accelerating pace of change and inordinate levels of waste. Other considerations, especially pertinent to design, are the aesthetic nature and fundamental character of modern products. They are clinically pristine, made from complex materials, and alienating. To the average person, they are incomprehensible and unrepairable – there is no clue to their provenance, no point of entry and no opportunity for understanding or dialogue.[42]

BEYOND INSTRUMENTAL REASON

Our long-standing philosophical and spiritual traditions are repositories of accumulated human knowledge and wisdom. They are often very ancient, their meanings are multi-layered and, because they are primarily metaphysical

in nature and are concerned with values, spirituality and behaviour, we cannot apply the essentially values-free methods used in the natural sciences; to do so is to fail to grasp their nature.[43] We make a great error if we attempt to read traditional texts as if they were imparting the kinds of explanatory knowledge about the world that science provides. As Cottingham tells us, such texts should *"primarily be understood in the context of our urgent need to change our lives"*.[44] Heidegger distinguishes between scientific ways of knowing, which are concerned with prediction and control, and human and social knowing.[45] The natural sciences aim to objectify experience and, when the human sciences apply the historical-critical method as a way of analyzing traditional philosophical-spiritual texts, they are attempting to do the same thing. Both are seeking repeatability of experiences but, according to Gadamer, applying such methods in the human sciences is inappropriate because they take no account of the historical authenticity of human experience; i.e. that in its quality or character it is historically situated.[46] Here, the term 'experience' does not refer simply to the experience of an individual, but to the accumulated heritage of experience of a particular culture and, more generally, of humanity. This recognition of the wisdom and contribution of those who came before us is, for instance, incorporated into the teachings of the Catholic Church.[47] It is for this very reason that Shortt argues that the spiritual tradition of the West, i.e. the Judeo-Christian tradition that is, itself, informed by Greek philosophy, offers a richer account of the human subject than that offered by secular modernity.[48] These traditions helped forge the ethical foundations of the West, and in many ways their teachings are not dissimilar to those of the other great philosophical and spiritual traditions of the world, which for millennia have collectively provided the bedrock for human behaviour, ethics and ideas about virtue and ultimate meaning.[49] In modern times, however, Western society's prioritization of scientific and economic rationalism has *"left humanity undeveloped in emotion, aesthetic ability, sentiment, and spirituality"*.[50] Over the last hundred years or so, the Western spiritual tradition and its teachings have increasingly become ostracized, disdained and, in many spheres, all but irrelevant. Ethical understandings grounded in spiritual tradition are no longer accredited constituents of political or corporate discourse; indeed, the European Union has emphatically excluded references to its Judeo-Christian heritage in its draft constitution and its subsequent declarations.[51,52] But without this or some other generally agreed

ethical underpinning, the moral expectations and ideas of right action in society remain nebulous and prone to neglect. When this occurs, there is the danger of a 'slippery slope' descent not only towards moral relativism but also towards a climate that lacks any higher vision of virtue and significance. Here I am referring to a notion of human purpose capable of offering a more profound sense of meaning than that presented by contemporary neoliberal democracies, with their predominantly instrumental focus on material comforts and extrinsic rewards. Without some firmer foundation, actions that may seem attractive or expedient in the short term may contribute, in the long term, to mounting social injustices and economic divisions, and ever more serious levels of environmental degradation. Indeed, the lack of such a foundation is regarded by some as a major deficiency in contemporary society. Merton was vehement in his criticism. Considering the teaching of early desert contemplatives, he said they *"distilled for themselves a very practical and unassuming wisdom that is at once primitive and timeless, and which enables us to reopen the sources that have been polluted or blocked up altogether by the accumulated mental and spiritual refuse of our technological barbarism"*.[53] While many might disagree with this view, there is clear evidence that current approaches are resulting in:

- major environmental calamities;[54]
- growing socio-economic disparities within the economically developed nations and between nations; and
- immoral and illegal practices among many of our institutions that were once regarded as pillars of society (see Table 2).

SECTOR	EXAMPLES OF ILLEGAL, IMMORAL OR REPREHENSIBLE PRACTICES
Government	- Numerous UK Members of Parliament found guilty of abusing parliamentary expenses rules to supplement their income.[55]
Banking	- Banks manipulated interest rates for profit through illegal practices that came to be known as the Libor Scandal.[56]
Church	- Revelations of widespread child abuse among priests in the Catholic Church – in USA, Europe and Australia.[57]
Immigration	- A property management company in Cardiff, UK required asylum seekers at one of their residences to wear red wristbands, as a condition for receiving food.[58,59] - In Middlesborough, UK front doors of houses used by asylum seekers were painted red, resulting in residents being targets of abuse and attacks.[60] - In Denmark, MPs approved plan to confiscate money and valuables exceeding $1,450 of asylum seekers.[61] - In USA, a candidate running for President called for Muslims to be barred from entering the country.[62]
Sports	- Doping scandals in cycling.[63] - Doping, extortion and corruption in international athletics.[64] - Bribery in international football.[65] - Match-fixing in cricket.[66] - Match-fixing in tennis.[67] - Cheating in American football.[68]
Media	- Child abuse by well-regarded public figures in British broadcast media.[69]
Industry: Resources	- The Niger Delta has produced billions of dollars in profits for multi-national oil corporations and for governments who have ignored the well-being of their own people. The region has been left environmentally devastated and traditional livelihoods have been shattered.[70]
Industry: Design and Manufacturing	- A German car manufacturer fitted 'defeat devices' to their diesel cars so it would appear that emissions were lower than was actually the case.[71] - Forced labour and child labour in electronics factories.[72,73]

TABLE 2: Illegal, immoral or reprehensible practices among prominent institutions

In a variety of ways, our current prioritization of consumerism goes against traditional beliefs about what constitutes a meaningful life. Through the ages, these have taught the importance of material simplicity and of putting our energies elsewhere. The Renaissance humanist Thomas More asked *"how any should value himself because his cloth is made of a finer thread"* and *"whether any outward thing can be called truly good"*.[74] He advocated the

importance of virtue, conscience and self-transcendence values, saying *"we should consider ourselves as bound by the ties of good-nature and humanity to use our utmost endeavours to help forward the happiness of all other persons"*.[75] Critically, as Smith has said, these directions are not about 'giving things up' per se. They are concerned with *"renunciation and replacement ... You are giving up something physical in order to access something spiritual. You are giving up something that is superfluous in order to access something necessary"*.[76]

The deductive and/or inductive reasoning methods of science are inappropriate here because these deeper ways of knowing incorporate values, beliefs and notions of meaning-seeking and meaning-making. More suitable approaches involve interpretative methods. When dealing with texts, and especially traditional spiritual texts, hermeneutical methods are used; these methods will be discussed further because they are also relevant to design. At this point, it is worth noting that 'traditions' do not simply preserve conventions, beliefs and practices in aspic; the aim is not to keep everything as it is. To remain relevant, traditions have to be continually adapted to meet the needs of the present; if they fail to do this, they tend to disappear. The current context can never be ignored because this is where traditions are enacted and where their truths and benefits are realized. Hence, it is inappropriate to think of tradition as simply 'harking back' to former times. Flourishing traditions are continually re-interpreted, continually 'made new'.

SELF-TRANSCENDENCE VALUES

In contrast to the self-enhancement values encouraged by consumer capitalism, which emphasize social status, wealth and personal image, self-transcendence values include:

- **universalism** – understanding and care of others and the natural world, equality, justice and wisdom;
- **benevolence** – concern and care for those we routinely encounter, including love, loyalty and forgiveness;
- **tradition** – commitment to and respect for customs and cultural or religious ideas, including moderation, detachment and humility;
- **security** – safety, stability and harmony in society, relationships and self, including a sense of belonging and reciprocity.[77]

As we shall see, the enactment of these 'beyond self' values is crucially important, not just for tackling sustainability but also because they can give our lives a sense of purpose and an enhanced sense of fulfilment.

Culture: Clearly, the values we live by will affect our actions in the world and contribute – for good or ill – to our cultural milieu. Barnwell suggests that culture is a reflection of shared values and meanings; it makes us who we are, moulding our patterns of thought and influencing our preferences and social norms.[78] For T. S. Eliot, culture was always more than we are conscious of because it constitutes the unnoticed background of our lives.[79] To some degree it is habit, but it is also reflective of what we are capable of and what we live for, including relationships, kinship and kindness; community and a sense of place; emotional and intellectual fulfilment; and a sense of ultimate purpose or meaning.[80] These two concepts – unconscious background and reflective existence – coexist while also being contradictory. Scruton distinguishes between them, calling the first common culture and the second high culture. He suggests that common culture can be understood as the *"defining essence of a nation"*, expressed in terms of its customs, practices and beliefs, whereas high culture is a product of individual growth, something that has to be cultivated, and it *"contains knowledge which is far more significant than anything that can be absorbed from the channels of popular communication"*.[81] At the heart of common culture are community, belonging, notions of the sacred and religion. These are vital aspects of human purpose, values, right behaviour and ethical vision[82] and it is these very factors that are strongly related to our notions of making the world a better place and our sense of personal well-being.[83] Indeed, recent studies demonstrate that attention to spiritual aspects of life, for example through religious service attendance, has a beneficial effect on health and well-being.[84]

These understandings of culture include allusions to ultimate meaning and to what life is about in terms of individual purpose and flourishing. There can be little doubt that it is these non-materialistic, spiritual aspects of our lives that have suffered most in modern times, due both to the demise of religion and the absence of any suitably elevating alternative. The reasons for this state of affairs are various but the result is that some of humanity's most profound paths to meaning have become culturally diminished and annexed

to the private realm. Consequently, for many, their role in creating a common sense of culture has become all but irrelevant.[85]

Whether through religion or other paths, we strive to make sense of the world with respect to our own lives and we interpret the things around us in ways that are in keeping with our level of understanding. Examining and analyzing the world from a scientific perspective, while important, can never provide us with answers to these deeper questions of meaning and value. In the West especially, while traditional religious avenues to meaning may have declined, other avenues still exist – such as the making of art and music, writing stories and creating rituals and routines.[86] These paths, however, are often more individualistic and therefore lack the shared themes, values and acts of communal ritual and fellowship found in religion. The vacuum thus created has been filled to a large extent by consumerism – the ground of shared meanings and purpose being commandeered by private agencies and vested interests. As a result, we are invited to look for meaning in entirely extrinsic goals and rewards, by purchasing material possessions and experiences. And through the psychological manoeuvrings of savvy marketing teams and the pervasive power of advertising we become preoccupied with trivia – endless newness in the form of brands, logos and product permutations.

In some ways, art has come to fill the void, with the contemporary gallery taking on the role once provided by religion. But instead of venerating the unknowable mystery of existence, we venerate the earthly gods of modern art. We speak in hushed tones and respectfully stand and stare – looking for something we cannot fully grasp. Just past the visible surface we look for depth. But even here the economic exigencies of modern society press in on us. Rather than lingering to appreciate art for its inspirational presence and intrinsic rewards, we are shuffled through to the final culminating ritual. As with religion, our visit ends with an act of communion – not the sacramental meal of bread and wine but, predictably, in an individualized, atomizing act of common consumption in the gallery shop – art's transcendence reduced to a fridge magnet (Figure 2).

FIGURE 2: Art's transcendence reduced to a fridge magnet

Despite the corrosive effects of economic instrumentalism entering virtually all walks of life, we can interpret the word 'culture' as referring broadly to human ideals that provide a foundation for mutual understanding and common purpose.[87,88] Bearing this in mind, it is self-evident that concern for others, reciprocity, justice, harmony, and other self-transcendence values are vital for maintaining a vibrant, meaningful culture. Here, notions such as charity and sufficiency are especially crucial.

Charity: Charity, charitable love or *agape* as it is referred to in the Christian tradition, can be understood as a disposition of concern and care towards one's fellow human beings. This relates to our personal well-being because, according to various spiritual traditions, we find meaning and fulfilment in life by transcending egocentric motives. The 14th-century theologian and philosopher Meister Eckhart maintained that, as we progress in terms of

our spiritual development through such practices as contemplation, we are able to more effectively perform charitable works and actions that are selfless.[89] Obviously, charity also relates to social well-being because it is directly concerned with the welfare of others; this includes hospitality and refraining from judging others.[90] It can extend, too, to the welfare of other species, habitats and natural places, by regarding them as intrinsic goods, not because they have some instrumental value.[91] The philosopher and atheist Bertrand Russell wrote, *"the loneliness of the human soul is unendurable; nothing can penetrate it except the highest intensity of the sort of love that religious teachers have preached; whatever does not spring from this motive is harmful, or at best useless".*[92] Hence, the teachings to which Russell refers should never be interpreted narrowly, in an exclusivist and exclusionary manner, but always in a way that fosters tolerance, reconciliation and fellowship. These ideas represent the very opposite of self-enhancement values, which are universally rejected by the major spiritual traditions of the world.[93,94]

Sufficiency: Traditional Western philosophical and spiritual teachings advocate lifestyles of self-control and material modesty, and we can draw connections here between reducing consumption and waste and the following.

1. **Nurturing social justice and peace:** for example, in Plato's *Republic*, the pursuit of luxury, excess and unlimited wealth is linked to injustice and war;[95]
2. **Creating a fairer society:** by reducing social injustice. To refer again to Thomas More, who was writing in the early 1500s at the very cusp of modernity and whose philosophy was based in a devoutly spiritual life, he suggested that the perfect society was one of modest living where each person was provided with the necessities of food, clothing, housing, health care and education, where working hours were relatively low, and the supply of consumer goods and frivolous pleasures was limited;[96]
3. **Developing a more inspiring and meaningful vision:** instead of being preoccupied with material comforts and questions of security, which dominate late-modern Western neoliberal political debate but lack any greater vision of meaning, significance and value;[97]

4. **Reducing pollution and environmental damage:** enabled by more modest lifestyles and lower levels of consumption.

Thus, ideas about moderation and sufficiency have been taught since earliest times, not least, as a way of ensuring peace and harmony. In our current context, contemporary forms of voluntary simplicity serve to both enhance personal happiness and well-being while also contributing to sustainability.[98]

Silence: This is a vital ingredient for leading a more contemplative, spiritual life; both external silence and internal silence.[99] The pervasive noise of contemporary life – much of it directly related to increased use of technology – can be seen as a barrier to contemplation and interiority. This is another reason why restraint is needed – to create space for silence; it is through a rejection of the excess driven by desire for pleasure[100] and through silence that we progress inwardly, spiritually.[101]

A sense of common purpose, charity and sufficiency are all critical factors in building a fairer, more responsible society. In this, there is a need to recognize the spiritual side of our nature and the important role of spiritual teachings and practices, which are often communal, in cultivating such values. This would seem a necessary condition for countering the relativism and societal fragmentation of modern society, which has been fomented by commercial interests and market logic. And it is here, too, that silence, reflection and contemplation can play an important role.

INTERPRETATION – FOR A MORE BALANCED, RESTORATIVE WAY FORWARD

Self-transcendence values, spiritual well-being and questions of goodness find expression in philosophy, religion and the arts. They are often related to place and they complement and provide balance to scientific ways of understanding the world. When pursued along with scientific endeavours they enable us to address detailed questions about the way the world works while also raising broader questions about meaning and purpose and so help us find fulfilment in our endeavours.

These areas of knowledge require the use of interpretive methods, in which interpretation, understanding and application comprise one unified

process.[102] Critically, application always involves the interpreter's own situation. As Godzieba has explained, *"The truth of any text, work of art, or musical work ... [or any other creative form] ... can only be grasped when applied to the interpreter's own lived experience".*[103] The temporal aspect of this means that the timeframe of a historically situated work, practice or tradition, and the timeframe of the interpreter come together. This fusion does not eliminate the time gap but it does yield a creative mix of continuity and difference, such that we become more aware of how the past has influenced our assumptions and expectations,[104] and this can spur new imaginative directions. This is why the process requires an openness to the claims of tradition. Significantly too, the validity of any such claim is not based on it being an historical artefact but on the fact that it speaks to the present.[105] As Godzieba puts it, *"any tradition is a 'history of effects' ... and ... all understanding is a consciousness effected by history".*[106]

Through fresh understandings and applications that are relevant to people's lives in the present, traditional teachings are continually made new. Thus, because these teachings emphasize self-transcendence values, these interpretive approaches are critical to today's questions of individual purpose, social justice and environmental care and, therefore, are essential to designers who wish to address sustainability.

Hermeneutical circle: Before discussing how these interpretive approaches relate to design, we will look briefly at interpretative methods more generally. Hermeneutics refers to the interpretation of texts, speech and human actions, as well as to the study or analysis of interpretive methods. While the term was originally used to refer to the interpretation of sacred texts, it is now applied more generally. In the case of scripture, there are four basic interpretative steps:[107]

- **Literal** – the basic 'outer' or factual meaning
- **Moral** – the lessons to be learned in terms of our proper behaviour towards others
- **Allegorical** – symbolic meanings of characters, objects, or events
- **Anagogical** – spiritual meanings and lessons that take us to a higher level of spiritual understanding.

As we proceed from the literal to the moral, allegorical and anagogical meanings, the further removed we become from specific outer details of behaviour and cultural convention and the closer we get to the deeper, contemplative traditions found in all the great philosophies and spiritual systems. And here we find common values – values that may be expressed through a host of different culture-specific practices.[108] Universally, these point to self-transcendence values.

These interpretive approaches involve a hermeneutical circle of understanding that circulates between the whole and the individual parts. In the case of a text, we have to understand the meaning of the individual parts in order to understand the whole, and we have to understand the whole in order to understand the meaning of the individual parts.[109] Interpretation is advanced by revolving between the two until a 'fit' is achieved that is capable of standing up to scrutiny.

Design and interpretation: Design is a creative process that similarly employs interpretation, understanding and application in a unified, inseparable process. It is this process that enables us to transform theoretical ideas and abstract concepts into tangible design outcomes. A similar hermeneutical circle describes this process. When designing, we consider the whole and the individual parts and we keep circulating between the two, responding to the emerging design ideas that we are externalizing and shaping.[110] And if we attempt to create work that is in accord with self-transcendence values this, too, will be part of the interpretative process.

However, when engaging in such processes, we should be wary of adhering to rigid frameworks. In recent times, as design has increasingly become a subject of academic research, there has been a tendency among researchers to produce all manner of frameworks, methods, systems and toolkits. Generally, however, their use is unsuited to processes that require creativity because they are too rigid and static. Designing involves imagination, serendipity, insight, and a mutually informing process of thinking and reflecting combined with performative actions. We are constantly interpreting, gaining understanding and applying ideas within a unified, flowing progression. This is why Godzieba makes the point that we must have ways of interpreting *during* a performative action. In his case, he is referring to musical performance but the point applies equally to designing – the process

flows and flourishes when it is fluid and flexible and where the emerging work results from *"the encounter between a guiding structural form and personal freedom"*.[111] In design, the guiding structural form will be the design intention or brief as well as broader aims. What I mean here is that, because of the severe and growing social and environmental consequences of consumerism, interpretation should not be conducted with respect only to the narrowly focussed, internal requirements of the project in hand, such as functionality, materials, manufacturability and economic viability. As we have been discussing, it should also take into account those broader ethical, symbolic and spiritual considerations found in the philosophical and spiritual traditions of one's culture. When the process of designing is informed by these meaning-laden cultural facets, then difference and newness will be interlaced with continuity. This more informed, reflective process can yield meaningful design outcomes because it recognizes tradition and collective, inter-generational wisdom while also allowing for fresh interpretations and originality. This notion of continuity combined with difference is also tied to personal design style, which is not purely subjective but is, in part, based in collective assent or verification,[112] a factor that also relates to broader cultural values.

Modernity, however, including the late-modernity of today, has failed to respect tradition, continuity and humanity's long heritage of wisdom teachings. While it may have produced many benefits, especially material, technological and economic, modernity also represents a rupture with the past – a rupture that has caused, and is still causing, untold harm.

PROGRESSIVE DESIGN PRAXIS

We will now consider a kind of design practice that is consistent with these values-based themes. More specifically we will look at how *Progressive Design Praxis* can foster an approach that is better able to address critical contemporary concerns related to equity, justice and environmental care.

Praxis: This term refers to a form of practice characterized by: purposive actions based in theory, values and/or circumstance; respect for accustomed ways of doing; and a coalescing of means and ends. Hence, it recognizes inherent connections between theory and practice, and between the wise determination of ends and the means of attaining those ends.[113] In addition, it is concerned with the role of creative activities in fostering humanistic social

principles through the ethical, economic and political dimensions of life.[114] Significantly, the 'end' to which praxis aims is *not* primarily an external object or extrinsic goal or benefit. Rather, it is the intrinsic goal of striving towards excellence and virtue. This inner goal applies both to the process and the outcome of the process. Thus, there is no clear distinction between means and ends, knower and known.

Praxis is different from theory, making and using – it is a kind of practical wisdom that embodies ethical values and virtues such as justice, truthfulness and friendship, all of which are ends in themselves, not the means to some other end.[115] Summarizing this understanding, Godzieba describes praxis as *"action based on reflection that changes the situation for the better"*.[116] Furthermore, the notion of 'better' is here grounded in the traditional philosophical-spiritual teaching of Western culture. And Buchanan points out that while the term praxis is used to describe purposefulness in human activity, in Marxist theory, it can also refer to resistance against the hegemonic status quo.[117]

These understandings, which involve such notions as wisdom, betterment and resistance to a dominant, and implicitly unjust, system, distinguish praxis from more objective, scientific approaches because praxis integrates actions with values and beliefs and denotes a *"general capacity to act so that one's projects and beliefs are in harmony with the world represented through them"*.[118]

Hence, praxis refers to a form of practice in which 'doing' and 'reflecting on doing according to an internal set of values' form one integrated whole. Thus, praxis is concerned not just with our actions but also with our intentions and motivations and their relationship to virtue. Importantly, praxis is progressed by an internal standard of excellence that is guided by reflective critique and 'making relevant' well-established, time-tested philosophical and spiritual teachings about values and virtue. This contrasts starkly with the predominantly extrinsic goals promoted by the modern phenomenon of consumer capitalism.

Progressive Design Praxis: Criticizing modernity's approaches to design, Scruton argues that we should not be imposing a comprehensive vision that goes *"against the instincts and plans of ordinary people"*, to do so, he says, *"is simply to repeat the error of the modernists"*.[119] Instead, he advocates 'side-constraints', by which he means some basic rules about what is and what is

not appropriate in a particular context, and which is less top-down and controlling. Considering in particular the design and production of material goods, these understandings suggest an approach that attempts to ensure the processes and outputs

- are consistent with self-transcendence values, and are culturally sensitive, relevant and warranted – judged not simply in terms of utility or profit but also with respect to individual flourishing, social well-being and environmental care;
- adhere to a design sensibility rooted in the local through the provenance of materials, forms and modes of making. These can contribute to artefacts being repairable, adaptable and kept in use. Thus, people become accustomed to them, and products can grow old with grace and be passed on to the next generation. Accordingly, our material culture becomes less wasteful and more meaningful – because it is permitted to acquire a history and symbolic value.
- employ production methods that, where possible, are human-scale, are within or close to local housing and at a size that encourages a sense of community and familiarity. Rather than continually growing one facility, it becomes more appropriate to branch off to create another 'local' facility in another area. This allows operations to be maintained at a community level, reducing shipping and commuting, and enabling any unforeseen detrimental effects to be localized, recognized and remediated.

These kinds of basic rules or side-constraints would help ensure more responsible and thoughtful forms of design practice. Importantly, such approaches are consistent with tradition, convention and consensus while also offering opportunities for change, originality and vitality. Our material culture would be constantly evolving while also constantly remaining. And it would fit with context and the everyday needs of people rather than standing out as 'designer icons' that promote status-related feelings, self-enhancement values and selfishness. In these ways, *Progressive Design Praxis* can offer ways of designing that enable positive, long-term benefits.

The aim of such design is to change the situation for the better, where 'better' is understood in broader terms than simply focussing on the internal

requirements of a particular project. Through its embedding of cultur-
ally relevant values and notions of virtue it also takes into account people,
community and the natural environment. This kind of design is, by necessity,
more encompassing and more considered. And it is progressive in the sense of
gradual advancement and improvement.

We are now in a position to offer a succinct description of this broader,
reflective design process.

> **Progressive Design Praxis** is a form of design practice that aims to
> change the situation for the better by striving to interpret, understand
> and apply the ethical values and notions of virtue found in the philo-
> sophical and spiritual traditions of one's culture.

By inference, this is a process that resists and strives to overcome injustices
in the dominant system. Also, by adapting the four modes of the herme-
neutical process discussed earlier, we can now summarize the basic rules in a
manner more suited to design. In this case, the four modes of interpretation,
equivalent to those employed for texts, can be expressed as practical, ethical,
symbolic and spiritual, as illustrated in Figure 3.

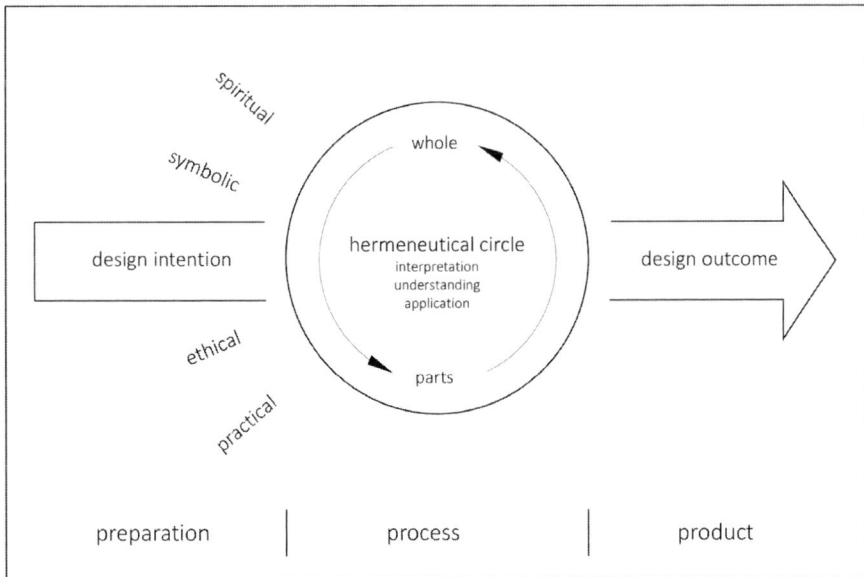

FIGURE 3: Progressive Design Praxis

Progressive Design Praxis can be understood as:

- a values-based process informed by the self-transcendence values of one's culture, which stem from its philosophical and spiritual traditions.
- a process in which the designer strives to interpret, understand and apply these enduring values in ways that are appropriate to the present situation. In doing so, account is taken of the stylistic and aesthetic values of one's own time, both to make the design relevant and because, by necessity, we interpret and understand through our own, contemporary eyes.
- a process that links reflection with action. It is thoughtful, philosophical and concerned with depth of meaning and inner progression in and through human actions. Being motivated by intrinsic goals of excellence and virtue, it is less concerned with passing trends, market-led fashions and other extrinsic objectives.
- a process that – because of its emphasis on self-transcendence values – is sensitive to sustainable principles i.e. issues of personal and social well-being, community and environmental care.[120]
- a process that recognizes the interpretive, temporal aspects of design and respects the historical basis of knowledge, enduring values and human wisdom, all of which inform and influence contemporary perspectives and understandings.

Figure 4 illustrates the relationships between Progressive Design Praxis, charity, sufficiency and critical elements of sustainability, namely personal well-being, social well-being and environmental care.

In developing design work within and for a particular culture there will be certain aspects that conform to, and others that differ from, expectations and conventions. These continuities and departures are dependent on a number of interrelated factors including the designer's experience, background and breadth of knowledge. In turn, these will affect the interpretation of design considerations and priorities. However, when these considerations and priorities include wider implications, so that we see our activities as being connected to a greater whole, then design starts to move towards a more magnanimous form of practice i.e. *Progressive Design Praxis.*

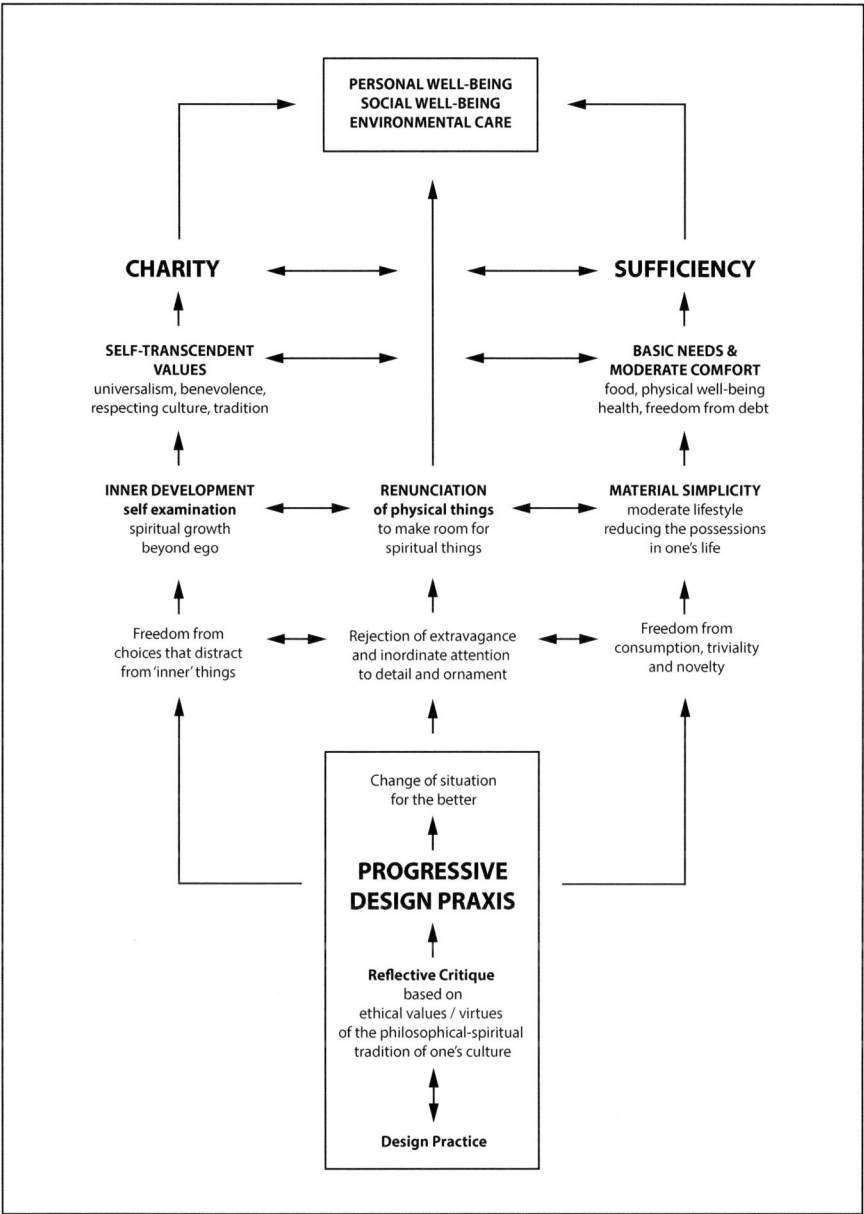

FIGURE 4: Progressive Design Praxis, Charity and Sufficiency

Importantly, its foundation in self-transcendence values is important not just for ethical decision-making, with its tendency towards mere compliance, but also for proactively making positive contributions by aspiring to 'the good' in and through our design decisions and actions. This broadens the designer's purview and demands a deeper consideration of one's actions and activities. In this process, the past is brought together and united with future possibilities in the here and now of the present – a present that is always changing, always different. And it is through this continual striving to enact and embody cultural, ethical and spiritual understandings and values that we are able to achieve meaningful human actions and meaningful design outputs.

CONCLUSIONS

The progressive, praxis-based understanding of design that has been developed in this final chapter transcends empiricist and reductionist theories of knowledge that have dominated Western thought throughout the modern period and still dominate it today. Drawing on insights offered by Blackburn,[121] *Progressive Design Praxis* has a number of distinctive qualities and characteristics. First, it recognizes the limitations of reason and its inability to solve contradictions. We can have well-founded reasoned arguments on both sides of a design issue but never reach a mutually acceptable solution because each position can rest on quite different ideological foundations; we see similar differences in other areas of life, such as politics. Second, it challenges the prominence of theory, which by definition is abstract and generalized and therefore unable to address the particularized experiences, customs and details relevant to locale. Because social norms and ways of knowing vary from one culture to another, it follows that to a greater or lesser extent praxis will be culture-dependent. This means that values-based approaches are related to cultural norms, which supports greater localization in design. Third, it raises the significance of design practice, which is always specific – i.e. concrete, tangible, not theoretical – and can be adapted to context and, *ipso facto*, is capable of addressing the particularities of place, culture and social mores. In contrast to much commercial design practice over the past century or more, which has been closely linked to human exploitation and environmental destruction, *Progressive Design Praxis* can be understood as a purposive values- and virtue-based version of design practice.

292

Clearly, then, *Progressive Design Praxis* is a form of design practice that seeks to distance itself from the destructive path of late-modern consumerism. An important element in this distancing is the restoration of the values and notions of virtue that emerge from a culture's philosophical and spiritual traditions. This, however, should not be construed as retrograde; to do so would be to misunderstand the intention and nature of praxis. Rather, *Progressive Design Praxis* is concerned with reorienting our priorities so that they are in closer accord with our full humanity – the rational and the intuitive, the logical and the emotional, facts and values. It is this balance that is needed for personal well-being, social cohesion and environmental care. *Progressive Design Praxis*, therefore, is about developing more informed, more intelligent ways forward – so that, as a society, we begin to see excess, wastefulness and inequity as socially unacceptable and those who indulge in such activities as harmful to individual well-being, community and planet.

Finally, conventional design practice in the contemporary corporate setting is, essentially, a means to a primarily commercial end. Within the same milieu, marketing and advertising constantly encourage us to fixate on personal wants. They foster discontent, fuel yearnings for more than we already have, and promise fulfilment through the satisfaction of those very material desires they have been instrumental in cultivating. A major IT company names its laptops *Envy*; kitchenware is sold under the label *Prestige*; cosmetics and perfumes are marketed under names like *Esteem*, *Eminence*, *Obsession* and *Covet*. And at the unveiling of a new luxury concept car, a company spokesperson recently said, *"the powerful have always understood the symbols through which they express their standing"*.[122] Where these messages of consumerism urge self-regard, selfishness and worldly acclaim, traditional spiritual teachings advise the opposite. They tell us that a meaningful life and personal happiness are to be found through self-discipline, and that contemplation and self-reflection help counter our tendencies to be seduced by materialistic gratification. They lead us towards virtues like humility and charity[123] and encourage sufficiency, equality, respect for tradition, forgiveness, the spiritual life, and care for the natural environment.[124] A reorientation towards these understandings and activities will be essential for realizing significant, positive change towards sustainability and for a developing a more mature, wiser notion of 'progress'.

ENDNOTES

PROLOGUE

1 Novaes, C. D. and Franklin, R. (2017) What is logic? *Aeon*, Aeon Media Group Ltd, London, 12 January 2017, available at https://aeon.co/essays/the-rise-and-fall-and-rise-of-logic, accessed 17 January 2017.

2 Storr, A. (1996) *Feet of Clay – Saints, Sinners, and Madmen: A Study of Gurus*, Free Press Paperback Edition [1997], Simon & Schuster, New York, NY, p. xiv.

CHAPTER 1: AS IT IS

1 Kim, Y. J. and Zhong C-B. (2017) Ideas rise from chaos: Information structure and creativity, *Organizational Behaviour and Human Decision Processes*, Vol. 138, pp. 15–27.

2 *Animal, Vegetable, Mineral – Organising Nature: A Picture Album* (2016) published to accompany the Wellcome Trust exhibition *Making Nature* curated by Honor Beddard, The Wellcome Trust, London, pp. 8–21.

CHAPTER 2: A COMPETITIVE STATE

1 RCI (2015) *Regional competitiveness statistics*, Eurostat, European Commission, 16 October 2015, available at http://ec.europa.eu/eurostat/statistics-explained/index.php/Regional_competitiveness_statistics, accessed 12 February 2017.

2 UK Government (2016) *'Reaching our Potential: Competitiveness in the EU' – Greece*, Report on a seminar organized by the British Embassy, in partnership with the Foundation for Economic & Industrial Research (IOBE), British Embassy Athens, updated 1 February 2016, available at https://www.gov.uk/government/world-location-news/reaching-our-potential-competitiveness-in-the-eu-greece, accessed 12 February 2017.

3 Vernon, M. (2008) *Wellbeing*, Acumen, Stocksfield, Northumberland, pp. 22–23.

4 Michaels, F. S. (2011) *Monoculture – How One Story is Changing Everything*, Red Clover Press, http://www.redcloverpress.com/, p. 39.

5 Collini, S. (2017) *Speaking of Universities*, Verso, London, p. 119.

6 Ibid., pp. 121–122.

7 Adams, R. (2017) University vice-chancellors are paid too much, says Lord Adonis, *The Guardian*, London, 13 July 2017, available at https://www.theguardian.com/education/2017/jul/13/university-vice-chancellors-are-paid-too-much-says-lord-adonis, accessed 20 August 2017.

8 Pells, R. (2017) St Olave's Grammar school 'unlawfully threw out' students who failed to get top grades, *The Independent*, London, 30 August, available at http://www.independent.co.uk/news/education/education-news/st-olaves-grammar-school-students-threw-out-unlawful-not-get-top-grades-orpington-south-london-a7919631.html, accessed 31 August 2017.

CHAPTER 3: SHARE PRICE

1 ARM chip designer to be bought by Japan's Softbank, 18 July 2016, *BBC News Online*, available at http://www.bbc.com/news/business-36822806, accessed 5 September 2016.

2 ARM founder says Softbank deal is 'sad day' for UK tech, 18 July 2016, *BBC News Online*, http://www.bbc.com/news/business-36827769, accessed 5 September 2016.

3 *Economic Advantages and Disadvantages of Foreign Takeovers, The*, New Direction Foundation, Brussels, Belgium, August 2014, available at http://europeanreform.org/files/New_Direction_-_Foreign_Takeovers.pdf, accessed 5 September 2016, p. 9.

CHAPTER 5: BRANDED

1 Buy-one-get-one-free degrees: when higher education meets discount pricing, *The Guardian*, London, Monday 8 August 2016.

2 Walt, V. (2010) Can BP Ever Rebuild Its Reputation, *Time*, Time Inc., New York, NY, 19 July 2010, available at http://content.time.com/time/business/article/0,8599,2004701-2,00.html, accessed 14 August 2017.

3 David, J. E. (2013) 'Beyond Petroleum' No More? BP Goes Back to Basics, *CNBC*, NBC Universal Group, Englewood Cliffs, NJ, 20 April 2013, available at http://www.cnbc.com/id/100647034, accessed 16 August 2016.

4 Bigelow (2015) 'Clean Diesel' leaves dirty taste for green-minded VW owners, *Autoblog*, Birmingham, MI, 20 October 2015, available at www.autoblog.com/2015/10/20/vw-owners-betrayed-clean-diesel/, accessed 6 August 2016.

5 Couglan, S. (2017) Universities to be warned over misleading adverts, *BBC News Online*, BBC, London, 10 November 2017, available at http://www.bbc.co.uk/news/education-41931610, accessed 10 November 2017.

6 Couglan, S. (2017) Six universities told to change advertising claims, *BBC News Online*, BBC, London, 15 November 2017, available at http://www.bbc.co.uk/news/education-41984465, accessed 15 November 2017.

CHAPTER 6: INVERSION

1 Russell, B. (1953) *Satan in the Suburbs and Other Stories*, Penguin Books Ltd, Harmondsworth, Middlesex.

2 Reynolds, M. (1962) *Little Boxes*, song lyrics available at http://people.wku.edu/charles.smith/MALVINA/mr094.htm, accessed 9 October 2016.

CHAPTER 7: UNBRANDED

1 Lambert, T. (n.d.) *A Brief History of Lancaster, Lancashire*, available at http://www.localhistories.org/lancaster.html, accessed 7 August 2016.

2 185,000 people use the city centre each week, *Lancaster Guardian*, Lancaster, UK, 1 August 2015, available at http://www.lancasterguardian.co.uk/news/business/185–000-people-use-the-city-centre-each-week-1-7384546, accessed 7 August 2016.

3 Seven new brands offering great quality fresh food and outstanding value, Tesco PLC, Welwyn Garden City, Hertfordshire, UK, available at http://www.tesco.com/groceries/zones/default.aspx?name=farms_brands, accessed 7 August 2016.

4 Sheffield, H. (2016) Tesco launches range of products named after farms that don't actually exist, *The Independent*, London, 24 March 2016, available at http://www.independent.co.uk/news/business/news/tesco-willow-boswell-rosedene-redmere-made-up-fictional-farms-a6949801.html, accessed 7 August 2016.

5 Boyle, D. (2013) *The Age to Come*, The Real Press Edition [2016], www.the realpress.co.uk, p. 51.

CHAPTER 9: PRESTIGE

1 *Seating* (2016) Emirates airline company, Dubai, United Arab Emirates, available at http://www.emirates.com/uk/english/flying/seating/seating.aspx, accessed 2 November 2016.

2 *Premium Economy Class Comparison Chart* (2016) Seat Guru, TripAdvisor, Needham, MA, United States, available at https://www.seatguru.com/charts/premium_economy.php, accessed 2 November 2016.

3 *Tier Benefits* (n.d.) Qantas Airways Limited, Mascot, New South Wales, Australia, available at https://www.qantas.com/fflyer/dyn/flying/tier-benefits, accessed 2 November 2016.

4 Kamo-no-Chomei (1212) *Hojoki: Visions of a Torn World*, Moriguchi, Y. and Jenkins, D. (trans.) [1996], Stone Bridge Press, Berkeley, CA, pp. 55–56.

5 Ibid., p75.

6 Feng, G. and English, J. (1989) *Tao Te Ching by Lao Tzu*, Vintage Books, New York, NY, Ch.1, 3, 5, 8 and 13.

7 Ibid., Chs 5 and 8.

CHAPTER 11: SELLERS ALL

1 Miller, A. (1949) *Death of a Salesman*, Penguin Books, London [1961].

CHAPTER 12: WASTE

1 *Apollo 13 Movie Clip – Square Peg in a Round Hole* (1995), available at https://www.youtube.com/watch?v=C2YZnTL596Q, accessed 10 August 2016.

2 *Apollo 13 Mission Commentary Transcript*, pp. 514–522, available at https://www.scribd.com/document/53152057/Apollo-13-PAO-Mission-Commentary-Transcript, accessed 10 August 2016.

3 *Apollo 13 Launch*, NASA, US Government, 2008, available at http://www.nasa.gov/multimedia/imagegallery/image_feature_305.html, accessed 10 August 2016.

CHAPTER 14: FAIR GAME

1 Ipsos-MORI (2016) Politicians are still trusted less than estate agents, journalists and bankers, *Ipsos MORI Veracity Index 2015: Trust in Professions*, Ipsos-MORI, London, 22 January 2016, available at https://www.ipsos-mori.com/researchpublications/researcharchive/3685/Politicians-are-still-trusted-less-than-estate-agents-journalists-and-bankers.aspx, accessed 12 February 2017.

2 Robinson, M. (2017) A contrarian voice: 'The Churches have disgraced themselves', *The Tablet*, London, 4 February 2017, p. 4.

CHAPTER 15: WHAT ELSE IS ON?

1 Postman, N. (1985) *Amusing Ourselves To Death: Public Discourse in the Age of Show Business*, Methuen London Ltd, London, p. 161.

2 Parrish, D. (2017) *Creative Industries*, available at http://www.davidparrish.com/creative-industries/, accessed 7 January 2017.

3 Creative Industries (2015) *UK Creative Industries – International Strategy Driving Global Growth for the UK Creative Industries*, Department for Culture, Media and Sport, UK Government, available at http://www.thecreativeindustries.co.uk/media/252528/ukti_creative_industries_action_plan_aw_rev_3-0_spreads.pdf, accessed 7 January, 2017, p. 8.

4 Jasper, D. (2014) *A Short Introduction to Hermeneutics*, Westminster John Knox Press, Louisville, KY, p. 12.

5 Scruton, R. (2000) *An Intelligent Person's Guide to Modern Culture*, St. Augustine Press, South Bend, IN, p. 102.

6 Ibid., p. 103.

7 Weir, P. (1998) *The Truman Show*, a movie by Peter Weir, screenplay by Andrew Niccol, Scott Rudin Productions, New York, NY. Last lines quotation from: American Movie Classics Company, New York, NY, available at http://www.filmsite.org/greatlastlines7.html, accessed 7 January 2017.

CHAPTER 20: LOCAL?

1 Lindner Sock Factory and Shop, Crookwell, New South Wales, Australia, available at http://www.lindnersocks.com.au/index.html, accessed 30 September 2016.

2 Seafood Company Sheds 120 Jobs, *BBC News Online*, 14 November 2006, available at http://news.bbc.co.uk/2/hi/uk_news/scotland/south_of_scotland/6146974.stm, accessed 1 October 2016.

CHAPTER 24: BECOMING HUMAN

1 RCUK (2016) Percentages based on Total Comprehensive Net Expenditure for each of the Research Council United Kingdom funding councils (AHRC; BBSRC; EPSRC; ESRC; MRC; NERC; STFC) as reported in their 2016 annual reports available at http://www.rcuk.ac.uk/media/news/160725/, accessed 3 December 2016.

2 Henley, D. (2016) *The Arts Dividend: Why Investment in Culture Pays*, Elliot and Thompson Ltd, London.

3 McMullan, T. (2016) *How a robot could be grandma's new carer*, *The Guardian*, London, 6
 November, available at https://www.theguardian.com/technology/2016/nov/06/robot-could-be-
 grandmas-new-care-assistant, accessed 3 December 2016.
4 Consequential Robots Ltd (2016) Miro, *Sheffield Robotics*, Sheffield, available at http://
 consequentialrobotics.com/miro/, accessed 3 December 2016.

CHAPTER 26: CRAFT 'N KITSCH

1 *Welsh Love Spoons* (2012) National Museum of Wales, available at https://museum.wales/
 articles/2012-09-16/Welsh-Lovespoons-1/, accessed 12 September 2016.
2 Reynolds, R. (2011) *A Bodger not a Botcher*, Potter Wright & Webb, available at http://www.
 potterwrightandwebb.co.uk/wood-2/a-bodger-is-not-a-botcher, accessed 12 September 2016.

CHAPTER 27: MODERN AND TRADITIONAL

1 Tempel, B. and Janssen, H. (2011) *Mondrian and De Stijl*, Gemeentemuseum, Den Haag.
 Exhibition details available at https://www.gemeentemuseum.nl/en/exhibitions/mondrian-de-
 stijl, accessed 15 December 2016.
2 ✓ Dormer, P. (1991) *The Meanings of Modern Design*, Thames and Hudson, London, pp. 19–20.
3 van Aken-Fehmers, M. S., Eliëns, T. M. and Lambooy, S. M. R. (2012) *Delft Wonderware*,
 Gemeentemuseum, Den Haag. Exhibition details available at https://www.gemeentemuseum.nl/
 en/exhibitions/delftware-wonderware, accessed 15 December 2016.
4 *New Delft* (n.d.) Royal Delft, Rotterdamseweg 196, 2628 AR Delft, available at http://www.
 royaldelft.com/product.asp?coll=4&cat=17, accessed 15 December 2016.

CHAPTER 28: DESIGN THINK

1 Orwell, G. (1949) *Nineteen Eighty-Four*, Penguin Books Ltd, Harmondsworth, Middlesex, p. 46.
2 Csikszentmihalyi, M. (1990) *Flow: The Psychology of Optimal Experience*, HarperPerennial, New
 York, NY, pp. 39–41.
3 Described to me during a private conversation with Professor Takeshi Sunaga, Tokyo University
 of the Arts, Tokyo, 24 October 2016.
4 Edwards, B. (2012) *Drawing on the Right Side of the Brain: The Definitive 4th Edition*, Souvenir
 Press, London, pp. 39–41.

CHAPTER 29: ENOUGH

1 The aphorism "God is in the details" may not have been created by modernist architect Mies van
 der Rohe, but he popularized its use in design, as reported in his *New York Times* obituary of 19
 August 1969 entitled 'Mies van der Rohe Dies at 83; Leader of Modern Architecture', available
 at http://www.nytimes.com/learning/general/onthisday/bday/0327.html, accessed 25 September
 2016.

CHAPTER 31: SEEING

1 For a useful and succinct account of the aesthetic attitude see King, A. (n.d.) The Aesthetic
 Attitude, *Internet Encyclopedia of Philosophy*, Fieser, J. (ed.), University of Tennessee, Martin, TN,
 available at http://www.iep.utm.edu/aesth-at/#SH4a, accessed 5 April 2017.
2 Marin, L. (2002) *On Representation*, Stanford University Press, Redwood City, CA, p. 277.
3 Kleiner, F. (2009) *Gardner's Art through the Ages: A Global History, Volume 2*, Cengage Learning,
 Stamford, CT, p. 538.
4 Marin, L. (1995) *To Destroy Painting*, University of Chicago Press, Chicago, IL, p. 101.
5 O'Neill, J. P. and Schultz, E. (eds) (1985) *The Age of Caravaggio* (Exhibition Catalogue),
 Metropolitan Museum of Art, New York, NY, p. 23.
6 Ruskin, J. (1846) Ch. XV, General Conclusions Respecting The Theoretic Faculty, Modern
 Painters Vol. II containing Part III, Section I & II, Of the Imaginative and Theoretic Faculties,
 Section I, p. 213, contained in Cook, E. T. and Wedderburn, A. (eds) (1904) *Library Edition:
 The Complete Works of John Ruskin, Vol. IV*, George Allen, London, p. 1023 of PDF version,

available at http://www.lancaster.ac.uk/depts/ruskinlib/Modern%20Painters, accessed 26 September 2014.

7 Ruskin, J. (1856) Ch. XVI, Of Modern Landscape, Modern Painters Vol. III containing Part IV Of Many Things, Section 18, p. 328, contained in Cook, E. T. and Wedderburn, A. (eds) (1904) *Library Edition: The Complete Works of John Ruskin, Vol. V*, George Allen, London, p. 1623 of PDF version, available at http://www.lancaster.ac.uk/depts/ruskinlib/Modern%20Painters, accessed 26 September 2014.

8 Ruskin, J. (1856) Ch. III, Of the Real Nature of Greatness of Style, Modern Painters Vol. III containing Part IV Of Many Things, Section 12, p. 56, contained in Cook, E. T. and Wedderburn, A. (eds) (1904) *Library Edition: The Complete Works of John Ruskin, Vol. V*, George Allen, London, p. 1339 of PDF version, available at http://www.lancaster.ac.uk/depts/ruskinlib/Modern%20Painters, accessed 26 September 2014.

9 Exhibitions in recent times have included *Caravaggio and His Followers in Rome*, National Gallery of Canada, Ottawa, 17 June to 11 September 2011, explored Caravaggio's influence on art; *Caravaggio and the Painters of the North* at the Museo Thyssen-Bornemisza, Madrid, 21 June to 18 September 2016, which focussed on Caravaggio's influence on artists of northern Europe.

10 Hibbard, H. (1983) *Caravaggio*, Westview Press, Boulder, CO., p. vii.

11 Ibid.

12 Ibid., p. 257.

13 Hughes, R. (1985) 'Caravaggio' a review of *The Age of Caravaggio* Exhibition at the Metropolitan Museum of Art, New York, original published in *Time* magazine, published in Hughes, R. (1990) *Nothing if not Critical*, Alfred A. Knopf, New York, NY, p. 35.

14 Ibid.

15 Ibid., p. 37.

16 Ibid., p. 36.

17 Ibid., p. 37.

18 Prose, F. (2005) *Caravaggio: Painter of Miracles*, HarperCollins, New York, NY, p. 146.

19 Ibid., p. 11.

20 Warwick, G. (2006) 'Introduction: Caravaggio in History', *Caravaggio: Realism, Rebellion, Reception*, G. Warwick (ed.), University of Delaware Press, Newark, DE, p. 13.

21 Ibid.

22 Ibid.

23 Portús, J. (2011) *El Prado en el Ermitage*, Museo Nacional del Prado, pp. 130–131, available at https://www.museodelprado.es/en/the-collection/art-work/agnus-dei/795b841a-ec81-4d10-bd8b-0c7a870e327b, accessed 23 October 2016.

24 Rams, D. (n.d.) *The power of good design: Dieter Rams's ideology, engrained within Vitsœ*, Vitsœ, London (founded by Niels Vitsœ and Otto Zapf in 1959 to manufacture the furniture design of Dieter Rams), available at http://www.designprinciplesftw.com/collections/ten-principles-for-good-design, accessed 11 April 2017.

25 Jeong, S-H., Kim, H., Yum, J-Y. and Hwang, Y. (2016) What type of content are smartphone users addicted to?: SNS vs. games, *Computers in Human Behaviour*, Elsevier, Amsterdam, Vol. 54, pp. 10–17.

26 Chen, H. (2015) Asia's smartphone addiction, *BBC News Online*, available at http://www.bbc.co.uk/news/world-asia-33130567, accessed 7 September 2015.

CHAPTER 32: HOW SHOULD WE LIVE?

1 Griffith, T. (trans.) (2000) *Plato: The Republic*, Ferrari, G. R. F. (ed.), Cambridge University Press, Cambridge, pp. 50–56.

2 Lee, D. (trans.) (1987) *Plato: The Republic*, Penguin Books, London, pp. 117–123.

3 Ecclesiastes 2:8–26; 6:2

4 Bartholomew, A. G. (2011) *Homiletic*, Vanderbilt Divinity School, Nashville, TN, Vol. 36, No. 1, p. 61, available at http://ejournals.library.vanderbilt.edu/index.php/homiletic/article/view/3441, accessed 28 December 2016.

5 Christianson, E. S. (2012) *Ecclesiastes through the Centuries*, Wiley-Blackwell, Chichester, UK, p141.

6 Staniforth, M. (trans.) (1964) *Marcus Aurelius: Meditations*, Penguin Books, London, pp. 35, 83, 121.

7 Kamo-no-Chomei (1212) *Hojoki: Visions of a Torn World*, Mariguchi, Y. and Jenkins, D. (trans.), Stone Bridge Press, Berkeley, CA, 1996, p. 75.

8 Thoreau, H. D. (1845) Walden, in *Walden and Civil Disobedience*, Penguin Books, London, 1983, p. 91.

9 Ibid., pp. 108–109.

10 Ibid., p. 346.

11 Ibid., pp. 48–69.

12 Ibid., p. 126.

13 Ibid., p. 135.

CHAPTER 33: MODERATION

1 Confucius, *The Doctrine of the Mean*, The Internet Classics Archive, Massachusetts Institute of Technology, available at http://classics.mit.edu/Confucius/doctmean.html, accessed 26 September 2016.

2 Sri Dhammananda, K. (1987) Chapter 5 Basic Doctrines: The Noble Eightfold Path: The Middle Way, *What Buddhists Believe*, Buddhist Missionary Society Malaysia, *Sabah* Branch, Kota Kinabalu, Malaysia, available at http://www.sinc.sunysb.edu/Clubs/buddhism/dhammananda/78.htm, accessed 27 September 2016.

3 Roebuck, V. (trans.) (2010) *The Dhammapada*, Penguin Group, London.

4 Bloom, A. (trans.) (1991) *The Republic of Plato*, 2nd Edition, Basic Books, HarperCollins Publishers, New York, NY, Book 10, Section 619a, p. 301.

5 Ross, W. D. (trans.) (2011) *The Nicomachean Ethics of Aristotle*, Pacific Publishing, Seattle, available at https://ebooks.adelaide.edu.au/a/aristotle/nicomachean/, accessed 26 September 2016, Book 2, Part 2.

6 Worms, F. (1989) The Teaching of Moderation, *The Jewish Quarterly*, Taylor and Francis, London, Vol. 36, No. 1, pp. 9–10.

7 Epistle of Paul and Timothy to the Philippians 4:5, *The New Testament*, KJV.

8 First Epistle to the Corinthians 9:25, *The New Testament*, KJV.

9 Second Epistle to the Corinthians 8:13–15, *The New Testament*, KJV.

10 Kamali, M. K. (2015) *The Middle Path of Moderation in Islam: The Quranic Principle of Wasatiyyah*, Oxford University Press, New York, pp. 1, 9, 211.

11 Goodridge, J. F. (trans.) (1959) *Piers the Ploughman*, [14th century] authorship attributed to William Langland, Penguin Group, London, [1966 edition], pp. 32, 36–37.

12 More, T. (1516) *Utopia*, Creative Commons Edition published by Planet eBook, available at http://www.planetebook.com/ebooks/Utopia.pdf, accessed 4 August 2016, p. 46.

13 Timani, H. S. (2016) Wealth and the Doctrine of *Al Fana* in the *Qur'an*, Chapter 9, (pp. 173–188) of *Poverty and Wealth in Judaism, Christianity, and Islam*, Kollar, N. R. and Shafiq, M. (eds), Palgrave Macmillan, New York, NY, p. 173.

14 Ross, A. (2016) Five die in French Alps in series of extreme sports accidents, *The Guardian*, London, 15 August 2016, available at https://www.theguardian.com/world/2016/aug/15/five-die-in-french-alps-in-series-of-extreme-sports-accidents, accessed 27 September 2016.

15 Wilkinson, R. and Pickett, K. (2009) *The Spirit Level: Why More Equal Societies Almost Always Do Better*, Allen Lane, Penguin Group, London, pp. 29, 222.

CHAPTER 36: CLOSEST TO THE DREAMING

1 Edwards, B. (1979) *Drawing on the Right Side of the Brain*, J. P. Tarcher Inc., Los Angeles, p. 55.

2 Edwards, B. (2012) *Drawing on the Right Side of the Brain: The Definitive 4th Edition*, Souvenir Press, London, pp. 65–66.

3 McGilchrist, I. (2009) *The Master and his Emissary: The Divided Brain and the Making of the Western World*, Yale University Press, New Haven, CT, pp. 389–401.

4 Edwards (2012) p. 72.

5 Yannu Muru, E. (n.d.) *The Dreaming – an information sheet*, Blue Mountains Walkabout, Sydney, Australia. Information available at www.BlueMountainsWalkabout.com, accessed 8 October 2016.

6 *Dreaming, The* (n.d.) Australian Government Website, available at http://www.australia.gov.au/about-australia/australian-story/dreaming, accessed 8 October 2016.

7 Feng, G. and English, J. (1989) *Tao Te Ching by Lao Tzu*, Vintage Books, New York, NY, Ch. 28, p. 30.

8 Ibid., Ch. 49, p. 51.

9 Ibid., Ch. 55, p. 57.

10 Gospel of Matthew, 19:14 and 11:25, *New International Version*.

11 Blake, W. (c.1803) Auguries of Innocence, in *The Selected Poems of William Blake*, Wordsworth Editions Ltd Ware, Hertfordshire, [1994], p. 137.

12 Wordsworth, W. (1798) We Are Seven, in Gill, S. (ed.) (2004) *William Wordsworth – Selected Poems*, Penguin Books Ltd, London, pp. 56–59.

CHAPTER 37: FRAGILE

1 Potter's Paw, (2002) The Nizwa Net, available at http://www.nizwa.net/heritage/wonderloop/wonderloop.html, accessed 29 September 2016.

2 Pascoe, B. (2014) *Dark Emu Black Seeds: agriculture or accident?* Magdala Books Aboriginal Corporation, Broome, Western Australia, pp. 26–27, 49.

3 Ibid., pp. 26, 43–44, 50–51.

4 *Times of Oman* (2014) Oman's Jebel Akhdar losing its green sheen as farmers migrate, 30 June 2014, available at http://timesofoman.com/article/36705/Oman/Oman's-Jebel-Akhdar-losing-its-green-sheen-as-farmers-migratedisqussion-0disqussion-0disqussion-0, accessed 28 September 2016.

CHAPTER 38: BEING ALIVE

1 Boswell, J. (1777) *The Life of Samuel Johnson, LL.D.*, Vol. 2, Charles Dilly, London, p. 160.

2 Maugham, W. S. (1919) *The Moon and Sixpence*, Vintage Books, Random House, New York, NY, p. 29.

CHAPTER 39: NATURE'S WISDOM

1 *The Restorative Power of Nature*, (2016) University of Leiden, Leiden, The Netherlands, published 18 January 2016, available at https://www.universiteitleiden.nl/en/news/2016/01/the-restorative-benefits-of-nature, accessed 16 April 2017.

2 Staats, H., Jahncke, H., Herzog, T. R. and Hartig, T. (2016) Urban Options for Psychological Restoration: Common Strategies in Everyday Situations, *PLoS ONE journal*, Cambridge, UK, Vol. 1, No. 1: e0146213, 5 January 2016, available at http://journals.plos.org/plosone/article?id=10.1371/journal.pone.0146213, accessed 16 April 2017, pp. 19–21.

3 Larson, J. and Kreitzer, M. J. (reviewers) (n.d.) *How Does Nature Impact Our Wellbeing?* Taking Charge of your Health and Wellbeing, University of Minnesota, Minneapolis, MN. This overview of recent research into the relationships between nature and human health and wellbeing is available at https://www.takingcharge.csh.umn.edu/enhance-your-wellbeing/environment/nature-and-us/how-does-nature-impact-our-wellbeing, accessed 16 April 2017.

4 White, M. P., Alcock, I., Wheeler, B. W. and Depledge, M. H. (2013) Would You Be Happier Living in a Greener Urban Area? A Fixed-Effects Analysis of Panel Data, *Psychological Science*, Sage Publications, Thousand Oaks, CA, Vol. 24, No. 6, p. 926.

5 Buchan, J. (2014) The Scot who became more Canadian than the Canadians, *The Spectator*, London, 15 February 2014, available at https://www.spectator.co.uk/2014/02/john-buchan-by-j-william-galbraith-review/, accessed 17 April 2017.

6 Buchan, J. (1941) *Sick Heart River*, Polygon (Birlinn), Edinburgh [2007], pp. 40–41.
7 Wordsworth, W. (1798) The Tables Turned, in Gill, S. (ed.) (2004) *William Wordsworth – Selected Poems*, Penguin Books Ltd, London, pp. 60–61.

CHAPTER 40: REPEATED PATTERNS

1 UNESCO International Round Table, Working Definitions (2001), Turin, Italy, 14/17 March 2001, available at http://www.unesco.org/culture/ich/en/events/international-round-table-intangible-cultural-heritage-working-definitions-00057, accessed 10 March 2017.
2 UNESCO Intangible Cultural Heritage (n.d.) *What is Intangible Cultural Heritage?*, UNESCO, available at http://www.unesco.org/culture/ich/en/what-is-intangible-heritage-00003, accessed 10 March 2017.

CHAPTER 41: PROFITS AND PEOPLE

1 Robinson, M. (2012) *When I Was a Child I Read Books*, Virago Press, London, p. 5.
2 Ruddick, G., Butler, S. and Allen, K. (2016) BHS rescue bid fails with loss of 11,000 jobs, *The Guardian*, London, 2 June 2016, available at https://www.theguardian.com/business/2016/jun/02/bhs-rescue-bid-fails-putting-11000-jobs-at-risk, accessed 11 March 2017.
3 Waugh, P. (2016) Sir Philip Green's £100m Superyacht Facing Seizure Under Plan To Help BHS Pensioners, *Huffington Post*, New York, NY, 23 November 2016, available at http://www.huffingtonpost.co.uk/entry/sir-philip-green-superyacht-seized-bhs-pensions-top-shop_uk_58348018e4b0ddedcf5b541a, accessed 11 March 2016.
4 Evans, J. (2014) What Quaker companies can teach us about well-being-at-work, *The History of Emotions Blog*, Queen Mary University London, 1 May 2014, available at https://emotionsblog.history.qmul.ac.uk/2014/05/what-quaker-companies-can-teach-us-about-well-being-at-work/, accessed 11 March 2017.
5 Cadbury Fact Sheet (n.d.) available at https://www.cadburyworld.co.uk/schoolandgroups/~/media/CadburyWorld/en/Files/Pdf/factsheet-cadbury-family, accessed 30 January 2017.
6 Dawkins, N. (2015) *History of Bournville*, Bournville's Resident Association, Bournville Village Council, 26 September 2015, available at http://bournvillevillagecouncil.org.uk/menu-pages/history-of-bournville.html, accessed 11 March 2017.
7 Weber, D. (2008) *A Visitor's Guide to Saltaire: UNESCO World Heritage Site*, Nemine Juvante (Saltaire) Publications, Bracknell, Berkshire, pp. 3, 18, 23, 24.
8 Schumacher, E. F. (1973) *Small is Beautiful: A Study of Economics as if People Mattered*, Abacus, Penguin Books, London.
9 Majurin, E. (2010) *Promising Practices: How cooperatives work for working women in Africa*, The Cooperative Facility for Africa (COOP AFRICA), International Labour Organization, March 2010, available at http://www.ilo.org/public/english/employment/ent/coop/africa/download/women_day_coop.pdf, accessed 11 March 2017.
10 ICA (2017) *International Cooperative Alliance*, Brussels, Belgium, available at http://ica.coop/, accessed 11 March 2017.
11 Gates Foundation (2017) *Bill and Melinda Gates Foundation*, available at http://www.gatesfoundation.org/, accessed 12 March 2017.
12 Mathiesen, K. (2015) What is the Bill and Melinda Gates Foundation?, *The Guardian*, London, 16 March 2015, available at https://www.theguardian.com/environment/2015/mar/16/what-is-the-bill-and-melinda-gates-foundation, accessed 12 March 2017.
13 Morgan, T. C. (2015) Melinda Gates: 'I'm Living Out My Faith in Action', *Christianity Today*, Christianity Today International, Carol Stream, IL, 28 July 2015, available at http://www.christianitytoday.com/ct/2015/july-august/melinda-gates-high-price-of-faith-action.html?start=1, accessed 12 March 2017.

CHAPTER 42: RETURN TO SYROS

1 Agriantoni, C. and Fenerli, A. (2010) *Ermoupoli – Syros, A historical tour*, Olkos, Athens, 2nd Edition, p. 22.

2 Ibid., pp. 17, 21.

3 Rieu, E. V. (trans.) (1946) *Homer: The Odyssey*, Penguin Books, London, Book I, Line 182, p. 30.

4 Agriantoni and Fenerli (2010), p. 15.

CHAPTER 44: ATOMIZATION

1 Rodionova, Z. (2016) UK pubs closing at a rate of 27 a week, Camra says, *The Independent*, London, Thursday, 4 February 2016, available at http://www.independent.co.uk/news/business/news/uk-pubs-closing-at-a-rate-of-27-a-week-camra-says-a6853686.html, accessed 23 August 2016.

2 Solana, J. (1920) Painting: *La tertulia del Café de Pombo* (The Gathering at the Café de Pombo) by artist José Gutiérrez Solana (1886–1945), painted in Madrid, Spain, 1920, Reina Sofia Museum, Madrid. Further information is available at http://www.museoreinasofia.es/en/collection/artwork/tertulia-cafe-pombo-gathering-cafe-pombo, accessed 23 August 2016.

CHAPTER 47: CHANGE

1 Robinson, M. (2012) *When I Was a Child I Read Books*, Virago, London, p16.

CHAPTER 49: NEW

1 Ecclesiastes 1:9

2 Gospel of Matthew, 6:21.

CHAPTER 52: RESURRECTION

1 Morris, C. (2016) Vinyl Record Sales are at a 28-Year High, *Fortune.com*, Time Inc., New York, NY, 6 April 2016, available at http://fortune.com/2016/04/16/vinyl-sales-record-store-day/, accessed 11 December 2016.

2 O'Connor, R. (2016) Vinyl album sales out-perform digital downloads for first time, *The Independent*, London, 6 December 2016, available at http://www.independent.co.uk/arts-entertainment/music/news/vinyl-sales-digital-downloads-albums-record-store-day-a7458841.html, accessed 11 December 2016.

3 Ellis-Peterson, H. (2016) Tables turned as vinyl sales overtake digital sales for first time in UK, *The Guardian*, London, 6 December 2016, available at https://www.theguardian.com/music/2016/dec/06/tables-turned-as-vinyl-records-outsell-digital-in-uk-for-first-time, accessed 11 December 2016.

4 Mellor, A. (2016) The return of the LP – what lies behind the renewed appeal of vinyl?, *Gramophone*, London, 30 June 2016, available at http://www.gramophone.co.uk/feature/the-return-of-the-lp-what-lies-behind-the-renewed-appeal-of-vinyl, accessed 11 December 2016.

CHAPTER 54: THE HUMAN TOUCH

1 Dostoyevsky, F. (1866) *Crime and Punishment*, Constance Garnett (trans.), Wordsworth Editions Ltd, [2000], Ware, Hertfordshire, p. 3.

2 Ibid., pp. 458–459.

3 Akunin, B. (2016) Speaking about *Crime and Punishment* on *World Book Club*, World Service, British Broadcasting Corporations, London, broadcast 03:06 hrs, 6 November, 2016.

4 Stern, N. (2006) *Stern Review: Economics of Climate Change*, H. M. Treasury, London, available at http://webarchive.nationalarchives.gov.uk/20080910140413/http://www.hm-treasury.gov.uk/independent_reviews/stern_review_economics_climate_change/stern_review_report.cfm, accessed 6 November 2016.

5 McKie, R. (2016) Nicholas Stern: cost of global warming 'is worse than I feared', *The Guardian*, London, 6 November 2016, available at https://www.theguardian.com/environment/2016/nov/06/nicholas-stern-climate-change-review-10-years-on-interview-decisive-years-humanity, accessed 6 November 2016.

6 Le Quéré, C., Andrew, R. M., Canadell, J. G., Sitch, S., Korsbakken, J. I., Peters, G. P., Manning, A. C., Boden6, T. A., Tans, P. P., Houghton, R. A., Keeling, R. F., Alin, S., Andrews,

O. D., Anthoni, P., Barbero, L., Bopp, L., Chevallier, F., Chini, L. P., Ciais, P., Currie, K., Delire, C., Doney, S. C., Friedlingstein, P., Gkritzalis, T., Harris, I., Hauck, J., Haverd, V., Hoppema, M., Goldewijk, K. K., Jain, A. K., Kato, E., Körtzinger, A., Landschützer, P., Lefèvre, N., Lenton, A., Lienert, S., Lombardozzi, D., Melton, J. R., Metzl, N., Millero, F., Monteiro, P. M. S., Munro, D. R., Nabel, J. E. M. S., Nakaoka, S., O'Brien, K., Olsen, A., Omar, A. M., Ono, T., Pierrot, D., Poulter, B., Rödenbeck, C., Salisbury, J., Schuster, U., Schwinger, J., Séférian, R., Skjelvan, I., Stocker, B. D., Sutton, A. J., Takahashi, T., Tian, H., Tilbrook, B., van der Laan-Luijkx, I. T., van der Werf, G. R., Viovy, N., Walker, A. P., Wiltshire, A. J., Zaehle, S. (2016) 'Global Carbon Budget 2016', *Earth System Science Data: The Data Publishing Journal*, Copernicus Publications, Göttingen, Germany, Vol. 8, pp. 607–608, 635, available at http://www.earth-syst-sci-data.net/8/605/2016/essd-8-605-2016.pdf, accessed 14 November 2016.

CHAPTER 55: PERSPECTIVE

1 Kirosawa, A. (1990) The Village of the Watermills, section 8 of the movie *Dreams*, 119 minutes, Japan, Distributed by Warner Brothers.

2 Longley, C. (2016) Meritocracy is ultimately a flawed project, *The Tablet*, London, 15 October 2016, p. 9.

3 Cottingham, J. (2016) Analytic Philosophy and Religious Knowledge, *Catholic Comments*, a podcast, Center for Catholic Thought, Creighton University, Omaha, NE, available at http://cucatholicctr.org/2016/09/analytic-philosophy-and-religious-knowledge/, accessed 22 October 2016.

CHAPTER 56: ART

1 Jiminéz-Blanco, M. D. (ed.) (2016) Romanesque Painting, *The Prado Guide*, 16th Edition, p. 24.

2 Gorky, Arshile (1948) *Last Painting (The Black Monk)*, Oil on canvas, 78.6 x 101.5 cm, Museo Thyssen-Bornemisza, Madrid, INV. Nr. 564 (1978.72). Image and information at http://www.museothyssen.org/en/thyssen/ficha_obra/397, accessed 23 August 2016.

3 Biography of Ashile Gorky available at http://www.theartstory.org/artist-gorky-arshile.htm, accessed 23 August 2016.

CHAPTER 58: ELEVATOR

1 Elevator photographs by Stuart Walker, taken at Ontario Elevator, Ames, Iowa, April 2017 – with thanks to Austin Stewart, Andrea Wheeler and Marwan Ghandour of Iowa State University.

CHAPTER 61: BEYOND PROTECTIONISM

1 Rhonheimer, M. (2012) Capitalism, Free Market Economy, and the Common Good: The Role of the State in the Economy, Ch. 1 in Schlag, M. and Mercado, J. A. (eds), *Free Markets and the Culture of Common Good*, Springer, New York, NY, pp. 1–3, 9–10.

2 Sachs, W. (2010) One World, *The Development Dictionary: A Guide to Knowledge as Power* Sachs, W. (ed.), 2nd Edition, Zed Books, London, pp. 112–113.

3 Ibid., p. 113.

CHAPTER 62: IP

1 Why drug prices in America are so high, *The Economist*, 12 September 2016, available at http://www.economist.com/blogs/economist-explains/2016/09/economist-explains-2?fsrc=scn/tw/te/bl/ed/, accessed 12 September 2016.

2 Kenber, W. (2016) 'Rip-off' drug firms exposed by *Times* face massive fines, *The Times*, Times Newspapers Ltd, London, Wednesday, 26 October 2016, p. 1.

3 More, T. (1516) *Utopia*, Creative Commons Edition published by Planet eBook, available at http://www.planetebook.com/ebooks/Utopia.pdf, accessed 4 August 2016, p46.

4 Griffith, T. (trans.) (2000) *Plato: The Republic*, Ferrari, G. R. F. (ed.), Cambridge University Press, Cambridge, pp. 50–56.

5 Wilkinson, R. and Pickett, K. (2009) *The Spirit Level: Why More Equal Societies Almost Always Do Better*, Allen Lane, Penguin Group, London, pp. 29, 222.

CHAPTER 63: COMMONALITY AND ORIGINALITY

1 Schmitz, M. (2017) A beautiful Church for the poor, *Catholic Herald*, London, 23 February, available at http://www.catholicherald.co.uk/issues/february-24th-2017/a-beautiful-church-for-the-poor/, accessed 28 February 2017.
2 Ibid.
3 Smith, Z. (2016) The Embassy of Cambodia, *The Penguin Book of the British Short Story Volume 2*, Hensher, P. (ed.), Penguin Books, London, p. 693.
4 Sim, S. (2007) *Manifesto for Silence: Confronting the Politics and Culture of Noise*, Edinburgh University Press, p. 50.
5 Franck, F. (1973) *The Zen of Seeing – Seeing/Drawing as meditation*, Vintage Books, New York, NY, p. xii.
6 Cain, S. (2012) *Quiet*, Penguin Books, London, p. 84.
7 Baldry, C. and Barnes, A. (2012) The open-plan academy: space, control and the undermining of professional identity, *Work Employment Society*, Sage Publications, Vol. 26, No. 2, pp. 229, 240.
8 Ballinger, L. (2016) How Dylan Thomas's writing shed inspired Roald Dahl, *BBC News*, BBC, London, 14 September 2016, available at http://www.bbc.co.uk/news/uk-wales-37342271, accessed 6 March 2016.
9 Blake, Q. (2008) Writers' rooms: Roald Dahl, *The Guardian*, London, 23 May 2008, available at https://www.theguardian.com/books/2008/may/23/writers.rooms.roald.dahl, accessed 6 March 2017.

CHAPTER 64: SECULAR SOCIETY

1 Armstrong, K. (2014) *Fields of Blood: Religion and the History of Violence*, Vintage, London, p. 2.
2 Piser, K. (2017) Why Forced Secularism in Schools Leads to Polarization, *The Atlantic*, The Atlantic Monthly Group, Boston, MA, February, available at https://www.theatlantic.com/education/archive/2017/02/why-forced-neutrality-leads-to-polarization/516222/, accessed 10 February 2017.
3 Gregg, S. (2017) Secularism, the new ancien régime, *Catholic Herald*, London, Wednesday, 1 February 2017, available at http://www.catholicherald.co.uk/issues/february-3rd-2017/secularism-the-new-ancien-regime/, accessed 5 February 2017.
4 Teahan, M. (2017) Podcast: Is secularism losing its grip on France? – an interview with Samuel Gregg, *Catholic Herald*, Friday, 3 February 2017, London, available at http://www.catholicherald.co.uk/commentandblogs/2017/02/03/podcast-is-secularism-losing-its-grip-on-france/, accessed 5 February 2017.

CHAPTER 66: MISREADING RELIGION

1 Clapping of hands is done to attract the attention of the spirits, see Davies, R. J. (2016) *Japanese Culture: The Religious and Philosophical Foundations*, Tuttle Publishing, Tokyo, pp. 40, 46.
2 Torres, H. (2016) Christians Face 'Unbearable' Situation in German Refugee Camps; Official Admits 'Underestimating Role of Religion', *Christian Today*, Christian Media Corporation, London, 19 October 2016, available at http://www.christiantoday.com/article/christians.face.unbearable.situation.in.german.refugee.camps.official.admits.underestimating.role.of.religion/98411.htm, accessed 1 November 2016.
3 Barrett, D. V. (2016) Report claims Christians are intimidated and attacked in German refugee homes, *The Catholic Herald*, London, 21 October 2016, available at http://www.catholicherald.co.uk/news/2016/10/21/report-claims-christians-are-intimidated-and-attacked-in-german-refugee-homes/, accessed 22 October 2016.
4 Armstrong, K. (2014) *Fields of Blood: Religion and the History of Violence*, Vintage, London, p. 1.
5 Keene, D. (trans.) (1967) *Essays in Idleness: The Tsurezuregusa of Kenkō*, Tuttle Publishing, Tokyo [1981], pp. 17–18.

CHAPTER 67: A STULTIFYING DUALISM

1 Steindl-Rast, D. (1977) Learning to Die, *Parabola*, Vol. 2, Issue 1, Winter, pp. 22–31, available at http://gratefulness.org/resource/learning-to-die/, accessed 10 February 2017.

2 Mishra, P. (2017) *Age of Anger*, Allen Lane, Penguin Books, London, p. 50.

3 Robinson, M. (2012) *When I Was a Child I Read Books*, Virago Press, London, pp. 12–18.

CHAPTER 68: FAITH

1 Lightman, B. (2011) Unbelief, Chapter 11, pp. 252–277, *Science and Religion Around the World*, Brook, J. H. and Numbers, R. N. (eds), Oxford University Press, New York, NY, p. 263.

2 Davis, A. (1961) Chagall at Vence, *The Guardian*, London, Thursday, 1 June, available at http://static.guim.co.uk/sys-images/Guardian/Pix/pictures/2013/5/24/1369408645374/Chagall-001.jpg, accessed 11 August 2016.

3 Colegate, I. (1980) *The Shooting Party*, Penguin Books Ltd, London, [2007], pp. 188–189.

4 Gospel of Mark 11:24, 'Therefore I tell you, whatever you ask for in prayer, believe that you have received it, and it will be yours.'

CHAPTER 70: ENCULTURATED BLINDNESS

1 In *Dark Emu Black Seeds* (2014) Magdala Books Aboriginal Corporation, Broome, Western Australia, pp. 26–27, Bruce Pascoe refers to the early 19th century journals of Scottish explorer of Australia, Thomas Livingstone Mitchell (1792–1855), where it is evident that Mitchell failed to understand that the landscape he described as having 'the appearance of an extensive park' was actually the result of generations of land management by the Aboriginal peoples.

2 See *Homer's Secret Iliad: The Epic of the Night Skies Decoded*, John Murray, London, 1999 and *Homer's Secret Odyssey*, The History Press, Stroud, Gloucester, 2011, both written by F. and K. Wood based on the research of E. Leigh.

3 Norris, R. and Norris, C. (2008) *Emu Dreaming: An Introduction to Australian Aboriginal Astronomy*, Emu Dreaming, Winston Hills, NSW.

4 Williams, A. Z. (2011) Faith no more, *The New Statesman,* London, 25 July 2011, available at http://www.newstatesman.com/religion/2011/07/god-evidence-believe-world, accessed 12 August 2016.

5 Gadamer, H. G. (1989) *Truth and Method*, Second Edition, Continuum, London [2004], p. 4.

6 Nicoll, M. (1950) *The New Man*, Penguin Books [1972], Baltimore, ML.

CHAPTER 71: A CHRISTMAS STORY

1 Vilinbakhova, T. (2000) Kazimir Malevich and the Sources of the Avant-Garde: Icon-Painting, in Cortenova, G. (ed.) *Kazimir Malevich and the Sacred Russian Icons: Avant-Garde and Traditional,* Electa Espana, Madrid. This section available at http://mostrestoriche.palazzoforti.it/Malevich/icone_en.html, accessed 19 December 2016.

2 Cortenova, G. (2000) From East to West: The Dream of the Spirit, in Cortenova, G. (ed.) *Kazimir Malevich and the Sacred Russian Icons: Avant-Garde and Traditional,* Electa Espana, Madrid. This section available at http://mostrestoriche.palazzoforti.it/Malevich/cortenova_en.html, accessed 19 December 2016.

3 Ibid.

4 Pelikan, J. (1990) *Imageo Dei: The Byzantine Apologia for Icons*, Princeton University Press, Princeton, NJ, p. 3.

5 Ware, K. (1987) The Theology and Spirituality of the Icon, in *From Byzantium to El Greco*, Royal Academy of Arts, London, p. 39.

6 Winterson, J. (2016) *Christmas Days*, Jonathan Cape, London, p. 3.

7 Luke 17:21, 'neither shall they say, Lo here! or, lo there! for, behold, the kingdom of God is within you', Authorized (King James) Version (AKJV).

8 Nicoll, M. (1959) *The New Man*, Penguin Books Inc., Baltimore, MD, pp. 32–34.

CHAPTER 73: ANOTHER REALITY

An earlier, shorter version of this chapter appeared in the *Journal of Interior Design*, John Wiley & Sons, Hoboken, NJ, Vol. X, No. Y, pp. xx–yy, Copyright © [2018]. Reproduced here with kind permission of the *Interior Design Educators Council* who retain copyright of the original paper.

EPIGRAPH: Keats, J. (1816) part of the 'Great Spirits' sonnet, 'Addressed to [Haydon]', in *John Keats: Selected Poems*, Penguin Group, London, p. 13.

1 Reno, R. R. (2016) Decline and fall of the post-Christian elite, *Catholic Herald*, London, Thursday 6 October 2016, available at http://www.catholicherald.co.uk/issues/october-7th-2016/decline-and-fall-of-the-post-christian-elite/, accessed 18 May 2017.

2 Eagleton, T. (2009) *Reason, Faith, and Revolution: Reflections on the God Debate*, Yale University Press, New Haven, CT, pp. 42–43.

3 Park, S. Q., Kahnt, T., Dogan, A., Strang, S., Fehr, E. and Tobler, P. N. (2017) A neural link between generosity and happiness, *Nature Communications*, Springer, New York, NY, No. 8, Article number: 15964, doi:10.1038/ncomms15964, published online 11 July 2017, available at https://www.nature.com/articles/ncomms15964, accessed 13 July 2017.

4 Atran, S. (2015) *Youth, Violent Extremism and Promoting Peace*, address to the UN Security Council 23 April 2015, available at http://blogs.plos.org/neuroanthropology/2015/04/25/scott-atran-on-youth-violent-extremism-and-promoting-peace/, accessed 28 November 2015.

5 Eagleton (2009) p. 69.

6 Duffy, E. (2017) *Reformation Divided: Catholics, Protestants and the Conversion of England*, Bloomsbury, London, p. 4.

7 Taylor, C. (1991) *The Malaise of Modernity*, Anansi, Concord, ON, p. 4.

8 Horkheimer, M. and Adorno, T. W. (1947) *Dialectic of Enlightenment*, G. Schmid Noerr (ed.), E. Jephcott (trans.), Stanford University Press, Stanford, CA, [2002], p. 1.

9 Eagleton (2009) p. 71.

10 Duffy (2017) p. 43.

11 Smit, T, (2017) Foreword in Evans, A. (2017) *The Myth Gap: What Happens When Evidence and Arguments Aren't Enough?*, Penguin Random House Group, London, p. x.

12 Armstrong, K. (2014) *Fields of Blood: Religion and the History of Violence*, Vintage, London, p. 1.

13 Campbell, J. (1949) *The Hero with a Thousand Faces*, Pantheon Books, Bollingen Foundation Inc., New York, NY, pp. 91–92.

14 Duffy (2017) p. 4, discussing the work of Brad Gregory.

15 Hughes, R. (1991) *The Shock of the New*, 2nd Edition (updated and enlarged), Thames and Hudson, London, pp. 10–11, 15, 40–48.

16 Duffy (2017) p. 10.

17 Duffy (2017) p. 4, discussing the work of Brad Gregory.

18 Atran (2015).

19 Eagleton (2009) p. 143.

20 Duffy (2017) p. 3.

21 Dreher, R. (2017) quoted in Jamison, C., 'Setting themselves apart', *The Tablet*, London, 17 June 2017, pp. 4–5.

22 Rebanks, J. (2015) *The Shepherd's Life: A Tale of the Lake District*, Allen Lane, Penguin Random House, London, p. 97.

23 Atran (2015).

24 Duffy (2017) p. 5.

25 Walton, S. (2017) Theory from the ruins, *Aeon Digital Magazine*, Aeon Media Group Ltd, Melbourne, Australia, 31 May 2017, available at https://aeon.co/essays/how-the-frankfurt-school-diagnosed-the-ills-of-western-civilisation, accessed 23 February 2018.

26 Cottingham, J. (2014) *Philosophy of Religion: Towards a More Humane Approach*, Cambridge University Press, New York, NY, p. 16.

27 MacCulloch, D. (2013) *Silence: A Christian History*, Allen Lane, Penguin Group, London, pp. 129–136.

28 Heywood, V. (2015) Foreword, *Enriching Britain: Culture, Creativity and Growth, Warwick Commission on the Future of Cultural Value*, authored by Neelands, J., Belfiore, E., Firth, C., Hart, N., Perrin, L., Brock, S., Holdaway, D. and Woddis, J., University of Warwick, Coventry, p. 9.

29 Romer, C. (2017) Education Minister: 'Don't worry about decline in arts subjects – computing is on the rise', *Arts Professional*, Histon, Cambridge, 7 July 2017, available at https://www.artsprofessional.co.uk/news/education-minister-dont-worry-about-decline-arts-subjects-computing-rise, accessed 11 July 2017.

30 Hughes, L. (2017) Theresa May accused of failing to show 'humanity' during Grenfell Tower visit, *The Telegraph*, Telegraph Media Group, London, 16 June 2017, available at http://www.telegraph.co.uk/news/2017/06/16/theresa-may-failed-show-humanity-grenfell-tower-visit-saysmichael/, accessed 24 June 2017.

31 Morley, N. (2017) Theresa May's first interview after Grenfell Tower protesters label her 'a coward', *Metro*, Associated Newspapers Limited, London, 17 June 2017, available at http://metro.co.uk/2017/06/17/theresa-may-first-interview-after-grenfell-tower-protesters-label-her-a-coward-6715096/, accessed 24 June 2017.

32 Armstrong, K. (2005) *A Short History of Myth*, Canongate, Edinburgh, p. 4.

33 Evans, A. (2017) *The Myth Gap: What Happens When Evidence and Arguments Aren't Enough?*, Penguin Random House Group, London, p. 25.

34 Segal, R. A. (2015) *A Very Short Introduction to Myth*, Oxford University Press, Oxford, 2nd Edition, p. 122.

35 Swartzberg, J. (2016) The Myth of Male Menopause, *Huffington Post*, New York, NY, 2 October 2016, http://www.huffingtonpost.com/berkeley-wellness/the-myth-of-male-menopause_b_9143272.html, accessed 25 June 2017.

36 Segal (2015) pp. 4–5.

37 Cupitt, D. (1982) *The World to Come*, SCM Press, London, p. 29 quoted in Coupe, L. (1997) *Myth*, Routledge, London, pp. 5–6.

38 Ibid.

39 Campbell (1949) pp. viii, 91–92, 142–143.

40 Evans (2017) pp. 25–27.

41 Gaiman, N. (1999) Some Reflections on Myth (with Several Digressions onto Gardening, Comics and Fairy Tales), in *The View from the Cheap Seats: Selected Non-Fiction*, Headline Publishing Group, London, p. 59.

42 Campbell (1949) p. 104.

43 Gaiman (1999) pp. 59–68.

44 Campbell (1949) pp. 177–181.

45 Ibid., p. 177

46 Ibid., pp. 190–191.

47 Walker, A. (1974) In Search of Our Mothers' Gardens, in Alice Walker's *In Search of Our Mothers' Gardens: Womanist Prose* (1983), The Women's Press, London, p. 233.

48 Walton (2017).

49 Evans (2017) pp. 64–67.

50 Brueggemann, W. (2014) *Reality, Grief, Hope: Three Urgent Prophetic Tasks*, William B. Erdeerdmans Publishing Company, Cambridge, UK, p. 159.

51 Ibid., pp. 88, 159.

52 Ibid., p. 128.

53 DESIS (2017) Network of Design for Social Innovation and Sustainability, available at http://www.desisnetwork.org/, accessed 30 June 2017.

54 Transition Network (2017) available at https://transitionnetwork.org/, accessed 30 June 2017.

55 Cohousing (2017) UK Cohousing Network available at https://cohousing.org.uk/, accessed 15 July 2017. An example of cohousing is the Lancaster Cohousing Project, Lancaster Cohousing Company Ltd Halton, Lancaster, UK, available at http://www.lancastercohousing.org.uk/, accessed 15 July 2017.

56 Examples include: *Object Therapy* (2017) Australian Design Centre, Canberra, ACT, both an exhibition and a design-centred project that explore transformation and notions of value through product reimagining and repair, available at https://australiandesigncentre.com/object-therapy/; *Edinburgh Remakery* (2017) a social enterprise that offers workspaces and courses for product repair, available at http://www.edinburghremakery.org.uk/; *Remakery* (2017) a London-based co-operative workshop space that helps build community skills and opportunities, available at http://remakery.org/about/; *Re Tuna Återbruksgalleria* (2017) a Swedish recycling centre and shopping mall for repaired and recycled goods, available at https://www.retuna.se/. All the above websites accessed 30 June 2017.

57 Buchanan, R. (1989) Declaration by Design: Rhetoric, Argument, and Demonstration in Design Practice, in Margolin, V. (ed.) *Design Discourse: History, Theory, Criticism*, The University of Chicago Press, Chicago, IL, pp. 93–94.

58 Evans (2017) p. xix.

59 Huxley, A. (1945) *The Perennial Philosophy*, Triad Grafton Books, London, [1991].

60 Armstrong (2005) pp. 136–138.

61 Dawkins, R. (2006) *The God Delusion*, Bantam Books, Penguin Group, London.

62 Hitchens, C. (2007) *God is Not Great*, Hatchette Book Group, New York, NY.

63 Eagleton (2009) p. 7.

64 Huxley (1945) pp. 2, 12–13.

65 Schumacher, E. F. (1973) *Small is Beautiful: A Study of Economics as if People Mattered*, Abacus, Penguin Books, London, pp. 45–51.

66 Morrisseau, N. (2008) *A Separate Reality* can be viewed online at: http://www.morrisseau.com/viewPhoto.php?fileID=505, accessed 18 July 2017.

67 McLuhan, E. (1984) The Emergence of the Images Makers, in *Norval Morrisseau and the Emergence of the Image Makers*, by E. McLuhan and T. Hill, Art Gallery of Ontario, Methuen, Toronto, ON, p. 28.

68 Phillips, R. (n.d.) *A Separate Reality*, text accompanying the painting by Norval Morrisseau at the Canadian Museum of History, Gatineau, QC, source: Ruth Phillips, Museum of Anthropology, University of British Columbia.

69 Woodlands School (2015) Woodlands School of Life: A Lesson in How to Make a Difference, *Native Art in Canada – An Ojibwa Elder's Art and Stories*, available at http://www.native-art-in-canada.com/woodlandsschool.html, accessed 18 July 2017.

70 Brooks, D. (2013) Baccalaureate Address, Sewanee University of the South, Sewanee, TN, May 11, 2013, available at http://news-archive.sewanee.edu/assets/uploads/David_Brooks_Baccalaureate_Speech2.pdf, accessed 16 June 2017.

71 Eagleton (2009) p. 83

CHAPTER 74: A WISDOM ECONOMY

1 I first introduced the notion of a wisdom economy in a paper entitled Design and Spirituality: Materials Culture for a Wisdom Economy, published in *Design Issues*, MIT Press, Cambridge, MA, Vol. 29, Issue 3, 2013, pp. 89, 105, 106.

2 Morrison, R. (1991) *We Build the Road as We Travel*, New Society Publishers, Philadelphia, PA, p. 65.

3 The founder of the Mondragon cooperatives, Father José María Arizmendiarrieta, had read the work of the Rochdale Pioneers who developed the cooperative principles. For A summary of these principles, see Thompson, D. J. (1994) Appendix B: Original Statutes of the Rochdale Society of Equitable Pioneers and Today's International Co-operative Alliance Co-operative Principles, *Weavers of Dreams: Founders of the Modern Co-operative Movement*, Center for Cooperatives, University of California, Davis, CA, pp. 142–143.

4 Ibid., pp. 46–51.

5 Cadbury Fact Sheet (n.d.) available at https://www.cadburyworld.co.uk/schoolandgroups/~/media/CadburyWorld/en/Files/Pdf/factsheet-cadbury-family, accessed 30 January 2017.

CHAPTER 75: FAIR SHARE

1 Manzini, E. and Jégou, F. (2003) *Sustainable Everyday – Scenarios for Urban Life*, Edizioni Ambiente, Milan.

2 *Sharing Depot*, Toronto, ON, available at https://sharingdepot.ca/, accessed 7 January 2017.

3 Strauss, I. E. (2017) The Original Sharing Economy, *The Atlantic*, Washington, DC, 3 January 2017, available at https://www.theatlantic.com/business/archive/2017/01/original-sharing-economy/511955/?utm_source=atltw, accessed 7 January 2017.

4 *Shareable*, San Francisco, CA, available at http://www.shareable.net/, accessed 7 January 2017.

5 Mytels, D. (2017) Palo Alto Residents Share Dishware to Reduce Waste, Build Community, *Shareable*, 5 January 2017, available at http://www.shareable.net/blog/palo-alto-residents-share-dishware-to-reduce-waste-build-community, accessed 7 January 2017.

6 Wilkinson, R. and Pickett, K. (2009), *The Spirit Level*, London: Allen Lane, Penguin Group, pp. 29, 232, 263–265.

CHAPTER 76: DESIGN RHAPSODY

1 Herbert, A. (1994) 'Ralf Vaughan Williams – Orchestral Works', liner notes of Vaughan Williams: Fantasia on Greensleeves, Fantasia on a Theme by Thomas Tallis, The Lark Ascending, Norfolk Rhapsody, In the Fen Country, 'Dives and Lazarus', The New Queen's Hall Orchestra, Barry Wordsworth (conductor), Argo, The Decca Record Company, London, 1994.

2 McNaught, W. (2015) *Peter Grimes* review: 'An orchestral score full of vivid suggestion and action', *The Guardian*, London, a reprint of the original review that appeared in the Manchester Guardian on 9 June 1945, published 29 December 2015, available at https://www.theguardian.com/music/from-the-archive-blog/2015/dec/29/benjamin-britten-peter-grimes-first-performance-1945, accessed 13 February 2017.

3 Orledge, R. (1994) 'Canteloube – Chants d'Auvergne', liner notes of Canteloube – Chants d'Auvergne, English Chamber Orchestra, Yan Pascal Tortelier (conductor), Arleen Auger (soprano), Virgin Classics, London.

CHAPTER 77: SPIRITUAL RENEWAL

1 Hall, J. and Beardsley, R. (1965) *Twelves Doors to Japan*, McGraw Hill, New York, NY, p. 125, referred to in Davies, R. J. (2016) *Japanese Culture: The Religious and Philosophical Foundations*, Tuttle Publishing, Tokyo, Japan, pp. 23–24.

2 Tarnas, R. (1991) *The Passion of the Western Mind*, Harmony Books, New York, NY, p. 383.

3 Hick, J. (1982) *God Has Many Names*, Westminster Press, Philadelphia, PA, p. 135.

4 Armstrong, K. (2007) *The Bible: The Biography*, Atlantic Books, London, p. 222.

5 Spurlock, R. S. (n.d) *Arnold Joseph Toynbee – An Historian's Approach to Religion*, The Gifford Lectures, Templeton Press, West Conshohocken, PA, available at http://www.giffordlectures.org/lectures/historians-approach-religion, accessed 3 November 2016.

6 Armstrong (2007) p. 223.

7 Spurlock (n.d).

8 Armstrong, K. (2014) *Fields of Blood: Religion and the History of Violence*, Vintage, London, p. 2.

9 Armstrong (2007) pp. 2–5.

10 Ibid., p. 229.

11 Hick (1982) p. 19.

12 This principle is summed up in the so-called Golden Rule, which is expressed in various ways around the world. Essentially, it says, *behave towards others as you would have them behave towards you.*

CHAPTER 79: IMPROVING THINGS

1 Cottingham, J. (2016) *How to Believe*, Bloomsbury, London, p. 16.

2 Atran, S. (2015) *Youth, Violent Extremism and Promoting Peace*, address to the UN Security Council 23 April 2015, available at http://blogs.plos.org/neuroanthropology/2015/04/25/scott-atran-on-youth-violent-extremism-and-promoting-peace/, accessed 28 November 2015.

3 Cottingham (2016) p. 17.

4 Armstrong, K. (2014) *Fields of Blood: Religion and the History of Violence*, Vintage, London, pp. 7–8.

CHAPTER 81: ONE MANIFESTATION OF WISDOM

1 Keene, D. (trans.) (1967) *Essays in Idleness: The Tsurezuregusa of Kenkō*, Tuttle Publishing, Tokyo, Chapter 120, p. 101.

2 Saul, J. R. (2005) *The Collapse of Globalism and the Reinvention of the World*, Viking, Penguin Group, Toronto, p. 31.

3 Ibid., pp. 24–25.

CHAPTER 82: WHY

1 Hayes, M. (2015) *When We Were Almost Like Men*, Smokestack Books Ltd, Grewelthorpe, Ripon, UK.

CHAPTER 84: A CREATIVE LIFE

1 Hesse Media Release (2012) *Hermann Hesse's dual talents in painting and poetry*, Kunst Museum, Bern, 26 March 2012, available at http://www.kunstmuseumbern.ch/admin/data/hosts/kmb/files/page_editorial_paragraph_file/file_en/522/120326_Medienmitteilung_HermannHesse_e.pdf?lm=1332747482, accessed 30 December 2016.

2 Stipes, J. (trans.) (1995) *The Fairy Tales of Hermann Hesse*, Bantam Books, New York, NY, p. IX.

CHAPTER 85: DELICATE, EVANESCENT THINGS

1 Figgis, M. (2005) *Mike Figgis on "Weekend"*, an interview with film director Mike Figgis discussing the work of French director Jean-Luc Godard, a special feature on the DVD of the film *WEEKEND* (1967) by Jean-Luc Godard, Artificial Eye, London. Also available as *Mike Figgis on Godard* at: https://www.youtube.com/watch?v=u9DWp5kZh8o, accessed 26 March 2017.

CHAPTER 87: DYING TO CREATE

1 Abra, J. (1995) Do the Muses Dwell in Elysium? Death As a Motive for Creativity, *Creative Research Journal*, Lawrence Erlbaum Associates, Inc., Mahwah, NJ, Vol. 8, No. 3, pp. 210–211.

2 Ecclesiastes 1:i–iii.

3 Steindl-Rast, D. (1977) Learning to Die, *Parabola*, Vol. 2, Issue 1, Winter, pp. 22–31, available at http://gratefulness.org/resource/learning-to-die/, accessed 10 February 2017.

4 Abra (1995) p. 213.

5 Steindl-Rast (1977).

CHAPTER 89: RAW DESIGN

1 Luke, D. (1988) Introduction to Thomas Mann's *Death in Venice and other Stories*, Vintage, Random House, London, [1998], p. viii in which Luke quotes from Mann's autobiographical essay 'A Sketch of My Life'.

2 Armstrong, K. (2014) *Fields of Blood: Religion and the History of Violence*, Vintage, London, pp. 7–8.

CHAPTER 92: THINGS THAT ENDURE

1 Armstrong, K. (2005) *A Short History of Myth*, Canongate, Edinburgh, p. 7.

2 Schimmel, A. (1992) *Rumi's World: The Life and Work of the Great Sufi Poet*, Shambhala Publications, Boston, MA, p. 115.

3 Armstrong, K. (2007) *The Bible: The Biography*, Atlantic Books, London, pp. 2–3.

4 Needleman, J. (1991) *Money and the Meaning of Life*, Doubleday Dell, New York, NY, p. 97.

5 Feng, G. and English, J. (1989) *Tao Te Ching by Lao Tzu*, Vintage Books, New York, NY, Ch. 1, p. 3.

6　Gospel of Matthew, 13:22; Gospel of Luke, 8:14.

7　Needleman (1991) p. 95.

8　Needleman (1991) pp. 68–69.

9　Nicoll, M. (1954) *The Mark*, Vincent Stuart, London, p. 67.

10　Wilson, A. N. (2015) *The Book of the People: How to Read the Bible*, Atlantic Books, London, p149.

11　This insight into Descartes is discussed by John Cottingham in his book, *How to Believe*, Bloomsbury, London, p. 9. The quotation by Descartes is from his *Letter to Chanut*, 15 June 1646.

CHAPTER 93: THE MARK MADE

1　Blake, W. (1794) The Tiger, originally published in *Songs of Experience*, in *The Selected Poems of William Blake*, Wordsworth Editions Ltd Ware, Hertfordshire, [1994], p. 76.

2　Liddell, H. G. and Scott, R. (1940) *A Greek–English Lexicon*, Oxford: Clarendon Press, available at http://www.perseus.tufts.edu/hopper/text?doc=Perseus:text:1999.04.0057:entry=a(marta/nw, accessed 25 November 2016.

3　Ibid.

4　Cunliffe, R. J. (1924) *A Lexicon of the Homeric Dialect*, Blackie and Son Limited, London, available at http://stephanus.tlg.uci.edu/cunliffe/#eid=541&context=lsj, accessed 25 November 2016.

5　Strong, J. (1894) *The Exhaustive Concordance of the Bible, Jennings & Graham, Cincinnati, OH*, available at https://www.blueletterbible.org/lang/lexicon/lexicon.cfm?Strongs=G264&t=KJV, accessed 25 November 2016.

6　Nicoll, M. (1954) *The Mark*, Vincent Stuart, London, pp. 201–202.

7　Griffith, T. (trans.) (2000) *Plato: The Republic*, Ferrari, G. R. F. (ed.), Cambridge University Press, Cambridge, pp50–56.

8　Armstrong, K. (2014) *Fields of Blood: Religion and the History of Violence*, Vintage, London, pp. 1, 77–78.

CHAPTER 94: HANDMADE

1　Grene, D. and Lattimore, R. (eds) (1959) 'Ajax' by Sophocles, *The Complete Tragedies*, (trans.) John Moore, Cambridge University Press, Cambridge, Vol. 2, p. 250.

CHAPTER 98: LIFE

1　Boswell, J. (1777) *The Life of Samuel Johnson, LL.D.*, Vol. 2, Charles Dilly, London, p. 160.

2　Maugham, W. S. (1919) *The Moon and Sixpence*, Vintage Books, Random House, New York, NY, p. 29.

CHAPTER 99: IMPROVISATION

1　Davis, M. (1959) *Kind of Blue*, Columbia Records, New York, NY.

2　Bill Evans, quoted in Kahn, A. (2000) *Kind of Blue: The Making of the Miles Davis Masterpiece*, De Capo Press, HarperCollins, New York, NY, p. 105.

3　Nisenson, E. (2000) *The Making of Kind of Blue: Miles Davis and His Masterpiece*, St. Martin's Press, New York, NY, p. 216.

4　Kahn, A. (2000) *Kind of Blue: The Making of the Miles Davis Masterpiece*, De Capo Press, HarperCollins, New York, NY, p. 178.

5　Ibid.

6　Ibid., p. 177.

7　Miles Davis and *Kind of Blue* (2014) *Witness*, BBC World Service, broadcast Wednesday 10 December 2014, 08:50 Local time, available at http://www.bbc.co.uk/programmes/p02dcqff, accessed 7 August 2017

8　Ibid.

9　NPR (2001) *Miles Davis: 'Kind of Blue'*, NPR Music, National Public Radio, Washington, DC,

available at http://www.npr.org/2011/01/04/10862796/miles-davis-kind-of-blue, accessed 7 August 2017.

10 Ibid.
11 Nisenson (2000) p. 216.
12 Kahn (2000) p. 16.
13 Kahn (2000) p. 200.
14 Spencer, J. M. (1996) Miles Davis' *Kind of Blue*, Critic's Corner, *Theology Today*, Sage Publications, Thousand Oaks, CA, Vol. 52, No. 4, p. 506.
15 Ibid., p. 507.
16 Ibid., pp. 508–509.
17 Cytowic, R. E. (1993) *The Man Who Tasted Shapes*, G. P. Putnam's Sons, New York, NY, MIT Press Edition [2003], p. 56.
18 Kandinsky, W. (1938) *Der Wert eines Werkes der konkreten Kunst*, available at http://kunstdirekt. net/kunstzitate/manual/index.html?kunstzitate_31_der_wert_eines_werkes_1938.htm, accessed 7 August 2017.
19 Mann, T. (1912) Death in Venice, in *Death in Venice and Other Stories*, D. Luke (trans.), Vintage Books, London [1998], p. 201.

CHAPTER 100: PROGRESSIVE DESIGN PRAXIS

An earlier, shorter version of this chapter, entitled Spirituality and Design: creating a meaningful material culture through progressive design praxis, is included in Laszlo Zsolnai, L. and Flanagan, B. (eds) (2018) *The Routledge International Handbook of Spirituality and Society*, New York & London: Routledge.

1 Taylor, C. (2007) *A Secular Age*. The Belknap Press of Harvard University Press, Cambridge, MA, p. 25.
2 Pratt, V., Brady, E. and Howarth, J. (2000) *Environment and Philosophy*, Routledge, London, pp. 81–84, extract available at http://www.vernonpratt.com/thehumanbeing/individualism.htm, accessed 12 February 2014.
3 Crompton, T. (2010) *Common Cause: The Case for Working with our Cultural Values*, WWF-UK, Woking, Surrey, pp. 9–11, available at http://assets.wwf.org.uk/downloads/common_cause_ report.pdf, accessed 8 May 2016.
4 Kasser, T. (2009) *Psychological Need Satisfaction, Personal Well-Being, and Ecological Sustainability*, *Ecopsychology*, Mary Ann Liebert, Inc., New Rochelle, NY, Vol. 1, No. 4, December 2009, p. 178.
5 Lansley, S. (1994) *After the Gold Rush – The Trouble with Affluence*, Century Business Books, London, p. 134.
6 Schwaabe, C. (2011) *Max Weber – The Disenchantment of the World*, J. Uhlaner (trans.), Goethe-Institut e.V., available at http://www.goethe.de/ges/phi/prt/en8250983.htm, accessed 14 February 2014.
7 Schwartz, B. (2004) *The Paradox of Choice*, HarperCollins, New York, NY, pp. 109, 132–133.
8 Monbiot, G. (2016) *How Did We Get Into This Mess: Politics, Equality and Nature*, Verso, London, p. 219.
9 Bourguignon, F. (2015) *The Globalization of Inequality*, Princeton University Press, Princeton, NJ, pp. 47, 117–118.
10 Crompton (2010) pp. 9–11.
11 Ibid.
12 Walker, S. (2014) *Designing Sustainability*, Routledge, Abingdon, Oxon, p. 42.
13 Ehrenfeld, J. R. and Hoffman, J. (2013) *Flourishing*, Stanford Business Books, Stanford, CA.
14 Davison, A. (2001) *Technology and the Contested Meanings of Sustainability*, State University of New York Press, Albany, NY, pp. 22–29.
15 Knowles, B. (2013) *Re-Imagining Persuasion: Designing for Self-Transcendence*, CHI 2013: Changing Perspectives, 27 April to 2 May 2013, Paris, France, ACM 978-1-4503-1952-2/13/04, p. 2715.

16 Crompton (2010) pp. 9–11.

17 SponGes (2016) *SponGES: Deep-sea Sponge Grounds Ecosystems of the North Atlantic: an integrated approach towards their preservation and sustainable exploitation*, University of Bergen, Norway, available at http://www.deepseasponges.org/?page_id=242, accessed 18 June 2016.

18 Defra (2007) *An introductory guide to valuing ecosystem services*, Department for Environment, Food and Rural Affairs, UK Government, London, p. 4, available at http://ec.europa.eu/environment/nature/biodiversity/economics/pdf/valuing_ecosystems.pdf, accessed 23 June 2016.

19 Kingley, P. (2013) Masdar: the shifting goalposts of Abu Dhabi's ambitious eco-city, *WIRED*, 17 December, available at http://www.wired.co.uk/magazine/archive/2013/12/features/reality-hits-masdar, accessed 14 March 2016.

20 Larson, C. (2009) China's Grand Plans for Eco-Cities Now Lie Abandoned, *Environment 360*, Yale University, New Haven CT, 6 April, available at http://e360.yale.edu/feature/chinas_grand_plans_for_ecocities_now_lie_abandoned/2138/, accessed 14 March 2016.

21 Goldberg, S. (2016) Masdar's zero-carbon dream could become world's first green ghost town, *The Guardian*, 16 February, available at http://www.theguardian.com/environment/2016/feb/16/masdars-zero-carbon-dream-could-become-worlds-first-green-ghost-town, accessed 14 March 2016.

22 McGirk, J. (2016) Why eco-cities fail, *China Dialogue*, 27 May, available at https://www.chinadialogue.net/books/7934-Why-eco-cities-fail/en, accessed 14 May 2016.

23 Kingley (2013).

24 Sze, J. (2015) *Fantasy Islands: Chinese Dreams and Ecological Fears in an Age of Climate Crisis*, University of California Press, Oakland, CA, p. 159.

25 Kingley (2013).

26 IDSA (2015) *What is Industrial Design*, Industrial Designers Society of America, Herndon, VA, available at http://www.idsa.org/education/what-is-industrial-design, accessed 20 February 2016.

27 Ulrich, K. T. and Eppinger, S. D. (1995) *Product Design and Development*, McGraw-Hill Inc., New York, NY, p. 3.

28 Simon, H. A. (1996) *The Sciences of the Artificial*, 3rd Edition, The MIT Press, Cambridge, MA, p. 111.

29 WDO (2017) *World Design Organization* (formerly the International Council of Societies of Industrial Design), Mission at: http://wdo.org/about/vision-mission/; Definition of Industrial Design by Professional Practise Committee , 29th General Assembly, Gwangju, South Korea, available at http://wdo.org/about/definition/, accessed 3 September 2017.

30 Scruton, R. (2016) *Confessions of a Heretic*, Nottinghill Editions, London, p. 6.

31 Merton, T. (1960) *The Wisdom of the Desert*, New Directions Publishing Corp., New York, NY, [1970], p. 4.

32 Jaspers, K. (1953) *The Origin and Goal of History*, Michael Bullock (trans.), Routledge & Kegan Paul Ltd London, (first published in German in 1949), pp. 1–3.

33 Kasser (2009) p. 178.

34 Hardy, T. (1872) *Under the Greenwood Tree*, Wordsworth Classics, Ware, Hertfordshire, [2004], p. 48.

35 Waterfield, R. (trans.) (2002) *Plato's Phaedrus*, Oxford World Classics, Oxford University Press, Oxford, p. 13.

36 de Sousa, V. (2010) Uma Lulik, a documentary film, available at https://vimeo.com/34499848, accessed 9 March 2016.

37 Paradiso, M. (2015) Chiara Vigo: The last woman who makes sea silk, *BBC News Magazine Online*, 2 September, available at http://www.bbc.co.uk/news/magazine-33691781, accessed 2 September 2015.

38 Rebanks, J. (2015) *The Shepherd's Life*, Allen Lane, Penguin Group, London, p. 38.

39 Pratt, V., Brady, E. and Howarth, J. (2000) *Environment and Philosophy*, Routledge, London, extract available at http://www.vernonpratt.com/thehumanbeing/individualism.htm, 12 February 2014.

40 Chaibong, H. (2000) 'The Cultural Challenge of Individualism', *Journal of Democracy*, The Johns Hopkins University Press, Baltimore, MD, Vol. 11, No. 1, p. 127.

41 Scheffler, S. (2013) *Death and the Afterlife*, Oxford University Press, New York, NY, p. 33.

42 Scruton (2016) pp. 72–74.

43 Gadamer, H. G. (1989) *Truth and Method*, 2nd Edition, Continuum, London [2004], p. 4.

44 Cottingham, J. (2014) *Philosophy of Religion: Towards a More Humane Approach*, Cambridge University Press, New York, NY, p. 16.

45 Eikeland O. (2014) 'Praxis' in Coghlan, D. and Brydon-Miller, M. (eds) (2014) *The Sage Encyclopedia of Action Research*, Sage Publications Ltd, London, pp. 653–657, Online Edition available at http://www.lancaster.www.lancaster.eblib.com.ezproxy.lancs.ac.uk/patron/FullRecord. aspx?p=1712670&echo=1&userid=dfvp8VDkAZ7aTpueA%2fon9w%3d%3d&tstamp=145517 5755&id=166D2B7C90C920F322EF6158A9EA09E57C1D802E, accessed 11 February 2016.

46 Gadamer (1989) p. 342.

47 *Gaudium Et Spes* (1965) Pastoral Constitution on The Church in the Modern World, *Gaudium Et Spes*, Promulgated by His Holiness, Pope Paul VI, 7 December, pp. 33–46, available at http:// www.vatican.va/archive/hist_councils/ii_vatican_council/documents/vat-ii_const_19651207_ gaudium-et-spes_en.html, accessed 10 March 2016.

48 Shortt, R. (2016) *God Is No Thing: Coherent Christianity*, Hurst and Company, London, p. 70.

49 Walker, S. (2013) Design and Spirituality: Materials Culture for a Wisdom Economy, *Design Issues*, Massachusetts Institute of Technology, Vol. 29, No. 3, Summer, pp. 89–107.

50 Xingzhong, Y. (2016) quoted in *Toward A Global Intellectual Response to Pope Francis' Environmental Thought* by V. Ialenti and Meridian 180, ReligiousLeftLaw.com, available at http://www.religiousleftlaw.com/2016/01/toward-a-global-intellectual-response-to-pope-francis-environmental-thought.html, accessed 8 February 2016.

51 Black, I. (2004) Christianity bedevils talks on EU treaty, *The Guardian*, London, 25 May, available at http://www.theguardian.com/world/2004/may/25/eu.religion, accessed 17 May 2016.

52 Pullella, P. (2007) *Pope criticises EU for excluding God*, Reuters, 24 March, available at http:// www.reuters.com/article/us-eu-anniversary-pope-idUSL2421365520070324, accessed 17 May 2016.

53 Merton (1960, p. 11.

54 IPCC (2014) *Climate Change 2014 Synthesis Report: Summary for Policymakers*, Intergovernmental Panel on Climate Change, Geneva, Switzerland, p. 2, available at https:// www.ipcc.ch/pdf/assessment-report/ar5/syr/AR5_SYR_FINAL_SPM.pdf, accessed 17 May 2016.

55 Syal, R. (2013) Denis MacShane pleads guilty to expenses fraud, *The Guardian*, Guardian Media Group, London, 18 May 2013, available at http://www.theguardian.com/politics/2013/nov/18/ denis-macshane-pleads-guilty-expenses-fraud, accessed 6 February 2016.

56 McBride, J., Alessi, C. and Sergie, M. A. (2015) *Understanding the Libor Scandal*, Council on Foreign Relations, New York, NY, available at http://www.cfr.org/united-kingdom/ understanding-libor-scandal/p28729, accessed 6 February 2016.

57 Boston Globe (2016) *Betrayal: The Crisis in the Catholic Church* by the Investigative Staff of the Boston Globe, Profile Books, London.

58 BBC (2016a) Food wristbands scrapped for Cardiff asylum seekers, *BBC News Online*, London, 25 January 2016, available at http://www.bbc.co.uk/news/uk-wales-35397109, accessed 6 February 2016.

59 Taylor, D. (2016) Asylum seekers made to wear coloured wristbands in Cardiff, *The Guardian*, Guardian Media Group, London, 24 January 2016, available at http://www.theguardian.com/ uk-news/2016/jan/24/asylum-seekers-made-to-wear-coloured-wristbands-cardiff, accessed 6 February 2016.

60 BBC News (2016) Every day there is an arson attack because of the red door, *BBC News Online*, London, 25 January 2016, available at http://www.bbc.co.uk/news/uk-35365814, accessed 6 February 2016.

61 *Al Jazeera* (2016) Danish MPs approve seizing valuables from refugees, *Al Jazeera Media Network*, Qatar, available at http://www.aljazeera.com/news/2016/01/danish-mps-vote-seizing-valuables-refugees-160126055035636.html, accessed 6 February 2016.

62 Healy, P. and Barbaro, M. (2015) Donald Trump Calls for Barring Muslims from Entering U.S., *New York Times*, Arthur Ochs Sulzberger Jr., Publisher, New York, NY, 7 December 2015, available at http://www.nytimes.com/politics/first-draft/2015/12/07/donald-trump-calls-for-banning-muslims-from-entering-u-s/, accessed 6 February 2016.

63 Nianas, H. (2015) Lance Armstrong doping; What we learned from his many lies, *The Independent*, Independent Print Limited, London, 27 January 2015, available at http://www.independent.co.uk/news/people/lance-armstrong-doping-what-we-learned-from-his-many-lies-10005386.html, accessed 6 February 2016.

64 Ingle, S. (2016) IAAF in crisis: a complex trail of corruption that led to the very top, *The Guardian*, Guardian Media Group, London, 7 January 2016, available at http://www.theguardian.com/sport/2016/jan/07/russia-doping-scandal-corruption-blackmail-athletics-iaaf, accessed 6 February 2016.

65 Phipps, C., Hills, D. and Graham, B. A. (2015) Fifa in crisis amid corruption arrests and World Cup voting inquiry – as it happened, *The Guardian*, Guardian Media Group, London, 27 May 2015, available at http://www.theguardian.com/football/live/2015/may/27/fifa-officials-arrested-on-corruption-charges-live, accessed 6 February 2016.

66 Hoult, N. (2016) South African cricket braced for huge match-fixing scandal after evidence of corruption in Ram Slam T20, *The Telegraph*, Telegraph Media Group, London, 13 January 2016, available at http://www.telegraph.co.uk/sport/cricket/international/southafrica/12097971/South-African-cricket-braced-for-huge-match-fixing-scandal-after-evidence-of-corruption-in-Ram-Slam-T20.html, accessed 6 February 2016.

67 Cox, S. (2016) Tennis match fixing: Evidence of suspected match-fixing revealed, *BBC Sport*, London, 18 January 2016, available at https://www.bbc.co.uk/sport/tennis/35319202, accessed 6 February 2016.

68 Nocera, J. (2016) True Scandal of Deflategate Lies in the N.F.L.s Behavior, *New York Times*, Arthur Ochs Sulzberger Jr., Publisher, New York, NY, 22 January 2016, available at http://www.nytimes.com/2016/01/23/sports/football/nfl-ignores-ball-deflation-science-at-new-england-patriots-expense.html?_r=0, accessed 6 February 2016.

69 Halliday, J. (2013) BBC: new child sex abuse allegations emerge against staff other than Savile, *The Guardian*, Guardian Media Group, London, 30 May 2013, available at http://www.theguardian.com/media/2013/may/30/bbc-staff-child-sex-abuse-allegations, accessed 6 February 2016.

70 Osodi, G. (2015) *Oil boom, Delta burns: photographs by George Osodi*, International Slavery Museum, Liverpool, 17 April 2015, available at http://www.liverpoolmuseums.org.uk/ism/exhibitions/osodi/, accessed 6 February 2016.

71 Hotten, R. (2015) Volkswagen: The scandal explained, *BBC News Online*, London, 10 December 2016, available at http://www.bbc.co.uk/news/business-34324772, accessed 6 February 2016.

72 Treong, T. (2014) *'Forced labor' rife in Malaysian electronics factories: report*, Reuters, London, 17 September 2014, available at http://www.reuters.com/article/us-malaysia-labour-report-idUSKBN0HC08E20140917, accessed 6 February 2016.

73 China Labor Watch (2014) Another Samsung supplier factory exploiting child labor, China Labor Watch (CLW), New York, NY, 10 July, http://www.chinalaborwatch.org/report/90, accessed 6 February 2016.

74 More, T. (1516) *Utopia*, Wisehouse Classics, *Ballingslöv*, Sweden, [2015], pp. 46,48.

75 Ibid., pp. 48, 53.

76 Smith, Z. (2016) *The Sayings of the Desert Fathers*, Catholic Comments Podcast, Department of Theology, Creighton University, Omaha, NE, 1 February 2016, available at http://cucatholicctr.org/2016/02/the-sayings-of-the-desert-fathers/, accessed 2 February 2016.

77 Common Cause (2011) *The Common Cause Handbook – A Guide to Values and Frames for Campaigners, Community Organisers, Civil Servants, Fundraisers, Educators, Social Entrepreneurs,*

Activists, Funders, Politicians, and everyone in between, Public Interest Research Centre, Machynlleth, Wales, pp. 13–14.

78 Barnwell, M. (2011) *Design, Creativity & Culture*, Black Dog Publishing, London, p. 12.

79 Eagleton, T. (2000) *The Idea of Culture*, Blackwell Publishing, Oxford, p. 113.

80 Ibid., pp. 115, 131.

81 Scruton, R. (2000) *An Intelligent Person's Guide to Modern Culture*, St. Augustine's Press, South Bend, IN, p. 2.

82 Ibid., p. 11.

83 Kasser (2009) pp. 175–180.

84 Li, S., Stampfer, M. J., Williams, D. R. and VanderWeele, T. J. (2016) Association of Religious Service Attendance With Mortality Among Women, *JAMA Internal Medicine*, American Medical Association Publishing Group, Chicago, IL, Vol. 176, No. 6, pp. 777–785.

85 Sherwood, H. (2016) People of no religion outnumber Christians in England and Wales – study, *The Guardian*, London, available at http://www.theguardian.com/world/2016/may/23/no-religion-outnumber-christians-england-wales-study, accessed 24 May 2016.

86 Shortt (2016) p. 78.

87 Eagleton (2000) p. 38.

88 Godzieba, A. J. (2014) "… AND FOLLOWED HIM ON THE WAY" (MK 10:52): IDENTITY, DIFFERENCE, AND THE PLAY OF DISCIPLESHIP, Catholic Theological Society of America Convention, 69th Annual Convention, San Diego, 5–8 June 2014, available at http://www.ctsa-online.org/past_conventions.html, accessed 16 February 2016.

89 Shortt (2016) p. 73.

90 Ward, B. (trans.) (1975) *The Sayings of the Desert Fathers – The Alphabetical Collection*, Cistercian Publications, Kalamazoo, MI and A. R. Mowbray, Oxford, p. xxiv.

91 *Laudato Si* (2015) *Encyclical Letter Laudato Si of the Holy Father Francis on Care for our Common Home*, Liberia Editrice Vaticana, print edition by Amazon.co.uk, Chapter 3, Section 115, p. 48.

92 Russell, B. (1975) *Autobiography*, Routledge Classics Edition [2010], Routledge, Abingdon, Oxon, p. 137.

93 Shortt (2016) p. 76.

94 Colliander, T. (1960) *Way of the Ascetics: The Ancient Tradition of Discipline and Inner Growth*, K. Ferré (trans.), St Vladimir's Seminary Press, Crestwood, NY, [2003], pp. 78–79.

95 Griffith, T. (2000) *Plato: The Republic*, G. R. F. Ferrari (ed.), Cambridge Texts in the History of Political Thought, Cambridge University Press, Cambridge, pp. 54–56.

96 Turner, P. (trans.) (1965) *Utopia* by Thomas More, Penguin Classics, Penguin Books Limited, Harmondsworth, Middlesex, pp. 13–14.

97 Atran, S. (2015) *Youth, Violent Extremism and Promoting Peace*, address to the UN Security Council 23 April 2015, available at http://blogs.plos.org/neuroanthropology/2015/04/25/scott-atran-on-youth-violent-extremism-and-promoting-peace/, accessed 28 November 2015.

98 Kasser (2009) p. 178.

99 Schellhorn, M. (2016) What John Cage can teach us about the Mass, *The Catholic Herald*, London, 18 February, available at http://catholicherald.co.uk/commentandblogs/2016/02/18/what-john-cage-can-teach-us-about-the-mass/, accessed 22 February 2016.

100 Rowe, C. (trans.) (2005) *Phaedrus* by Plato, Penguin Classics, Penguin Group, London, lines 237d4–238a7.

101 Shortt (2016) p. 64.

102 Gadamer (1989) pp. 306–307.

103 Godzieba (2014) p. 5.

104 Ibid.

105 Gadamer (1989) p. 355.

106 Godzieba (2014) p. 5.

107 Walker (2014) p. 57.

108 Ibid

109 Snodgrass, A. and Coyne, R. (1997) Is Designing Hermeneutical?, *Architectural Theory Review,* Journal of the Department of Architecture, The University of Sydney, Vol. 1, No. 1, p. 12.

110 Ibid., p. 22.

111 Godzieba (2014) p. 7.

112 Cottingham (2014) pp. 21–22.

113 Heidegger, M. (1962) *Being and Time,* Macquarrie, J. and Robinson, E. (trans.), Blackwell, Oxford, pp. 409–410.

114 Honderich, T. (ed.) (1995) *The Oxford Dictionary of Philosophy,* Oxford University Press, Oxford, description of praxis based on Nicholas Lobkowicz, *Theory and Practice: History of a Concept from Aristotle to Marx* (Notre Dame, IN, 1967), p. 1804, Online Edition available at https://alingavreliuc.files.wordpress.com/2010/10/honderich-ted-ed-the-oxford-companion-to-philosophy.pdf, accessed 25 April 2016.

115 Eikeland (2014) p. 654.

116 Godzieba, A. (2016) *Christianity as Music,* Catholic Comments (podcast), Center of Catholic Thought, Creighton University, Omaha, NE, 7 February 2016, 11'59"–12'03", available at http://cucatholicctr.org/2016/02/christianity-as-music/, accessed 24 July 2017.

117 Buchanan, I. (2010) *A Dictionary of Critical Theory,* Oxford University Press, Oxford, Oxford Reference Online Edition available at http://www.oxfordreference.com.ezproxy.lancs.ac.uk/view/10.1093/acref/9780199532919.001.0001/acref-9780199532919-e-554?rskey=fgyET4&result=555, accessed 11 February 2016.

118 Scruton, R. (1996) *A Dictionary of Political Thought,* 2nd Edition, Macmillan, London, p. 434.

119 Scruton, R. (2016) *Confessions of a Heretic,* Nottinghill Editions, London, pp. 65–85.

120 Crompton (2010) pp. 9–11.

121 Blackburn, S. (2008) *The Oxford Dictionary of Philosophy,* Oxford University Press, Oxford, Online Edition, available at http://www.oxfordreference.com/view/10.1093/acref/9780199541430.001.0001/acref-9780199541430-e-2470?rskey=uJpFoC&result=2471, accessed 25 April 2016.

122 Davies, R. (2016) Rolls-Royce unveils first driverless car complete with silk 'throne', *The Guardian,* London, 16 June 2016, available at https://www.theguardian.com/business/2016/jun/16/rolls-royce-unveils-first-driverless-car-vision-next-100, accessed 17 June 2016.

123 Johnston, W. (ed.) (2005) *The Cloud of Unknowing & the Book of Privy Counseling,* Image Books, Doubleday, New York, NY, pp. 54–56.

124 Common Cause (2011) p. 13.

BIBLIOGRAPHY

Abra, J. (1995) Do the Muses Dwell in Elysium? Death As a Motive for Creativity, *Creative Research Journal*, Lawrence Erlbaum Associates, Inc., Mahwah, NJ, Vol. 8, No. 3, pp. 205–217.

Agriantoni, C. and Fenerli, A. (2010) *Ermoupoli – Syros, A historical tour*, Olkos, Athens, 2nd Edition.

Akunin, B. (2016) Speaking about *Crime and Punishment* on *World Book Club*, World Service, British Broadcasting Corporations, London, broadcast 03:06 hrs, 6 November 2016.

Al Jazeera (2016) Danish MPs approve seizing valuables from refugees, *Al Jazeera Media Network*, Qatar, available at http://www.aljazeera.com/news/2016/01/danish-mps-vote-seizing-valuables-refugees-160126055035636.html, accessed 6 February, 2016.

Al-Mamun Al-Suhrawardy, A. S. A (1905) *The Sayings of Muhammad*, Citadel Press, Carol Publishing Group, New York, NY, [1990].

Animal, Vegetable, Mineral – Organising Nature: A Picture Album (2016) published to accompany the Wellcome Trust exhibition *Making Nature* curated by Honor Beddard, The Wellcome Trust, London

ARM chip designer to be bought by Japan's Softbank, 18 July 2016, *BBC News Online*, available at http://www.bbc.com/news/business-36822806, accessed 5 September 2016.

ARM founder says Softbank deal is 'sad day' for UK tech, 18 July 2016, *BBC News Online*, http://www.bbc.com/news/business-36827769, accessed 5 September 2016.

Armstrong, K. (2005) *A Short History of Myth*, Canongate, Edinburgh.

Armstrong, K. (2007) *The Bible: The Biography*, Atlantic Books, London.

Armstrong, K. (2014) *Fields of Blood: Religion and the History of Violence*, Vintage, London.

Atran, S. (2015) *Youth, Violent Extremism and Promoting Peace*, address to the UN Security Council 23 April 2015, available at http://blogs.plos.org/neuroanthropology/2015/04/25/scott-atran-on-youth-violent-extremism-and-promoting-peace/, accessed 28 November 2015.

Baldry, C. and Barnes, A. (2012) The open-plan academy: space, control and the undermining of professional identity, *Work Employment Society*, Sage Publications, Vol. 26, No. 2, pp. 228–245.

Ballinger, L. (2016) How Dylan Thomas's writing shed inspired Roald Dahl, *BBC News*, BBC, London, 14 September 2016, available at http://www.bbc.co.uk/news/uk-wales-37342271, accessed 6 March 2016.

Barnwell, M. (2011) *Design, Creativity & Culture*, Black Dog Publishing, London.

Barrett, D. V. (2016) Report claims Christians are intimidated and attacked in German refugee homes, *The Catholic Herald*, London, 21 October 2016, available at http://www.catholicherald.co.uk/news/2016/10/21/report-claims-christians-are-intimidated-and-attacked-in-german-refugee-homes/, accessed 22 October 2016.

Bartholomew, A. G. (2011) *Homiletic*, Vanderbilt Divinity School, Nashville, TN, Vol. 36, No. 1, p. 61, available at http://ejournals.library.vanderbilt.edu/index.php/homiletic/article/view/3441, accessed 28 December 2016.

BBC (2016) Food wristbands scrapped for Cardiff asylum seekers, *BBC News Online*, London, 25 January 2016, available at http://www.bbc.co.uk/news/uk-wales-35397109, accessed 6 February 2016.

BBC (2016) Every day there is an arson attack because of the red door, *BBC News Online*, London, 25 January 2016, available at http://www.bbc.co.uk/news/uk-35365814, accessed 6 February 2016.

Bigelow (2015) 'Clean Diesel' leaves dirty taste for green-minded VW owners, *Autoblog*, Birmingham, MI, 20 October 2015, available at www.autoblog.com/2015/10/20/vw-owners-betrayed-clean-diesel/, accessed 6 August 2016.

Black, I. (2004) Christianity bedevils talks on EU treaty, *The Guardian*, London, 25 May, available at http://www.theguardian.com/world/2004/may/25/eu.religion, accessed 17 May 2016.

Blackburn, S. (2008) *The Oxford Dictionary of Philosophy*, Oxford University Press, Oxford, Online Edition, available at http://www.oxfordreference.com/view/10.1093/acref/9780199541430.001.0001/acref-9780199541430-e-2470?rskey=uJpFoC&result=2471, accessed 25 April 2016.

Blake, Q. (2008) Writers' rooms: Roald Dahl, *The Guardian*, London, 23 May 2008, available at https://www.theguardian.com/books/2008/may/23/writers.rooms.roald.dahl, accessed 6 March 2017.

Blake, W. (1794) The Tiger, originally published in *Songs of Experience*, in *The Selected Poems of William Blake*, Wordsworth Editions Ltd Ware, Hertfordshire, [1994], p. 76.

Blake, W. (c.1803) Auguries of Innocence, in *The Selected Poems of William Blake*, Wordsworth Editions Ltd, Ware, Hertfordshire, [1994].

Bloom, A. (trans.) (1991) *The Republic of Plato*, 2nd Edition, Basic Books, HarperCollins Publishers, New York, NY, Book 10.

Blumer, T. J. (2004) *Catawba Indian Pottery: The Survival of a Folk Tradition*, The University of Alabama Press, Tuscaloosa, AL.

Boston Globe (2016) *Betrayal: The Crisis in the Catholic Church* by the Investigative Staff of the Boston Globe, Profile Books, London.

Boswell, J. (1777) *The Life of Samuel Johnson, LL.D.*, Vol. 2, Charles Dilly, London.

Bourguignon, F. (2015) *The Globalization of Inequality*, Princeton University Press, Princeton, NJ.

Boyle, D. (2013) *The Age to Come*, The Real Press Edition, [2016], www.the realpress.co.uk.

Brooks, D. (2013) Baccalaureate Address, Sewanee University of the South, Sewanee, TN, 11 May 2013, available at http://news-archive.sewanee.edu/assets/uploads/David_Brooks_Baccalaureate_Speech2.pdf, accessed 16 June 2017.

Brueggemann, W. (2014) *Reality, Grief, Hope: Three Urgent Prophetic Tasks*, William B. Erdeerdmans Publishing Company, Cambridge, UK.

Buchan, J. (1941) *Sick Heart River*, Polygon (Birlinn), Edinburgh, [2017], Chapter 11, pp. 40–49.

Buchan, J. (2014) The Scot who became more Canadian than the Canadians, *The Spectator*, London, 15 February 2014, available at https://www.spectator.co.uk/2014/02/john-buchan-by-j-william-galbraith-review/, accessed 17 April 2017.

Buchanan, I. (2010) *A Dictionary of Critical Theory*, Oxford University Press, Oxford, Oxford Reference Online Edition, available at http://www.oxfordreference.com.ezproxy.lancs.ac.uk/view/10.1093/acref/9780199532919.001.0001/acref-9780199532919-e-554?rskey=fgyET4&result=555, accessed 11 February 2016.

Buchanan, R. (1989) Declaration by Design: Rhetoric, Argument, and Demonstration in Design Practice, in Margolin, V. (ed.) *Design Discourse: History, Theory, Criticism*, The University of Chicago Press, Chicago, IL, pp. 91–109.

Campbell, J. (1949) *The Hero with a Thousand Faces*, Pantheon Books, Bollingen Foundation Inc., New York, NY.

Cadbury Fact Sheet (n.d.) available at https://www.cadburyworld.co.uk/schoolandgroups/~/media/CadburyWorld/en/Files/Pdf/factsheet-cadbury-family, accessed 30 January 2017.

Cain, S. (2012) *Quiet*, Penguin Books, London.

Chaibong, H. (2000) 'The Cultural Challenge of Individualism', *Journal of Democracy*, The Johns Hopkins University Press, Baltimore, MD, Vol. 11, No. 1, pp. 127–134.

Chen, H. (2015) Asia's smartphone addiction, *BBC News Online*, available at http://www.bbc.co.uk/news/world-asia-33130567, accessed 7 September 2015.

China Labor Watch (2014) Another Samsung supplier factory exploiting child labor, China Labor Watch (CLW), New York, NY, 10 July 2014, http://www.chinalaborwatch.org/report/90, accessed 6 February 2016.

Christianson, E. S. (2012) *Ecclesiastes through the Centuries*, Wiley-Blackwell, Chichester, UK.

Cohousing (2017) UK Cohousing Network available at https://cohousing.org.uk/, accessed 15 July 2017. An example of cohousing is the Lancaster Cohousing Project, Lancaster Cohousing Company Ltd Halton, Lancaster, UK, available at http://www.lancastercohousing.org.uk/, accessed 15 July 2017.

Colegate, I. (1980) *The Shooting Party*, Penguin Books Ltd, London, [2007], pp. 188–189.

Colliander, T. (1960) *Way of the Ascetics: The Ancient Tradition of Discipline and Inner Growth*, K. Ferré (trans.), St Vladimir's Seminary Press, Crestwood, NY, [2003].

Collini, S. (2017) *Speaking of Universities*, Verso, London.

Common Cause (2011) *The Common Cause Handbook – A Guide to Values and Frames for Campaigners, Community Organisers, Civil Servants, Fundraisers, Educators, Social Entrepreneurs, Activists, Funders, Politicians, and everyone in between*, Public Interest Research Centre, Machynlleth, Wales.

Confucius, *The Doctrine of the Mean*, The Internet Classics Archive, Massachusetts Institute of Technology, available at http://classics.mit.edu/Confucius/doctmean.html, accessed 26 September 2016.

Consequential Robots Ltd (2016) Miro, *Sheffield Robotics*, Sheffield, available at http://consequentialrobotics.com/miro/, accessed 3 December 2016.

Cortenova, G. (2000) From East to West: The Dream of the Spirit, in Cortenova, G. (ed.) *Kazimir Malevich and the Sacred Russian Icons: Avant-Garde and Traditional*, Electa Espana, Madrid. This section available at http://mostrestoriche.palazzoforti.it/Malevich/cortenova_en.html, accessed 19 December 2016.

Cottingham, J. (2014) *Philosophy of Religion: Towards a More Humane Approach*, Cambridge University Press, New York, NY.

Cottingham, J. (2016) Analytic Philosophy and Religious Knowledge, *Catholic Comments*, a podcast, Center for Catholic Thought, Creighton University, Omaha, NE, available at http://cucatholicctr.org/2016/09/analytic-philosophy-and-religious-knowledge/, accessed 22 October 2016.

Cottingham, J. (2016) *How to Believe*, Bloomsbury, London.

Couglan, S. (2017) Universities to be warned over false course adverts, *BBC News Online*, BBC, London, 10 November 2017, available at http://www.bbc.co.uk/news/education-41931610, accessed 10 November 2017.

Coupe, L. (1997) *Myth*, Routledge, London.

Cox, S. (2016) Tennis match fixing: Evidence of suspected match-fixing revealed, *BBC Sport*, London, 18 January 2016, available at February 2016.

Creative Industries (2015) *UK Creative Industries – International Strategy Driving global growth for the UK creative industries*, Department for Culture, Media and Sport, UK Government, available at http://www.thecreativeindustries.co.uk/media/252528/ukti_creative_industries_action_plan_aw_rev_3–0_spreads.pdf, accessed 7 January 2017.

Crompton, T. (2010) *Common Cause: The Case for Working with our Cultural Values*, WWF-UK, Woking, Surrey, available at http://assets.wwf.org.uk/downloads/common_cause_report.pdf, accessed 8 May 2016.

Csikszentmihalyi, M. (1990) *Flow: The Psychology of Optimal Experience*, HarperPerennial, New York, NY.

Cunliffe, R. J. (1924) *A Lexicon of the Homeric Dialect*, Blackie and Son Limited, London, available at http://stephanus.tlg.uci.edu/cunliffe/#eid=541&context=lsj, accessed 25 November 2016.

Cytowic, R. E. (1993) *The Man Who Tasted Shapes*, G. P. Putnam's Sons, New York, NY, MIT Press Edition [2003].

David, J. E. (2013) 'Beyond Petroleum' No More? BP Goes Back to Basics, *CNBC*, NBC Universal Group, Englewood Cliffs, NJ, 20 April 2013, available at http://www.cnbc.com/id/100647034, accessed 16 August 2016.

Davies, R. (2016) Rolls-Royce unveils first driverless car complete with silk 'throne', *The Guardian*, London, 16 June 2016, available at https://www.theguardian.com/business/2016/jun/16/rolls-royce-unveils-first-driverless-car-vision-next-100, accessed 17 June 2016.

Davies, R. J. (2016) *Japanese Culture: The Religious and Philosophical Foundations*, Tuttle Publishing, Tokyo.

Davis, A. (1961) Chagall at Vence, *The Guardian*, London, Thursday, 1 June, available at http://static.guim.co.uk/sys-images/Guardian/Pix/pictures/2013/5/24/1369408645374/Chagall-001.jpg, accessed 11 August 2016.

Davison, A. (2001) *Technology and the Contested Meanings of Sustainability*, State University of New York Press, Albany, NY.

Dawkins, N. (2015) *History of Bournville*, Bournville's Resident Association, Bournville Village Council, 26 September 2015, available at http://bournvillevillagecouncil.org.uk/menu-pages/history-of-bournville.html, accessed 11 March 2017.

Dawkins, R. (2006) *The God Delusion*, Bantam Books, Penguin Group, London.

Defra (2007) *An introductory guide to valuing ecosystem services*, Department for Environment, Food and Rural Affairs, UK Government, London, available at http://ec.europa.eu/environment/nature/biodiversity/economics/pdf/valuing_ecosystems.pdf, accessed 23 June 2016.

DESIS (2017) Network of Design for Social Innovation and Sustainability, available at http://www.desisnetwork.org/, accessed 30 June 2017.

de Sousa, V. (2010) Uma Lulik, a documentary film, available at https://vimeo.com/34499848, accessed 9 March 2016.

Dormer, P. (1991) *The Meanings of Modern Design*, Thames and Hudson, London.

Dostoyevsky, F. (1866) *Crime and Punishment*, Constance Garnett (trans.), Wordsworth Editions Ltd, [2000], Ware, Hertfordshire.

Dreaming, The (n.d.) Australian Government Website, available at http://www.australia.gov.au/about-australia/australian-story/dreaming, accessed 8 October 2016.

Dreher, R. (2017) quoted in Jamison, C., 'Setting themselves apart', *The Tablet*, London, 17 June 2017, pp. 4–5.

Duffy, E. (2017) *Reformation Divided: Catholics, Protestants and the Conversion of England*, Bloomsbury, London.

Eagleton, T. (2000) *The Idea of Culture*, Blackwell Publishing, Oxford.

Eagleton, T. (2009) *Reason, Faith, and Revolution: Reflections on the God Debate*, Yale University Press, New Haven.

Easwaran, E. (trans.) (2000) *The Bhagavad Gita*, Vintage Spiritual Classics, Random House, New York, NY.

Economic Advantages and Disadvantages of Foreign Takeovers, The, New Direction Foundation, Brussels, Belgium, August 2014, available at http://europeanreform.org/files/New_Direction_-_Foreign_Takeovers.pdf, accessed 5 September 2016.

Edinburgh Remakery (2017) a social enterprise that offers workspaces and courses for product repair, available at http://www.edinburghremakery.org.uk/, accessed 30 June 2017

Edwards, B. (1979) *Drawing on the Right Side of the Brain*, J. P. Tarcher Inc., Los Angeles.

Edwards, B. (2012) *Drawing on the Right Side of the Brain: The Definitive 4th Edition*, Souvenir Press, London.

Ehrenfeld, J. R. and Hoffman, J. (2013) *Flourishing*, Stanford Business Books, Stanford, CA.

Eikeland O. (2014) 'Praxis' in Coghlan, D. and Brydon-Miller, M. (eds) (2014) *The Sage Encyclopedia of Action Research*, Sage Publications Ltd, London, pp. 653–657, Online Edition accessed at http://www.lancaster.www.lancaster.eblib.com.ezproxy.lancs.ac.uk/patron/FullRecord.aspx-?p=1712670&echo=1&userid=dfvp8VDkAZ7aTpueA%2fon9w%3d%3d&tstamp=145517575 5&id=166D2B7C90C920F322EF6158A9EA09E57C1D802E, accessed 11 February 2016, pp. 654–657.

Ellis-Peterson, H. (2016) Tables turned as vinyl sales overtake digital sales for first time in UK, *The Guardian*, London, 6 December 2016, available at https://www.theguardian.com/music/2016/dec/06/tables-turned-as-vinyl-records-outsell-digital-in-uk-for-first-time, accessed 11 December 2016.

Epistle of Paul and Timothy to the Philippians 4:5, *The New Testament*, KJV.

Evans, A. (2017) *The Myth Gap: What Happens When Evidence and Arguments Aren't Enough?*, Penguin Random House Group, London.

Evans, J. (2014) What Quaker companies can teach us about well-being-at-work, *The History of Emotions Blog*, Queen Mary University London, 1 May 2014, available at https://emotionsblog.history.qmul.ac.uk/2014/05/what-quaker-companies-can-teach-us-about-well-being-at-work/, accessed 11 March 2017.

Feng, G. and English, J. (1989) *Tao Te Ching by Lao Tzu*, Vintage Books, New York, NY.

Ferrari, G. R. F. (ed.) (2000) *Plato: The Republic*, T. Griffith (trans.), Cambridge University Press, Cambridge.

Figgis, M. (2005) *Mike Figgis on "Weekend"*, an interview with film director Mike Figgis discussing the work of French director Jean-Luc Godard, a special feature on the DVD of the film *WEEKEND* (1967) by Jean-Luc Godard, Artificial Eye, London. Also available as *Mike Figgis on Godard* at https://www.youtube.com/watch?v=u9DWp5kZh8o, accessed 26 March 2017.

First Epistle to the Corinthians 9:25, *The New Testament*, KJV.

Franck, F. (1973) *The Zen of Seeing – Seeing/Drawing as meditation*, Vintage Books, New York, NY.

Gadamer, H. G. (1989) *Truth and Method*, 2nd Edition, Continuum, London, [2004].

Gaiman, N. (1999) Some Reflections on Myth (with Several Digressions onto Gardening, Comics and Fairy Tales), in *The View from the Cheap Seats: Selected Non-Fiction*, Headline Publishing Group, London, pp. 59–68.

Gates Foundation (2017) *Bill and Melinda Gates Foundation*, available at http://www.gatesfoundation.org/, accessed 12 March 2017.

Gaudium Et Spes (1965) Pastoral Constitution on The Church in the Modern World, *Gaudium Et Spes,* Promulgated by His Holiness, Pope Paul VI, 7 December, available at http://www.vatican.va/archive/hist_councils/ii_vatican_council/documents/vat-ii_const_19651207_gaudium-et-spes_en.html, accessed 10 March 2016.

Gibson, D. *Destiny – learning to live by preparing to die*, Inter-Varsity Press, London, p. xi.

Godzieba, A. (2016) *Christianity as Music*, Catholic Comments (podcast), Center of Catholic Thought, Creighton University, Omaha, NE, 7 February 2016, available at http://cucatholicctr.org/2016/02/christianity-as-music/, accessed 24 July 2017.

Godzieba, A. J. (2014) "…AND FOLLOWED HIM ON THE WAY" (MK 10:52): IDENTITY, DIFFERENCE, AND THE PLAY OF DISCIPLESHIP, Catholic Theological Society of America Convention, 69th Annual Convention, San Diego, 5–8 June 2014, available at http://www.ctsa-online.org/past_conventions.html, accessed 16 February 2016.

Goldberg, S. (2016) Masdar's zero-carbon dream could become world's first green ghost town, *The Guardian*, 16 February, available at http://www.theguardian.com/environment/2016/feb/16/masdars-zero-carbon-dream-could-become-worlds-first-green-ghost-town, accessed 14 March 2016.

Goodridge, J. F. (trans.) (1959) *Piers the Ploughman*, [14th century] authorship attributed to William Langland, Penguin Group, London, [1966 Edition].

Gorky, Arshile (1948) *Last Painting (The Black Monk)*, Oil on canvas, 78.6 x 101.5 cm, Museo Thyssen-Bornemisza, Madrid, INV. Nr. 564 (1978.72). Image and information at http://www.museothyssen.org/en/thyssen/ficha_obra/397, accessed 23 August 2016.

Gospel of Matthew, 19:14 and 11:25, *New International Version*.

Gregg, S. (2017) Secularism, the new ancien régime, *Catholic Herald*, London, Wednesday, 1 February 2017, available at http://www.catholicherald.co.uk/issues/february-3rd-2017/secularism-the-new-ancien-regime/, accessed 5 February 2017.

Grene, D. and Lattimore, R. (eds) (1959) 'Ajax' by Sophocles, *The Complete Tragedies*, John Moore (trans.), Cambridge University Press, Cambridge, Vol. 2.

Griffith, T. (2000) *Plato: The Republic*, G. R. F. Ferrari (ed.), Cambridge Texts in the History of Political Thought, Cambridge University Press, Cambridge.

Hall, J. and Beardsley, R. (1965) *Twelves Doors to Japan*, McGraw Hill, New York, NY, p. 125, referred to in Davies, R. J. (2016) *Japanese Culture: The Religious and Philosophical Foundations*, Tuttle Publishing, Tokyo, Japan.

Halliday, J. (2013) BBC: new child sex abuse allegations emerge against staff other than Savile, *The Guardian*, Guardian Media Group, London, 30 May 2013, available at http://www.theguardian.com/media/2013/may/30/bbc-staff-child-sex-abuse-allegations, accessed 6 February 2016.

Hardy, T. (1872) *Under the Greenwood Tree*, Wordsworth Classics, Ware, Hertfordshire, [2004].

Hayes, M. (2015) When We Were Almost Like Men, Smokestack Books Ltd, Grewelthorpe, Ripon, UK.

Healy, P. and Barbaro, M. (2015) Donald Trump Calls for Barring Muslims from Entering U.S., *New York Times*, Arthur Ochs Sulzberger Jr., Publisher, New York, NY, 7 December 2015, available at http://www.nytimes.com/politics/first-draft/2015/12/07/donald-trump-calls-for-banning-muslims-from-entering-u-s/, accessed 6 February 2016.

Heidegger, M. (1962) *Being and Time*, Macquarrie, J. and Robinson, E. (trans.), Blackwell, Oxford, available at https://docs.google.com/file/d/0BylvcBG7_xG_bzVkQUxSbnk1ODg/edit, accessed 4 June 2016.

Henley, D. (2016) *The Arts Dividend: Why Investment in Culture Pays*, Elliot and Thompson Ltd, London.

Herbert, A. (1994) 'Ralf Vaughan Williams – Orchestral Works', liner notes of Vaughan Williams: Fantasia on Greensleeves, Fantasia on a Theme by Thomas Tallis, The Lark Ascending, Norfolk Rhapsody, In the Fen Country, 'Dives and Lazarus', The New Queen's Hall Orchestra, Barry Wordsworth (conductor), Argo, The Decca Record Company, London, 1994.

Hesse Media Release (2012) *Hermann Hesse's dual talents in painting and poetry*, Kunst Museum, Bern, 26 March 2012, available at http://www.kunstmuseumbern.ch/admin/data/hosts/kmb/files/page_editorial_paragraph_file/file_en/522/120326_Medienmitteilung_HermannHesse_e.pdf?lm=1332747482, accessed 30 December 2016.

Heywood, V. (2015) Foreword, *Enriching Britain: Culture, Creativity and Growth, Warwick Commission on the Future of Cultural Value*, authored by Neelands, J., Belfiore, E., Firth, C., Hart, N., Perrin, L., Brock, S., Holdaway, D. and Woddis, J., University of Warwick, Coventry, pp. 8–9.

Hibbard, H. (1983) *Caravaggio*, Westview Press, Boulder, CO.

Hick, J. (1982) *God Has Many Names*, Philadelphia, PA.

Hitchens, C. (2007) *God is Not Great*, Hatchette Book Group, New York, NY.

Honderich, T. (ed.) (1995) *The Oxford Dictionary of Philosophy*, Oxford University Press, Oxford, description of praxis based on Nicholas Lobkowicz, *Theory and Practice: History of a Concept from Aristotle to Marx* (Notre Dame, IN, 1967), Online Edition available at https://alingavreliuc.files.wordpress.com/2010/10/honderich-ted-ed-the-oxford-companion-to-philosophy.pdf, accessed 25 April 2016, p. 1804.

Horkheimer, M. and Adorno, T. W. (1947) *Dialectic of Enlightenment*, G. Schmid Noerr (ed.), E. Jephcott (trans.), Stanford University Press, Stanford, CA, [2002].

Hotten, R. (2015) Volkswagen: The scandal explained, *BBC News Online*, London, 10 December 2016, available at http://www.bbc.co.uk/news/business-34324772, accessed 6 February 2016.

Hoult, N. (2016) South African cricket braced for huge match-fixing scandal after evidence of corruption in Ram Slam T20, *The Telegraph*, Telegraph Media Group, London, 13 January 2016, available at http://www.telegraph.co.uk/sport/cricket/international/southafrica/12097971/South-African-cricket-braced-for-huge-match-fixing-scandal-after-evidence-of-corruption-in-Ram-Slam-T20.html, accessed 6 February 2016.

Hughes, L. (2017) Theresa May accused of failing to show 'humanity' during Grenfell Tower visit, *The Telegraph*, Telegraph Media Group, London, 16 June 2017, available at http://www.telegraph.co.uk/news/2017/06/16/theresa-may-failed-show-humanity-grenfell-tower-visit-saysmichael/, accessed 24 June 2017.

Hughes, R. (1985) 'Caravaggio' a review of *The Age of Caravaggio* Exhibition at the Metropolitan Museum of Art, New York original published in *Time* magazine, published in Hughes, R. (1990) *Nothing if not Critical*, Alfred A. Knopf, New York, NY, pp. 33–37.

Hughes, R. (1991) *The Shock of the New*, 2nd Edition (updated and enlarged), Thames and Hudson, London.

Huxley, A. (1945) *The Perennial Philosophy*, Triad Grafton Books, London, [1991].

ICA (2017) *International Cooperative Alliance*, Brussels, Belgium, available at http://ica.coop/, accessed 11 March 2017.

ICSID (2015) *Redefining Industrial Design*, Professional Practise Committee, International Council of Societies of Industrial Design, 29th General Assembly, Gwangju, South Korea, available at http://www.icsid.org/about/about/articles31.htm, accessed 22 February 2016.

IDSA (2015) *What is Industrial Design*, Industrial Designers Society of America, Herndon, VA, available at http://www.idsa.org/education/what-is-industrial-design, accessed 20 February 2016.

Ingle, S. (2016) IAAF in crisis: a complex trail of corruption that led to the very top, *The Guardian*, Guardian Media Group, London, 7 January 2016, available at http://www.theguardian.com/sport/2016/jan/07/russia-doping-scandal-corruption-blackmail-athletics-iaaf, accessed 6 February 2016.

IPCC (2014) *Climate Change 2014 Synthesis Report: Summary for Policymakers*, Intergovernmental Panel on Climate Change, Geneva, Switzerland, available at https://www.ipcc.ch/pdf/assessment-report/ar5/syr/AR5_SYR_FINAL_SPM.pdf, accessed 17 May 2016.

Ipsos-MORI (2016) Politicians are still trusted less than estate agents, journalists and bankers, *Ipsos MORI Veracity Index 2015: Trust in Professions*, Ipsos-MORI, London, 22 January 2016, available at https://www.ipsos-mori.com/researchpublications/researcharchive/3685/Politicians-are-still-trusted-less-than-estate-agents-journalists-and-bankers.aspx, accessed 12 February 2017.

Jasper, D. (2014) *A Short Introduction to Hermeneutics*, Westminster John Knox Press, Louisville, KY.

Jaspers, K. (1953) *The Origin and Goal of History*, Michael Bullock (trans.), Routledge & Kegan Paul Ltd London, (first published in German in 1949).

Jeong, S-H., Kim, H., Yum, J-Y. and Hwang, Y. (2016) What type of content are smartphone users addicted to?: SNS vs. games, *Computers in Human Behaviour*, Elsevier, Amsterdam, Vol. 54, pp. 10–17.

Jiminéz-Blanco, M. D. (ed.) (2016) Romanesque Painting, *The Prado Guide*, 16th Edition.

Johnston, W. (ed.) (2005) *The Cloud of Unknowing & the Book of Privy Counseling*, Image Books, Doubleday, New York, NY.

Kahn, A. (2000) *Kind of Blue: The Making of the Miles Davis Masterpiece*, De Capo Press, HarperCollins, New York, NY.

Kamali, M. K. (2015) *The Middle Path of Moderation in Islam: The Quranic Principle of Wasatiyyah*, Oxford University Press, New York.

Kamo-no-Chomei (1212) *Hojoki: Visions of a Torn World*, Moriguchi, Y. and Jenkins, D. (trans.) [1996], Stone Bridge Press, Berkeley, CA.

Kandinsky, W. (1938) *Der Wert eines Werkes der konkreten Kunst*, available at http://kunstdirekt.net/kunstzitate/manual/index.html?kunstzitate_31_der_wert_eines_werkes_1938.htm.

Kasser, T. (2009) *Psychological Need Satisfaction, Personal Well-Being, and Ecological Sustainability*, *Ecopsychology*, Mary Ann Liebert, Inc., New Rochelle, NY, Vol. 1, No. 4, December 2009, pp. 175–180.

Keats, J. (1816) *John Keats: Selected Poems*, Penguin Group, London.

Keene, D. (trans.) (1967) *Essays in Idleness: The Tsurezuregusa of Kenkō*, Tuttle Publishing, Tokyo, [1981].

Kenber, W. (2016) 'Rip-off' drug firms exposed by *Times* face massive fines, *The Times*, Times Newspapers Ltd, London, Wednesday, 26 October 2016.

Kim, Y. J. and Zhong C-B. (2017) Ideas rise from chaos: Information structure and creativity, *Organizational Behaviour and Human Decision Processes*, Vol. 138, pp. 15–27.

King, A. (n.d.) The Aesthetic Attitude, *Internet Encyclopedia of Philosophy*, Fieser, J. (ed.), University of Tennessee, Martin, TN, available at http://www.iep.utm.edu/aesth-at/#SH4a, accessed 5 April 2017.

Kingley, P. (2013) Masdar: the shifting goalposts of Abu Dhabi's ambitious eco-city, *WIRED*, 17 December, available at http://www.wired.co.uk/magazine/archive/2013/12/features/reality-hits-masdar, accessed 14 March 2016.

Kirosawa, A. (1990) The Village of the Watermills, section 8 of the movie *Dreams*, 119 minutes, Japan, Distributed by Warner Brothers.

Kleiner, F. (2009) *Gardner's Art through the Ages: A Global History, Volume 2*, Cengage Learning, Stamford, CT.

Knowles, B. (2013) *Re-Imagining Persuasion: Designing for Self-Transcendence*, CHI 2013: Changing Perspectives, 27 April to 2 May 2013, Paris, France, ACM 978-1-4503-1952-2/13/04, pp. 2713–2718.

Lambert, T. (n.d.) *A Brief History of Lancaster, Lancashire*, available at http://www.localhistories.org/lancaster.html, accessed 7 August 2016.

Lansley, S. (1994) *After the Gold Rush – The Trouble with Affluence*, Century Business Books, London.

Larson, C. (2009) China's Grand Plans for Eco-Cities Now Lie Abandoned, Environment 360, Yale University, New Haven CT, 6 April, available at http://e360.yale.edu/feature/chinas_grand_plans_for_ecocities_now_lie_abandoned/2138/, accessed 14 March 2016.

Larson, J. and Kreitzer, M. J. (reviewers) (n.d.) *How Does Nature Impact Our Wellbeing?* Taking Charge of your Health and Wellbeing, University of Minnesota, Minneapolis, MN, available at https://www.takingcharge.csh.umn.edu/enhance-your-wellbeing/environment/nature-and-us/how-does-nature-impact-our-wellbeing, accessed 16 April 2017.

Laudato Si (2015) *Encyclical Letter Laudato Si of the Holy Father Francis on Care for our Common Home*, Liberia Editrice Vaticana, print edition by Amazon.co.uk, Chapter 3, Section 115.

Le Quéré, C., Andrew, R. M., Canadell, J. G., Sitch, S., Korsbakken, J. I., Peters, G. P., Manning, A. C., Boden6, T. A., Tans, P. P., Houghton, R. A., Keeling, R. F., Alin, S., Andrews, O. D., Anthoni, P., Barbero, L., Bopp, L., Chevallier, F., Chini, L. P., Ciais, P., Currie, K., Delire, C., Doney, S. C., Friedlingstein, P., Gkritzalis, T., Harris, I., Hauck, J., Haverd, V., Hoppema, M., Goldewijk, K. K., Jain, A. K., Kato, E., Körtzinger, A., Landschützer, P., Lefèvre, N., Lenton, A., Lienert, S., Lombardozzi, D., Melton, J. R., Metzl, N., Millero, F., Monteiro, P. M. S., Munro, D. R., Nabel, J. E. M. S., Nakaoka, S., O'Brien, K., Olsen, A., Omar, A. M., Ono, T., Pierrot, D., Poulter, B., Rödenbeck, C., Salisbury, J., Schuster, U., Schwinger, J., Séférian, R., Skjelvan, I., Stocker, B. D., Sutton, A. J., Takahashi, T., Tian, H., Tilbrook, B., van der Laan-Luijkx, I. T., van der Werf, G. R., Viovy, N., Walker, A. P., Wiltshire, A. J., Zaehle, S. (2016) Global Carbon Budget 2016, *Earth System Science Data: The Data Publishing Journal*, Copernicus Publications, Göttingen, Germany, Vol. 8, pp. 605–649, available at http://www.earth-syst-sci-data.net/8/605/2016/essd-8–605–2016.pdf, accessed 14 November 2016.

Lee, D. (trans.) (1987) *Plato: The Republic*, Penguin Books, London.

Li, S., Stampfer, M. J., Williams, D. R. and VanderWeele, T. J. (2016) Association of Religious Service Attendance With Mortality Among Women, *JAMA Internal Medicine*, American Medical Association Publishing Group, Chicago, IL, Vol. 176, No. 6, pp. 777–785.

Liddell, H. G. and Scott, R. (1940) *A Greek–English Lexicon*, Oxford: Clarendon Press, available at http://www.perseus.tufts.edu/hopper/text?doc=Perseus:text:1999.04.0057:entry=a(marta/nw, accessed 25 November 2016.

Lightman, B. (2011) Unbelief, Chapter 11, pp. 252–277, *Science and Religion Around the World*, Brook, J. H. and Numbers, R. N. (eds), Oxford University Press, New York, NY.

Lindner Sock Factory and Shop, Crookwell, New South Wales, Australia, available at http://www.lindnersocks.com.au/index.html, accessed 30 September 2016.

Longley, C. (2016) Meritocracy is ultimately a flawed project, *The Tablet*, London, 15 October 2016, p. 9.

MacCulloch, D. (2013) *Silence: A Christian History*, Allen Lane, Penguin Group, London.

Majurin, E. (2010) Promising Practices: How cooperatives work for working women in Africa, The Cooperative Facility for Africa (COOP AFRICA), International Labour Organization, March 2010, available at http://www.ilo.org/public/english/employment/ent/coop/africa/download/women_day_coop.pdf, accessed 11 March 2017.

Mann, T. (1998) *Death in Venice and other Stories*, Vintage, Random House, London.

Manzini, E. and Jégou, F. (2003) *Sustainable Everyday – Scenarios for Urban Life*, Edizioni Ambiente, Milan.

Marin, L. (1995) *To Destroy Painting*, University of Chicago Press, Chicago, IL.

Marin, L. (2002) *On Representation*, Stanford University Press, Redwood City, CA.

Mathiesen, K. (2015) What is the Bill and Melinda Gates Foundation?, *The Guardian*, London, 16 March 2015, available at https://www.theguardian.com/environment/2015/mar/16/what-is-the-bill-and-melinda-gates-foundation, accessed 12 March 2017.

Maugham, W. S. (1919) *The Moon and Sixpence*, Vintage Books, Random House, New York, NY, p. 29.

McBride, J., Alessi, C. and Sergie, M. A. (2015) *Understanding the Libor Scandal*, Council on Foreign Relations, New York, NY, available at http://www.cfr.org/united-kingdom/understanding-libor-scandal/p28729, accessed 6 February 2016.

McGilchrist, I. (2009) *The Master and his Emissary: The Divided Brain and the Making of the Western World*, Yale University Press, New Haven, CT.

McGirk, J. (2016) Why eco-cities fail, *China Dialogue*, 27 May, available at https://www.chinadialogue.net/books/7934-Why-eco-cities-fail/en, accessed 14 May 2016.

McKie, R. (2016) Nicholas Stern: cost of global warming 'is worse than I feared', *The Guardian*, London, 6 November 2016, available at https://www.theguardian.com/environment/2016/nov/06/nicholas-stern-climate-change-review-10-years-on-interview-decisive-years-humanity, accessed 6 November 2016.

McLuhan, E. (1984) The Emergence of the Images Makers, in *Norval Morrisseau and the Emergence of the Image Makers*, by E. McLuhan and T. Hill, Art Gallery of Ontario, Methuen, Toronto, ON, pp. 28–108.

McMullan, T. (2016) How a robot could be grandma's new carer, *The Guardian*, London, 6 November, available at https://www.theguardian.com/technology/2016/nov/06/robot-could-be-grandmas-new-care-assistant, accessed 3 December 2016.

McNaught, W. (2015) *Peter Grimes* review: 'An orchestral score full of vivid suggestion and action', *The Guardian*, London, a reprint of the original review that appeared in the *Manchester Guardian* on 9 June 1945, published 29 December 2015, available at https://www.theguardian.com/music/from-the-archive-blog/2015/dec/29/benjamin-britten-peter-grimes-first-performance-1945, accessed 13 February 2017.

Mellor, A. (2016) The return of the LP – what lies behind the renewed appeal of vinyl?, *Gramophone*, London, 30 June 2016, available at http://www.gramophone.co.uk/feature/the-return-of-the-lp-what-lies-behind-the-renewed-appeal-of-vinyl, accessed 11 December 2016.

Merton, T. (1960) *The Wisdom of the Desert*, New Directions Publishing Corp., New York, NY, [1970].

Michaels, F. S. (2011) *Monoculture – How One Story is Changing Everything*, Red Clover Press, http://www.redcloverpress.com/.

Miles Davis and *Kind of Blue* (2014) *Witness*, BBC World Service, broadcast Wednesday 10 December 2014 08:50 Local time, available at http://www.bbc.co.uk/programmes/p02dcqff, accessed 7 August 2017

Miller, A. (1949) *Death of a Salesman*, Penguin Books, London, [1961].

Mishra, P. (2017) *Age of Anger*, Allen Lane, Penguin Books, London.

Monbiot, G. (2016) *How Did We Get Into This Mess: Politics, Equality and Nature*, Verso, London.

More, T. (1516) Utopia, Creative Commons Edition published by Planet eBook, available at http://www.planetebook.com/ebooks/Utopia.pdf, accessed 4 August 2016.

More, T. (1516) *Utopia*, Wisehouse Classics, Ballingslöv, Sweden, [2015].

Morgan, T. C. (2015) Melinda Gates: 'I'm Living Out My Faith in Action', *Christianity Today*, Christianity Today International, Carol Stream, IL, 28 July 2015, available at http://www.christianitytoday.com/ct/2015/july-august/melinda-gates-high-price-of-faith-action.html?start=1, accessed 12 March 2017.

Morley, N. (2017) Theresa May's first interview after Grenfell Tower protesters label her 'a coward', *Metro*, Associated Newspapers Limited, London, 17 June 2017, available at http://metro.co.uk/2017/06/17/theresa-may-first-interview-after-grenfell-tower-protesters-label-her-a-coward-6715096/, accessed 24 June 2017.

Morris, C. (2016) Vinyl Record Sales are at a 28-Year High, *Fortune.com*, Time Inc., New York, NY, 6 April 2016, available at http://fortune.com/2016/04/16/vinyl-sales-record-store-day/, accessed 11 December 2016.

Morrison, R. (1991) *We Build the Road as We Travel*, New Society Publishers, Philadelphia, PA.

Morrisseau, N. (2008) *A Separate Reality* can be viewed online at http://www.morrisseau.com/viewPhoto.php?fileID=505, accessed 18 July 2017.

Mytels, D. (2017) Palo Alto Residents Share Dishware to Reduce Waste, Build Community, *Shareable*, 5 January 2017, available at http://www.shareable.net/blog/palo-alto-residents-share-dishware-to-reduce-waste-build-community, accessed 7 January 2017.

Needleman, J. (1991) *Money and the Meaning of Life*, Doubleday Dell, New York, NY.

New Delft (n.d.) Royal Delft, Rotterdamseweg 196, 2628 AR Delft, available at http://www.royaldelft.com/product.asp?coll=4&cat=17, accessed 15 December 2016.

New Testament – The Holy Bible, New International Version, Zondervan Publishing House, Grand Rapids, MI.

Nianas, H. (2015) Lance Armstrong doping; What we learned from his many lies, *The Independent*, Independent Print Limited, London, 27 January 2015, available at http://www.independent.co.uk/news/people/lance-armstrong-doping-what-we-learned-from-his-many-lies-10005386.html, accessed 6 February 2016.

Nicoll, M. (1950) *The New Man*, Penguin Books [1972], Baltimore, ML.

Nicoll, M. (1954) *The Mark*, Vincent Stuart, London.

Nisenson, E. (2000) *The Making of Kind of Blue: Miles Davis and His Masterpiece*, St. Martin's Press, New York, NY.

Nocera, J. (2016) True Scandal of Deflategate Lies in the N.F.L.s Behavior, *New York Times*, Arthur Ochs Sulzberger Jr., Publisher, New York, NY, 22 January 2016, available at http://www.nytimes.com/2016/01/23/sports/football/nfl-ignores-ball-deflation-science-at-new-england-patriots-expense.html?_r=0, accessed 6 February 2016.

Norris, R. and Norris, C. (2008) *Emu Dreaming: An Introduction to Australian Aboriginal Astronomy*, Emu Dreaming, Winston Hills, NSW.

Novaes, C. D. and Franklin, R. (2017) What is logic? *Aeon*, Aeon Media Group Ltd, London, 12 January 2017, available at https://aeon.co/essays/the-rise-and-fall-and-rise-of-logic, accessed 17 January 2017.

NPR (2001) *Miles Davis: 'Kind of Blue'*, NPR Music, National Public Radio, Washington, DC, available at http://www.npr.org/2011/01/04/10862796/miles-davis-kind-of-blue, accessed 7 August 2017.

O'Connor, R. (2016) Vinyl album sales out-perform digital downloads for first time, *The Independent*, London, 6 December 2016, available at http://www.independent.co.uk/arts-entertainment/music/news/vinyl-sales-digital-downloads-albums-record-store-day-a7458841.html, accessed 11 December 2016.

O'Neill, J. P. and Schultz, E. (eds) (1985) *The Age of Caravaggio* (Exhibition Catalogue), Metropolitan Museum of Art, New York, NY.

Object Therapy (2017) Australian Design Centre, Canberra, ACT, both an exhibition and a design-centred project that explore transformation and notions of value through product reimagining and repair, available at https://australiandesigncentre.com/object-therapy/, accessed 30 June 2017.

Orledge, R. (1994) 'Canteloube – Chants d'Auvergne', liner notes of Canteloube – Chants d'Auvergne, English Chamber Orchestra, Yan Pascal Tortelier (conductor), Arleen Auger (soprano), Virgin Classics, London.

Orwell, G. (1949) *Nineteen Eighty-Four*, Penguin Books Ltd, Harmondsworth, Middlesex.

Osodi, G. (2015) *Oil boom, Delta burns: photographs by George Osodi*, International Slavery Museum, Liverpool, 17 April 2015, available at http://www.liverpoolmuseums.org.uk/ism/exhibitions/osodi/, accessed 6 February 2016.

Paradiso, M. (2015) Chiara Vigo: The last woman who makes sea silk, *BBC News Magazine Online*, 2 September, available at http://www.bbc.co.uk/news/magazine-33691781, accessed 2 September 2015.

Park, S. Q., Kahnt, T., Dogan, A., Strang, S., Fehr, E. and Tobler, P. N. (2017) A neural link between generosity and happiness, *Nature Communications*, Springer, New York, NY, No. 8, Article number: 15964, doi:10.1038/ncomms15964, published online 11 July 2017, available at https://www.nature.com/articles/ncomms15964, accessed 13 July 2017.

Parrish, D. (2017) *Creative Industries*, available at http://www.davidparrish.com/creative-industries/, accessed 7 January 2017.

Pascoe, B. (2014) *Dark Emu Black Seeds: agriculture or accident?* Magdala Books Aboriginal Corporation, Broome, Western Australia.

Pelikan, J. (1990) *Imageo Dei: The Byzantine Apologia for Icons*, Princeton University Press, Princeton, NJ.

Phillips, R. (n.d.) *A Separate Reality*, text accompanying the painting by Norval Morrisseau at the Canadian Museum of History, Gatineau, QC, source: Ruth Phillips, Museum of Anthropology, University of British Columbia.

Phipps, C., Hills, D. and Graham, B. A. (2015) Fifa in crisis amid corruption arrests and World Cup voting inquiry – as it happened, *The Guardian*, Guardian Media Group, London, 27 May 2015, available at http://www.theguardian.com/football/live/2015/may/27/fifa-officials-arrested-on-corruption-charges-live, accessed 6 February 2016.

Piser, K. (2017) Why Forced Secularism in Schools Leads to Polarization, *The Atlantic*, The Atlantic Monthly Group, Boston, MA, February, available at https://www.theatlantic.com/education/archive/2017/02/why-forced-neutrality-leads-to-polarization/516222/, accessed 10 February 2017.

Plato: *Phaedo* 68b–c, in Tredennick, H. and Tarrant, H. (trans.) *The Last Days of Socrates*, Penguin, London, [2003].

Portús, J. (2011) *El Prado en el Ermitage,* Museo Nacional del Prado, Madrid.

Postman, N. (1985) *Amusing Ourselves To Death: Public Discourse in the Age of Show Business*, Methuen London Ltd, London.

Potter's Paw, The (2002) Nizwa Net, available at http://www.nizwa.net/heritage/wonderloop/wonderloop.html, accessed 29 September 2016.

Pratt, V., Brady, E. and Howarth, J. (2000) *Environment and Philosophy*, Routledge, London, extract available at http://www.vernonpratt.com/thehumanbeing/individualism.htm, 12 February 2014.

Premium Economy Class Comparison Chart (2016) Seat Guru, TripAdvisor, Needham, MA, United States, available at https://www.seatguru.com/charts/premium_economy.php, accessed 2 November 2016.

Prose, F. (2005) *Caravaggio: Painter of Miracles*, HarperCollins, New York, NY.

Pullella, P. (2007) *Pope criticises EU for excluding God*, Reuters, 24 March, available at http://www.reuters.com/article/us-eu-anniversary-pope-idUSL2421365520070324, accessed 17 May 2016.

Rams, D. (n.d.) *The power of good design: Dieter Rams's ideology, engrained within Vitsœ*, Vitsœ, London (founded by Niels Vitsœ and Otto Zapf in 1959 to manufacture the furniture design of Dieter Rams), available at http://www.designprinciplesftw.com/collections/ten-principles-for-good-design, accessed 11 April 2017.

RCI (2015) *Regional competitiveness statistics*, Eurostat, European Commission, 16 October 2015, available at http://ec.europa.eu/eurostat/statistics-explained/index.php/Regional_competitiveness_statistics, accessed 12 February 2017.

RCUK Annual Report (2016) Research Councils UK, Swindon (AHRC; BBSRC; EPSRC; ESRC; MRC; NERC; STFC), available at http://www.rcuk.ac.uk/media/news/160725/, accessed 3 December 2016.

Rebanks, J. (2015) *The Shepherd's Life: A Tale of the Lake District*, Allen Lane, Penguin Random House, London.

Remakery (2017) a London-based co-operative workshop space that helps build community skills and opportunities, available at http://remakery.org/about/, accessed 30 June 2017.

Reno, R. R. (2016) Decline and fall of the post-Christian elite, *Catholic Herald*, London, Thursday 6 October 2016, available at http://www.catholicherald.co.uk/issues/october-7th-2016/decline-and-fall-of-the-post-Don't christian-elite/, accessed 18 May 2017.

Restorative Power of Nature, The (2016) University of Leiden, Leiden, The Netherlands, published 18 January 2016, available at https://www.universiteitleiden.nl/en/news/2016/01/the-restorative-benefits-of-nature, accessed 16 April 2017.

ReTuna Återbruksgalleria (2017) a Swedish recycling centre and shopping mall for repaired and recycled goods, available at https://www.retuna.se, accessed 30 June 2017.

Reynolds, M. (1962) *Little Boxes*, song lyrics available at http://people.wku.edu/charles.smith/MALVINA/mr094.htm, accessed 9 October 2016.

Reynolds, R. (2011) *A Bodger not a Botcher*, Potter Wright & Webb, available at http://www. potterwrightandwebb.co.uk/wood-2/a-bodger-is-not-a-botcher, accessed 12 September 2016.

Rhonheimer, M. (2012) Capitalism, Free Market Economy, and the Common Good: The Role of the State in the Economy, Ch. 1 in Schlag, M. and Mercado, J. A. (eds), *Free Markets and the Culture of Common Good*, Springer, New York, NY, pp. 3–40.

Rieu, E. V. (trans.) (1946) *Homer: The Odyssey*, Penguin Books, London.

Robinson, M. (2012) *When I Was a Child I Read Books*, Virago Press, London.

Robinson, M. (2017) A contrarian voice: 'The Churches have disgraced themselves', *The Tablet*, London, 4 February 2017, pp. 4–5.

Rodionova, Z. (2016) UK pubs closing at a rate of 27 a week, Camra says, *The Independent*, London, Thursday 4 February 2016, available at http://www.independent.co.uk/news/business/news/ uk-pubs-closing-at-a-rate-of-27-a-week-camra-says-a6853686.html, accessed 23 August 2016.

Roebuck, V. (trans.) (2010) *The Dhammapada*, Penguin Group, London.

Romer, C. (2017) Education Minister: 'worry about decline in arts subjects – computing is on the rise', *Arts Professional*, Histon, Cambridge, 7 July 2017, available at https://www.artsprofessional. co.uk/news/education-minister-dont-worry-about-decline-arts-subjects-computing-rise, accessed 11 July 2017.

Ross, A. (2016) Five die in French Alps in series of extreme sports accidents, *The Guardian*, London, 15 August 2016, available at https://www.theguardian.com/world/2016/aug/15/five-die-in-french-alps-in-series-of-extreme-sports-accidents, accessed 27 September 2016.

Ross, W. D. (trans.) (2011) *The Nicomachean Ethics of Aristotle*, Pacific Publishing, Seattle, available at https://ebooks.adelaide.edu.au/a/aristotle/nicomachean/, accessed 26 September 2016, Book 2.

Rowe, C. (trans.) (2005) *Phaedrus* by Plato, Penguin Classics, Penguin Group, London, lines 237d4–238a7.

Ruddick, G., Butler, S. and Allen, K. (2016) BHS rescue bid fails with loss of 11,000 jobs, *The Guardian*, London, 2 June 2016, available at https://www.theguardian.com/business/2016/ jun/02/bhs-rescue-bid-fails-putting-11000-jobs-at-risk, accessed 11 March 2017.

Ruskin, J. (1846) Ch. XV, General Conclusions Respecting The Theoretic Faculty, Modern Painters Vol. II containing Part III, Section I & II, Of the Imaginative and Theoretic Faculties, Section I, p213, contained in Cook, E. T. and Wedderburn, A. (eds) (1904) *Library Edition: The Complete Works of John Ruskin, Vol. IV*, George Allen, London, p. 1023 of PDF version, available at http:// www.lancaster.ac.uk/depts/ruskinlib/Modern%20Painters, accessed 26 September 2014.

Ruskin, J. (1856) Ch. XVI, Of Modern Landscape, Modern Painters Vol. III containing Part IV Of Many Things, Section 18, p. 328, contained in Cook, E. T. and Wedderburn, A. (eds) (1904) *Library Edition: The Complete Works of John Ruskin, Vol. V*, George Allen, London, p. 1623 of PDF version, available at http://www.lancaster.ac.uk/depts/ruskinlib/Modern%20Painters, accessed 26 September 2014.

Ruskin, J. (1856) Ch. III, Of the Real Nature of Greatness of Style, Modern Painters Vol. III containing Part IV Of Many Things, Section 12, p56, contained in Cook, E. T. and Wedderburn, A. (eds) (1904) *Library Edition: The Complete Works of John Ruskin, Vol. V*, George Allen, London, p. 1339 of PDF version, available at http://www.lancaster.ac.uk/depts/ruskinlib/ Modern%20Painters, accessed 26 September 2014.

Russell, B. (1953) *Satan in the Suburbs and Other Stories*, Penguin Books Ltd, Harmondsworth, Middlesex.

Russell, B. (1975) *Autobiography*, Routledge Classics Edition [2010], Routledge, Abingdon, Oxon.

Sachs, W. (2010) One World, *The Development Dictionary: A Guide to Knowledge as Power*, Sachs, W. (ed.), 2nd Edition, Zed Books, London, pp. 111–126.

Saul, J.R. (2005) *The Collapse of Globalism and the Reinvention of the World*, Viking, Penguin Group, Toronto.

Scheffler, S. (2013) *Death and the Afterlife*, Oxford University Press, New York, NY.

Schellhorn, M. (2016) What John Cage can teach us about the Mass, *The Catholic Herald*, London, 18 February, available at http://catholicherald.co.uk/commentandblogs/2016/02/18/what-john-cage-can-teach-us-about-the-mass/, accessed 22 February 2016.

Schimmel, A. (1992) *Rumi's World: The Life and Work of the Great Sufi Poet*, Shambhala Publications, Boston, MA.

Schmitz, M. (2017) A beautiful Church for the poor, *Catholic Herald*, London, 23 February, available at http://www.catholicherald.co.uk/issues/february-24th-2017/a-beautiful-church-for-the-poor/, accessed 28 February 2017.

Schumacher, E. F. (1973) *Small is Beautiful: A Study of Economics as if People Mattered*, Abacus, Penguin Books, London.

Schwaabe, C. (2011) *Max Weber – The Disenchantment of the World*, Uhlaner, J. (trans.), Goethe-Institut e. V., available at http://www.goethe.de/ges/phi/prt/en8250983.htm, accessed 14 February 2014.

Schwartz, B. (2004) *The Paradox of Choice*, HarperCollins, New York, NY.

Scruton, R. (1996) *A Dictionary of Political Thought*, 2nd Edition, Macmillan, London.

Scruton, R. (2000) *An Intelligent Person's Guide to Modern Culture*, St. Augustine Press, South Bend, IN.

Scruton, R. (2016) *Confessions of a Heretic*, Nottinghill Editions, London.

Seafood Company Sheds 120 Jobs, *BBC News Online*, 14 November 2006, available at http://news.bbc.co.uk/2/hi/uk_news/scotland/south_of_scotland/6146974.stm, accessed 1 October 2016.

Seating (2016) Emirates airline company, Dubai, United Arab Emirates, available at http://www.emirates.com/uk/english/flying/seating/seating.aspx, accessed 2 November 2016.

Second Epistle to the Corinthians 8:13–15, The New Testament, KJV.

Segal, R. A. (2015) *A Very Short Introduction to Myth*, Oxford University Press, Oxford, 2nd Edition.

Shareable, San Francisco, CA, available at http://www.shareable.net/, accessed 7 January 2017.

Sharing Depot, Toronto, ON, available at https://sharingdepot.ca/, accessed 7 January 2017.

Sheffield, H. (2016) Tesco launches range of products named after farms that don't actually exist, *The Independent*, London, 24 March 2016, available at http://www.independent.co.uk/news/business/news/tesco-willow-boswell-rosedene-redmere-made-up-fictional-farms-a6949801.html, accessed 7 August 2016.

Sherwood, H. (2016) People of no religion outnumber Christians in England and Wales – study, *The Guardian*, London, available at http://www.theguardian.com/world/2016/may/23/no-religion-outnumber-christians-england-wales-study, accessed 24 May 2016.

Shortt, R. (2016) *God Is No Thing: Coherent Christianity*, Hurst and Company, London.

Sim, S. (2007) *Manifesto for Silence: Confronting the Politics and Culture of Noise*, Edinburgh University Press.

Simon, H. A. (1996) *The Sciences of the Artificial, Cambridge*, 3rd Edition, The MIT Press, Cambridge, MA.

Smith, Z. (2016) The Embassy of Cambodia, *The Penguin Book of the British Short Story Volume 2*, Hensher, P. (ed.), Penguin Books, London, pp. 687–708.

Smith, Z. (2016) *The Sayings of the Desert Fathers,* Catholic Comments Podcast, Department of Theology, Creighton University, Omaha, NE, 1 February 2016, available at http://cucatholicctr.org/2016/02/the-sayings-of-the-desert-fathers/, accessed 2 February 2016.

Snodgrass, A. and Coyne, R. (1997) Is Designing Hermeneutical?, *Architectural Theory Review*, Journal of the Department of Architecture, The University of Sydney, Vol. 1, No. 1, pp. 65–97.

Solana, J. (1920) Painting: *La tertulia del Café de Pombo* (The Gathering at the Café de Pombo) by artist José Gutiérrez Solana (1886–1945), painted in Madrid, Spain, 1920, Reina Sofia Museum, Madrid. Further information is available at http://www.museoreinasofia.es/en/collection/artwork/tertulia-cafe-pombo-gathering-cafe-pombo, accessed 23 August 2016.

Spencer, J. M. (1996) Miles Davis' *Kind of Blue*, Critic's Corner, *Theology Today*, Sage Publications, Thousand Oaks, CA, Vol. 52, No. 4, pp. 506–510.

SponGes (2016) *SponGES: Deep-sea Sponge Grounds Ecosystems of the North Atlantic: an integrated approach towards their preservation and sustainable exploitation*, University of Bergen, Norway, available at http://www.deepseasponges.org/?page_id=242, accessed 18 June 2016.

Spurlock, R. S. (n.d) *Arnold Joseph Toynbee – An Historian's Approach to Religion*, The Gifford Lectures, Templeton Press, West Conshohocken, PA, available at http://www.giffordlectures.org/lectures/historians-approach-religion, accessed 3 November 2016.

Sri Dhammananda, K. (1987) Chapter 5 Basic Doctrines: The Noble Eightfold Path: The Middle Way, *What Buddhists Believe, Buddhist Missionary Society* Malaysia, *Sabah* Branch, Kota Kinabalu, Malaysia, available at http://www.sinc.sunysb.edu/Clubs/buddhism/dhammananda/78.htm, accessed 27 September 2016.

Staats, H., Jahncke, H., Herzog, T. R. and Hartig, T. (2016) Urban Options for Psychological Restoration: Common Strategies in Everyday Situations, *PLoS ONE journal*, Cambridge, UK, Vol. 1, No. 1: e0146213, 5 January 2016, available at http://journals.plos.org/plosone/article?id=10.1371/journal.pone.0146213, accessed 16 April 2017, pp. 1–24.

Staniforth, M. (trans.) (1964) *Marcus Aurelius: Meditations*, Penguin Books, London.

Steindl-Rast, D. (1977) Learning to Die, *Parabola*, Vol. 2, Issue 1, Winter, pp. 22–31, available at http://gratefulness.org/resource/learning-to-die/, accessed 10 February 2017.

Stern, N. (2006) *Stern Review: Economics of Climate Change*, H. M. Treasury, London, available at http://webarchive.nationalarchives.gov.uk/20080910140413/http://www.hm-treasury.gov.uk/independent_reviews/stern_review_economics_climate_change/stern_review_report.cfm, accessed 6 November 2016.

Stipes, J. (trans.) (1995) *The Fairy Tales of Hermann Hesse*, Bantam Books, New York, NY.

Storr, A. (1996) *Feet of Clay – Saints, Sinners, and Madmen: A Study of Gurus*, Free Press Paperback Edition [1997], Simon & Schuster, New York, NY.

Strauss, I. E. (2017) The Original Sharing Economy, *The Atlantic*, Washington, DC, 3 January 2017, available at https://www.theatlantic.com/business/archive/2017/01/original-sharing-economy/511955/?utm_source=atltw, accessed 7 January 2017.

Strong, J. (1894) *The Exhaustive Concordance of the Bible*, Jennings & Graham, Cincinnati, OH, available at https://www.blueletterbible.org/lang/lexicon/lexicon.cfm?Strongs=G264&t=KJV, accessed 25 November 2016.

Swartzberg, J. (2016) The Myth of Male Menopause, *Huffington Post*, New York, NY, 2 October 2016, http://www.huffingtonpost.com/berkeley-wellness/the-myth-of-male-menopause_b_9143272.html, accessed 25 June 2017.

Syal, R. (2013) Denis MacShane pleads guilty to expenses fraud, *The Guardian*, Guardian Media Group, London, 18 May 2013, available at http://www.theguardian.com/politics/2013/nov/18/denis-macshane-pleads-guilty-expenses-fraud, accessed 6 February 2016.

Sze, J. (2015) *Fantasy Islands: Chinese Dreams and Ecological Fears in an Age of Climate Crisis*, University of California Press, Oakland, CA.

Tarnas, R. (1991) *The Passion of the Western Mind*, Harmony Books, New York, NY.

Taylor, C. (1991) *The Malaise of Modernity*, Anansi, Concord, ON.

Taylor, C. (2007) *A Secular Age*, The Belknap Press of Harvard University Press, Cambridge, MA.

Taylor, D. (2016) Asylum seekers made to wear coloured wristbands in Cardiff, *The Guardian*, Guardian Media Group, London, 24 January 2016, available at http://www.theguardian.com/uk-news/2016/jan/24/asylum-seekers-made-to-wear-coloured-wristbands-cardiff, accessed 6 February 2016.

Teahan, M. (2017) Podcast: Is secularism losing its grip on France? *Catholic Herald*, Friday 3 February 2017, London, available at http://www.catholicherald.co.uk/commentandblogs/2017/02/03/podcast-is-secularism-losing-its-grip-on-france/, accessed 5 February 2017.

Tempel, B. and Janssen, H. (2011) *Mondrian and De Stijl*, Gemeentemuseum, Den Haag. Exhibition details available at https://www.gemeentemuseum.nl/en/exhibitions/mondrian-de-stijl, accessed 15 December 2016.

Thompson, D. J. (1994) Appendix B: Original Statutes of the Rochdale Society of Equitable Pioneers and Today's International Co-operative Alliance Co-operative Principles, *Weavers of Dreams: Founders of the Modern Co-operative Movement*, Center for Cooperatives, University of California, Davis, CA.

Thoreau, H. D. (1845) Walden, in *Walden and Civil Disobedience*, Penguin Books, London, 1983.

Tier Benefits (n.d.) Qantas Airways Limited, Mascot, New South Wales, Australia, available at https://www.qantas.com/fflyer/dyn/flying/tier-benefits, accessed 2 November 2016.

Timani, H. S. (2016) Wealth and the Doctrine of *Al Fana* in the *Qur'an*, Chapter 9, (pp.173–188) of *Poverty and Wealth in Judaism, Christianity, and Islam*, Kollar, N. R. and Shafiq, M. (eds), Palgrave Macmillan, New York, NY.

Times of Oman (2014) Oman's Jebel Akhdar losing its green sheen as farmers migrate, 30 June 2014, available at http://timesofoman.com/article/36705/Oman/Oman's-Jebel-Akhdar-losing-its-green-sheen-as-farmers-migratedisqussion-0disqussion-0disqussion-0, accessed 28 September 2016.

Torres, H. (2016) Christians Face 'Unbearable' Situation in German Refugee Camps; Official Admits 'Underestimating Role of Religion', *Christian Today*, Christian Media Corporation, London, 19 October 2016, available at http://www.christiantoday.com/article/christians.face.unbearable.situation.in.german.refugee.camps.official.admits.underestimating.role.of.religion/98411.htm, accessed 1 November 2016.

Transition Network (2017) available at https://transitionnetwork.org/, accessed 30 June 2017.

Treong, T. (2014) *'Forced labor' rife in Malaysian electronics factories: report*, Reuters, London, 17 September 2014, available at http://www.reuters.com/article/us-malaysia-labour-report-idUSKBN0HC08E20140917, accessed 6 February 2016.

Turner, P. (trans.) (1965) *Utopia* by Thomas More, Penguin Classics, Penguin Books Limited, Harmondsworth, Middlesex.

Udânavargu, Thesaurus Literaturae Buddhicae, Jens Braarvig, Asgeir Nesøen, Tibetan and Norwegian Institute of Palaeography and Historical Philology, University of Oslo, Oslo, Norway, complete text in English available at https://www2.hf.uio.no/polyglotta/index.php?page=fulltext&view=fulltext&vid=71&cid=110637&mid=208435, accessed 30 January 2017.

UK Government (2016) *'Reaching our Potential: Competitiveness in the EU' – Greece*, Report on a seminar organized by the British Embassy, in partnership with the Foundation for Economic & Industrial Research (IOBE), British Embassy Athens, updated 1 February 2016 available at https://www.gov.uk/government/world-location-news/reaching-our-potential-competitiveness-in-the-eu-greece, accessed 12 February 2017.

Ulrich, K. T. and Eppinger, S. D. (1995) *Product Design and Development*, McGraw-Hill Inc., New York, NY.

UNESCO Intangible Cultural Heritage (n.d.) *What is Intangible Cultural Heritage?*, UNESCO, available at http://www.unesco.org/culture/ich/en/what-is-intangible-heritage-00003, accessed 10 March 2017.

UNESCO International Round Table, Working Definitions (2001), Turin, Italy, 14/17–03–2001, available at http://www.unesco.org/culture/ich/en/events/international-round-table-intangible-cultural-heritage-working-definitions-00057, accessed 10 March 2017.

van Aken-Fehmers, M. S., Eliëns, T. M. and Lambooy, S. M. R. (2012) *Delft Wonderware*, Gemeentemuseum, Den Haag. Exhibition details available at https://www.gemeentemuseum.nl/en/exhibitions/delftware-wonderware, accessed 15 December 2016.

Vernon, M. (2008) *Wellbeing*, Acumen, Stocksfield, Northumberland.

Vilinbakhova, T. (2000) Kazimir Malevich and the Sources of the Avant-Garde: Icon-Painting, in Cortenova, G. (ed.) *Kazimir Malevich and the Sacred Russian Icons: Avant-Garde and Traditional*, Electa Espana, Madrid. This section available at http://mostrestoriche.palazzoforti.it/Malevich/icone_en.html, accessed 19 December 2016.

Walker, A. (1974) In Search of Our Mothers' Gardens, in Alice Walker's *In Search of Our Mothers' Gardens: Womanist Prose*, 1983, The Women's Press, London, pp. 231–243.

Walker, S. (2013) Design and Spirituality: Materials Culture for a Wisdom Economy, *Design Issues*, MIT Press, Cambridge, MA, Vol. 29, Issue 3, pp. 89–107.

Walker, S. (2014) *Designing Sustainability*, Routledge, Abingdon, Oxon.

Walton, S. (2017) Theory from the ruins, *Aeon Digital Magazine*, Aeon Media Group Ltd, Melbourne, Australia, 31 May, 2017.

Ward, B. (trans.) (1975) *The Sayings of the Desert Fathers – The Alphabetical Collection*, Cistercian Publications, Kalamazoo, MI and A. R. Mowbray, Oxford.

Ware, K. (1987) The Theology and Spirituality of the Icon, in *From Byzantium to El Greco*, Royal Academy of Arts, London.

Warwick, G. (2006) Introduction: Caravaggio in History, *Caravaggio: Realism, Rebellion, Reception*, G. Warwick (ed.), University of Delaware Press, Newark, DE.

Waterfield, R. (trans.) (2002) *Plato's Phaedrus*, Oxford World Classics, Oxford University Press, Oxford.

Waterfield, R. (trans.) (2006) *Plato: Philebus*, Penguin Books, London.

Waugh, P. (2016) Sir Philip Green's £100m Superyacht Facing Seizure Under Plan To Help BHS Pensioners, *Huffington Post*, New York, NY, 23 November 2016, available at http://www. huffingtonpost.co.uk/entry/sir-philip-green-superyacht-seized-bhs-pensions-top-shop_ uk_58348018e4b0ddedcf5b541a, accessed 11 March 2016.

Weber, D. (2008) *A Visitor's Guide to Saltaire: UNESCO World Heritage Site*, Nemine Juvante (Saltaire) Publications, Bracknell, Berkshire.

Weir, P. (1998) *The Truman Show*, a movie by Peter Weir, screenplay by Andrew Niccol, Scott Rudin Productions, New York, NY. Last lines quotation from: American Movie Classics Company, New York, NY, available at http://www.filmsite.org/greatlastlines7.html, accessed 7 January 2017.

Welsh Love Spoons (2012) National Museum of Wales, available at https://museum.wales/ articles/2012–09–16/Welsh-Lovespoons-1/, accessed 12 September 2016.

White, M. P., Alcock, I., Wheeler, B. W. and Depledge, M. H. (2013) Would You Be Happier Living in a Greener Urban Area? A Fixed-Effects Analysis of Panel Data, *Psychological Science*, Sage Publications, Thousand Oaks, CA, Vol. 24, No. 6, pp. 920–928.

Why drug prices in America are so high, *The Economist*, 12 September 2016, available at http://www. economist.com/blogs/economist-explains/2016/09/economist-explains-2?fsrc=scn/tw/te/bl/ed/, accessed 12 September 2016.

Wilkinson, R. and Pickett, K. (2009) *The Spirit Level: Why More Equal Societies Almost Always Do Better*, Allen Lane, Penguin Group, London.

Williams, A. Z. (2011) Faith no more, *The New Statesman*, London, 25 July 2011, http://www. newstatesman.com/religion/2011/07/god-evidence-believe-world.

Wilson, A. N. (2015) *The Book of the People: How to Read the Bible*, Atlantic Books, London.

Winterson, J. (2016) *Christmas Days*, Jonathan Cape, London.

Wood, F. and Wood, K. (1999) *Homer's Secret Iliad: The Epic of the Night Skies Decoded*, John Murray, London.

Wood, F. and Wood, K. (2011) *Homer's Secret Odyssey*, The History Press, Stroud, Gloucester.

Woodlands School (2015) Woodlands School of Life: A Lesson in How to Make a Difference, *Native Art in Canada – An Ojibwa Elder's Art and Stories*, available at http://www.native-art-in-canada. com/woodlandsschool.html, accessed 18 July 2017.

Wordsworth, W. (1798) We Are Seven, in Gill, S. (ed.) (2004) *William Wordsworth – Selected Poems*, Penguin Books Ltd, London, pp. 56–59.

Wordsworth, W. (1798) The Tables Turned, in Gill, S. (ed.) (2004) *William Wordsworth – Selected Poems*, Penguin Books Ltd, London, pp. 60–61.

Worms, F. (1989) The Teaching of Moderation, *The Jewish Quarterly*, Taylor and Francis, London, Vol. 36, No. 1, pp. 9–10.

Xingzhong, Y. (2016) quoted in *Toward A Global Intellectual Response to Pope Francis' Environmental Thought* by V. Ialenti and Meridian 180, ReligiousLeftLaw.com, available at http://www. religiousleftlaw.com/2016/01/toward-a-global-intellectual-response-to-pope-francis-environmental-thought.html, accessed 8 February 2016.

Yannu Munu, E. (n.d.) *The Dreaming – an information sheet*, Blue Mountains Walkabout, Sydney, Australia. Information available at www.BlueMountainsWalkabout.com, accessed 8 October 2016.

INDEX

Note: page numbers in italic type refer to
Figures; those in bold type refer to Tables.

Aboriginal cultures, Australia 165; children and
 art 86; land management practices 88
action figure, broken *50*
Adderley, Julian 'Cannonball' 266
adolescence: rites of passage 169; *see also*
 children; young people
Adorno, T. 184
Agnus Dei (Zurbarán) 70–71
agriculture, industrial 130, *131–140*
airline industry, status differentials in 25–26
Akunin, Boris 121
allegorical interpretation 284, 285
allegorical level of seeing 71
anagogical interpretation 284, 285
Annunciation, The (Poussin) 69
another reality 182–184, 187–198; design
 directions 193–197; language of myth
 188–191; overcoming the current
 condition 191–193; root of the problem
 184–188
Antigone 100
Antwerp 218
Apollo 13 30
Apple 71
Aristotle 80
Armstrong, K. 158, 209
art/arts 125–126, 280, *281*; commodification
 of 198; crafts as 60; devaluation of 55–56,
 187; and drive 127–128; RAW (Religion,
 Art and War) design 230–231
artefacts 255, *256–263*
Arts Council of England 56
ASA (Advertising Standards Authority) 19
astronomy, and mythical stories 165
atomization 103–104
augmented reality 24
'Auguries of Innocence' (Blake) 86
Australia: traditional landscapes 88; *see also*
 Aboriginal cultures, Australia
authenticity, and tradition 106–107
axial man 272–273

balance, and progressive design praxis 274–274
banking industry: immoral and illegal practices
 277; loss of respect for 33, 34

Barnwell, M. 279
Bauhaus 71
beauty: augmented 24; and fragility 88–89
Bellori, G. P. 68
benevolence 278
Bible, the 165–166, 192, 195–196, 209; and
 children 86; *Ecclesiastes* 77; Genesis 211;
 symbolic language 241–242; *see also*
 Christianity
Blackburn, S. 292
Black Square (Malevich) 167, *168*
Blake, William 86
blindness, enculturated 164–166
Bon Marche, The 108
BP 19
branding 18–19; and unbranded goods 22–23;
 see also marketing and advertising
Braun 71
British Home Stores 96
Britten, Benjamin 207
Brooks, David 197
Brueggemann, Walter 193
Buchan, John 91
Buchanan, I. 287
Buddhism 80, 159, 161, 196, 243
businesspeople, loss of respect for 33–34

Cadbury company, Birmingham 96
Campbell, J. 185
Canada 91
Canteloube, Joseph 207
Caravaggio, M. 67–70, 73
carbon 48, *49–54*
cathedrals 243
Catholic Church 150, 201, 275; *see also*
 Christianity
CDs (compact discs) 116
Chagall, Marc 162
Chambers, Paul 266
change 108–109
Chants d'Auvergne (Canteloube) 207
charity 281–282
Chartres cathedral 243
children: and art 86; *see also* adolescence
China 42, 43, 86, 94, 95
Christianity 80, 150, 162, 169, 196, 209, 243;
 see also Catholic Church; church, the
Christianson, E. S. 77

Christmas Day (Winterson) 168–169
church, the: immoral and illegal practices **277**;
 see also Catholic Church; Christianity
classification, limitations of 3
clients, designing for 230
climate change: and the decline of Western
 civilization 209; *Stern Review* 121; *see also*
 environmental issues
Cobb, Jimmy 266
co-design 193
cohousing projects 194
Colegate, Isabel 162
Coleridge, Samuel Taylor 93
Coltrane, John 266
commonality, and originality 149–152, *153*
common culture 279
communal creativity 151–152
community, restoration of 195
companies 6–7
competitiveness 4–5
Confucius 80
consumerism 79, 186–187, 269, 277, 280, 293;
 and crafts 60; environmental impact of 72
consumption, reduction of 159, 203, 219, 245
contemplation 249
cooperative movement 97; Mondragon
 cooperatives, Spain 201
'cosmopolitan localism' 145–146
Cottingham, John 124, 275
countries, and competitiveness 4
cowboy country, western Canada 44–45
crafts 142–143; as intangible cultural heritage
 94–95; and kitsch 59–60; raising status
 of 60
creative activities: rituals and routines of
 150–151, 152; and sustainability 122
creative and cultural industries 36–37, 127
creative disciplines, and universities 225
creative life 223
creativity: and death 227–228; and faith 162;
 and improvisation 265–267; and myth
 190–191; and spirituality 266–267; and
 tradition 227–228
credit card, out-of-date *51*
Crime and Punishment (Dostoyevsky) 121
crucifixes 243, *263*
cultural renewal, and spirituality 208
Cultural Revolution, China 94
culture: common 279; high and low 211–212,
 279; and progressive design praxis
 279–281, *281*; *see also* creative and cultural
 industries; cultural renewal, and spirituality
Cumbria 273

Dahl, Roald 151
Darwin, Charles 161
Davis, Miles 266–267
Dawkins, Richard 161
death, and creativity 227–228
Death of a Salesman (Miller) 29
Deepwater Horizon explosion 19
deference, loss of 33–34
Delft Wonderware exhibition 61–62
Descartes, René 242
design: and interpretation 285–286; Rams' ten
 principles of good design 71–72;
 RAW (**R**eligion, **A**rt and **W**ar) 230–231;
 as a values-based discipline 214–215
design directions 193–197
design practice 220
design research 194; foundational issues 194;
 interdependence 195–197; practical
 initiatives 194
design rhapsody 206–207
design thinking 63–64; too much of 65
DESIS *(International Design Network for Social*
 Innovation and Sustainability) 194
de Sousa, Victor 273
digital music 116, 117
digital photography 119–120
disenchanted world view 184, 269
disposable razor *53*
Doctrine of the Mean, The (Confucius)
 80
Dostoyevsky, F. 121
drawing 85
Dreaming stories, in Australian Aboriginal
 cultures 86
drive 127–128
drop spindle *257*

East Timor 273
Ecclesiastes 77
Eckhart, Meister 281–282
eco-dystopian narrative 206
eco-modernism 271
economic growth 81, 269
economic rationalism 4
economy 142–143
Edwards, Betty 85
Eliot, T. S. 279
enculturated blindness 164–166
enduring things 240–243
England: Industrial Revolution 93, 95
enlightenment 161
Enlightenment, the 161, 184, 195
entertainment, passive 35–37

environmental issues 186, 192, 276, 283;
 misguided technological solutions **270**,
 271–272; sharing schemes 204–205;
 see also climate change; sustainability
ethics: *ethical* level of seeing 71; and science and
 technology 213–216
European Union 275
Evans, Bill 266
explorers, nineteenth-century 164

faith 161–162; *see also* religion
family owned businesses 7
financial services industry: immoral and illegal
 practices **277**; loss of respect for 33, 34
fly-tipping 114
folk arts 59
folk music 207
food, augmented 24
foraging 251–252
found materials 30–31
fragility 88–89
France, secularism in 155
fridge magnets 280, *281*
Fry, R. 69, 70
Feuerbach, Ludwig 195

Gadamer, H. G. 268, 275
Gaiman, Neil 190
games development 36–37
Gates, Bill and Melinda/Gates Foundation
 97
Gathering at the Café Pombo (Solana) 104
gathering places 104
Germany: refugee integration policy 158
Glass, Philip 212
globalization 81, 94, 144, 145, 214; and
 production 42–43, 218–219
Godzieba, A. J. 284, 285, 287
Golden Rule 245
Gómez de la Serna, Ramón 104
Gorky, Arshile 126
governments: immoral and illegal practices **277**;
 see also politicians
grain elevators 130, *131–140*
Gray, Eileen 151
Grayling, Anthony 161
Great Buddha of Kamakura, Japan 243
Greece 4; classical 165, 209, 211
Grenfell Tower fire, London 187–188
grief, and loss 192

Hadid, Zaha 151
hamartanó 245

handmade artefacts 244, 247–248, 255,
 256–263
Hardy, Thomas 273
Hayes, Martin 221
Heidegger, M. 275
hermeneutical circle of interpretation 268,
 284–285
Hesse, Hermann 223
Hibbard, H. 68
Hick, J. 209
high culture 211–212, 279
high places 211
Hitchens, Christopher 161
Hojoki (Kamo-no-Chomei) 78
home exchange schemes 204
Homer 165, *175,* 177
hope, and loss 192
Horkheimer, M. 184
Hughes, R. 68, 70
humanities, devaluation of 55–56
human touch 212–122
Huxley, Aldous 195, 196
Huxley, Thomas H. 195
hypodermic syringe, used *54*

icons, religious 167, 168
ideas, ephemeral nature of 224–225
Iliad, The (Homer) 165
imagery, Reformation's destruction of 187
immigration **277**
immoral and illegal practices 276, **277**
'impact' 127
improvisation 265–267
individualism 269
individuals, creative activities of 150–151, 152
Industrial Designers' Society of America 271
Industrial Revolution 93, 95
industry: immoral and illegal practices **277**;
 see also banking industry; pharmaceuticals
 industry
innovation 72
instrumental reason, and progressive design
 praxis 274–278, **277**
intangible cultural heritage 94–95
interpretation 283–285; and design 285–286
inversion 20–21
IP (intellectual property) 147–148
Irish Woolfest, Boorowa, New South Wales 42
Islam 80, 209, 241, 243
Ive, Jonathan 71

jazz 265–267
Jebel Akhdar 87–88

Johnson, Samuel 89
Jones, Quincy 265
Judaism 80, 169, 243

Kaaba, the 243
Kahn, A. 265, 266
Kamo-no-Chomei 78
Kandinsky, Wassily 267
Keats, John 182
Kelly, Wynton 266
Kenkō 159
Keynes, John Maynard 145
Kind of Blue 265–267
kintsugi 115
kitsch, and crafts 59–60
Koran, the 241; *see also* Islam

ladle *261*
laïcité 155
Lake District 93
Lanzi, L. 68
Lao Tzu 241
Last Painting (The Black Monk) (Gorky) 126
left-brain thinking 64, 85, 86
leftover materials 30–31
legacy 83
libraries 203
'Library of Things' 204–205
Lindner Sock Factory 42–43
literal interpretation 284, 285
local, the 288; and business ownership 7;
 and globalized production 42–43; and
 unbranded goods 22–23; and universities
 57–58
Longhi, R. 69
Longley, C. 124
loss, and recovery 192
low culture 211–212
low places 211
Lyrical Ballads (Wordsworth and Coleridge)
 93

machine-made products 244–245, 247
Maimonides 80
Malevich, Kazimir 167, 168, 170
Mann, Thomas 230, 267
Marcus Aurelius 77–78
marketing and advertising 214–215, 293; *see
 also* branding
mark of the hand 244
Marx, Karl 195
mass-produced products, and RAW (**R**eligion,
 Art and **W**ar) design 230–231

material goods: metaphysical conception of
 243; reduced consumption of 159, 203,
 219, 245
materialism 269
Maugham, W. S. 89
May, Theresa 187–188
meaning, in life 227–228
media: immoral and illegal practices 277
Meditations (Marcus Aurelius) 77–78
menorah 243
mental health, and natural environments 90–92
Merton, Thomas 272, 276
metaphysical texts 240–242, 274–275
Middle Way, The (Gautama Buddha) 80
Mies van der Rohe, L. 65
Miller, Arthur 29
minimalism 72
Mitchell, Thomas 88
mobile phones *see* smartphones
moderation 80–82
modernism 61–62, 151
modernity 191, 286
Mondragon cooperatives, Spain 201
Mondrian, Piet 61
Mondrian & De Stijl exhibition,
 Gemeentemuseum, Den Haag 61, 62
moral interpretation 284, 285
More, Thomas 147–148, 277–278, 282
Morrisseau, Norval 196–197
music: high and low culture in 212; and
 rhapsody 206–207; and ritual 117–118;
 spirituality and improvisation 266–267
myth: ancient 164–165; and creativity
 190–191; high and low places in 211;
 mythical thinking 183, 188–191, 197,
 198; mythic objects 173, 174, *175,* 176,
 177, 178, *179,* 180, *181*

Native American cultures 169, 196–197
nature, wisdom of 90–92
Needleman, Jacob 241
neoliberalism 269
Nineteen Eighty-Four (Orwell) 63
Norfolk Rhapsody No. 1 (Vaughan Williams)
 206–207
novelty 49

oak swill basket *256*
Odyssey, The (Homer) 165, *175,* 177
On Origin of Species (Darwin) 161
originality, and commonality 149–152, *153*
Orwell, G. 63

Panayia Evangelistria 158
Pandora myth *181*
passive entertainment 35–37
past, the 83
peace 282
perspective 123–124
Peter Grimes (Britten) 207
Phaedrus (Plato) 273
pharmaceuticals industry 147
Pherecydes of Syros 100, 178, *179*
philanthropy 96–98, 201
photographs 119–120
Plato 148, 273, 282
poetry 220–221
politicians: loss of respect for 33–34; *see also* governments
Postman, N. 35, 36
Poussin, N. 67–68, 69, 70
practical level of seeing 71
praxis 286–287; and theory 124; *see also* progressive design praxis
prayer rugs 243
prestige 25–27
privatization, of property 10, *11–17*
production: globalized 42–43, 218–219; human scale 288; *see also* handmade artefacts; mass-produced products
profit, and science and technology 214–215
progressive design praxis 268–269, 286–290, *289, 291,* 292–293; and balance 272–274; and instrumental reason 274–278, **277**; and interpretation 283–286; and self-transcendence values 278–283, *281,* 288, 292; and values 269, **270**, 271–272
Prometheus 180
property, privatization of 10, *11–17*
Prose, F. 68, 70
protectionism 144–146
pubs 103

Rams, Dieter 71–72, 151
RAW (**R**eligion, **A**rt and **W**ar) design 230–231
realism, and loss 192
reality: augmented 24; *see also* another reality
Reformation 184, 185
refugee integration policy, Germany 158
rejuvenation 238, *239*
religion 154–155, 184–185; as a communal activity 159–150; misreading of 157–159; and philanthropy 201; RAW (**R**eligion, **A**rt and **W**ar) design 230–231; and science 160, 195–196; Western perspectives on 154, 158, 209–210; *see also* Buddhism; Christianity; faith; Islam; Judaism
religious art 167–170
religious studies 55
repair 114–115; *see also* waste
Republic (Plato) 282
research 56
respect, loss of 33–34
resurrection 116–118
rhapsody 206–207
Rietveld, Gerrit 61, 151
right-brain thinking 64
ritual: communal 159–150; and music 117–118
Robinson, Marilynne 34
Romanticism 86, 93
Rowntree company, York 96
ruination 234, *235*
Rumi, Jalāl ad-Dīn Muhammad 241
Ruskin, J. 68
Russell, Bertrand 20, 282

sacred time 156
Saltaire/Titus Salt 96–97
Sardinia 273
satchel *258*
Scheffler, S. 274
scholarship 56
Schumacher, E. F. 97, 196
science: domination of 55–56, 187; and myth 188–189; and religion 160, 195–196; and technology 213–215; as a way of knowing 240, 275
Scruton, R. 36, 279, 287–288
sea silk *(byssus)* 273
secularism 154–155, 158, 182–183, 209
security 278
seeing, changing ways of 67–73
self-transcendence values 288, 292; and progressive design praxis 278–283, *281*
selling and salesmen 29
Separate Reality, A. (Morrisseau) 196–197
service design 193
Shanghai, China 95
Shareable, San Francisco 204
shareholders 6–7
Sharing Depot, Toronto, Canada 204–205
sharing schemes 203–205
shepherding 273
Shortt, R. 275
Sick Heart River (Buchan) 91
Siddhartha (Hesse) 223
silence 283
Simon, Herbert 271

simplicity/simple living 78–79, 245, 282–283
single-use camera *49*
skill 265
Small is Beautiful (Schumacher) 97, 196
smartphones 73, 103; addictive qualities of 72;
 defunct *52*; ways of interpreting 71–72, 73
Smith, Adam 145
Smith, Zadie 76, 150
snow goggles *259*
social equity/inequality 185–186, 269, 276; and
 wisdom economy 201–202
social justice 282
social knowing 275
social media 18, 29; *see also* smartphones
Socrates 77, 80, 273
Solana, José Gutierrez 104
Sophocles 248
Spencer, J. M. 266
spiritual awakening, in myths 190
spirituality, and improvisation 266–267
spiritual quest 215–216
spiritual renewal 208–210
sports: immoral and illegal practices **277**
Starck, Philippe 151
status differentials 25–27
Steindl-Rast, D. 228
STEM (science, technology, engineering and
 mathematics) subjects 55–56
Steppenwolf (Hesse) 223
Stern, Nicholas/*Stern Review: The Economics of
 Climate Change* 121
sticky-rice basket *260*
studio model of design training 63–64
studios 151
suburbia 20
Sudo Park, Tokyo 157
sufficiency 282–283, 290, *291*
suggestion, power of 20
supermarkets, and branding 22
sustainability 159, 185, 290, *291*; and
 misguided technological solutions **270**,
 271–272; and spirituality 208; *see also*
 environmental issues
symbolic language 241–242
symbolism, in non-Western art 85–86
Syros 99–101

Tables Turned, The (Wordsworth) 91–92
Taverner, John 212
taxonomies, limitations of 3
technology, and science 213–215
'technoscience' 213–215
techo-utopian narrative 206

theory, and praxis 124
thinking-and-doing 63, 64, 67
Thirty-Nine Steps, The (Buchan) 91
Thomas, Dylan 151
Thoreau, Henry David 78–79
Thyssen Gallery 125–126
Timani, H. S. 81
time, sacred 156
timelessness 266
Titian 69
towns 13
toy boat *262*
Toynbee, Arnold 208, 209, 210
tradition 278; and authenticity 106–107; and
 creativity 227–228; loss of 83; rejection
 of 185
traditional cultures and communities 87–88,
 273–274; and material resources 142; and
 nineteenth-century explorers 164
traditional texts 240–242, 274–275
Transition Network 194
transporting of goods 218–219
trivia 224–225, 280
trust, loss of 33–34

Uma Lulik (de Sousa) 273
unbranded goods 22–23
Under the Greenwood Tree (Hardy) 273
UNESCO: Intangible Cultural Heritage
 initiative 94–95
universalism 278
universities: and branding 18; and
 competitiveness 5; and creative and
 cultural industries 36–37; and creative
 work 225; internationalization 57–58; and
 marketing 19; poor relationships with local
 communities 57–58
urbanization: China 94; Industrial Revolution 93
useless things 226
utility 226

values 293; and design 214–215; and
 progressive design praxis 266, 269, **270**,
 271–272, 278–283, *281*; and science and
 technology 213–216; self-transcendence
 278–283, *281*
Van Doesburg, Theo 61
Vaughan Williams, R. 206–207
Veronese, P. 69
vinyl records, resurrection of 116–118
*Virgin and Child with Angels Appearing to the
 Saints Anthony Abbot and Paul, the Hermit*
 (Veronese) 69

virgin birth 169–170
vocation 127–128
Volkswagen emissions scandal 19
voluntary simplicity *see* simplicity/simple living

wabi sabi 115
Walker, Alice 191
Walton, S. 186, 191
war: RAW (**R**eligion, **A**rt and **W**ar) design
 230–231
warrior's quest 215
Warwick, G. 70
Wasatiyyah 80
waste 30–31; fly-tipping 114; *see also* repair
'We Are Seven' (Wordsworth) 86
well-being, and natural environments 90–92
Welsh love spoons 59
Western civilization: decline of 208–209; loss of
 spiritual traditions 275; metaphysical texts
 in 241; need for spiritual renewal 209–210;
 and religion 154, 158
Westwood, Vivienne 151
whittling 249–250
Winterson, Jeanette 168–169
wisdom, of nature 90–92
wisdom economy 201–202
Woodlands School of Arts 197
wool, and globalized production 42–43
word, the, supremacy over imagery 187
Wordsworth, William 86, 91–92, 93
work, importance and nature of 201–202, 245
workshop model of design training 64
World Design Organization 271
writing sheds 151

yarn, and globalized production 42–43
Yonoya comb shop, Tokyo 112–113
young people: addictive qualities of
 smartphones 72; rites of passage 169

Zurbarán, F. de 70–71